HALSTON

RIZZOLI
NEW YORK

New York Paris London Milan

HALSTON

INVENTING AMERICAN FASHION

LESLEY FROWICK

WITH A FOREWORD BY LIZA MINNELLI

RIZZOLI
NEW YORK

New York Paris London Milan

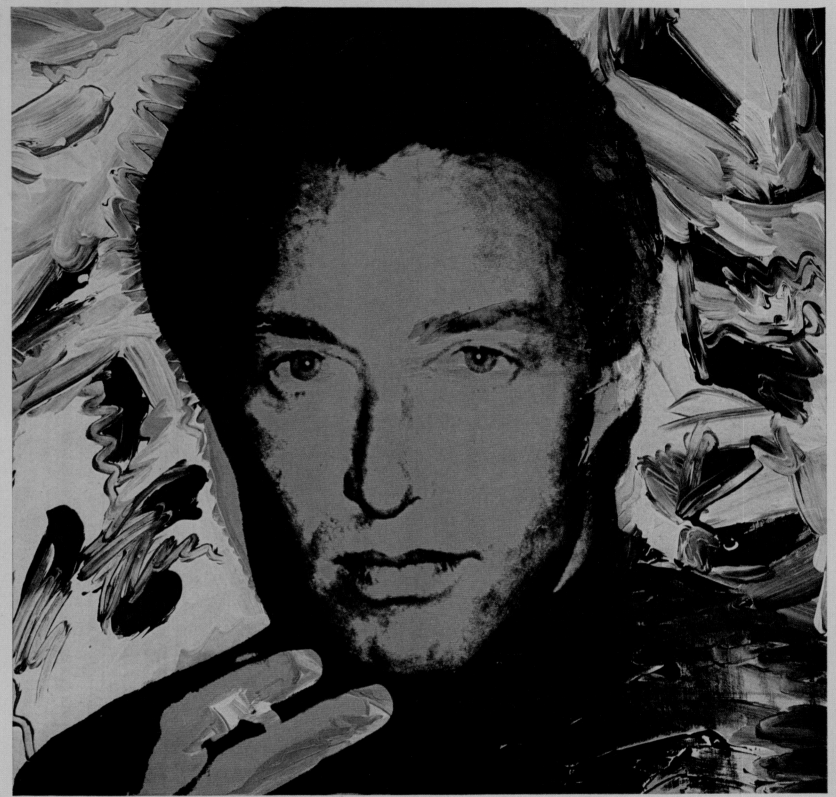

ANDY WARHOL 1974

HALSTON

33 EAST 68TH STREET, NEW YORK, N.Y. 10021 U.S.A.

CONTENTS

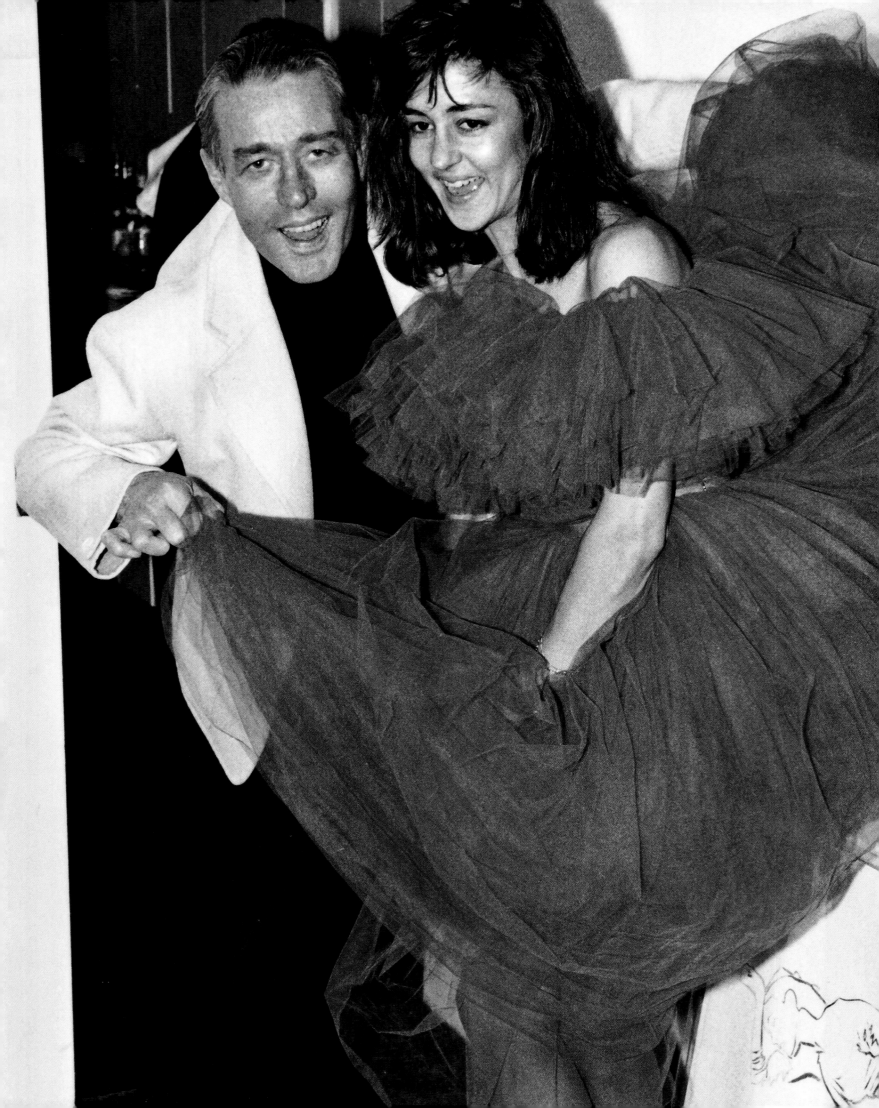

INTRODUCTION BY LESLEY FROWICK

"YOU ARE ONLY AS GOOD AS THE PEOPLE YOU DRESS." — HALSTON

That's how Halston had planned to start his autobiography. He was going to write it with his longtime friend, the fashion journalist Marylou Luther, and outlined his ideas for it, including his opening quote, in a letter he sent to her in 1987. Sadly, that never happened—he fell ill before the project got off the ground. But before he died, Halston told me he was leaving me his personal archive so that, if I chose to, I could tell the story that he never had a chance to begin.

I could not, however, bring myself to begin right away. But as the twenty-year anniversary of his death loomed, I knew it was time to get started. I opened boxes and started to read. Though I had known Halston was organized and meticulous, it was only then that I realized just how organized and meticulous he was. He kept everything. It's through his own timeline of newspaper clippings and quotes, coupled with never-before-published images of him with his friends and family, that I've been able to tell his story. After four long yet energizing years of research and interviews with his inner circle, I can confidently say that this is the definitive story of my beloved uncle Halston. It's not the one that's most often told—that of the social butterfly who seemingly preferred to go clubbing rather than be in the design studio—but of the person I knew.

Halston and I were born on the same day, April 23, twenty-six years apart. I always felt this gave us a special bond. I would have stuck my hand in the fire to protect him. In return, he did everything he could for me, as he did for everyone he loved. As his fame grew, he never lost sight of his roots, his work ethic, or his family. His built-in compass guided him through the most trying, challenging, and extravagant of times. He was always able to poke fun at himself. "I am just a dressmaker," he used to proclaim. Another Halston saying was, "There are no problems, only opportunities," a fitting motto for a man who saw life through rose-colored glasses (no doubt of his own design).

I had the extreme privilege of landing in Halston's New York orbit at the tender age of twenty-three. I was a tomboy, though, thanks to a childhood spent as a Foreign Service brat in various European capitals, one with a cosmopolitan veneer. As he did everyone who crossed his path, Halston transformed me into what he'd call a "glamour puss." He instinctively knew the right colors, styles, and proportions for everyone's body type and lifestyle. He always had a solution to whatever problem was at hand. Not surprisingly, his entourage looked to him for answers, whether it was about what to wear or how to resolve their life's dramas. He taught me how to carry myself, how to walk into a room tall and proud, how to rise above uncomfortable events, and how to navigate the mean streets of Manhattan. What he did not teach me was how to deal with losing him. After twenty-four years, I still miss him enormously.

This is a story of a self-made man who rose from the amber prairies to the glittering heights of success in Manhattan. Along the way, he created a uniquely American definition of chic that remains relevant to this day—one of simplicity made elegant. He was the first superstar American designer. Without Halston, there would have been no Tom Ford, no Calvin Klein. Instead of looking to Europe, he designed for American women and the busy yet casual lives they led. When I interviewed Hamish Bowles for this book he told me, "Halston held a mirror up to his times. You had a sense of a new American woman emerging who led a busy life with multiple layers of responsibility and wanted clothes that were flattering, glamorous, and uncomplicated, luxurious in an understated way." He was a pioneer, not only in the clothes he designed, but in the way he built his business. With Halston, the house he lived in, the people he chose as his friends, the food he ate—all were as important as the clothes he designed. Halston lived his aesthetic every day, far before the concept of branding had become commonplace.

Yet for all his exterior bravado, he fervently protected his privacy and that of his entourage's. His family was incredibly important to him, as were his Midwestern roots. He never forgot where he came from or the people who helped him along the way. It's this person I wanted to write about. This is the story of the man behind the black cashmere turtleneck—my mentor, my friend, my beloved uncle, Halston.

Halston and I celebrating our shared birthday, April 23, 1988. The purple tulle party dress was a special gift from family friend and "Halstonette" Nancy North.

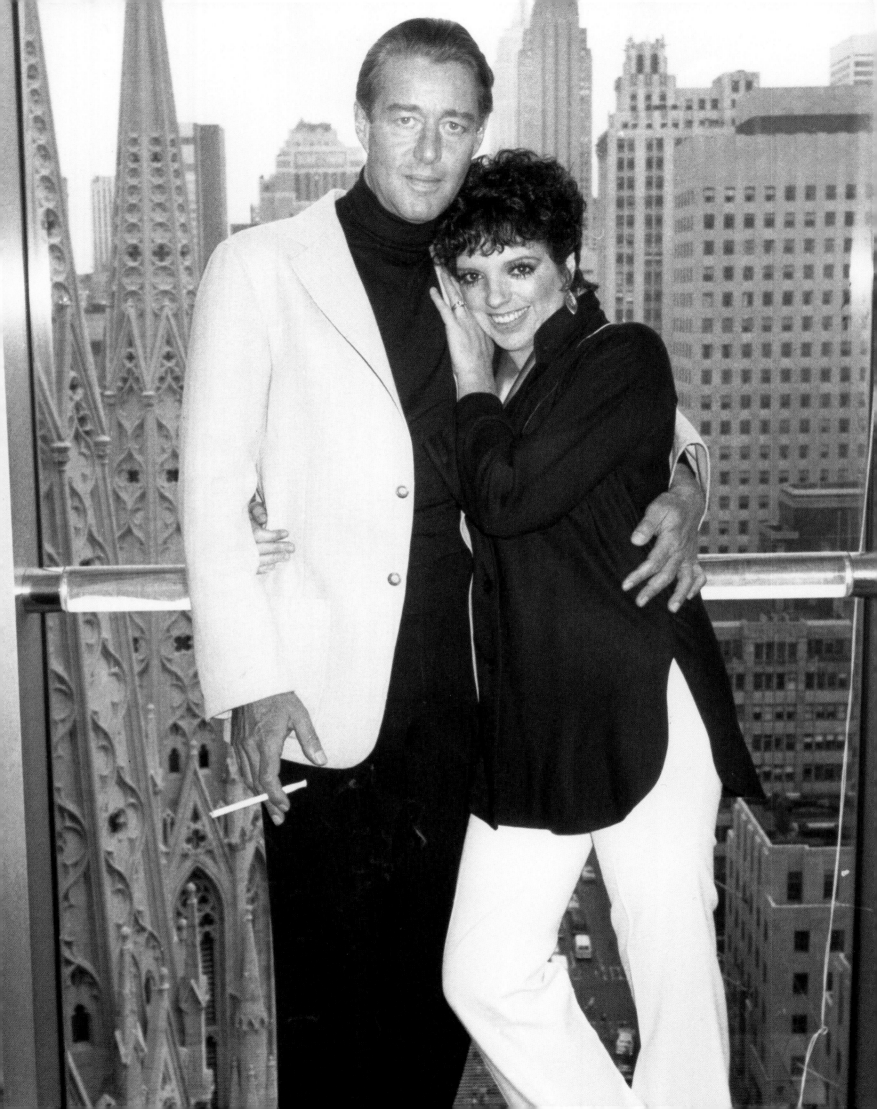

WHATEVER MAKES YOU HAPPY BY LIZA MINNELLI

Halston came into my life in the late 1960s via my god-mother, Kay Thompson. Kay was not only a gifted musician, composer, and author, she was also the chicest person in the world, so of course she knew about Halston. Kay discovered him at one of the small boutiques that existed at Bloomingdale's at the time. I remember her taking me there and saying, "This is what you need." His clothes were so simple and minimal and fashionable. They let the body tell the story, versus the clothes "fighting" the body. I tried on an argyle suit made of soft wool—a long, straight-lined jacket with patch pockets and a slight flair in the pants and at the cuff. "Perfect!" said Kay. She then took me to Halston's studio on East 68th Street. He was such a gorgeous, open, warm, and inviting man. He was a maverick—a kind maverick. When Kay introduced us, she said, "Liza? Halston!?" And that was it. Halston was my best friend. We talked all the time. I called him every day, even when I was on tour. If I was in town, I would go over to his place for lunch just to hang out. I was there one day soon after we first met when he had me try on a cashmere sweater set. It was beautiful and plain, cut exactly right and the perfect length. Of course, I loved it. He said, "Take it, it's yours." That was so Halston. "Whatever makes you happy, honey." He would say that all the time. And he meant it. He was unbelievably generous with his time and his talent. I'd call him at one o'clock in the afternoon and say, "I have a party to go to tonight," or "I'm performing on a TV show," and he would reply, "All right, come over this afternoon at three." And he would have the perfect thing for me to wear in time for the event—always understated, always gorgeous. Halston designed everything I wore to my shows. He would say, "Talk to me." I would tell him what the shows were about and my part in them. He said I described things so well that I inspired him. "I want you to shine, Liza," he would tell me. "Leave it to me. You sing and I'll work on the costumes."

He had a wonderful philosophy: "Whatever works." He would find the best way to make something work, whether it was for himself or someone else.

When Halston learned I would be taking a trip to Marbella, at the invitation of the Rothschilds, he was very specific: "I want you to go out and buy five pieces of Vuitton luggage," he said. So I went out and got the suitcases. He said, "Send them to me and come back to me in two weeks." When I went to pick up the luggage, he showed me how to wear everything he had made—but to do so he had put together a book with arrows! It included all the outfits I needed to wear and when, all the way down to the accessories. I trusted him so much I didn't even ask what the clothes were going to look like. I knew enough to choose him. And I listened. Halston was such a good listener, too. He knew what would make everything just a little better for people. If he sensed someone needed him, he took care of every detail. With my husband Mark, when I was pregnant, we had a miscarriage rather far along. I called Halston from Lake Tahoe to let him know about our sad news. Before we got back home to New York he had our apartment, which we had just purchased, decorated. When we walked through the door every single candle was lit. It was such a generous gesture—like everything he did, it was perfect.

When he got sick, he wouldn't tell anyone. In those days people didn't treat AIDS like a disease; instead it was a label. He said nothing because he didn't want people to be uncomfortable. He never explained himself because he didn't have to. When I would call him at the hospital and ask, "How are you doing, honey?" he would say, "Oh, I just hate the sheets." He told me, "I am doing fine, darling, just fine. Don't you worry. Just do what you do and I'll always be with you."

Halston was, and is, such a huge part of my life. He is still with me. I can't tell you how much I think of him all the time.

Halston and Liza Minnelli, c. 1978, at Halston's Olympic Tower showroom overlooking the spires of St. Patrick's Cathedral and downtown Manhattan.

ONLY OPPORTUNITIES

In the beginning, things weren't so glamorous. Roy Halston Frowick, the somewhat unwieldy moniker my uncle was saddled with, was a child of the Depression, born in Des Moines, Iowa, on April 23, 1932. His family life, though secure and happy, wasn't wealthy or privileged. He was the second of four children of James Edward Frowick, a great-grandson of Norwegian immigrants whose surname was anglicized from Fruvik, and Hallie Mae Holmes Frowick. He was named Roy after his father's brother, and Halston after his maternal grandfather. My father, Robert, better known as Bob, was two years older. The two other Frowick kids were Sue, who was born five years after Roy, and Donald, who arrived eight years after his sister. My dad was born on the dining table of my grandparents' house, but at his father's insistence, Roy was the first of the Frowick kids to be born in the hospital.

Baby Roy, as he was known to differentiate him from his uncle, was a big, handsome infant. My great-aunt Dottie remembers the compliments my grandmother Hallie Mae would get about her two oldest sons: "The ladies would all comment on how adorable they were. They look so different —Halston was fair with green eyes and Bobby dark complexioned with brown eyes," she told me. "The ladies never believed they both belonged to Hallie." Halston's first publicity came at the tender age of two, when he was voted the "Healthiest City Boy" at the Iowa State Fair.

Halston's charm was evident early on. At the age of six he fashioned a May Day basket for his friend Beverly Beaumont, a little girl from the neighborhood. In a foreshadowing of his later life, this sweet gesture came with press coverage: a photo of him presenting the flowers to her appeared in the *Des Moines Register*. Halston's feeling for fashion came early, too. His mother,

Hallie Mae, was his first muse. He created one-of-a-kind hats for her from an early age using flowers from their garden or, on one memorable occasion, items from her kitchen. She wore this particular creation to church, where one of the other women remarked on her lovely hat's resemblance to Chore Boy pot scrubbers. Family lore has it that Hallie Mae just smiled, acknowledging the compliment but not divulging just how accurate her friend's assessment was!

Halston also loved making over his cousins and siblings. When the family would gather at his great-uncle Harry and great-aunt Lucy's farm, he'd dress them up in cast-off grownups' clothes, which he'd accessorize with chicken-feather headdresses. During World War II, like school kids across America, he knitted for troops overseas. Forty years later, as we lounged on deck chairs at his house in Montauk, he told me about it. "We would put our books to one side and the teacher would give us all knitting needles and yarn and we would knit for an hour for the soldiers and the war effort," he remembered. Though I would guess that most of the boys rolled their eyes when the wool came out, Halston enjoyed the challenge. He always liked working with his hands, even when he had a staff to execute his vision.

By the time he was a teenager at Benjamin Bosse High School in Evansville, Indiana, where the Frowick family moved in 1942, Halston was a highly sought-after wardrobe counselor. Every season, he'd decide what his crew of friends—which, in another foreshadowing of his adult life, was made up of kids from the best families in town—should wear, putting his own spin on their outfits. A sweater tied around the shoulders, a look he'd later render in cashmere for his upscale clients, became his signature finishing touch. Tall, handsome, and

Opposite: Young "Baby Roy" Halston Frowick, c. 1935. Early on, adults began calling him "Halston" to differentiate his name from his Uncle Roy's. Above: Halston presenting a May Day basket of his own design to his neighbor Beverly Beaumont, c. 1937. This sweet gesture prompted press coverage in the *Des Moines Register*.

11

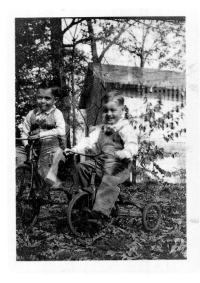

S ophisticated international star that he was, Halston nonetheless described himself as being "as American as apple pie." Born into a close-knit, loving family, he played with siblings and swam in the nearby lake, visited the family farm, and—true to form—loved to dress up his cousins and siblings in cast-off grown-ups' clothes, which he'd accessorize himself.

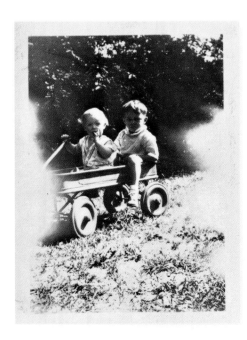

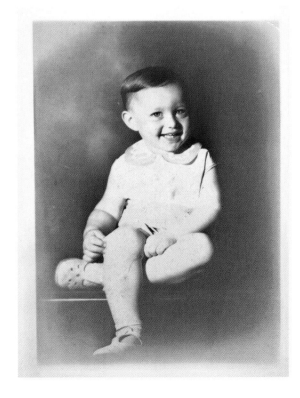

Above: Photographs from Halston's childhood, 1935–40. Opposite: A young Halston, already photogenic, at the family farm in Slater, Iowa, c. 1940.

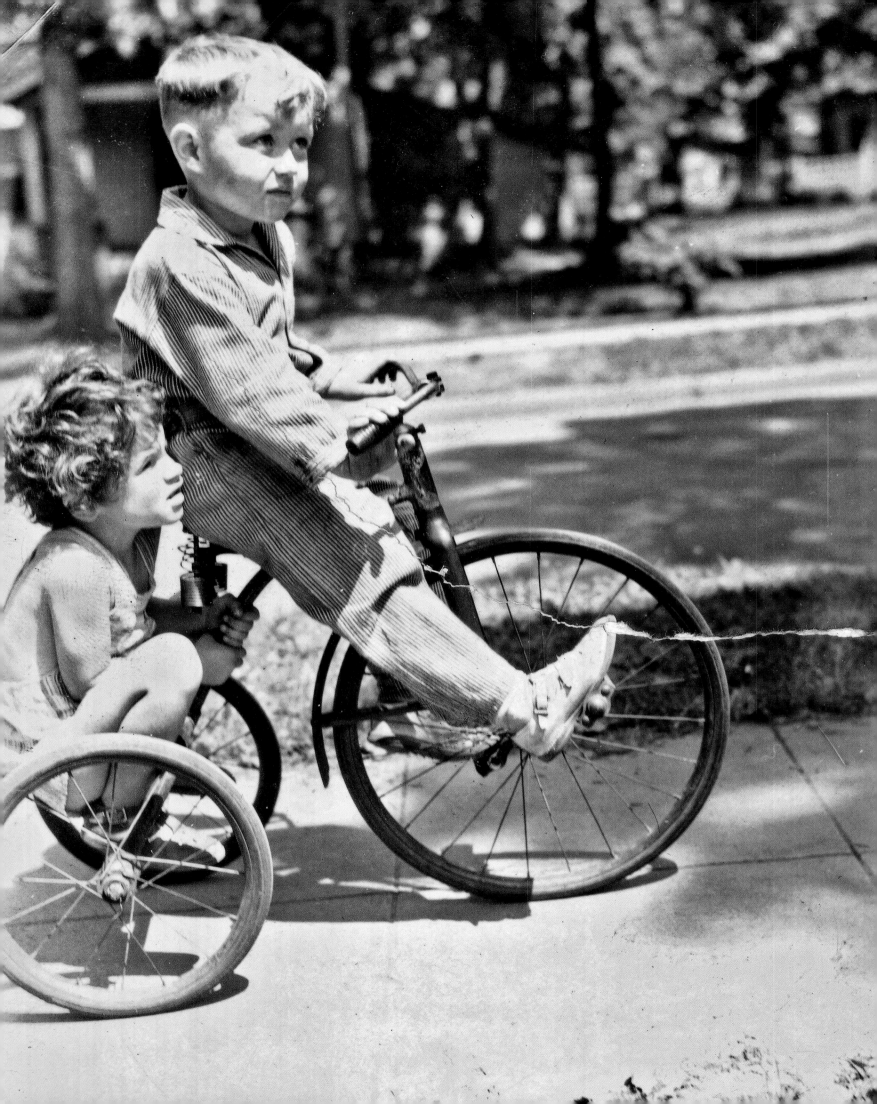

H

alston on his tricycle, 1937 (opposite). Photographs from Halston's childhood and teenage years, including his school portrait, 1945 (right). Always dressed to the nines, Halston became a valued wardrobe consultant for his friends.

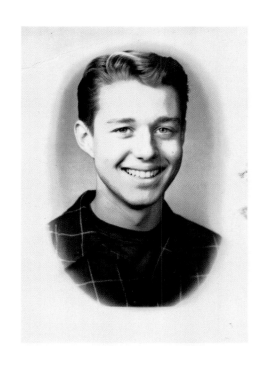

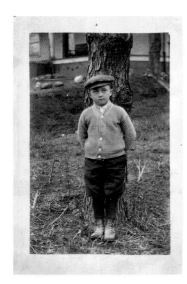

a great dancer, he was popular and very social. He was also an Eagle Scout, a fact that may seem at odds with his glossy fashion designer image but one that was true to the private man. "Halston was plain as a cornfield once you finally got to know him—it was that Midwest thing," says the interior designer Jeffrey Bilhuber. "He was earnest, hardworking, diligent. Good learners come from wide-open fields. If given the opportunity to rise they exceed expectations. They build vertically because everything is horizontal in their world. I think they never forget their Midwestern roots."

Halston certainly didn't. Years later, when he couldn't make it to a high school reunion, he sent a vial of Halston perfume for every woman in his class. And when he embarked on what turned out to be a disastreous relationship with J. C. Penney, he did so because he wanted every woman to enjoy stylish clothes. "You know me, I'm American as apple pie," he told *Women's Wear Daily* at the time. "I'm the original Mr. Sweater Set. I like casual clothes and have never been able to make them. When I was a kid, I shopped in J. C. Penney. Remember, I come from Des Moines, Iowa."

After a spring semester in 1952 at Indiana University, Halston decided it was time to move on to wider pastures. He enrolled in an evening school class in fashion illustration at the Chicago Art Institute (now the School of the Art Institute of Chicago) and secured a job designing windows at the Carson Pirie Scott and Company department store. He didn't last long at the institute— his teachers told him he knew as much as they did—but the window-dressing job was to have a long-lasting impact on his career.

As it was in Chicago that the Halston legend began, this is a good place to explain the evolution of his name. After he launched his business, Halston told the press that "Roy Halston Frowick" didn't fit on a label so he shortened it to "Halston," the name he'd used since he was a kid. That much is true, but there's more to the story than that. As a name, "Baby Roy" obviously had a short shelf life. By the time he was a toddler, little Roy was answering to "Halston," a name that stuck until he went to Indiana University, where he became known as "Fro." It's as Fro that he moved to Chicago and started making a name for himself as a

hat designer. Conscious that he was laying the ground for his future image, he encouraged his friends to drop the "Fro" in favor of the more patrician-sounding "Halston." The name Roy, as he used to say, sounded too "hick" while the name Frowick . . . well, that just gets caught on the lower part of your uvula. As he did with his designs, he eliminated the extraneous in order to keep the focus on the essential. His first personal edit resulted in a streamlined, vaguely aristocratic-sounding name that hinted at a New England heritage. In fact, the name Halston has been in the family for generations. My grandmother Hallie Mae's name is a feminized version of it. Her father, Wilbur Halston Holmes, was the first Halston in the family. My brother is George Halston, his son is Colby Halston, and my son is John Halston. Though officially he went by R. Halston Frowick, "Halston" was the name that he used for the rest of his life. He was ready for one-name fame even before it happened.

His work as a window designer at the city's best department store brought Halston into contact with Chicago's social elite, who turned out to be the first customers for the hats he was beginning to make on an old sewing machine in his apartment on Chicago's Gold Coast. "Hats were very big business in those days," he later remembered. "Especially in a windy city like Chicago." Throughout the 1950s and into the 1960s, millinery was an indispensable part of the fashionable woman's wardrobe. Though it's difficult to imagine now, to leave the house without a hat was a major faux pas.

The breadth of Halston's clientele expanded dramatically after he met André Basil Hofner, a German-born hairdresser whose exclusive salon in the elegant Ambassador Hotel was popular with socialites and Hollywood A-listers. The two allegedly became lovers. Hofner, who went by the name Basil, acted as the younger man's mentor, introducing him to his high-society friends and traveling with him to Europe. One impressionable introduction was to Salvador Dalí. Though the two never became intimate friends, Dalí and his wife Gala did invite Halston to their color-coordinated dinners and once to their retreat on the Spanish coast. Dalí requested that Halston arrive

for the weekend on the couple's rowboat—standing in the prow dressed as Louis XIV, with the rowing Gala as Marie Antoinette. With Basil's help, Halston was soon moving in the city's loftiest social circles. One of the people he met as a result was the American couturier Charles James, whose mother was a Chicago patrician. Charles's architectural approach to design would have a major influence on Halston. In 1968, he told *Women's Wear Daily*, "Charles James played a very important part in my life. I met him in Chicago and he introduced me to a high element in fashion. I am a great admirer of his."

Halston persuaded Basil to let him set up a tag-team operation at Basil's salon, then called the Boulevard Salon, at 900 North Michigan Avenue. When a client of note had an appointment, Basil would let Halston know so that he could be in the salon when she came in. After a quick assessment of her coloring and features, Halston would dash home—by this time he'd moved to a town house on nearby Astor Street—and whip up a few chapeaux. He'd return to the salon in time to show off his handiwork before the end of the appointment, sometimes when the ladies were still under the dryer. Inevitably, they took the bait offered by the charming young man with the basket full of hats. Among the women who acquired early Halstons this way was Fran Allison of television show *Kukla, Fran and Ollie* fame—his first celebrity client. Halston had such success with this sales method that before long he was able to open his own hat shop, called Halston, at 952 North Michigan Avenue.

By 1954, Peg Zwecker, the powerful fashion editor of the *Chicago Daily News*, wrote of Halston, "very creative and talented, this young designer has a flair for making just the right hat to suit the wearer." Zwecker sent a few of Halston's hats and some sketches to her friend Lilly Daché in New York, at the time the most famous milliner in the country. Daché called back and said, "Send that boy to me immediately!" Halston never forgot Zwecker's kindness. Peg's son Bill Zwecker later wrote, "He credited her in virtually every interview he gave, and when she retired in 1978, he gifted her with a beautiful diamond pendant."

A summons from Lilly Daché was not to be ignored. In 1957, Halston packed up his hatboxes and his alligator loafers, hopped into his Mercedes-Benz convertible, and set off for the Big Apple, the city of his dreams. Upon arrival, he went straight to the Waldorf Astoria, where he'd booked one of the more modest

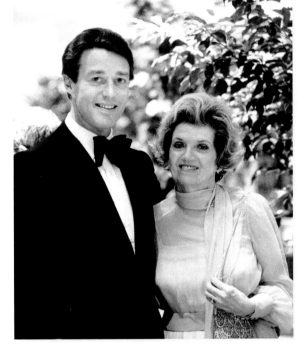

rooms. On being told that the only thing available was the penthouse suite, he didn't miss a beat: he booked it immediately. To top off that extravagance, he scheduled a press conference for the next morning to announce that he'd arrived, thereby transforming an unfortunate error into a public-relations opportunity. It was classic Halston, a prime example of one of his favorite sayings, "There are no problems, only opportunities." As he used to tell me when he was showering my family with Halston originals, "You need to create the illusion of success for people to pay attention."

He didn't stay at the Waldorf for long. He got an apartment at 360 East 55th Street, not far from the Lilly Daché boutique on 56th Street. He was at Lilly Daché for only one year because he wasn't allowed to put his name on his designs and never felt he got the recognition he deserved. The opportunity to move on came, as so much in his life did, through his social connections. One day in early 1958, while he was having lunch with Charles James at La Côte Basque, the upper-crust Manhattan restaurant that was a favorite of Jacqueline Onassis (Jacqueline

Chicago Daily News fashion editor Peg Zwecker (wearing a gown Halston designed for her) and Halston, c. 1976. Halston never forgot Zwecker's generosity in sending a few of his hats and sketches to famed milliner Lilly Daché. Daché invited him to New York—and the rest, as they say, is history.

Kennedy at the time) and Frank Sinatra, he noticed that the Bergdorf family was sitting at the next table. With them was Jessica Daube, a.k.a. Miss Jessica, the well-known head of Bergdorf Goodman's millinery department. The two parties had something in common—both were involved with the same big society wedding. Bergdorf's was supplying the dress and Halston, through his job at Lilly Daché, was making the headpieces. As he later remembered, "Miss Jessica felt I must be something special because I was doing this social plum. So she leaned across the table and said to me, 'If you are ever going to make a change, come talk to me.'" (*WWD*, January 9, 1964) Later that year, Halston did exactly that and jumped ship to Bergdorf's, where he was not only granted his own label, Halston of Bergdorf, but given a budget that allowed him to satisfy his taste for luxury. Miss Jessica and Miss Brandies, the store's two dowager buyers, took him under their collective wing. He traveled to Paris with them on their semi-annual buying trips, where they introduced him to the world of haute couture. He sketched the shows for Bergdorf's reference.

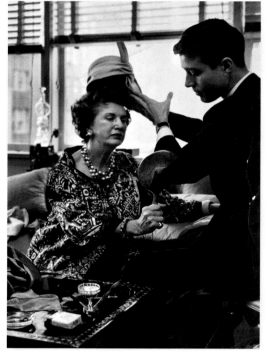

For a young designer with ambition, Bergdorf's was the place to be. The millinery salon was the epicenter for that particular combination of style, money, and social cachet that makes the fashion world tick. Harold Koda, the chief curator at the Costume Institute of the Metropolitan Museum of Art, describes it as a place "where you saw the whole spectrum of New York society, including Broadway stars and rising young socialites together with the New York establishment." This fit right in with Bergdorf's reputation as the most exclusive department store in the city, one whose clientele had their own mannequins and hat molds waiting for them in the made-to-order storerooms.

For these ladies, ordering a hat was a leisurely affair, one that gave them plenty of time to interact with the man designing it. Halston was in his element—and, as Koda observed, it laid the groundwork for his later success. "When you are a milliner, it's just one step away from being a hairdresser in the circumstances of the intimacy of your interaction with the client. You are working with her not only in terms of her own predisposition of styles she wants to wear; you are encouraging her to move forward or in another direction. Couturiers frequently don't have that kind of direct relationship with clients, as they are in the back room; they have their vendeuses on the floor. But as a milliner in that kind of salon, working directly with your clients, that was an important consideration in terms of Halston's ability to be so successful in dressing all the luminaries of New York society by the late 1970s."

While Halston toiled away at Bergdorf Goodman, Andy Warhol, another out-of-towner who was to become the quintessential New Yorker and change the way his profession was viewed, was enjoying his first successes as a fashion illustrator. The two probably met in the early 1960s and went on to become close friends. To quote from Andy's diary, "I met Halston through Joe Eula the illustrator. He took me to Bergdorf and introduced me to Halston, who was designing hats for them. Hats were hot then, especially Halston's." Andy and Halston shared striking similarities. They had similar backgrounds and rose from humble beginnings to positions of power and influence. They were both close to their mothers and looked after them in their old age. They were both fascinated by celebrity. They bought houses within blocks of each other, Andy at Lexington and 75th Street and Halston on 63rd Street just off Lexington. But more importantly, they both took American staples—

Above: Halston assisting Miss Jessica, doyenne of the second-floor millinery salon at Bergdorf Goodman, where he was manager from 1958 to 1967. Opposite (clockwise from top left): A Halston design for a pillbox hat appointed with burnt peacock feathers, 1960; Halston's floppy orange organza hat in this sketch was immortalized on a *Harper's Bazaar* cover, shot by Richard Avedon, January 1960.

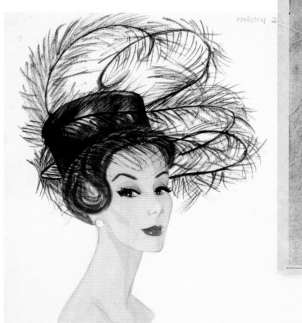

HALSTON

3 Shapes for Conversation

ORIG. Halston
M-4-9

OPEN
CROWN
ON
HAT

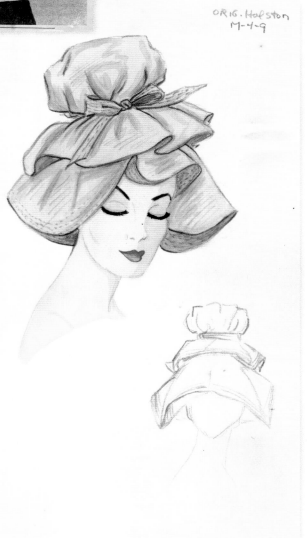

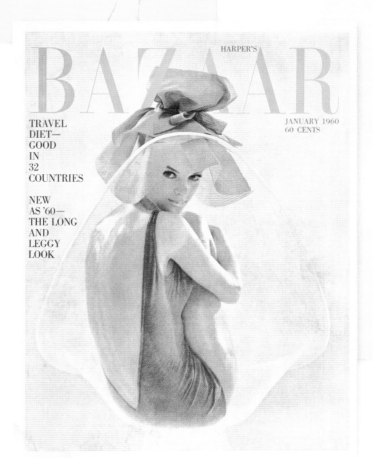

HARPER'S

BAZAAR

JANUARY 1960
60 CENTS

TRAVEL
DIET—
GOOD
IN
32
COUNTRIES

NEW
AS '60—
THE LONG
AND
LEGGY
LOOK

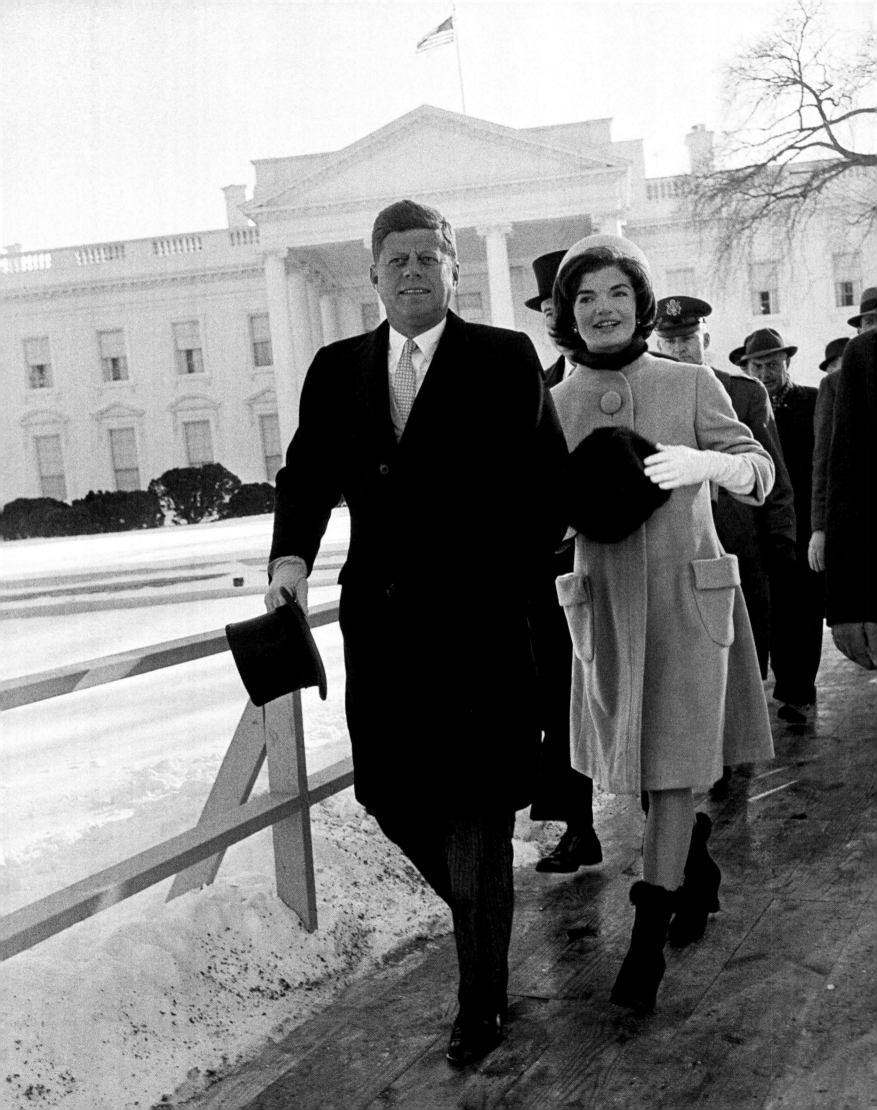

Campbell's soup and Brillo soap pads for Andy, sweater sets and shirtdresses for Halston—and turned them into iconic, highly sought-after images. No wonder Halston later commissioned Andy to design ads for him. Vincent Fremont, Andy's business manager, recalls the many Warhol artwork "deals" brokered between Halston, Victor Hugo (the messenger), and Andy. He said, "It was like a trade thing but it was convoluted."

Although they often griped about each other behind their backs, Andy and Halston needed each other. They were both enormously impressed with each other's successes. As Bob Colacello puts it, "Andy and Halston were alike. If you walked into a room and you didn't know what was going on you would wonder why they were the centers of attraction, because they seemed to be saying or doing very little. Everyone else was orbiting around them, creating all the activity and trying to entertain and amuse H and Andy. They were both shy, yet they had all this power. It seemed like a passive power, yet neither was passive at all. They were both very ambitious, very cunning, driven."

By 1959, *Women's Wear Daily* was heralding Halston as "New York's top milliner." I'm certain it was a position he relished. As the fashion writer Marylou Luther remembers, "He was like the host of Bergdorf. Famous women from all over the country if not the world came in for his charm and his hats. He knew the culture of fashion early on."

While Halston was happily making hats in New York, my family was in Montreal, where my dad was posted as a junior Foreign Service officer at the American consulate. My mother, Shirley Frowick, didn't have a coat warm enough for the cold Canadian winters, and she remembers Halston coming for a visit in 1960 bearing a black mink for her. "He had a friend who was a furrier in New York, maybe a colleague at Bergdorf, who recut the mink

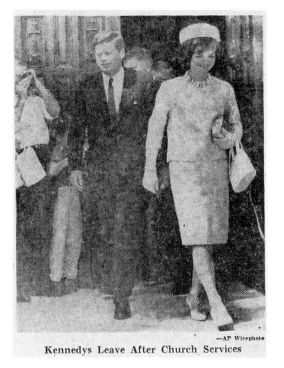

—AP Wirephoto
Kennedys Leave After Church Services

coat for me. It was kind of worn out around the edges so he had all the worn-out parts cut off and had it refitted for me and I loved it. It is not something you forget when someone gives you a mink coat!" This kind of generosity was typical of Uncle H, who showered all of us with presents every chance he got. I still remember how glamorous my mother looked in her Halston finery. He even gave her the most famous hat he ever designed, the pillbox that Jackie Kennedy wore to her husband's inauguration in 1961. Unlike the thousands of women who rushed out to buy a copy in the days after photos of Jackie looking soignée in her matching coat and fur muff appeared, my mother had the real deal. In a letter to Halston dated June 12, 1961, Diana Vreeland, then fashion editor of *Harper's Bazaar* wrote, "The cloches for Mrs. Kennedy are marvelous. Between her beauty and your talent, you have indeed made a young woman in a hat look perfection." The whole family was over-the-top ecstatic that Halston had the singular honor of making the new First Lady's hat and, needless to say, my mother still has hers. But while this was the best known of the hats Halston made for Jackie, it wasn't the only one. He was her favorite milliner on the campaign trail and during the White House years. Legend has it that they both had the same head size, so Halston could try on the Kennedy chapeaux as he was fashioning them. When he launched his own business, both she and her sister, the stunningly beautiful Lee Radziwill, remained loyal customers.

In 1962, Halston won his first Coty American Fashion Critics' Special Award for innovation in millinery. Though discontinued in 1985, the Coty Awards were once the highest honor an American fashion designer could aspire to. Halston won four altogether: two Special Awards for millinery (the second, for a total look of fashion, was awarded in 1969), a women's wear award (popu-

Opposite: President John F. Kennedy and Jacqueline Kennedy on their way to the parade in honor of Kennedy's inauguration, January 20, 1961. Looking flawless in coat, gloves, and mink muff, Jacqueline also wears the beige felt pillbox hat Halston designed for her—his most famous millinery creation. Above: The Kennedys after church service, c. 1961.

larly known as a Winnie) in 1971, and a Return Winnie award in 1972; in addition, in 1974 Halston was elected to the Coty Hall of Fame, the highest award in American fashion. According to Peg Zwecker's story about the awards, published in the *Chicago Daily News* on September 28, 1962, five of his hats were featured: "his high turbans and toques, a series of his modernized babushkas in mink, leather and satin, and a group of dramatic evening hats in black velvet or tulle." The ceremony was at Lincoln Center and though my excited parents couldn't make it, they did send a telegram, as did many other people—this, remember, was back when long-distance telephone calls cost a fortune. My grandmother Hallie Mae, who was by then living in Florida, was there, though. As soon as she arrived in New York, Halston whisked her to Kenneth to have her hair done and then outfitted her in a printed silk jersey shirtdress. He had a knack for making those in his inner circle feel special.

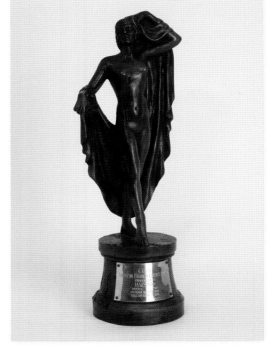

In 1963, *Women's Wear Daily* cited "Mrs. Kennedy, Mrs. Paley, the Queen of England, Mrs. Guinness, the Duchess of Windsor and of course Diana Vreeland" as the women who set the tone for international style. It goes without saying that Halston was fitting most of these pacesetters in his millinery magic. His designs during this era ranged from simple fedoras to dramatic cape hats of knee-length jersey. Two of his favorite materials were feathers and mink—"If a woman can have only one hat she should own a mink," he said—which he sculpted into hair-concealing turbans and cloches. He whipped organdy into chef's-hat and puff-pastry shapes, and designed a rhinestone-studded fishnet mask. It was an era of immaculate grooming, multiple outfit changes per day, and high glamour. My family got to witness it all in April 1964, when we stopped off in New York on our way to my dad's latest assignment to

then-communist Romania. We stayed with Halston at his apartment on East 65th Street, which he'd decorated in a Taurus-theme, with horn chairs and horn end tables and impala horns on the wall (he later referred to it as his "horny apartment"). Halston took us kids to see *Snow White and the Seven Dwarfs* in a 1950s-era checkered cab. He loved to play the role of uncle with all of his eleven nieces and nephews. Halston was always so funny that we were inevitably beguiled in his company, holding his hands and following him like little ducklings.

My mother, meanwhile, was outfitted for her new life behind the Iron Curtain. Halston wanted every member of his family to look good, but my parents and we three kids were special cases because we were representing the United States of America abroad. He presented my mother with several hats, including a dark-brown velvet, broad-brimmed hat similar to the one featured in the Audrey Hepburn classic *Breakfast at Tiffany's* and a black crocheted one with a high, stiff crown and a broad floppy brim dotted with little white flowers. "It had a black silky ribbon that went around it tied by Halston in a bow," she remembers. "He taught me how to make a Halston bow (essentially a fluffy square-knot bow with short, crisp endings). I do it every year at Christmas." For the going-away party, he and his close friend the interior designer Angelo Donghia threw in my parents' stateroom on the SS Constitution, Halston gave her a black Balenciaga dress, which she wore with white gloves, a string of opera-length pearls, and her hair in a high bun finished with a rhinestone-and-pearl hairpin. My grandmother Hallie Mae came to New York to see us off and was also dressed in an ensemble provided by Halston, a beige, quilted, Chanel-style swing coat with matching hat that he designed. Ever the perfectionist showman, he primped her

Above: Halston won four Coty American Fashion Critics' awards. This is his award for being elected into the Coty Hall of Fame, presented in 1974. Opposite: Illustrations by Halston of hat designs made while he was manager of the custom millinery salon at Bergdorf Goodman, c. 1963.

JERRY SILVERMAN
1610

Halston 1595

Halston
(PUBLICITY)
1704

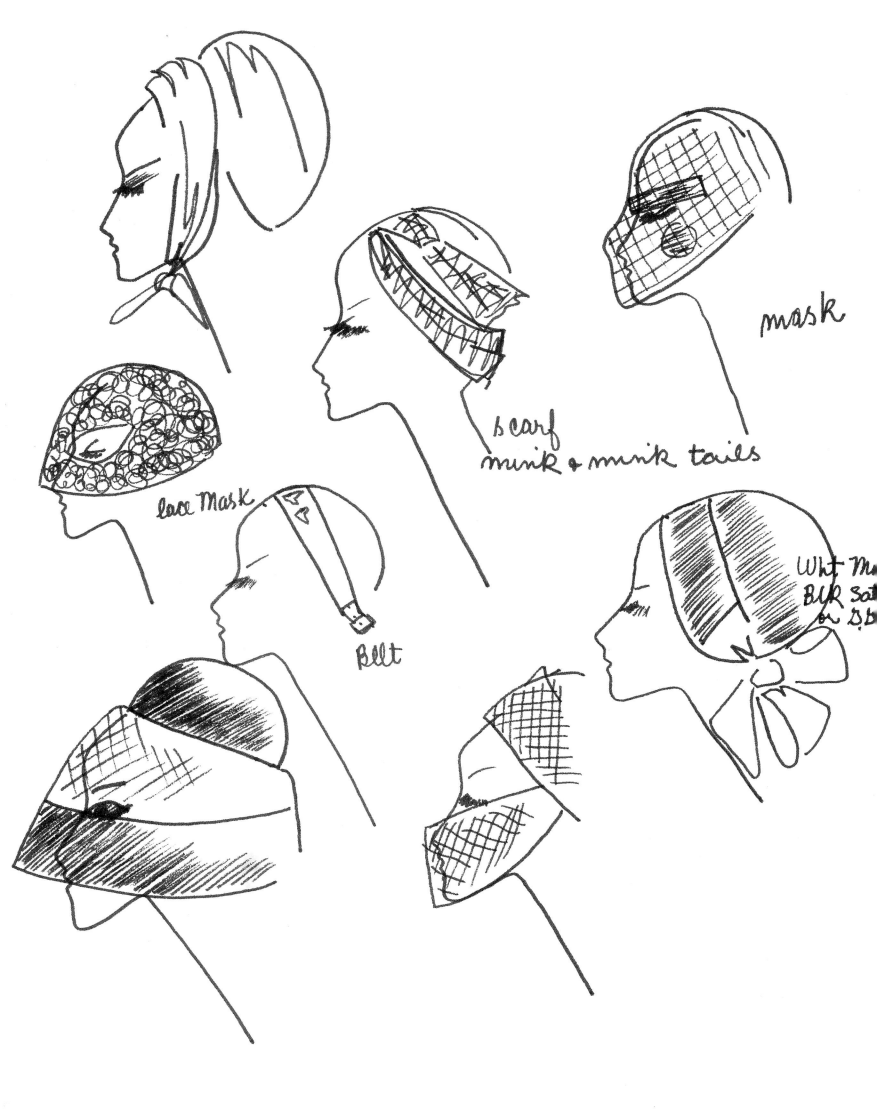

mask

scarf
mink & mink tails

lace Mask

Belt

Wht M___
BLR Sat___
o. D.b___

on the dock before boarding the ship for our farewell party. Thanks to Halston, everyone looked great. It was a champagne and caviar event, but unfortunately I remember very little of it—we three children fast became groggy and passed out due to the very strong Dramamine our mom had us consume prior to our first transatlantic crossing.

Though I loved our two-year sojourn in Romania, where I learned to speak the language and made friends with gypsies, for my parents it was a different experience. It was the height of the Cold War, provisions were scant, and everything from our phone to our shoes was bugged. A running joke was to talk into the chandelier if you wanted something in the house fixed or to find something that had been, shall we say, misplaced. So when Halston offered to take my mother to Paris and have her tag along to a fashion show, she jumped at the offer. Halston had been invited by Coco Chanel, who wanted to meet the talented whiz kid from the United States who was already giving the French a run for their money. For my mother, one of the highlights of the trip was going out for an evening of dinner and discotequing

with Halston, the fashion columnist Eugenia Sheppard of the *New York Herald Tribune*, the shoe designer Roger Vivier, and Angelo Donghia—giants in their fields, all of them. "I wore the black Givenchy cocktail dress and I had a Halston hat that went with it. He had just given me a Chanel baroque pearl choker necklace with matching earrings and the Chanel gold cuff with pink coral balls on the ends that looked fabulous with the dress. Maybe he had just purchased them from Coco but he never said," she remembers. Nor did the glamour end there. On her return from Paris she received a black suede hood with silver fox trim that encircled the face and formed a scarf that could be looped around the neck, the *ne plus ultra* of *après-ski* chic.

But while he was undoubtedly generous, Halston was never one to mince words if he felt one of his presents didn't suit you. He once gave my grandmother an oversize chain-link bracelet only to take it back. "You're too fat for it," he said and handed it over to my mother. Another time my mother was the target of his shoot-from-the-hip advice, an event that mortified her at the time but that she now chuckles about. "There was a fancy function in Washington that I was to attend and I had to have something new to wear so I went up to New York to search for the perfect Halston dress," she says. "He was making tank dresses out of clingy silk jersey with little jackets to go over them. I really loved those dresses but I had gained a few pounds. I wanted to try the jersey tank dress on but it was not in my size. The gal helped me find one smaller so I could see how the neckline and the sleeves fell and if the shoulder straps were wide enough. Halston came in when I had it on and without missing a beat he said, 'You look like a sausage in that—take that dress off.' I made off with something from the boutique but it was not that sexy little jersey tank dress that I lusted after."

Halston always knew what worked best on everyone and had no qualms about taking things back to recycle to a more appropriate recipient. To be fair, he always compensated the original owner with a new bauble or gown that was a better fit.

By the late summer of 1966, my family was back in the United States. As usual, we returned by ocean liner via New York and spent some time staying with Halston. As we had just come from communist Romania, where to be in possession of a stick of chewing gum counted as wealth—I gave pieces of Juicy Fruit to our neighbors before we left, which they stored at the bottom of a water-filled glass for a good year between chewings— Uncle H's apartment was a revelation. Through the eyes of an

Halston sketches of hats, 1967. A prolific sketcher, Halston kept notebooks full of doodles, designs, and even projected accounting figures to prepare for the opening of his own salon on East 68th Street.

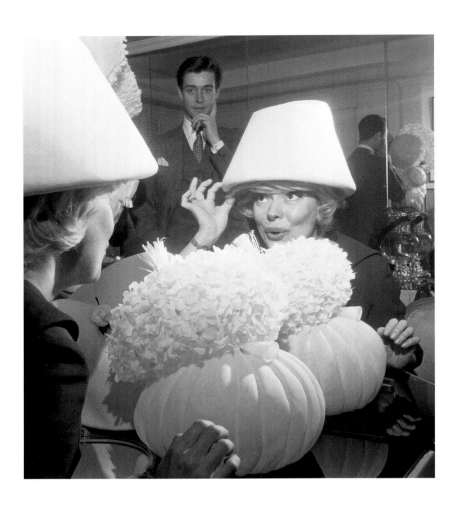

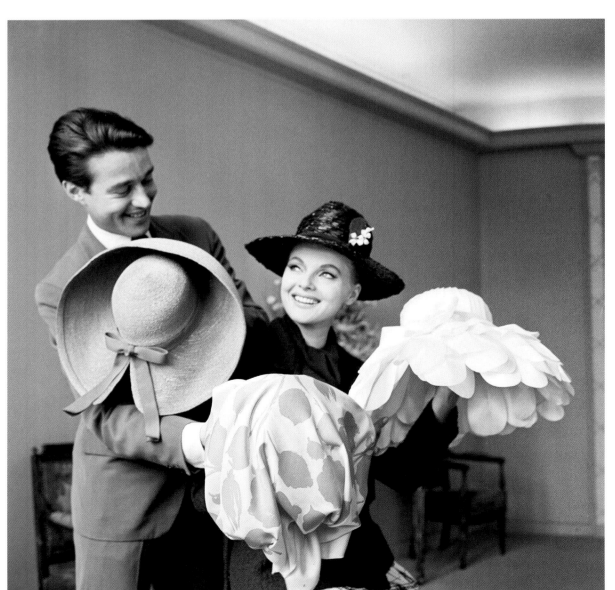

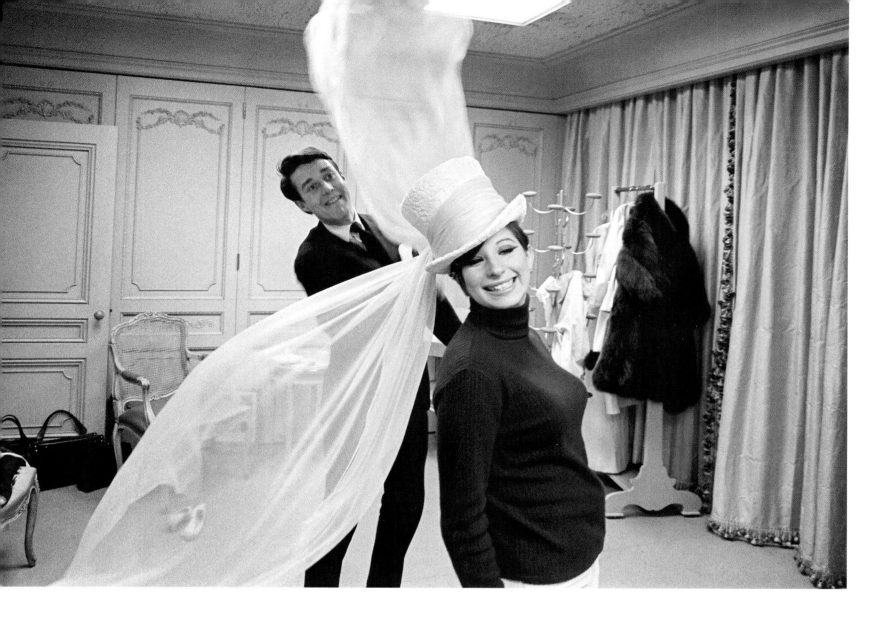

A ctress Carol Channing (opposite top) trying on an elaborate hat at Bergdorf Goodman with Halston looking on, March 21, 1964; (opposite bottom) Halston and Italian actress Virna Lisi looking at hats at Bergdorf Goodman, May 21, 1964. Above: During a fitting at Bergdorf Goodman, Barbra Streisand and Halston have giddy fun with one of the hats he designed for her TV special, *My Name is Barbra*, March 16, 1965. Below: Halston and Miss Jessica holding the bridal veil before a Park Avenue wedding, c. 1964.

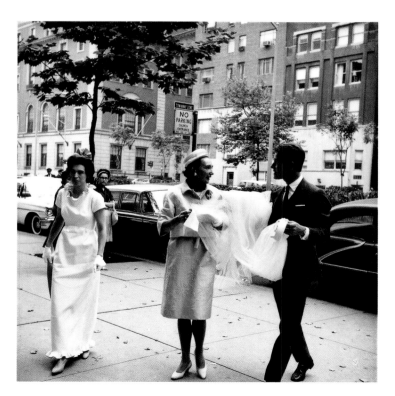

THE DIPLOMAT

A Prestige Window on the World

JULY-AUGUST 1964
Midsummer Special
FIFTY CENTS

TRAVEL

·

PERSONALITIES

·

FASHION

BAZAAR

JAN. 1966 HARPER'S 75¢

WHAT'S
NEW?
67
Fashions
For '66

HOW TO:
Lose
Weight
Without
Hunger

DREAMS:
Door
To The
Unknown

BAZAAR

APRIL 1963 HARPER'S 60¢

HEAD
OVER
HEELS
IN LOVE
WITH
FASHION
BEAUTY
CONVERSATION

HOW TO
EXERCISE
WITHOUT
REALLY TRYING

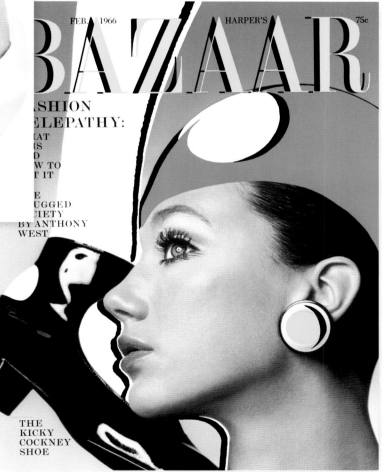

BAZAAR

FEB. 1966 HARPER'S 75¢

FASHION
TELEPATHY:
WHAT
IS
AND
HOW TO
GET IT

THE
RUGGED
SOCIETY
BY ANTHONY
WEST

THE
KICKY
COCKNEY
SHOE

The beautifully soft, voluptuous folds of Halston's white broad-brimmed organza hat showcased on the cover of *The Diplomat*, August 1964 (opposite). *Harper's Bazaar* covers, early 1960s, shot by Richard Avedon (top and left) and Hiro (below). Halston strongly believed a hat should make the wearer more glamorous and exciting than anyone else.

eight-year-old it was like being in an elegant museum of exotic animals, the zebra quietly relaxing on the floor, the snowy white owl peering through its glass chamber, the impala antlers poking through the walls as though the entire beast would burst forth any moment, and the cow-horn chairs. All were phenomenally fantastic to me. I recall Halston being amused (though at the time I did not understand why) at how we could not wait to hit the streets in search of a chili dog from Nick the Greek.

Among Halston's circle of acquaintances in New York during this period was Truman Capote. Like Halston, Capote cultivated friendships with glamorous and beautiful women. Where they differed was that Halston could keep a secret. Capote wrote a tell-all novel, *Answered Prayers*, that revealed sordid details about the personal lives of the women he called his "swans." Though the novel wasn't published until after his death, he sold four chapters of it to *Esquire* in the mid-1970s, an act that resulted in his exile to social Siberia. Long before then, though, he hosted what's been described as the party of the century, his Black and White Ball. Held on November 28, 1966, in honor of *Washington Post* publisher Katharine Graham, it had a guest list that included the best-known people in the world.

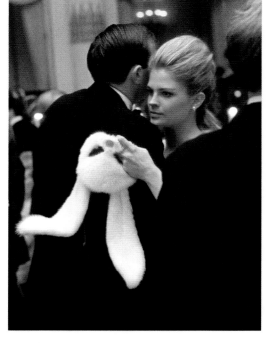

The ball was held at the Plaza Hotel, which at the time was the top of the list of fancy venues for all significant events, such as debutante balls and theater openings. As soon as the date was decided, *le tout societé* swung into action, booking hair appointments with Kenneth and ordering gowns (Capote stipulated that everyone had to wear black or white), jewels, and accessories from world-renowned designers. Then Truman played his ace: The ball would be masked. He'd invited the most famous and beautiful people in the world and was asking them to hide their far-from-camera-shy-faces behind masks.

Amazingly, everyone complied, even Andy Warhol, who wore an improvised paper mask.

Many of the guests wanted a mask designed by Halston, who had just launched his own line of ready-to-wear at Bergdorf's. In fact, he was run off his feet with mask orders, even telling the press, "The ladies have killed me." Some clients also ordered a coordinating dress, including the model Marisa Berenson, who is the granddaughter of the legendary couturiere Elsa Schiaparelli. For her, Halston designed a full-length silk black velvet strapless gown trimmed with ermine. On the day of the ball, the hours went by and there was no sign of her. When a panicked Candice Bergen arrived at the last minute to pick up her costume, Halston assumed Marisa was going to be a no-show and gave Candice the velvet dress, along with the white mink bunny mask he'd made for her. Candice happily left to get ready. And then, much to Halston's surprise, Marisa showed up. Rather than disappoint her (and suffer the bad publicity), he quickly altered a white hooded satin wedding dress from his latest collection at Bergdorf's and delivered it to her apartment just in time for her to slip it on and dash to the ball.

Less exhilarating but ultimately better for his public profile was the mask Halston made for the evening's guest of honor, Katharine Graham, who, since taking over the *Post* after her husband's suicide in 1963, had become the most powerful woman in the country. His first suggestion was a handheld one with jet beading to match the trim on her white wool Balmain dress. But because she had to greet everyone as they arrived, she was afraid that kind of mask would make shaking hands too difficult. So Halston devised cloth-covered earpieces that allowed the mask to stay in place without disrupting Mrs. Graham's hairdo. It was the start of a long and happy relationship. For the

Above: Candice Bergen at Truman Capote's Black and White Ball at the Plaza Hotel, November 28, 1966. Her mink rabbit mask and velvet gown were designed by Halston. Opposite: Katharine Graham, the guest of honor, with Truman Capote. Halston designed her mask not only to match the jet-beaded trim on her Balmain dress but also to stay in place without mussing her hair.

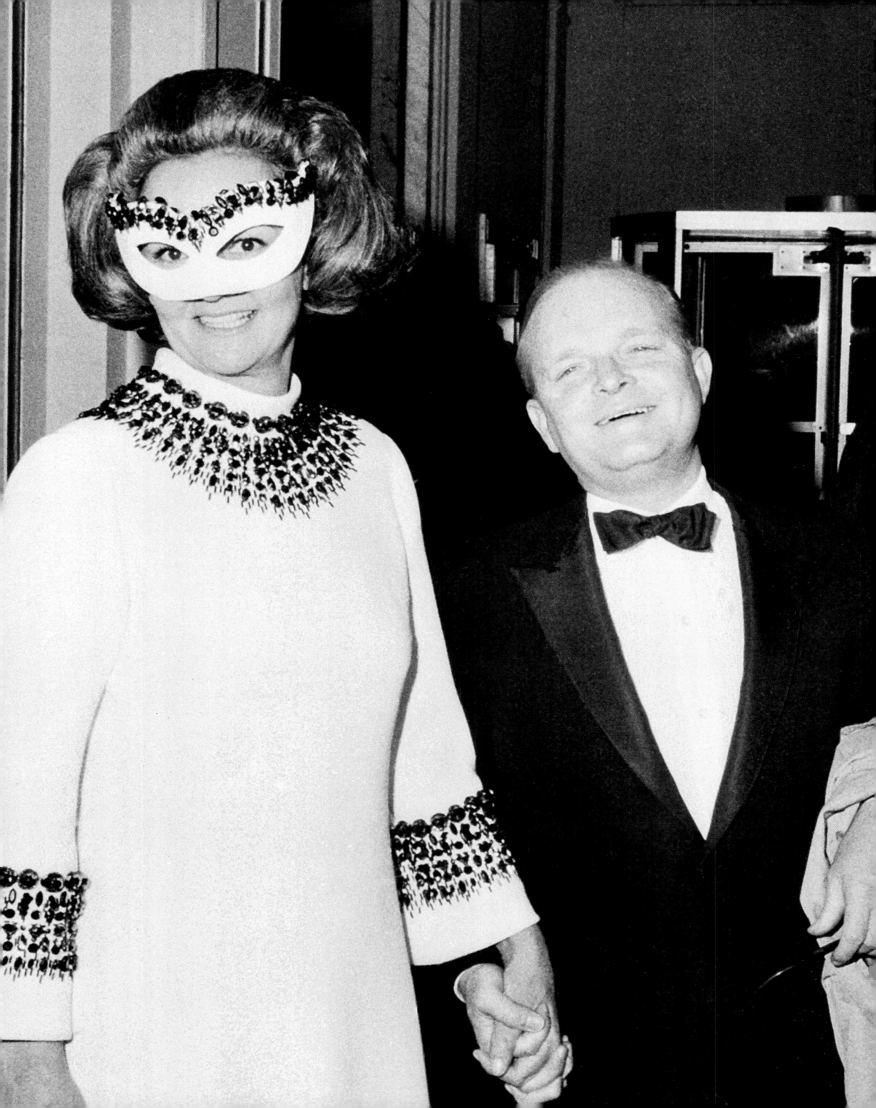

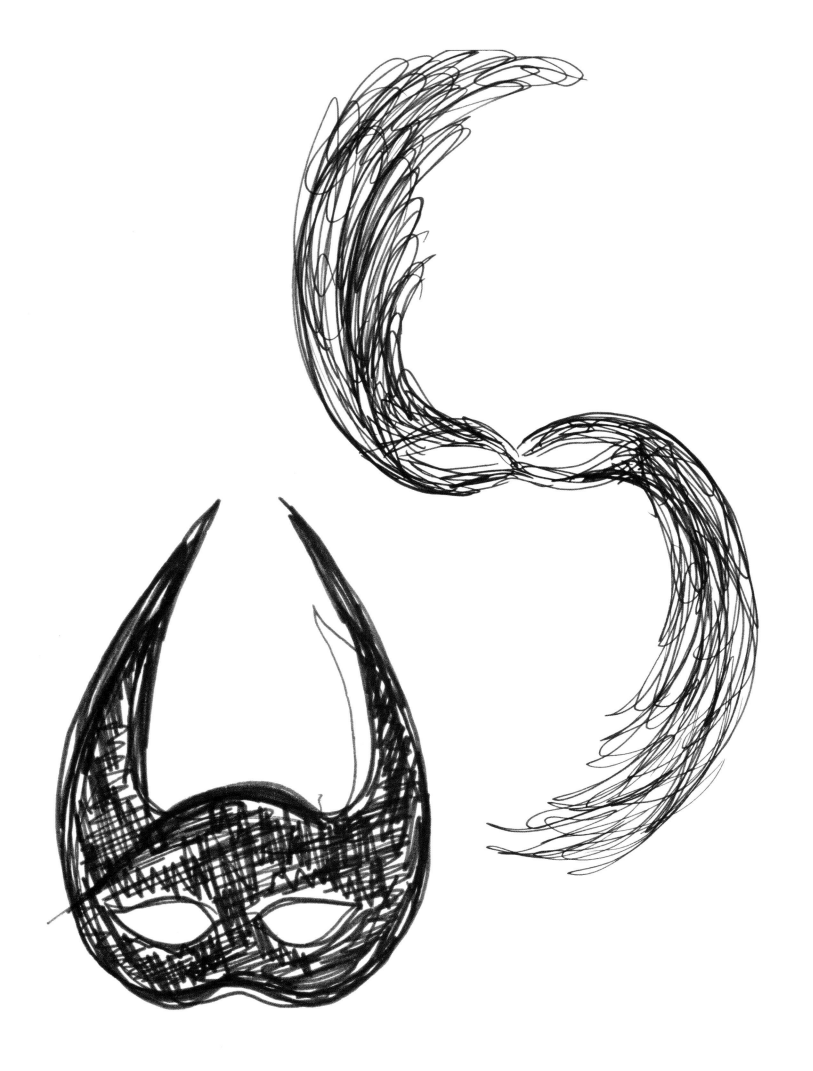

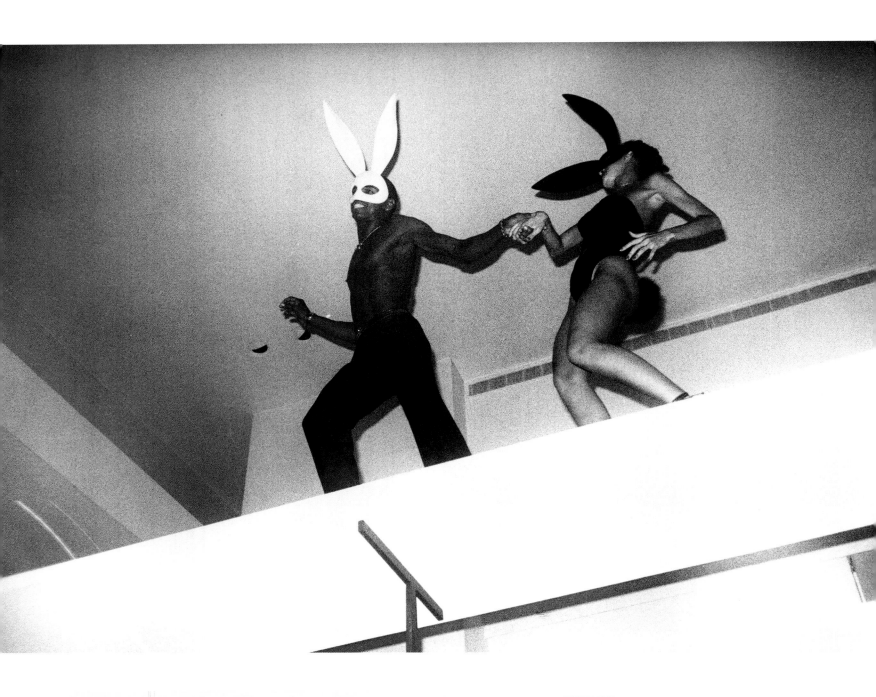

S terling St. Jacques and Pat Cleveland joyfully dancing on the mezzanine at Halston's town house after the Skowhegan benefit ball, 1975. Below: A sketch by Halston for a mask, c. 1975. His rabbit masks were worn by many glamorous denizens of the 1970s party world. Opposite: Illustrations by Joe Eula of outfits and masks for the Skowhegan ball, 1975. Opposite: (bottom left) Halston, wearing one of his own rabbit masks, with a model at Magic, Fantasy, and Dreams, a costume ball benefit for the Skowhegan School of Painting and Sculpture, October 25, 1975.

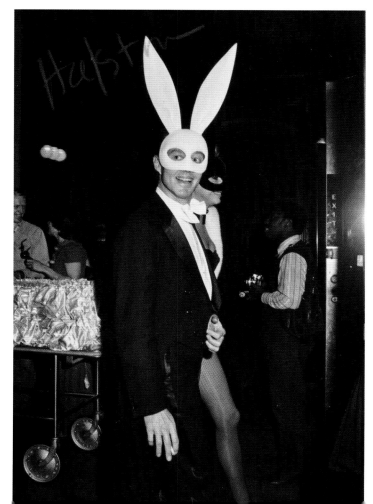

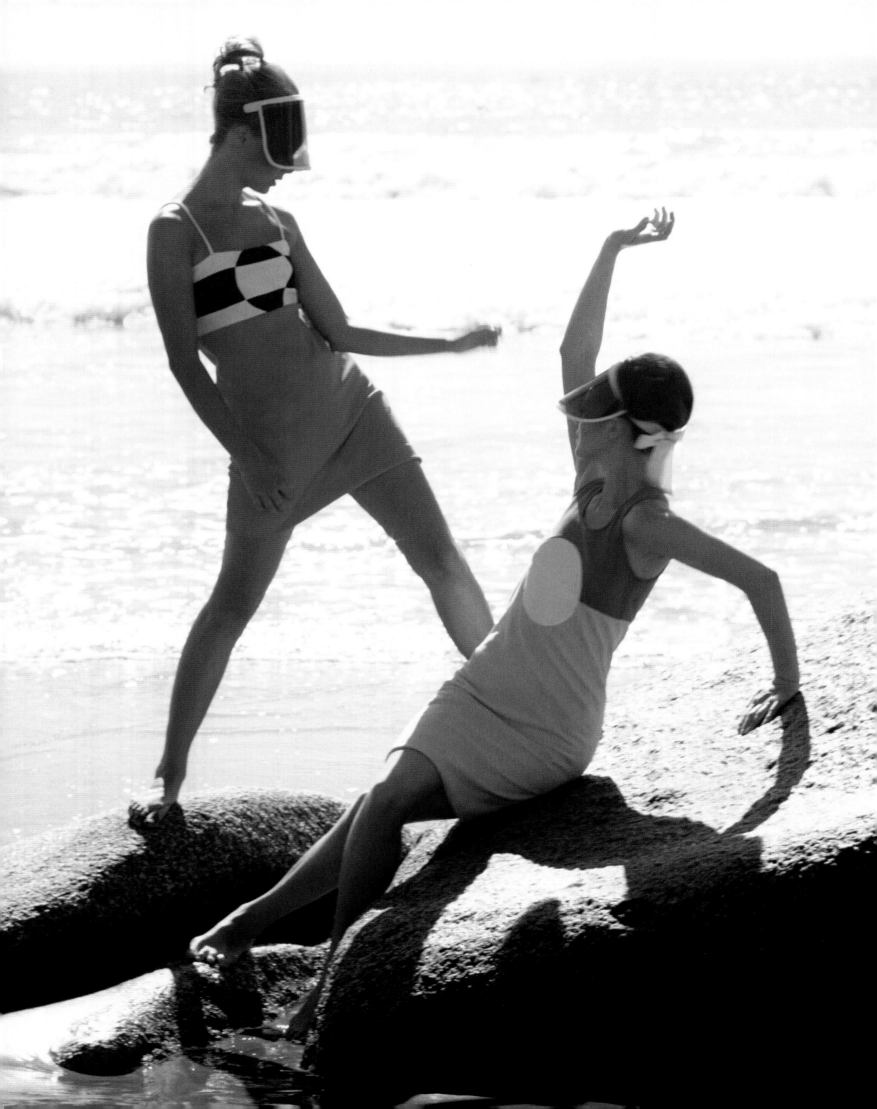

next two decades, Mrs. Graham was a loyal Halston customer, relying on him to provide her with both day and evening wear. At the tribute to him thrown by Liza Minnelli in 1990, she remembered him as the solver of all her wardrobe dilemmas. "My first memory of Halston was when I asked him to make my mask for my mid-life debutante party, the Black and White Ball, at the time he was just leaving Bergdorf. I relied on him entirely for what I wore, before I was one of fashion's one hundred neediest cases. He taught me so much and vastly expanded my vision and style. Although we were not close personal friends, I felt as though we were because he was the way he was. He brought a personal interest and sensitivity to our relationship and to all the women he dressed. There were Babe Paley, Liz Taylor, and Liza, Amanda Burdon, and my daughter Lally Weymouth. He was just as nice to the kids as he was to us."

By the time of the Black and White Ball, Halston was experiencing growing pains. As earlier as 1964, he'd told Angela Cuccio of *Women's Wear Daily* that he dreamed of going out on his own. "If I were to design clothes and yes, I'd love to—and maybe someday I will, they'd have to be snappy, all function and ease . . . for day, simple Action Clothes that women can breathe in, work in, play in. Nights— that's different . . . time to splurge, live the dream that's fashion. The simpler by day, the more extravagant after dark . . . pile on beads from floor to ceiling and somehow it works! And let's face it, dresses are not going to have feathers and fuss in the future . . . we'll go on simplifying . . . everything uncluttered . . . this is a tailor's world, not a dressmakers world." (*WWD*, September 16, 1964)

Two years after outlining his ready-to-wear vision, Halston was given the chance to put it into action by designing an apparel collection for Bergdorf. It was conceived of as a merchandising

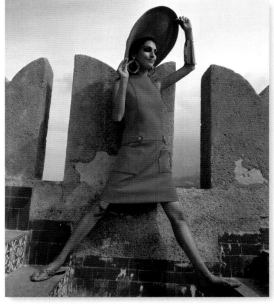

innovation that would bridge the gap between couture and ready-to-wear. He presented this first collection in June 1966, under the label From Halston for the Boutique on the Second Floor Bergdorf Goodman, in a show that was far more informal than the usual couture format. As music played, the models, including Marisa, walked casually down the runway as though out for a stroll on Fifth Avenue. The press—and his loyal ladies —applauded. *Women's Wear Daily* was there for the fashion show, and got this quote from Halston, who had shown up at 7:00 a.m. that morning to set up the chairs (have I mentioned that he was a perfectionist?): "I didn't want to make clothes for kids. I wanted feminine clothes for women between twenty-two and fifty-five years old, the woman who wants to look chic but not conspicuous, soft rather than hard. So I designed eighteen costumes that are interchangeable. It's a something-for-everyone collection." The air kissing and congratulations were so intense, the article goes on to say, that the scene resembled "the top of the stairs at Chanel except no one was speaking French." (*WWD*, June 29, 1966)

Having his own boutique at Bergdorf was an essential acid test for Halston. The two collections he designed for the luxury department store gave him the experience and the impetus to break out on his own after ten years of working under the thumb of others. When he came down with hepatitis later that year and had to take six weeks off work to convalesce, he spent the time deciding how he would chart his future course. He saw that the future of fashion was changing. More women were going out to work, and they demanded comfort and ease from their clothes. He wanted to provide them with simple but luxurious clothing that met their needs while satisfying their desire for glamour. And he wanted to do it under his own name. It was time to move on.

Opposite: Models posing on the beach in Acapulco wearing wraparound sunshields by Halston, April 1966. Above: Model Barbara Bach sporting a broad-brimmed red hat by Halston in Palermo, Sicily, c. 1967.

BALENCIAGA
02

CARDIN 418

GRES
101

ST. LAURENT
18

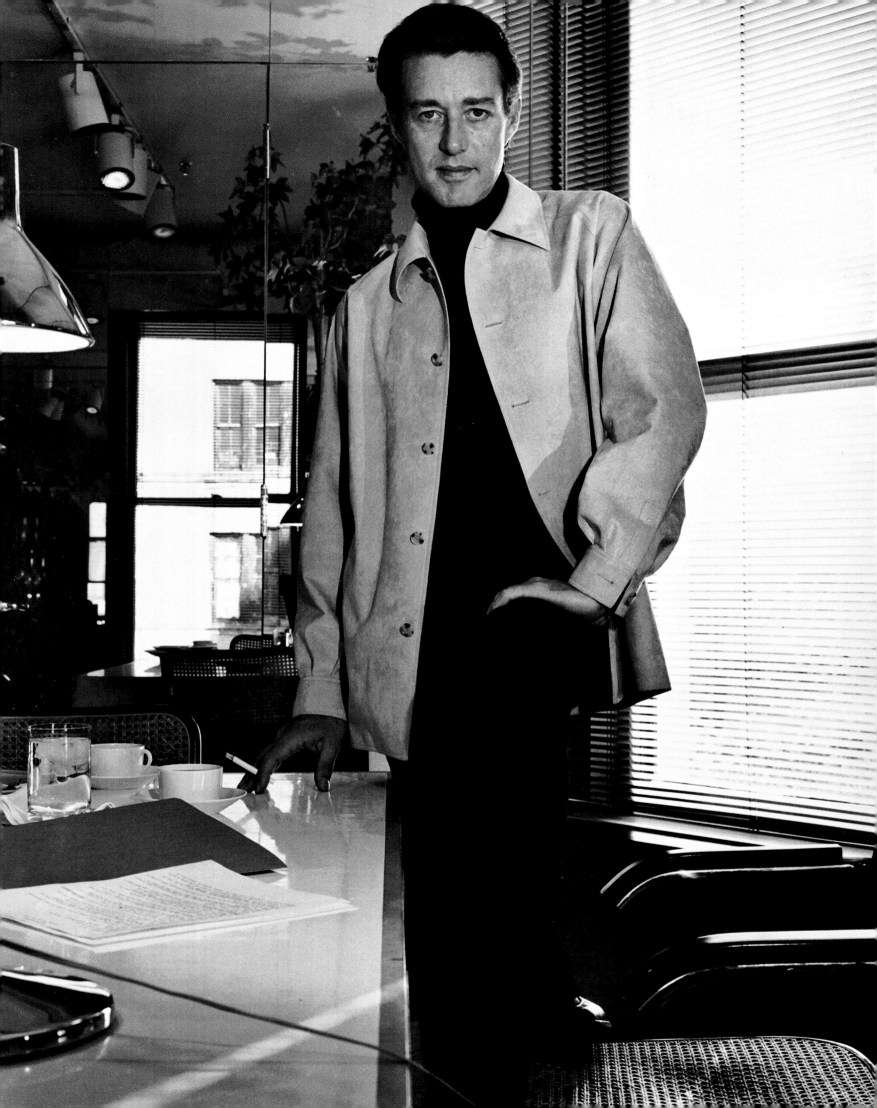

MOVE WITH FASHION

With the help of socialite Estelle Marsh Watlington, who plunked down $125,000 based on a deal that was reputedly drafted on an envelope, Halston was able to launch Halston Ltd. in October 1968 with three partners: Joel Schumacher, a former partner in the trendsetting Manhattan boutique Paraphernalia; Frances Stein, who had been an editor at *Glamour*; and Joanne Creveling, a Macy's executive. Joel Schumacher recalls the first time he saw Halston at La Grenouille: "He was, of course, as handsome as a movie star, I think the most beautiful of all of us. I saw Halston take a white napkin and make a hat out of it in about two seconds and he sent it to over to Sally Kirkland, a high-powered fashion journalist. It was really quite charming."

From the start, Halston wanted his showroom to be different from anything else on Seventh Avenue. For one thing, it wasn't anywhere near the garment district. When a prospective space on 15 East 55th Street fell through, he rented the third floor of a five-story town house at 33 East 68th Street just off Madison Avenue. In choosing to launch uptown, Halston was a trendsetter. This location put him right next door to where some of the world's

most dedicated clotheshorses lived. He made it easy for these women, soon to be regular clients, to drop in on him for a little impromptu socializing, an open invitation that was reinforced by the showroom's cozy, welcoming atmosphere.

Instead of the standard Seventh Avenue decor of industrial gray walls and bare floors, Halston enlisted the interior designer Angelo Donghia to create a safari-inspired oasis that looked more like a living room than a place of business—it was only when you walked through the hidden door to the workrooms that it was obvious where you were. Batik-printed fabrics hung from the walls, sisal carpeting covered the floor, and the smell of Rigaud candles filled

the air. There was a horn love seat upholstered in light brown suede, plus four other horn chairs, as well as huge wicker armchairs and footstools, banquettes that looked like three stacked cushions, Chinese-style Chippendale desks, cane end tables, and two armless slipper chairs. Angelo worried that the look would be cliché hippie but in the end it was floor-to-ceiling chic.

From the inception of his business, Halston made clothes that were true to his signature classic but relaxed style. The comfort of the retro sweater sets in luxurious cashmeres, gracefully tied around the shoulders or hips; the fluid chiffon caftans in royal colors; the elegant pajamas in cut velvets; the resurrection of a collegiate argyle; the uncomplicated pullover with elastic waistbands or self sashes; the chic shirtdress in much-sought-after Ultrasuede fabric; the casually tailored pants with silky blouses; the halter evening dresses in sexy silk jersey—these served as the foundation of his collections for the balance of his career, peppered with new variations or innovative twists as he envisioned them. They were modern clothes for modern women. As *Vogue* editor-in-chief Grace Mirabella told Newsweek in 1972, "From the start as a designer, the clothes coming out of Halston's couldn't be found anywhere else. They were for the attractive and important woman, the busy woman to whom life means something. Here were the clothes you could do it all in."

Halston showed his first ready-to-wear collection in December 1968, a highly tactile, wearable range of clothes that included pants and simple shirts in silk chiffon and jersey, ultra-light chiffon and velvet dresses, and lots of knit ensembles. The next morning, Babe Paley, wife of the CBS board chairman and one of Truman Capote's "swans," strolled into his salon and ordered an argyle pantsuit. His second customer was Mrs. Charles

Opposite: Halston in a signature Ultrasuede jacket, at his 68th Street design room, c. 1975. Ultrasuede was the perfect match for Halston's luxurious yet carefree designs. Above and pp. 44–47: Victor Hugo's unfailingly clever—and always provocative—window displays at the Halston boutique on Madison Avenue at 68th Street, c. 1974.

Engelhard, wife of the late platinum magnate, who came to his atelier with her Christmas shopping list in hand. Without ever intending to, Halston had gone into the made-to-order business. He eventually found himself designing eight collections a year: four ready-to-wear, two made-to-order, and two men's. The business grew quickly, and as it did he took over more floors in the building, eventually expanding to all five, including the ground floor, where he opened his first retail boutique in 1972 at 813 Madison Avenue, the first of its kind for an American designer. Joel remembers "how simple yet complicated the clothes were. It was, I think, the first time that fashion editors looked at an American designer as closely as they did the Parisian designers."

But in the beginning, 68th Street was a simple atelier with just a few employees. The atmosphere was familial, in large part because Halston had a habit of hiring his friends or people he liked. Among the key players in the early days were the model-turned-jewelry designer Elsa Peretti, photographer and model Berry Berenson, models Pat Cleveland, Karen Bjornson, Chris Royer, and Nancy North, and Nancy's husband, Bill Dugan, with Halston doing his own

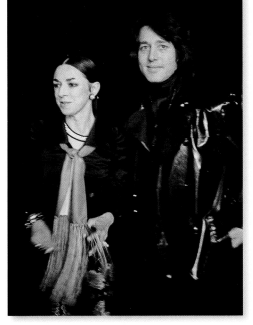

illustrations until Stephen Sprouse arrived in 1972 for a few years. Then followed a series of legendary players among others: Victor Hugo, Dennis Christopher, Perucho (Pedro Valls), Enric (Enrique Maza), and Joe Eula, the unparalleled fashion illustrator. Halston had met some of these people through Charles James, who continued to be an important influence on his designs.

In fact, James briefly worked for Halston. He was lured out of his sanctum at the Chelsea Hotel with the offer of a place to stay (the fifth floor at 68th Street was sometimes used as a temporary crash pad for Halston's friends; Elsa Peretti stayed there, too) and the position of fashion consultant-engineer with Halston's newly formed enterprise. Halston explained to the *New York Times* in 1970, "He helped shape the collection, like Balenciaga helped Givenchy." In short order it was evident that there was not enough room for the two egos, so James returned to the Chelsea, perhaps a bit frayed around the psyche. But Halston continued to encourage James's genius, even assisting with Charles James's fashion show at the Electric Circus on December 16, 1969. The Electric Circus was a trendy club on St. Marks Place in the East Village that embodied the wild and creative side of the era's nightlife culture. Drew Ryan, the son of D. D. Ryan, who began as a Halston client and ended up working for him, remembers going there with his parents when he was very young. "You would walk in past go-go

girls in cages, groovy music—everything you think of the 1960s was the Electric Circus." Andy Warhol was a frequent patron and it may have been there that he and Halston actually met. Photos from the legendary show, which included such historically important James designs as his two-tone satin figure-eight skirt dress, his sculptured cocoon-style cape jacket, and his bias-cut silk satin dresses, reveal a guest list that ran the gamut of the avant-garde art scene. Halston is in his full-blown 1960s look, with long, shaggy hair and his silver concho belt. It was a quasi passing of the torch from one generation to the next. As Harold Koda put it in an interview for this book, "There are people who create fashions using techniques and forms that are pre-existing but modifying them, ornamenting them, and changing proportions and silhouettes so it is of their time. But in rare instances there are designers who extend the vocabulary of techniques to something that forms a new language, and Halston is one of them."

Clients and friends dropped by 68th Street and hung out, sometimes with their children in tow. Jane Holzer recalls going to visit a few times with her son Rusty clad in his little army suit with her ermine cape draped around his shoulders. Halston was impressed by

Above: Halston with his close friend D. D. Ryan at the Charles James retrospective at the Electric Circus, New York's trendy downtown nightclub, December 16, 1969. Opposite and pp. 50–53: Halston initiated and hosted the Charles James show to honor the designer who had been such an inspiration to him.

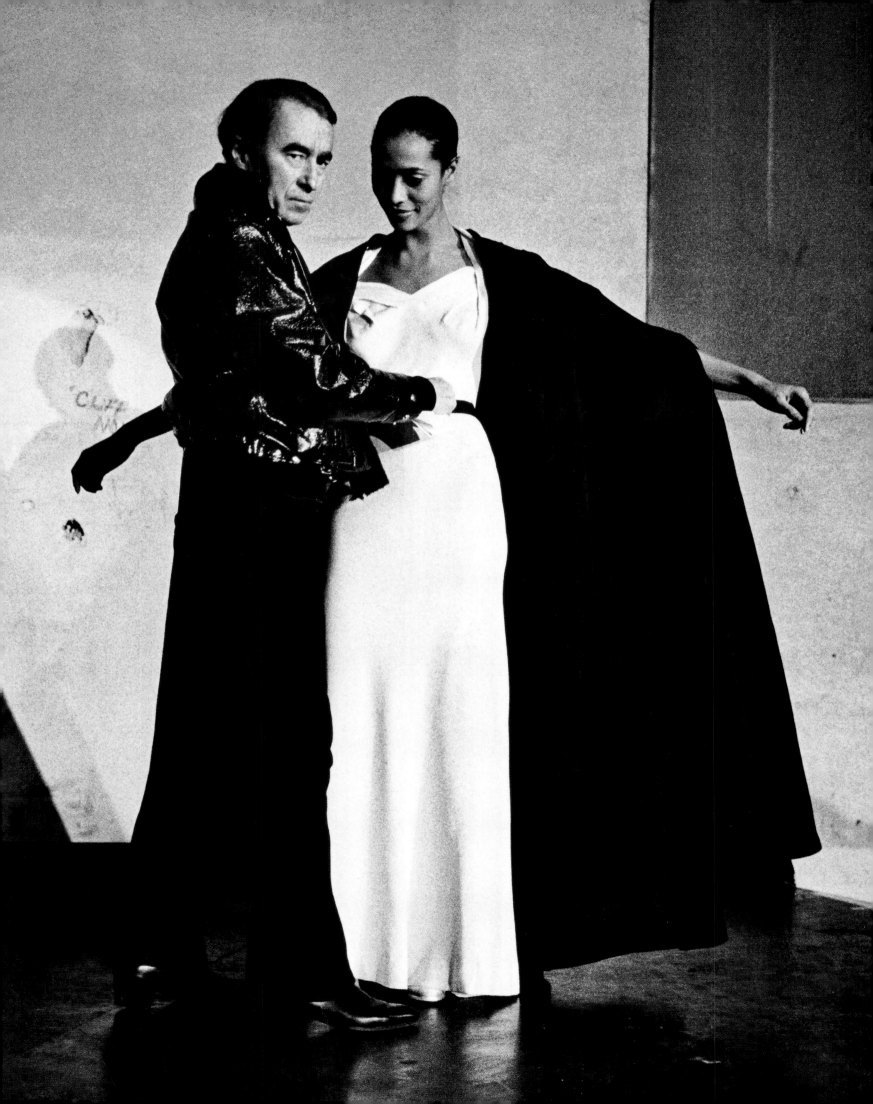

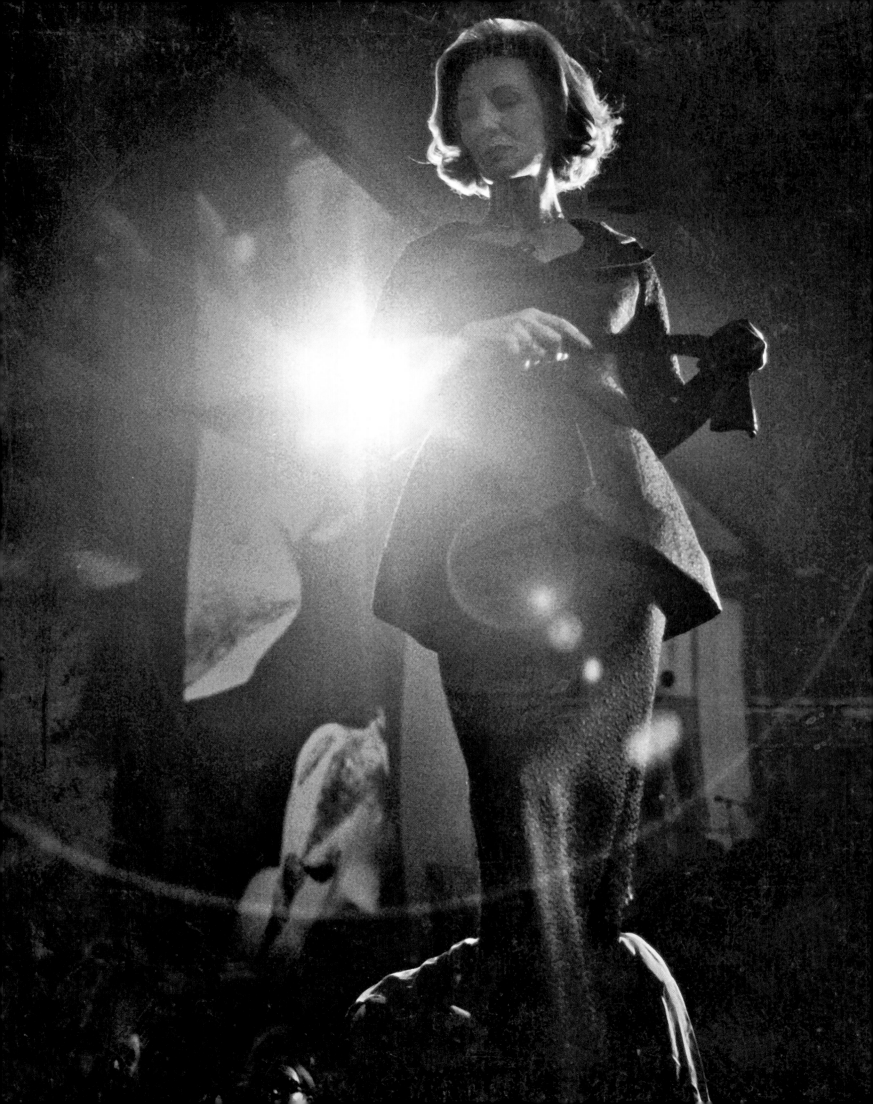

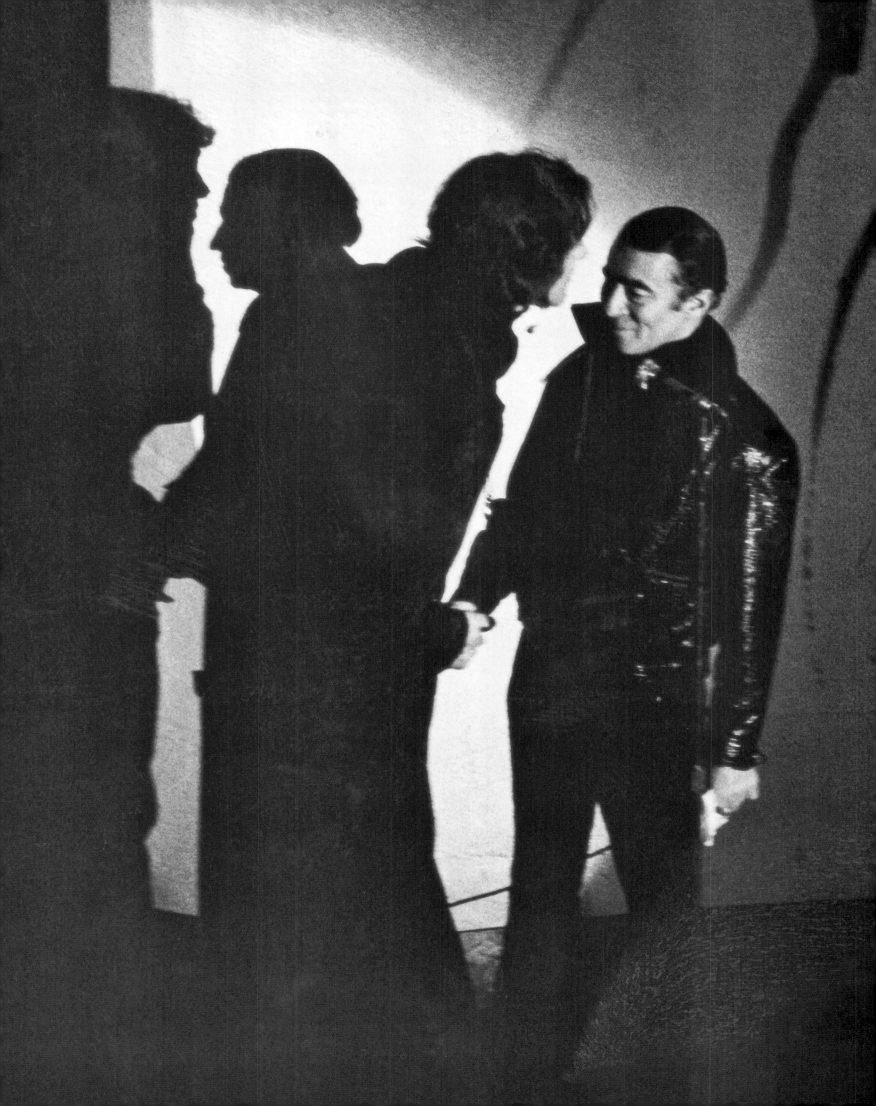

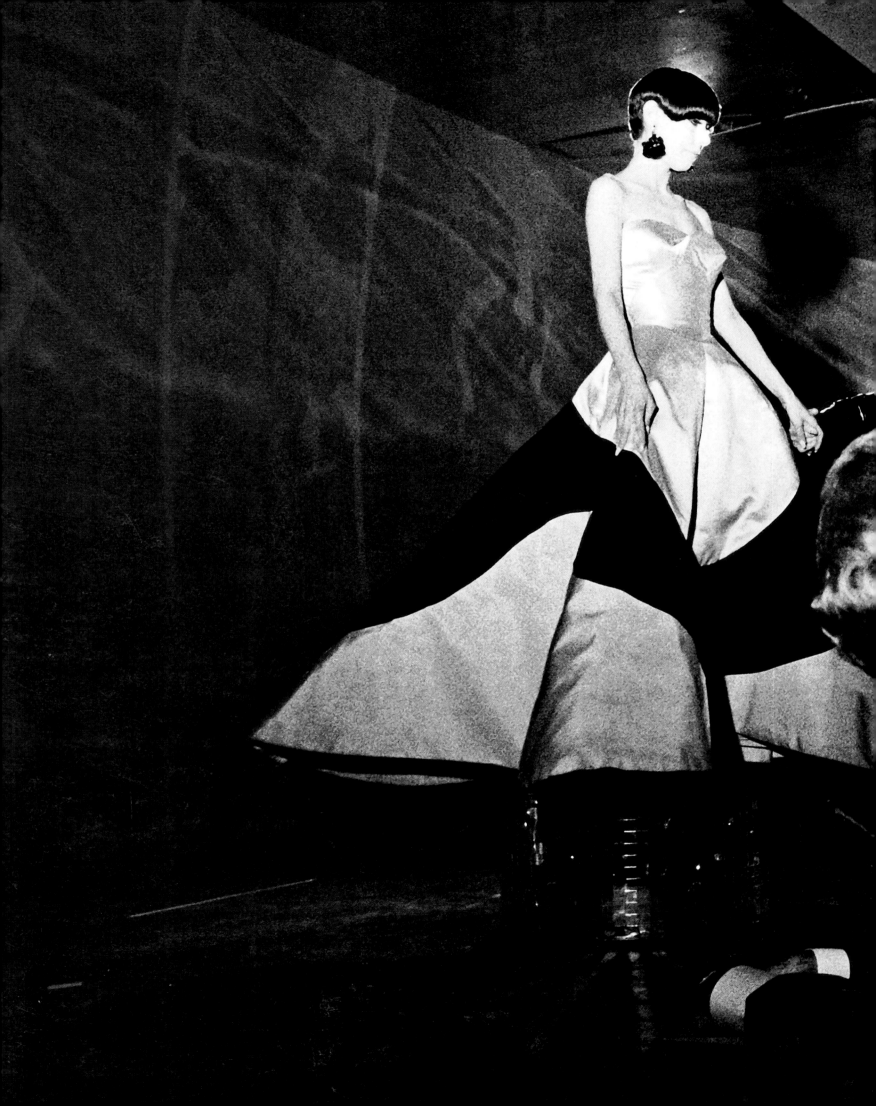

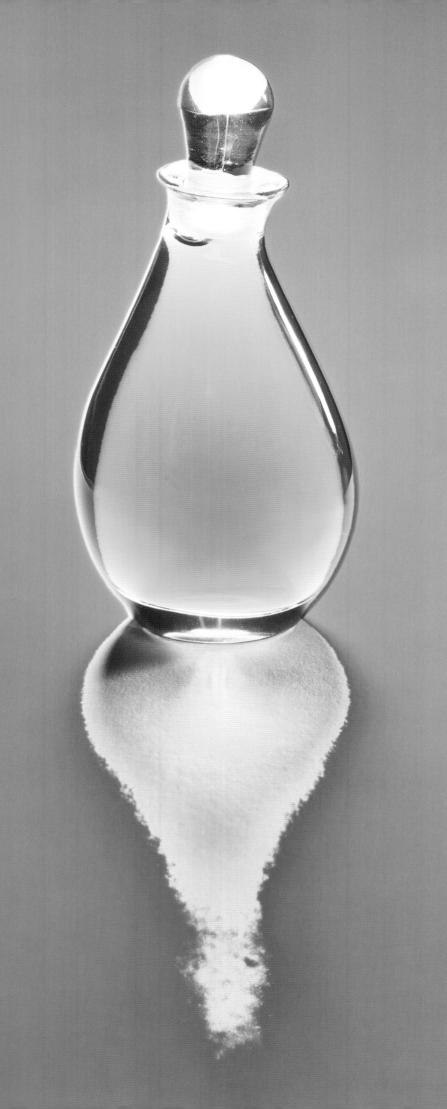

Rusty's budding fashion sense. "It was a family," says Karen Bjornson, one of Halston's favorite models. "We took care of everything, we set up chairs, we wrapped and delivered packages at Christmas, we made lunch, we held pins. We stayed as long as we needed to be there. And I wanted to be there, it was my life."

Halston kept a daily log, religiously noting the weather, who dropped by, how much money came in, and how much was spent. Everything would stop at lunchtime and the staff would gather to eat together, proper meals that could include salad, quiche, and a bottle of wine or a pitcher of iced tea. At first one of the studio assistants would be dispatched to make lunch. Then, in 1972, the incomparable Viola McKee joined the staff. Halston said she just appeared one day, prompted by the showroom's cleaning lady, who attended the same church as Viola and had mentioned to her that he was looking for a cook. Viola was Halston's devoted cook/surrogate mother until he moved to California in 1989. Her kind and gentle spirit reminded me so much of my grandmother's that it did not surprise me that she and Halston had such a mutually respectful relationship. At 68th Street, Viola made

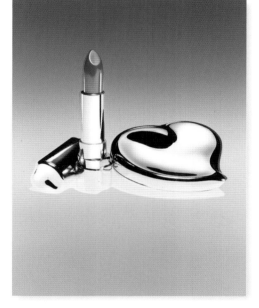

homey American food like stews, fried fish, and hamburgers on a hot plate in the hallway. Halston promised her a real kitchen with all the conveniences, though, and she finally got it when the business moved to the Olympic Tower in 1978. She made Halston breakfast, usually toast, juice, and tea or coffee, and lunch for up to twenty people every day. When he started going to Montauk for the weekends, she'd send him off with baked hams, chicken potpie, and pound cake.

Life was never dull at 68th Street, in large part because there were so many strong personalities there. Elsa Peretti, who had arrived from Italy in 1968 to be a model and artist, was one of the more extreme examples. Elsa and Halston became close friends, linked together like two tall, elegant giraffes dancing a tango. Halston

commissioned Elsa to design jewelry for his line and eventually to design the bottle for his perfume. She had agreed to a one-time design fee for the bottle and as payment chose instead of money a sable peacoat made by Halston licensee Ben Kahn. When a miniature version of the bottle she designed was subsequently used as a gift with purchase, Elsa felt that the agreement had been broken. She and Halston were sitting in his living room, arguing about it when she got up and threw the sable into the fireplace before storming out into the cold night. Equally incensed, Halston then kicked the coat farther into the flames, later commenting to his assistant Bill Dugan, "Sable fur really stinks when it burns." Though Elsa and Halston were eventually able to patch things up, their relationship was never the same after the sable coat's cremation.

Just as volatile was Victor Hugo, who was responsible for designing the windows of the ground floor of the Halston boutique. A born provocateur and a well-known intimate of Halston's, with whom he had an on-again-off-again affair, he once showed up for a black-tie event dressed in nothing but a fishnet body suit accessorized with a jock strap, spike heels, and a cashmere cape. On another occasion, he paraded across a brand-new, very expensive carpet in Halston's town house in bare feet that were dripping with red paint. Joel Schumach remembers a call from an incensed Halston after this particular incident. Joel's advice was, "Leave it, it sounds fabulous!" Photographer Charles Tracy recalls giving a popular portrait that he had shot of Elsa to Halston, who loved it so much he actually hung it in his apartment. The next time Tracy visited Halston, Victor had nailed silver spoons all over it. Victor's window displays, though, were witty. His Patty Hearst mise-en-scène, complete with a machine gun–toting bandit and Halston-clad hostages, was topically political. The window that presented him with particular trouble, however, was that of the mannequins decked

Opposite: Elsa Peretti–designed perfume bottle, and cosmetic designs inspired by her, above, launched between 1975 and 1983. Photography by Hiro. Peretti's glass bottle for Halston's first scent and the sleek lipstick and compact set have the fluid, graceful look of his designs.

out in Ultrasuede with matching Hartmann Ultrasuede luggage, lined up to catch their flight. It took a New York minute for a clever burglar to break the glass windows, shove armloads of silk and cashmeres into the fancy suitcases, and make a hasty escape before the cops arrived.

D. D. Ryan, style maven, socialite, and former *Harper's Bazaar* editor, met Halston in the early 1960s. They were on the same intellectual wavelength. She was a fiercely loyal friend till the end, and then some. She officially went to work for Halston in the early 1980s but they were close long before that. Her son Drew remembers visiting Halston's showroom when he was a child. "My mom would take me on Wednesday afternoons. We would go up Madison Avenue making all her stops, which usually culminated at Halston's newly opened salon on 68th. I was in third grade and hungry so we would all go eat a hamburger at a place downstairs. I remember sitting with D. D. and Halston and whoever else would come along at the table. We would end up sitting at his salon and I would watch the people come and go—Pat Ast, Bill Berkson, Berry Berenson. Halston struck me as a dashing, handsome, appealing character. I had names for everyone in those days. I called Truman 'The Abominable Snowman.' My nickname for Halston was 'Plush.' He was one of my two favorites of my parents' most favorite friends. We had a very special relationship and that was the theme that ran through my entire relationship with him—it never changed."

Absolutely integral to the Halston team were his models, or the "Halstonettes," as they came to be called. Though the cast varied, there were a few stalwarts in this group, including Elsa Peretti and Karen Bjornson, of course, as well as Pat Cleveland, Nancy North, Alva Chinn, Shirley Ferro, and Chris Royer. "He was like a protective older brother," says Pat Cleveland, who began working with Halston soon after he moved into the 68th

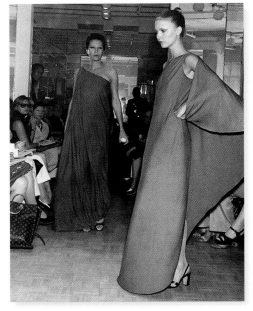

Street salon. "When I was young and going home late from a long day's work with him, he would escort me home so that I would be safe." Chris Royer—"Chrissy" to Halston—was summoned to 68th Street after Halston noticed her in a spread in *Mademoiselle*. She describes the elevator doors opening to the scent of Rigaud candles and the sight of a group of fashionable men seated on comfy ivory couches. "The interview was great but I kept thinking, 'When will I get to meet Halston the man?'" Chris finally asked when she was going to meet Halston and wondered how old he was. The handsome man sitting next to her said, "Oh, he is old enough!" "After a few moments," Chris continues, "a black-clad assistant popped his head into the room to announce to the man sitting next to me, 'Halston, Jackie Onassis has arrived.'" The penny dropped and Chris realized she had been talking to Halston all along. He thought it was hilarious and hired her on the spot. Halston kept his house models in the studio all day because he worked out his designs on them, draping and pinning to find the most flattering fits. "Walking in front of the mirror is how we figured out the nuances of fabric movement to look most flattering on each of us," says Chris. "But Pat Cleveland could feel it without even looking. He had the eye to see flaws in the way we walked and helped us girls to figure out how to work the fabric of the dresses as we modeled them."

Nancy North, a model who was part of the Factory crowd before becoming a Halstonette, remembers how sensitive he was to criticism. "At the emotional level he wanted nothing more than to be loved. He was looking for that," she says. "His sensitive side he hid. It was a facade of tough 'nothing bothers me' but he was sensitive. If he had bad press it wounded him. It would hurt him not for the business but personally."

Halston became so close to some of the models that he even

Opposite and pp. 58–61: Halston fashion show, 1975. Refined and chic, Halston's creations—from halter jumpsuits with cutouts to fluid blouses and A-line skirts—were simply electric on the runway.

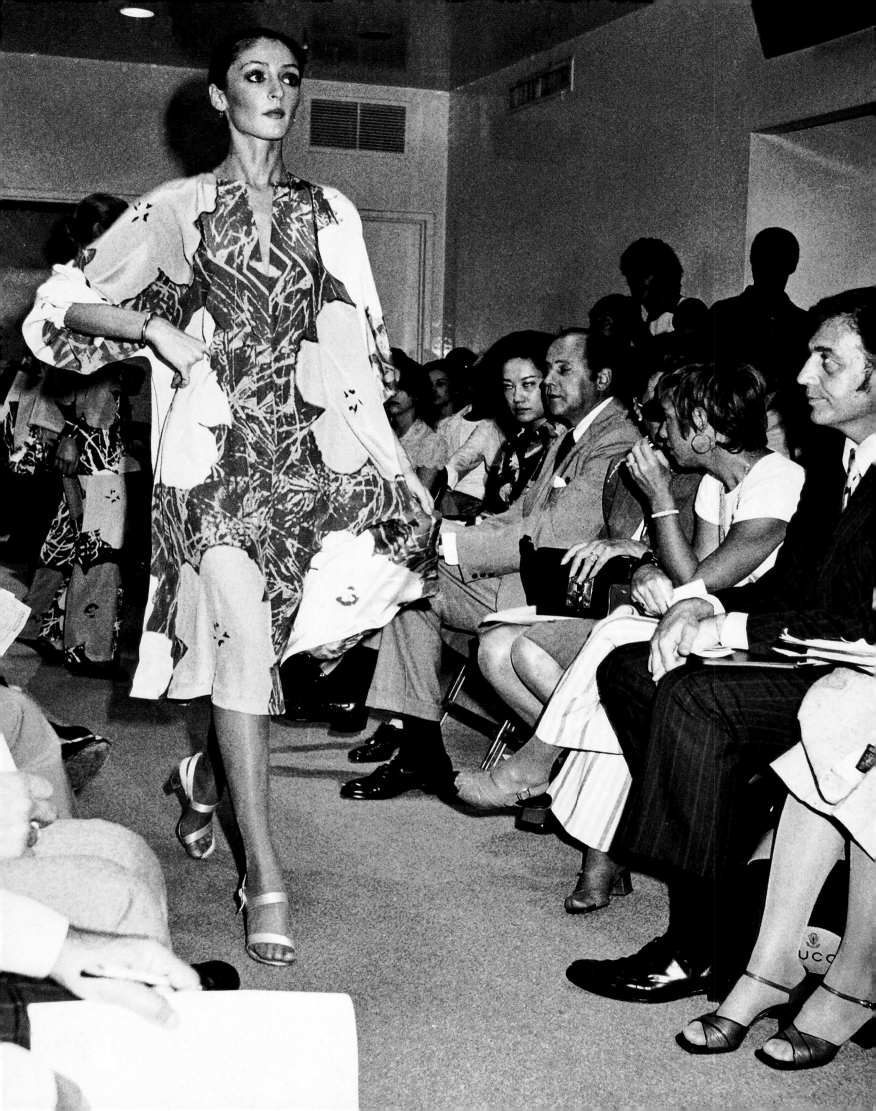

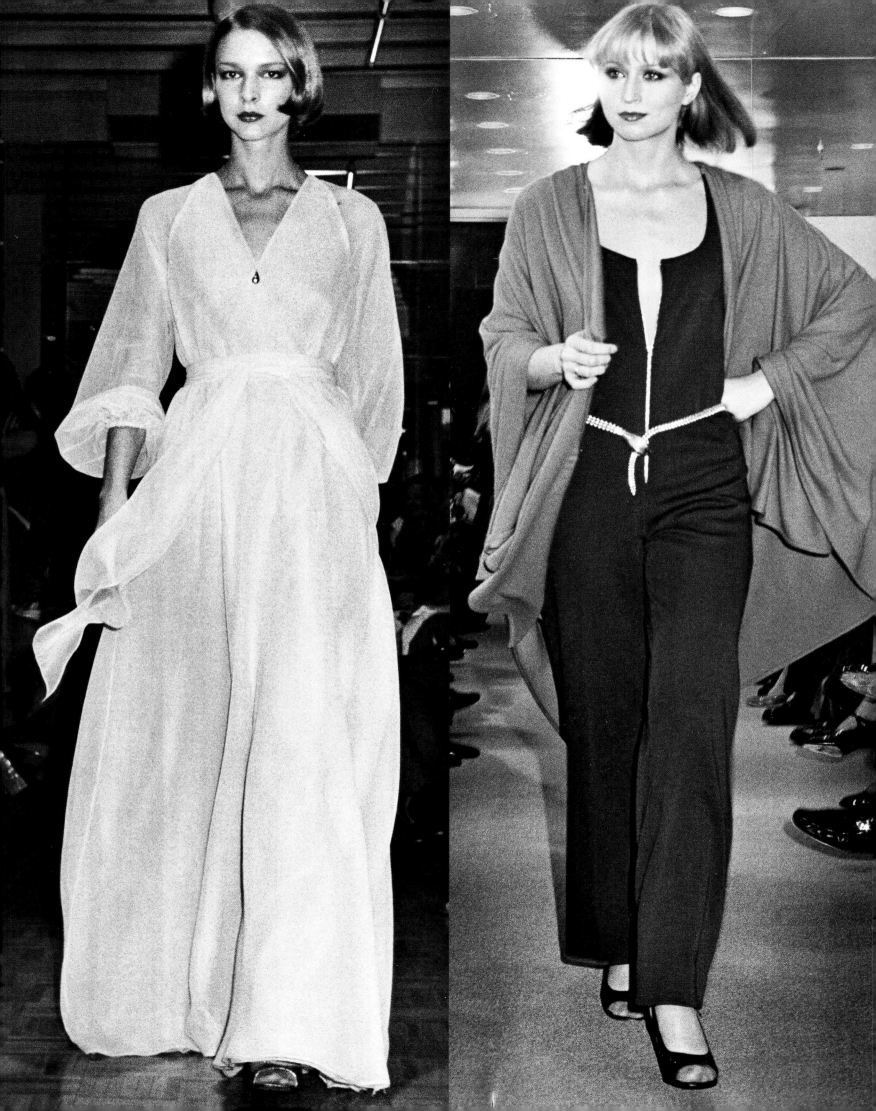

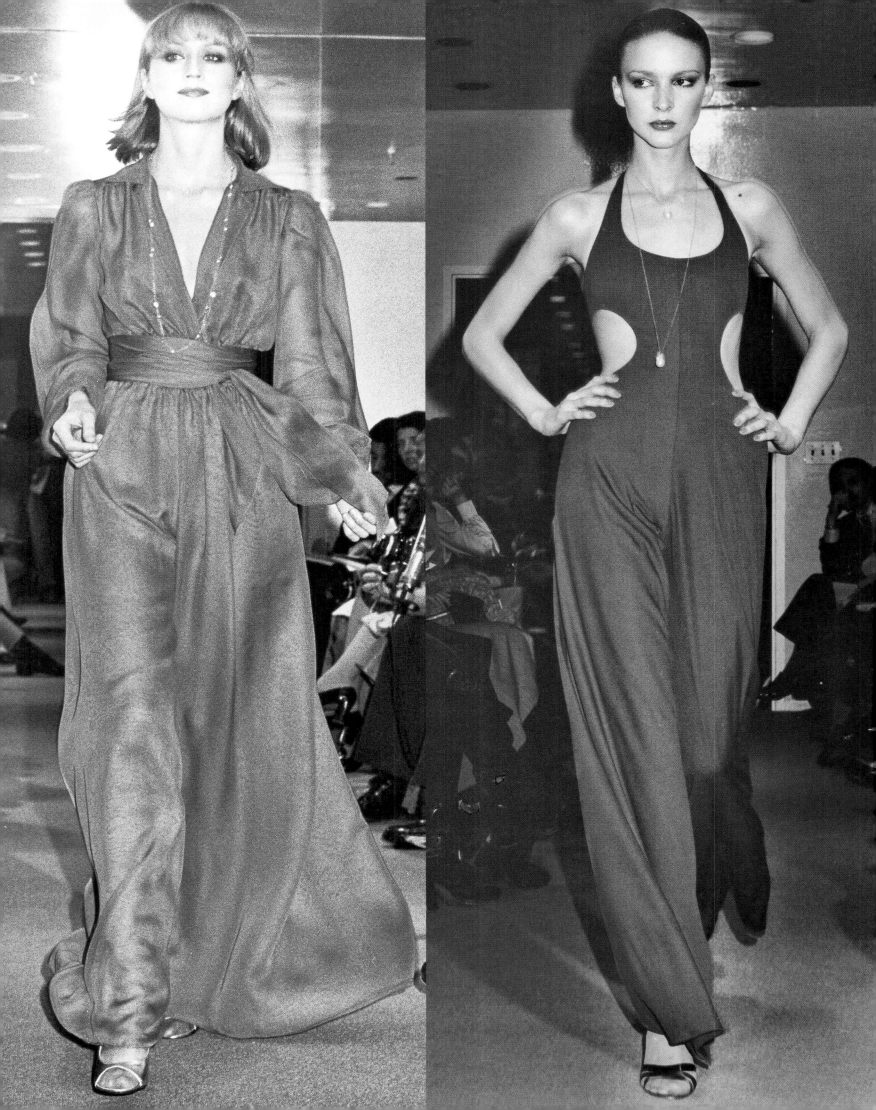

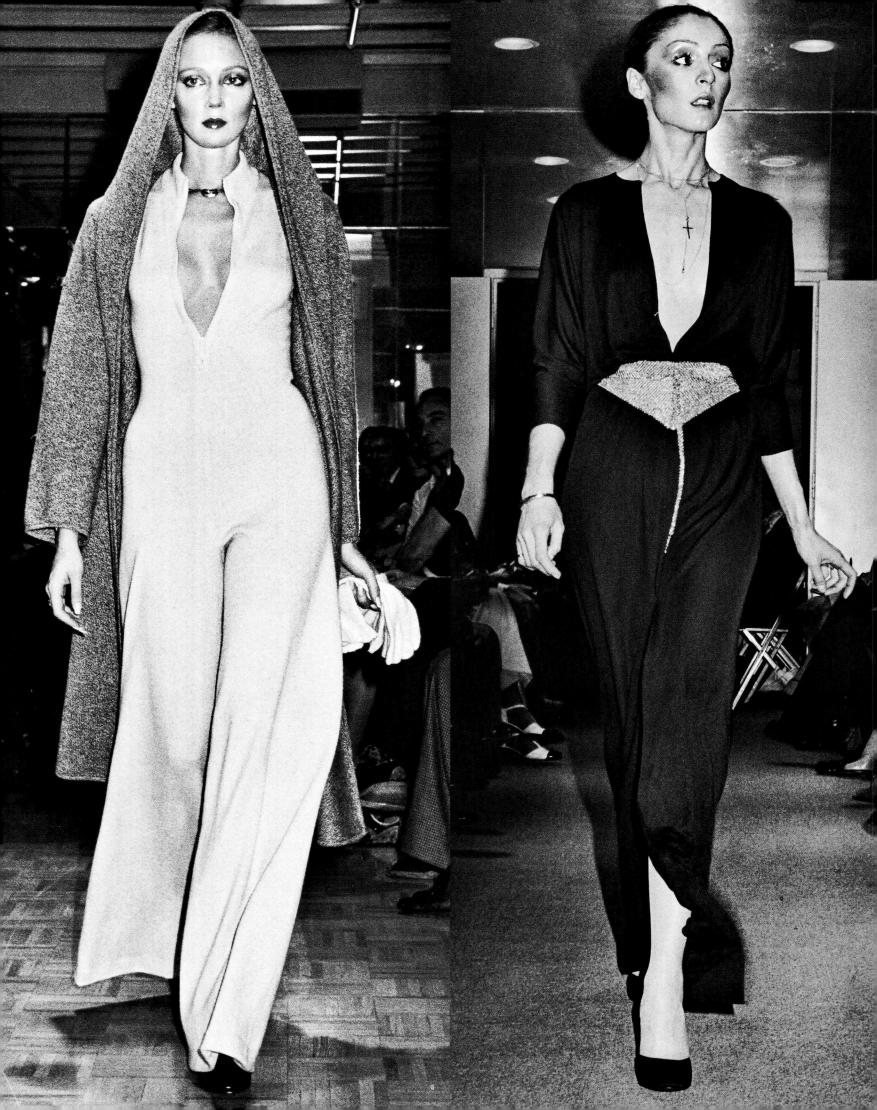

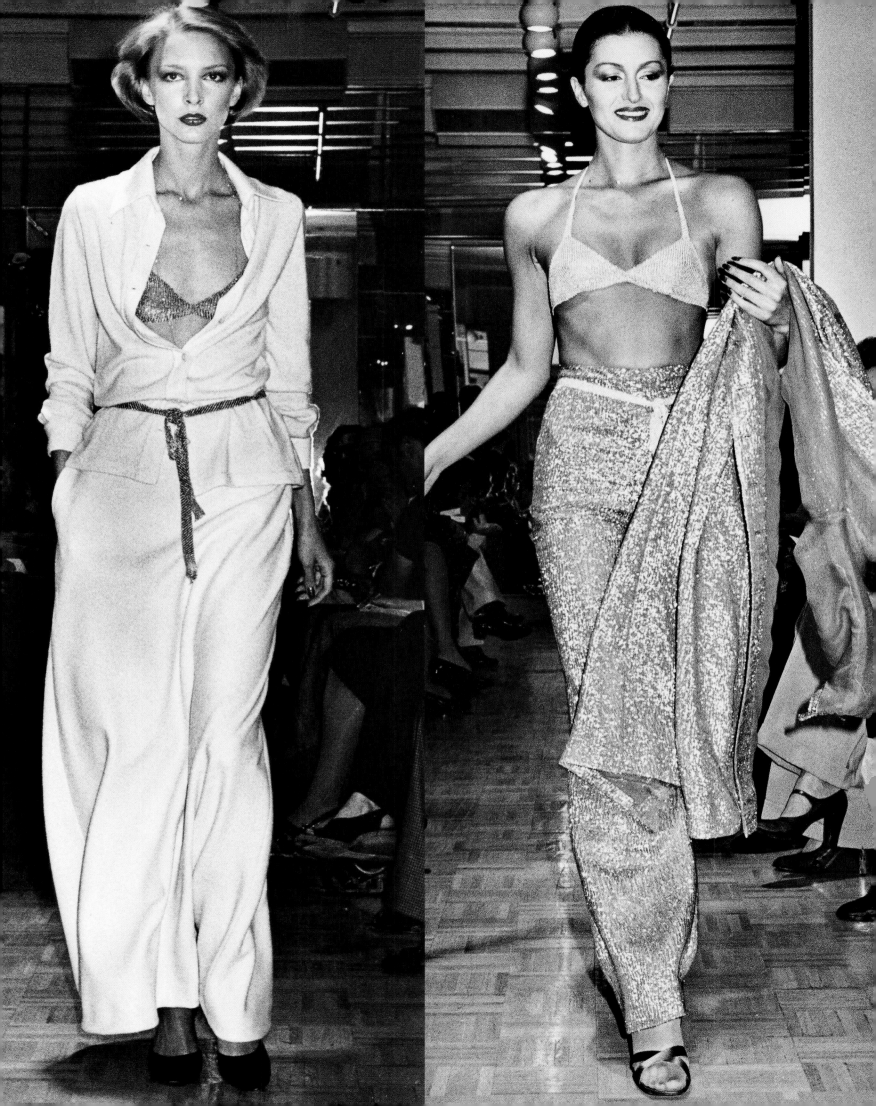

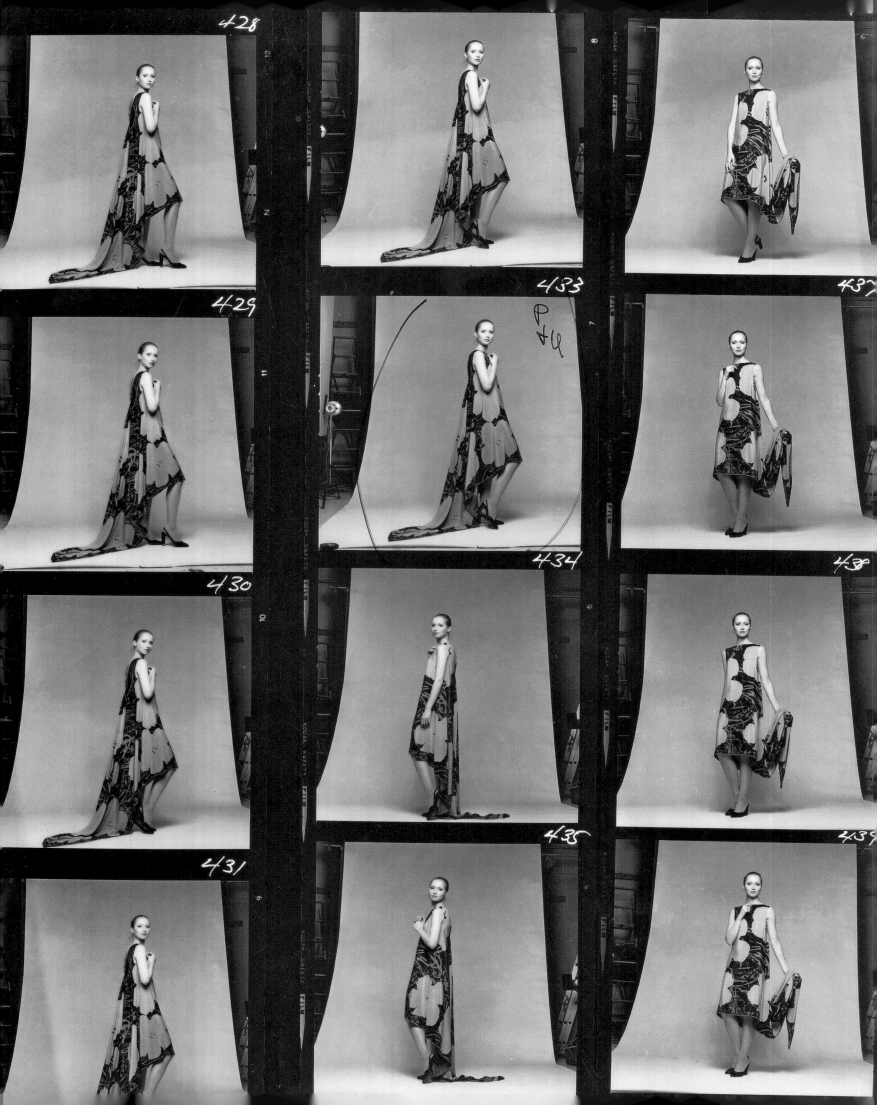

made their wedding dresses—iridescent pink taffeta for Marisa Berenson, whom he walked down the aisle; ivory chiffon for Nancy North; and white satin charmeuse for Karen Bjornson, whose reception he hosted, with Bill Cunningham as official photographer. He became so close to Karen and her husband, Tim MacDonald, that he would visit them at their houses in Manhattan and Connecticut and invited them to stay with him in Montauk when their New York apartment was being renovated. When Liza Minnelli (he made her wedding dress, too, when she married Mark Gero) bought an apartment on the Upper East Side, Halston suggested that she have Tim, an interior decorator, design the place for her. "Liza was about to go off to make the movie *Arthur* and had asked Halston to decorate the apartment for her," Tim says. "He said, 'Yes, of course I can do that but you need a decorator and I have someone for you. He invited Mark and Liza over for dinner and Karen and me. Mark showed up early; I had plans drawn up and had them all laid out all over the floor. Liza wasn't sure about working with me—she did not know anything about me. The night she was to get back from the set of *Arthur*, Halston brought Rigaud

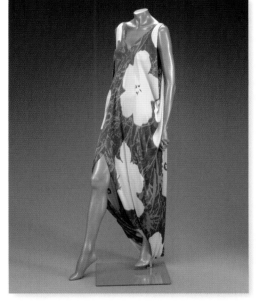

candles and accessories and lit each candle, placed chairs the way he would like them, making sure it was home for her. As soon as Mark carried Liza across the threshold the phones started ringing. She called us: 'Come over now—this is more than I ever expected.' I loved that Halston was there to support me, too. It was a gift to both of us." Liza's apartment landed Tim his first *Architectural Digest* cover.

These insightful gestures were what laced together Halston's friendships. When Liza was nominated for an Academy Award for *Cabaret* in 1972, he designed the dress she wore to the ceremony. He knew her date was going to be her father, Vincente Minnelli, whose favorite color was yellow. In homage, Halston

made Liza a stunning yellow silk jersey dress—the perfect accessory for her shiny Oscar.

Naeem Khan, who came to work for Halston via his family's beading and embroidery business in India, recalls him as a father figure, albeit one with access to the sort of people and events that most dads can only dream of. A month into his job, and only weeks after arriving in New York without so much as a pair of winter boots, Halston had Khan's first tuxedo made for him in the workroom at 68th Street and sent him shopping at Yves Saint Laurent. He wore the tuxedo to a party Halston took him to at Studio 54 a few weeks later. "I forgot what the theme was but all the waitresses were naked with their pubic hair sculpted into a heart shape and dyed pink," Naeem says. "So here I am, a kid, this is totaling blowing me away. The waitress comes up to take my order, my hands shaking so much, and there I am sitting with a full-on view of you know what."

By the time Halston had opened his business, my family was back in the States, living in Connecticut while my dad was on sabbatical from the State Department at Yale. Halston would visit us for an afternoon with snazzy friends, such as the designer Bill Smith and other chic men. As a kid, I was dazzled by their charm. One house call was just before Christmas. He gave my brothers a pair of wooden skis and me an 18-karat gold Taurus medallion in honor of our shared birth date. On another visit he draped what looked like a piece of fabric on my mother. She remembers being puzzled as to what form this fabric was going to take and being astonished at how it fell right into simple, perfect folds on her body—it was actually a bias-cut silk jersey dress.

In 1970, we were living in Europe again, this time enjoying the plum diplomatic assignment of Paris. My parents had countless embassy functions to attend and Uncle H saw to it that they were prepared. He gave my father several of his lightly worn

Opposite: Contact sheet of Halston's Warhol–inspired flower dress modeled by Chris Royer, 1974. Above: Halston's flower dress, Fall 1974. A master of minimalism, Halston also combined ingenious construction (the dress is created from a single length of fabric) with bright bursts of Pop-art color.

suits and tuxedos and my mother boxes and boxes of clothes—silk jersey and sequined evening-wear pajamas, chiffons, and tie-dyed sweaters. As I was finally old enough to wear Halston, he also sent goodies for me, too. I was too young, short, and skinny to wear the fancy pajama suits but soon sprouted up and into the knit pantsuits and turtlenecks with matching tunic-length vests. They were in hunter green, black, dark brown, and mustard colors. I particularly loved the black turtleneck ensemble. In fact, to this day black turtlenecks are my uniform. And though I adored the dark blue, fuchsia, orange, and white tie-dyed cashmere sweater, my skin was too sensitive to wear it without an under layer and so it was, alas, recycled to a fellow foreign-service brat. Can I count the ways I have kicked myself since? Good fortune, however, has put that very same sweater back into my life by way of an Internet search in which I learned it lives on at the Costume Institute at the Metropolitan Museum of Art, where it was sent by Lauren Bacall, a big Halston fan. I can enjoy it vicariously! Halston was in Paris that season to attend the fashion shows. Although we didn't go to any of them with him,

he did procure tickets for my mother and me to attend the spring collection at the House of Dior on the rue du Faubourg Saint-Honoré—quite a treat for an eleven-year-old girl. We dined at my dad's favorite watering hole, Au Pied de Cochon, as of yet to be overrun with tourists. Halston was full of funny stories that entertained us through our salty *soupe à l'oignon* and *salade verte*. We drove back to our Left Bank apartment in our icon of American capitalism, a butter-yellow Pontiac Tempest convertible with the top down. Halston loved the experience. Typically, my dad would make a few revolutions, so to speak, around the Arc de Triomphe, to the bewilderment of the gendarmes (if it was raining he would just put up his umbrella) before heading home for a

chat over a frosty Pernod in the parlor. As we were socializing there came a waft of a skunky odor, which was my brother delving into his stash in his room. I guess he either forgot to blow it out the window or thought in his self-absorbed adolescence that no one would know what it was. Halston got a chuckle out of the scandalous scene and said something like "Attaboy!" In our kitchen that night he taught us how to paint black T-shirts with bleach. I recall mine was designed with a peace sign, which was a prevalent symbol of the day. On his trips he was always in the company of a good-looking man. If there was any question in my father's mind as to why he was still a bachelor, the subject went unspoken until the end.

The early 1970s were an exciting time for Halston. By February 1970, *Women's Wear Daily* was saying of him, "In just one year Halston has become such a super source of fashion—he seems to know what we want and should have to wear." Two of his best-known designs, the caftan and the Ultrasuede shirtdress, date from this period. Beginning in 1970, he began including them in his collections, in sumptuous fabrics like silk chiffon. After Babe Paley wore a tie-dyed one to a museum opening in 1971, Halston received orders from dozens of ladies who wanted one of their own. It was an ingenious move on his part and one of the fashion crazes of the early 1970s, a dress that a woman of any size could look good in.

In the early days at 68th Street, Will and Eileen Richardson, owners of Up Tied, produced tie-dyed fabrics for Halston's caftans and his casual pajamas. These hip designs were then succeeded by Halston caftans and gowns hand painted for him by a Japanese woman named Reiko Ehrman, who had been referred to him by fellow designer James Galanos. She had originally stopped by 68th Street and left her only samples, a few scarves and a three-yard length of silk that she'd hand

Above: Halston did his own illustrations until Stephen Sprouse, who would become a singular designer in his own right, joined Halston as his assistant in 1972.

Pages 64–69: Illustrations by Stephen Sprouse, paired with runway shots.

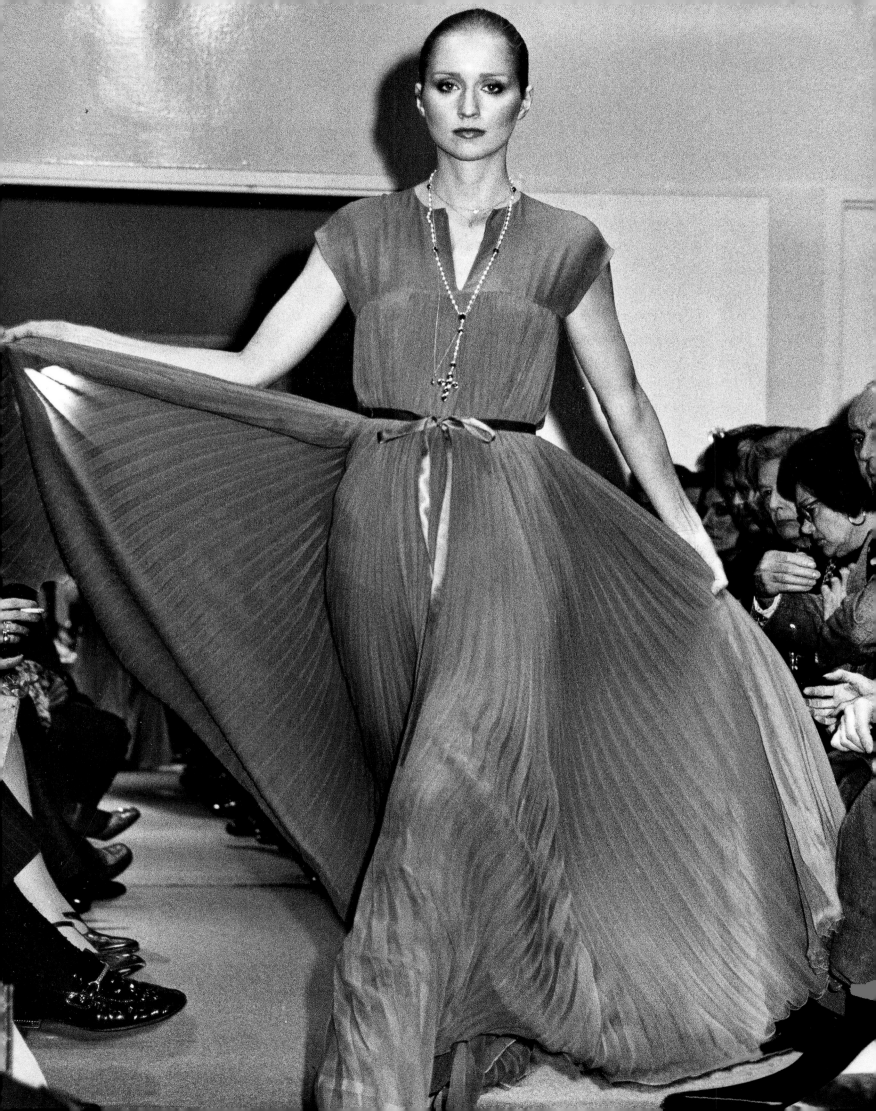

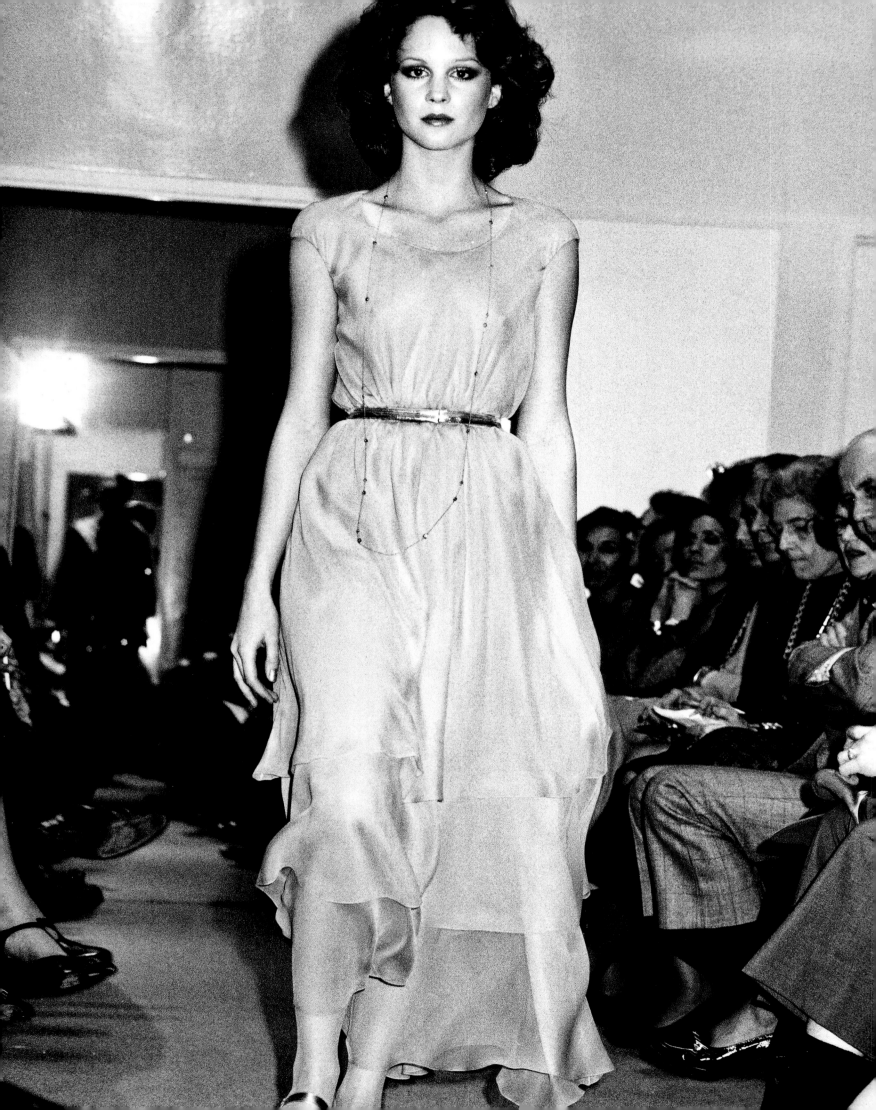

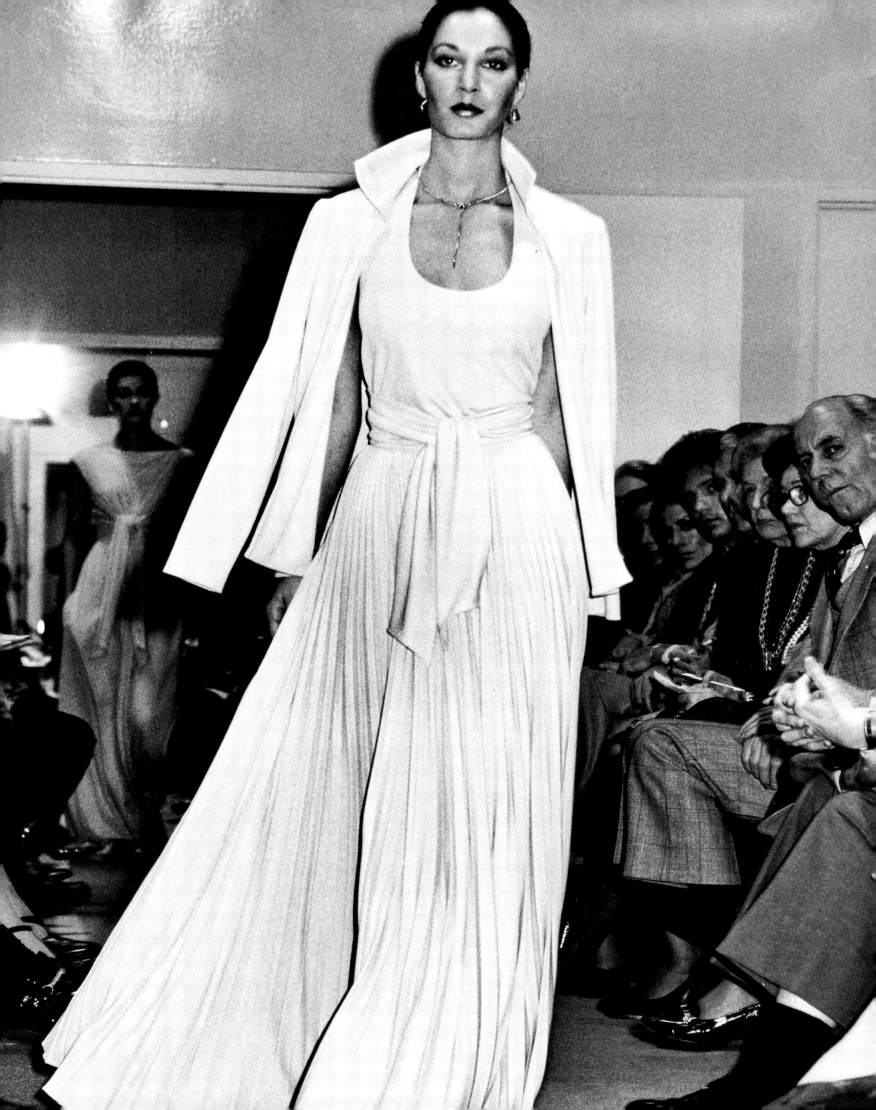

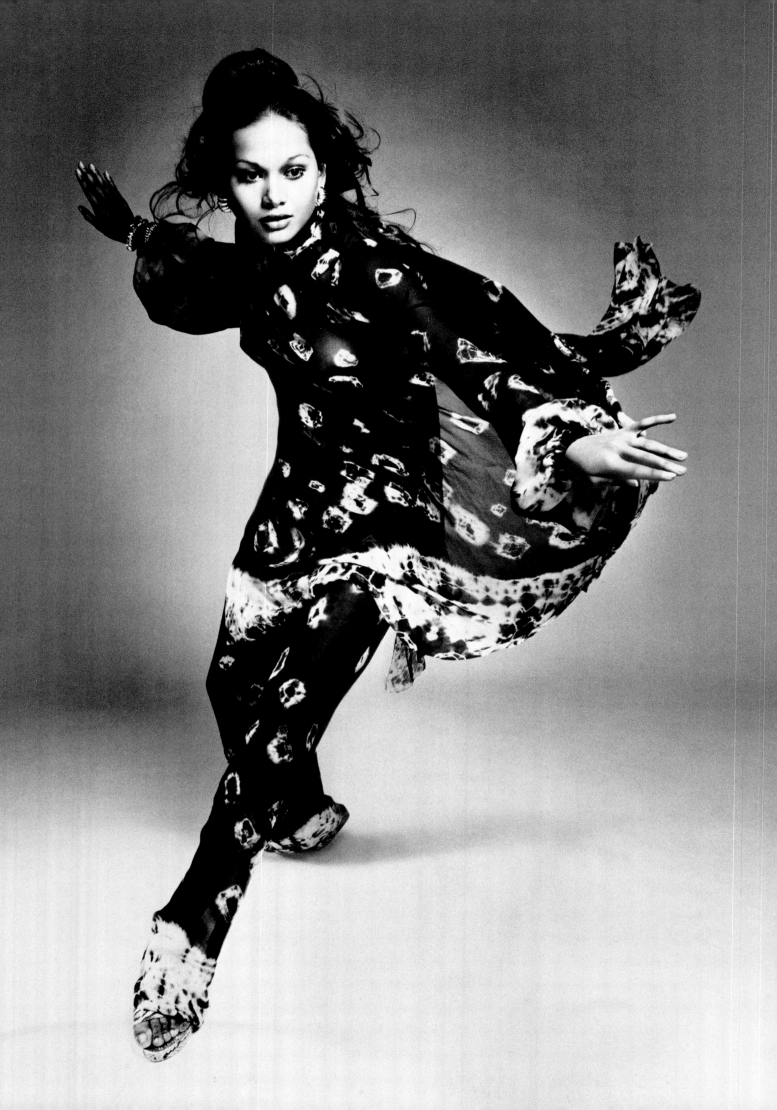

painted in her kitchen using a traditional Japanese silk-painting technique. Not expecting much, she had gone straight back home, only to be greeted by her husband, who'd told her to jump back into the cab and get back to Halston's as soon as possible. She had dashed back and there he was in the show-room, standing in front of the three-way mirror, draping Reiko's three yards of hand-painted silk chiffon over the shoulder of Karen Bjornson. "He told me that he was thinking of bringing this Arabic style to his ladies—the caftan," Reiko remembers.

For the next five years she hand painted fabric exclusively for Halston, who then created exquisite one-of-a-kind silk caftans and evening wear. Only rarely did he request special designs, for the most part trusting her unique artistry. She'd paint the silk, then bring it to 68th Street. One day when she was presenting a new fabric design, Halston asked her if he could get her anything. Not being a native English speaker, she replied only, "I would enjoy coke." Halston was so taken aback he called out to his assistants, "Reiko wants coke!" They all laughed, Reiko says. For Halston's fifth anniversary, he asked her to transform a Warhol painting of a flower into fabric for a scarf. She obliged and

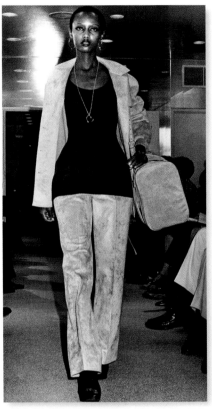

Halston had the design printed and made into scarves for his party guests.

Possibly even more popular than the caftan was Halston's Ultrasuede shirtdress. He first saw the fabric about six months before its American release, at a party. Among the guests was the designer Issey Miyake, who'd used the piece of Ultrasuede he'd been given by Toray Industries, the Japanese mill that created it, to make a shirt for himself. Halston immediately saw the potential of the soft, luxurious yet machine-washable fabric, but he mis-understood Issey to say that it was water-repellent, which prompted him to make his first Ultrasuede design, for his Spring 1971

collection, a raincoat. In fact, Ultrasuede doesn't repel water but absorbs it—which didn't prevent the coat from being a runaway success, so there may be some truth to Halston's proclamation, made to the *New York Times* in 1977 that "it doesn't rain on the rich." He followed the raincoat up with a simple shirtdress, model number 704. It turned out to be one of the defining dresses of the decade—everyone from Jacqueline Onassis to Princess Grace had one, as well as countless other stylish American women.

Though other designers worked with Ultrasuede, few had the success that Halston did. This was because he treated it like real suede, in-structing his seamstresses to stitch flat seams and eschewing linings. This made his Ultrasuede garments supple and flat-tering. That they could be washed and left to drip dry only added to their appeal. Most manufacturers were limited to no more than seventy-five thousand square yards of Ultrasuede a year but there was no such restriction placed on Halston—he bought as much as he could and still could have sold more.

In 1972, Halston won his fourth Coty Award, a Return Winnie (he won again two years later, this time a Hall of Fame Award, which effectively retired him from the running after that). At the ceremony at Lincoln Center, he staged a fashion show that was very much in keeping with the times. Billed as an "onstage happening by Andy Warhol," it featured both Halston's regular models as well as Warhol Super-stars Candy Darling, Baby Jane Holzer, Donna Jordan, and Jane Forth. Instead of walking down the runway, the models were instructed to do their own thing: Donna Jordan tap-danced, Jane Forth came out with her baby son, Lily Auchincloss cooked a strip of bacon, Berry Berenson played the guitar and sang a folk song, Karen Bjornson played a jingle on her clarinet, and China Machado played the bongos. The event culminated in the

Opposite: Studio shot by Hiro of a model in Halston-designed tie-dyed chiffon pajamas, 1970. Above: Supermodel Iman modeling an Ultrasuede pantsuit with matching shoulder bag, 1975. Following pp.: Advertising for a sumptuously hued tie-dyed caftan, 1972. Halston's interpretation of the classic caftan became one of the fashion crazes of the 1970s.

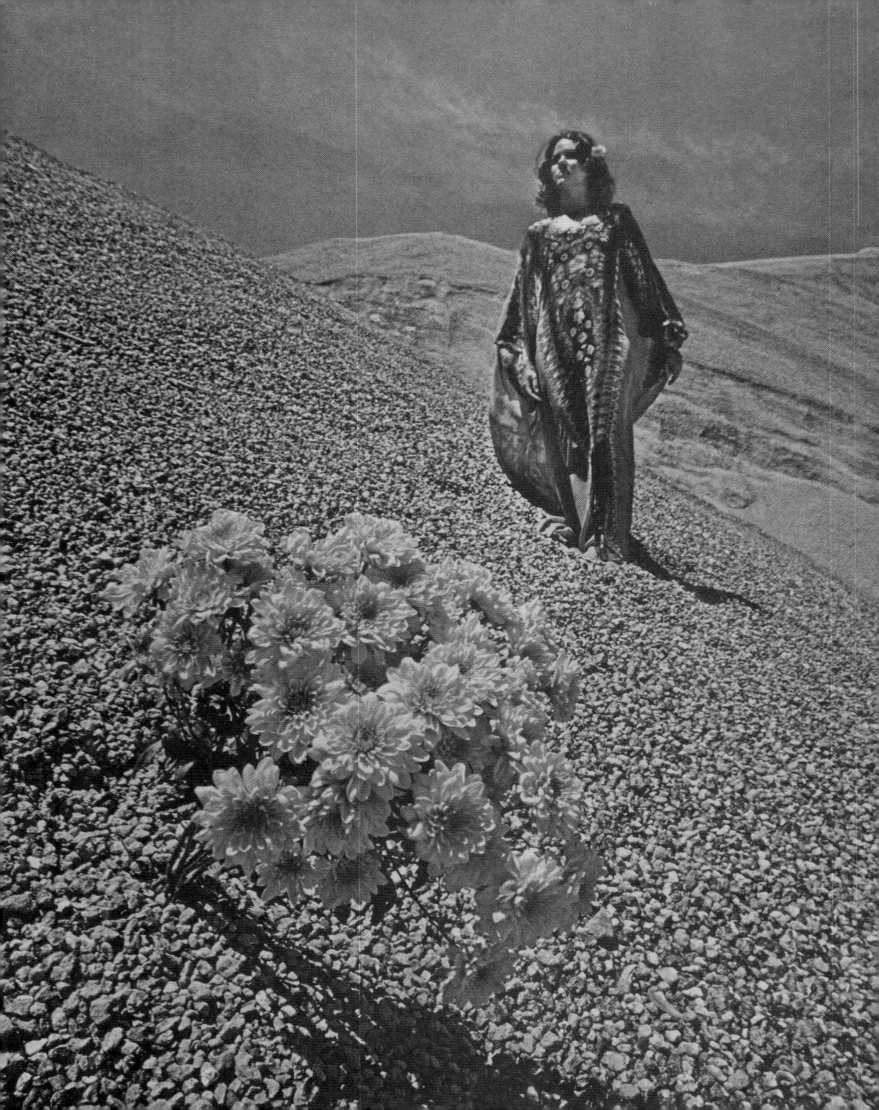

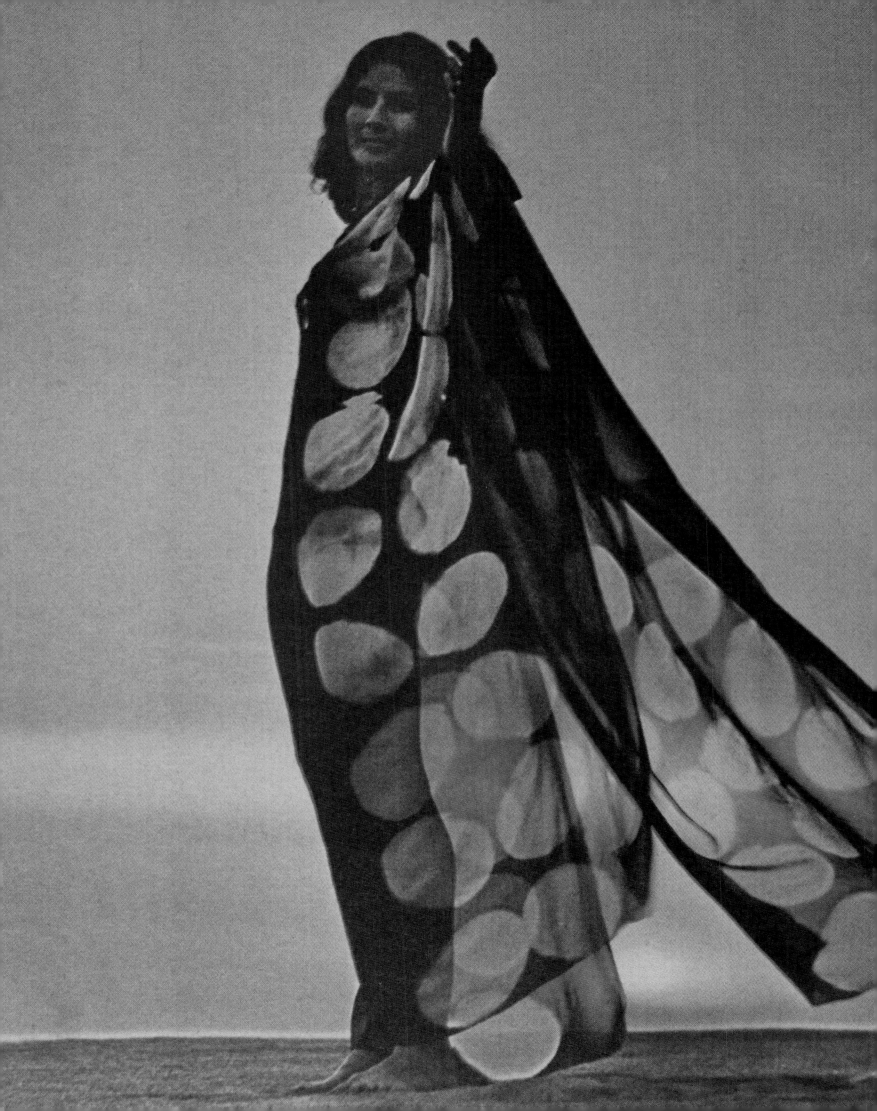

appearance of one of Halston's favorite companions and models (she often sashayed down the runway in one of his caftans), the two-hundred-pound Pat Ast, who jumped out of an enormous cake and bellowed "Happy Birthday!" The audience was clearly bemused. Halston, meanwhile, had a great time. "It was fun and camp," he told *Women's Wear Daily* in October 1972. "If it shook some people up, good. I loved it. The whole thing freaked me out." Though this kind of grooviness was not the image that later came to be associated with Halston, it was characteristic of the early days of his company—more freewheeling and counter cultural than the ultra-sophisticated slickness that Halston came to exemplify. The actor Dennis Christopher, who went to work for Halston in 1972 as a stockroom boy after meeting him at a party at Berry Berenson's pad—Halston's preferred method of screening potential employees—and eventually graduated to the design room, remembers that Halston brought him on board even though he couldn't so much as sew on a button. In the evenings, after most of the staff had left, he says, "We would roll a great big fat joint. I would stay just about every night unless Halston had to fly out of there. Essentially he'd say, 'We are going to decide what the ladies of America are going to wear.' We'd have a big laugh on that because we were sort of high but we were creatively jazzed. Often, at the end of these things he would say, 'Okay, we are leaving in fifteen minutes. Tonight we are going to Diana Vreeland's house for dinner.' He would bring us everywhere. We ate lunch almost every day together. Sometimes he would make the lunches private, with just us assistants, but usually not—he wanted a mix of people. There was the table set always at a certain time. Sometimes you did not know until ten minutes before lunch that you were not invited and would have to run out and get your own sandwich. Often we were lunching with the ladies—Mrs. Onassis, Ali McGraw, Marlo Thomas. We loved the lunches because with the eighty-seven dollars a week that we made after taxes, we did not have to pay for a sandwich." Also tough to pay for, remembers Dennis, was the all-black uniform of slacks and cashmere turtleneck that Halston employees were required to wear, just like the boss. "They would run you up a pair of black crepe pants but you would have to buy your own sweater. It might take eight to ten paychecks to pay it back and it was so smelling of BO because you wore it every single day!" Halston, on the other hand, bought his turtlenecks in bulk from P. Celli of Italy. Pat Cleveland remembers seeing neat stacks of them in his closet, next to dozens of black wool gabardine pants and red, black, and white cashmere jackets—all the elements of his uniform. "He wore the turtlenecks because he told me his neck was too long," she says. "I used to call him 'my swan.'"

He could be an exacting employer. "There was a cruel streak," Dennis remembers. "He could use you just for target practice. He could tear you down for any idea you presented and make it so ridiculous that you would never dream of coming up with another idea. After a while you realized that if you mentioned something, you did not say it is your idea. You feed the idea into the atmosphere, so a few days later he would say, 'Oh, I was thinking. . . .' Stephen [Sprouse who got his start in fashion as Halston's illustrator] wanted us to do mini dresses, and then it was all of a sudden—oh yes, 'the Skimp.' You had to set the stage, and he liked to own the ideas that came out of there. It was a good lesson. When you are working with someone of that talent and genius, they are always looking for input to make their own creations."

Despite the tongue-lashings, Halston was generous to a fault. When Dennis got his first New York City apartment, Halston lent him $1,500 to cover moving expenses. "I was not able to pay him back as long as I worked for him," he says. "But after the movies that I appeared in, I went back to see him at Olympic Tower and I had fifteen one-hundred-dollar bills. I gave it to him and he flipped. He said, 'Of all the people I have ever loaned to, absolutely no one has ever paid me back.' He was really quite moved, and I was moved, too."

Things began to get a bit more buttoned-up at Halston when the company was acquired by Norton Simon in early November 1973. Though he'd already been approached by Revlon and Chanel, Halston felt comfortable with Norton Simon chairman David Mahoney, even going sailing on his yacht with him and his wife,

Illustration by Joe Eula of Pat Ast in a Halston-designed caftan during a road-trip trunk show, Fall 1976. Following pp.: Contact sheet of a publicity portrait of Halston, 1987, shot for an ad Halston took out in the *New York Times* to promote a Martha Graham School of Contemporary Dance auction, which featured Warhol serigraphs.

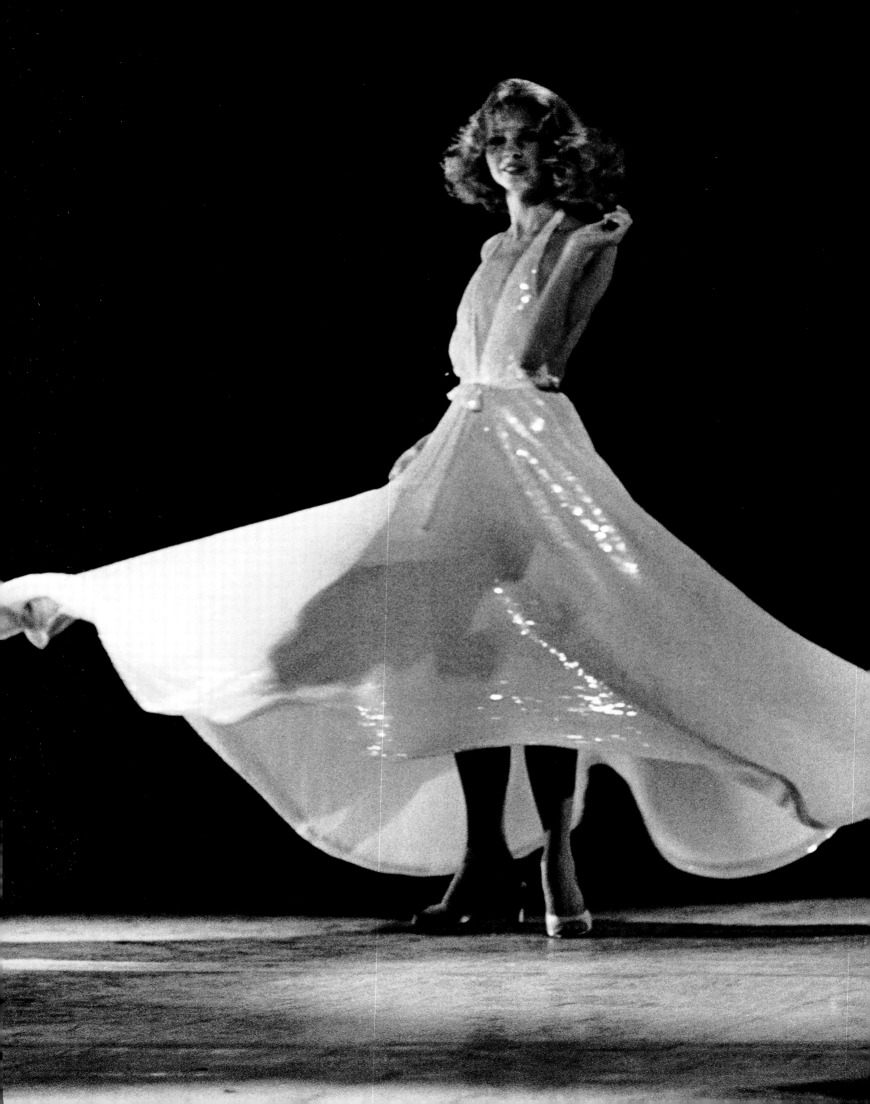

Hillie, who was a loyal Halston customer. At the time of the deal, Halston personally owned Halston Ltd., which produced ready-to-wear and custom-made clothes. He'd also signed licensing agreements with other companies to manufacture and sell products bearing his name. The deal with Norton Simon changed Halston's business significantly. For one thing, it gave him a big infusion of cash. Norton Simon paid $16 million for the ready-to-wear line, the couture business, and the Halston trademark, forming a new company called Halston Enterprises. According to Halston's attorney, Malcolm Lewin, Halston had sold his trademark and a large percentage of rights to his name. However, his agreement with Norton Simon guaranteed some control of design under his name as long as he was alive. Simon made Halston president of the new company and installed Michael Lichtenstein as the managing director. Halston was thrilled and the deal was the envy of every designer on Seventh Avenue, especially given that Norton Simon owned the Max Factor cosmetics line, which meant that it was only a matter of time before a Halston fragrance was released. The agreement made Halston an instant millionaire, as we discovered when he called us in Paris to share his news.

HALSTON LIMITED

THIRTY THREE EAST SIXTY EIGHTH STREET · NEW YORK 10021

For Halston, 1973 was a banner year. The month after he signed with Norton Simon, he was invited to take place in what turned out to be the fashion show of the century at Versailles. Earlier that year, Eleanor Lambert, the reigning queen of American fashion publicity and Halston's publicist into the 1980s, met with art conservator Gérald Van der Kemp and decided that immediate and appropriately extravagant action had to be taken in order to save the dilapidated Château de Versailles. The logical solution, they determined, would be to stage an exotic fashion show fit for a king (or queen, as it were) on the stage of the Queen's Theatre. As they rattled off the names of potential

French designers, Eleanor Lambert proclaimed that it could not take place unless an equal number of American designers were invited to participate. And so it happened. The undertaking was chaired by the only person who had the energy and the connections to make it happen, the Baroness Marie-Hélène de Rothschild. A smattering of American socialites lent their influence from over the pond as well, all in an effort to raise money for the Versailles Foundation, which was led by the intrepid Van der Kemp. The plan was to stage a week's worth of fanciful activities and livery-laced receptions, culminating in what was christened Le Grand Divertissement à Versailles, i.e., an over-the-top fashion show.

In November, along with Stephen Burrows, Bill Blass, Oscar de la Renta, and Anne Klein, Halston accepted the invitation of the five leading French couturiers (Hubert de Givenchy, Yves Saint Laurent, Pierre Cardin, Emanuel Ungaro, and Marc Bohan of Christian Dior) and the Baroness to present a special collection for the benefit of the Château de Versailles. The American designers planned to show their best designs on the hottest models and select high-profile friends, in Halston's case Jane Holzer, Liza, Betsy Theodoracopulos, Marisa Berenson, and Kitty Hawks. The plan was to present their collections to musical accompaniment with Liza Minnelli performing the opening number under the direction of her godmother, Kay Thompson. Each designer assumed financial responsibility for his or her own show.

The first event was a dinner at Maxim's, with the bill footed by David Mahoney of Norton Simon. He spent more than $25,000 on the evening, the first time in sixteen years that the restaurant had been taken over for a private affair. Nancy North, one of the Halston models along for the ride, remembers, "We models all showed up decked out in Halstons, looking

Karen Bjornson twirling in a Halston white sequin dress onstage in Le Grand Divertissement at the Château de Versailles, November 1973. Karen transformed the stage, beautifully expressing the essence of the Halston look, as shown in Stephen Sprouse's original sketch of the design, above.

HALSTON LIMITED

Chris　　　　　　　*Black & White*

THIRTY THREE EAST SIX[]TH STREET

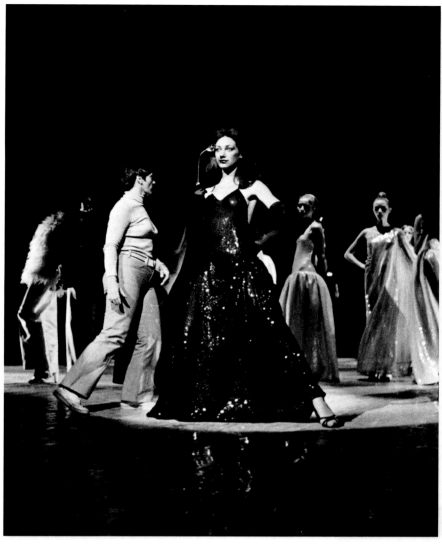

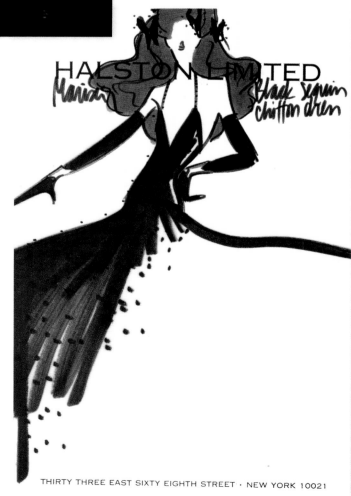

O nstage for Halston's segment of Le Grand Divertissement at the Château de Versailles, November 1973 (pp. 80–89), with sketches by Stephen Sprouse of Chris Royer, Marisa Berenson, Alva Chinn, China Machado, Nancy North, Pat Cleveland, and Elsa Peretti. China Machado holds an Elsa Peretti–designed sterling silver and feather fan. Drawings of layered chiffon dresses (pp. 82, 83, 87) and a black sequin Halston gown (p. 86) by Stephen Sprouse.

HALSTON LIMITED

Frede 3 layer chif.

THIRTY THREE EAST SIXTY EIGHTH STREET · NEW YORK 10021

HALSTON LIMITED

Rita

3 layer chiffon

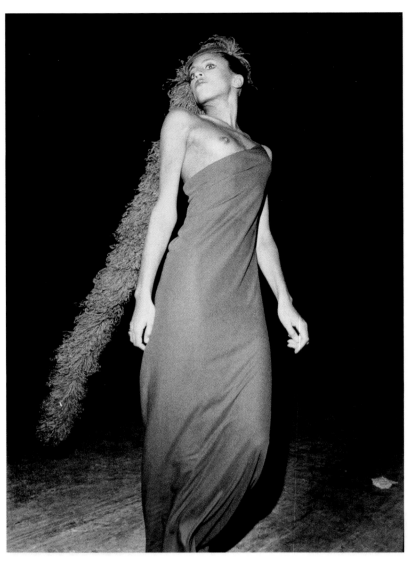

HALSTON LIMITED.
Alva Brown crepe jer.
 Red feather hat

HALSTON LIMITED

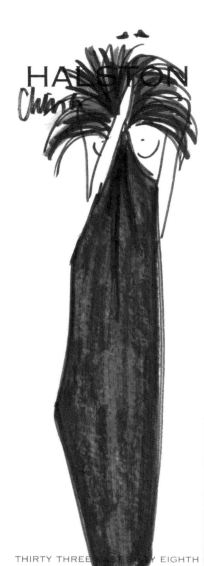

Chantx
Black over green
chiffon - coq feathers

THIRTY THREE EAST SIXTY EIGHTH

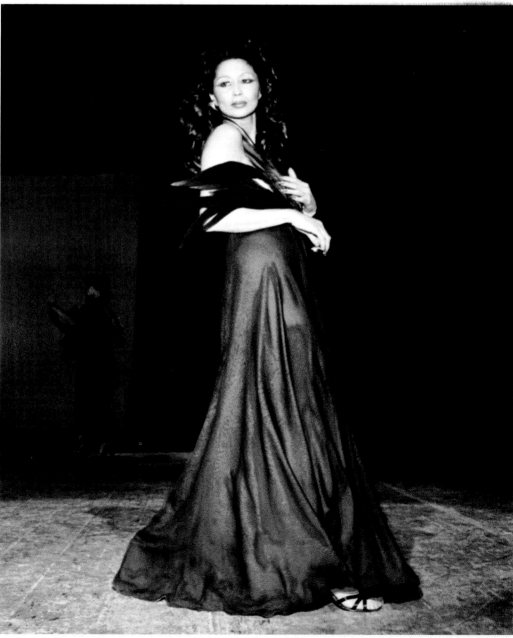

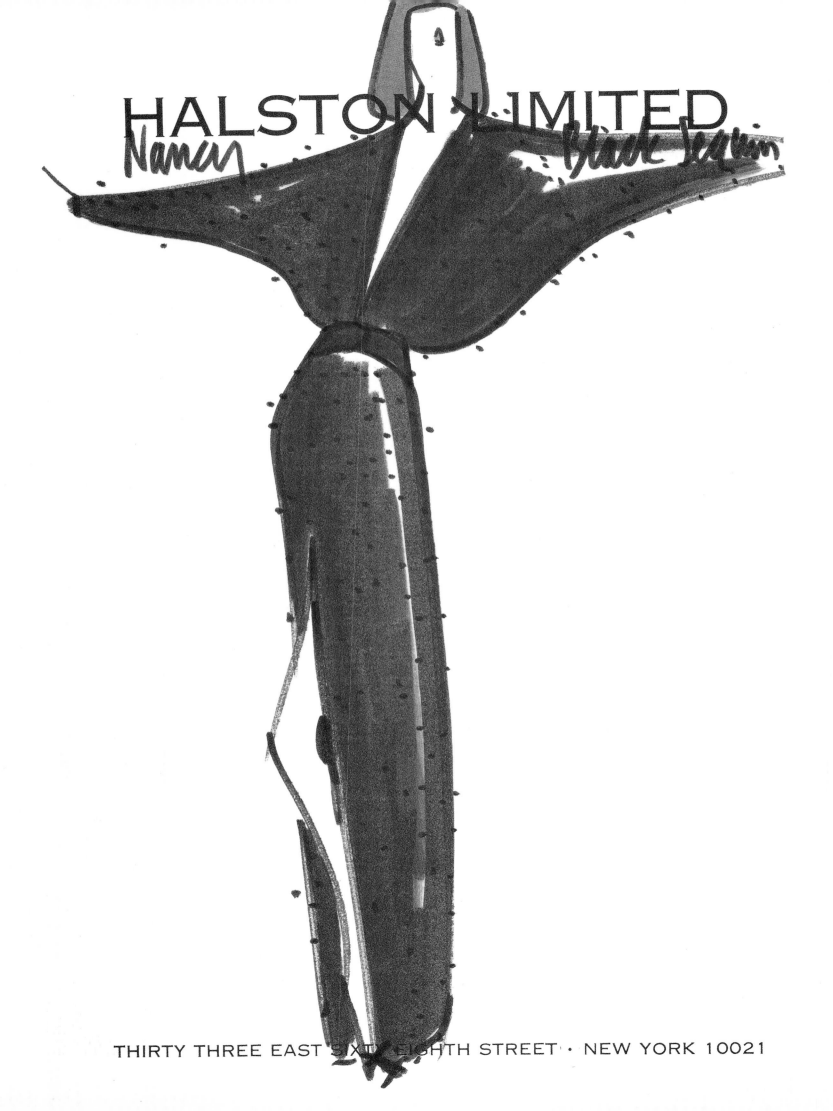

HALSTON LIMITED

Nancy

Black Season

THIRTY THREE EAST SIXTY EIGHTH STREET · NEW YORK 10021

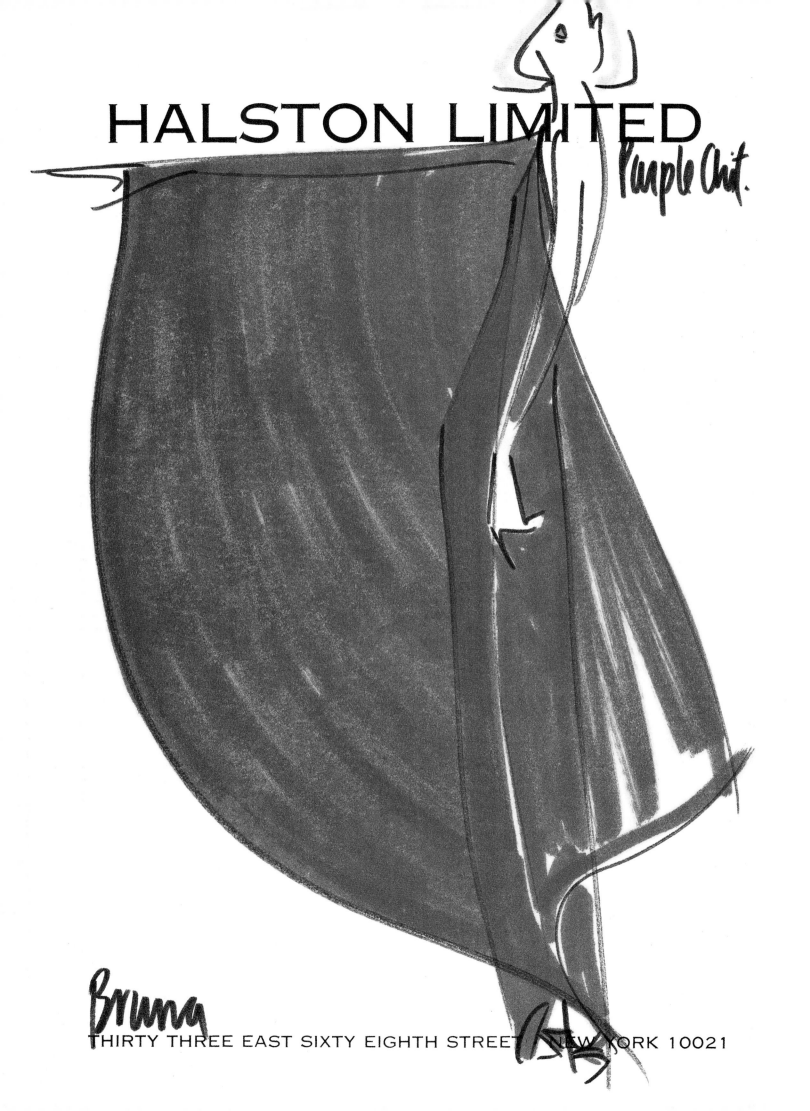

HALSTON LIMITED

Purple Chit.

Bruna

THIRTY THREE EAST SIXTY EIGHTH STREET NEW YORK 10021

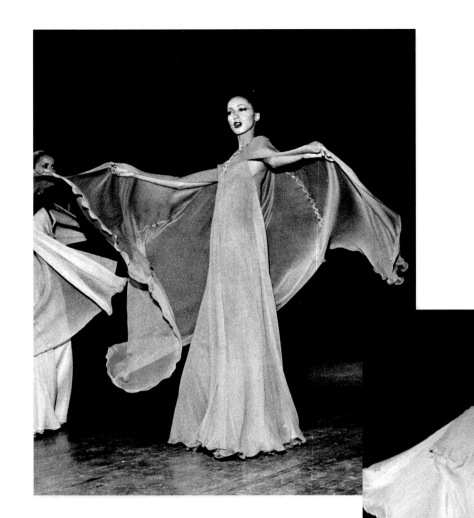

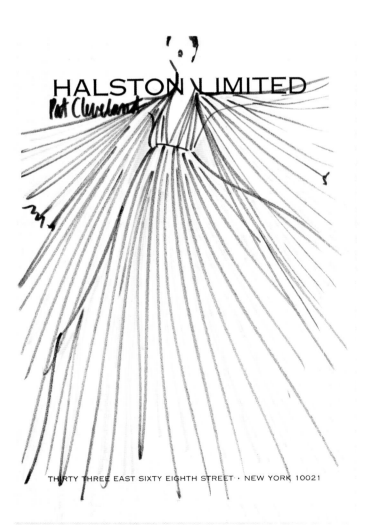

HALSTON LIMITED

Pat Cleveland

THIRTY THREE EAST SIXTY EIGHTH STREET · NEW YORK 10021

HALSTON LIMITED

Elsa

White crepe jersey
shell bag

THIRTY THREE EAST SIXTY EIGHTH STREET · NEW YORK 10021

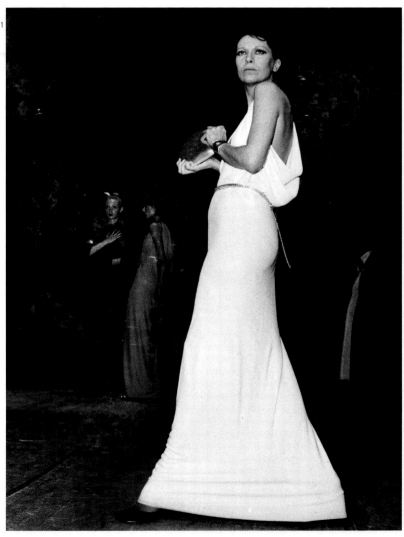

the most glamorous of all. The Duke and Duchess of Windsor, Princess Grace of Monaco. Oh my god, we were sitting in between them. I thought I had died and gone to heaven." Stephen Burrows remembers that Betsy Theodoracopulos was wearing a Halston tanktop dress of garnet bugle beads. "She started to spin and could not stop spinning—it was so heavy," he says.

The opening night's festivities were followed by several days of rehearsals in less than optimal conditions: no heat, no light, and no food. Worse, the Americans had to wait until the French were done with their rehearsals, which wasn't until ten o'clock in the evening, before they could rehearse. Tensions ran high. There were several displays of temper, including one by Halston. Chris Royer, one of his models at the event, says, "Halston got on stage wearing a green leather jacket with mirrored glasses and exclaimed, 'I have had enough! We are entitled like all the others—we have the right to rehearse.' He went out to the limo with rolled-up windows and Liza followed him to calm him down. After her talk with him, she and Kay Thompson came back and said to the girls, 'Okay, this is what we are going to do,' and so Liza and Kay Thompson directed the show."

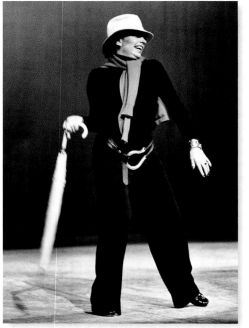

Despite the odds, the Americans pulled it together. Halston managed to convince them that they should all show their clothes together in the opening and closing portions of their show, which proved to be one of the highlights of the evening. The next day, November 28, 1973, was show time. That evening, Madame de Rothschild personally greeted each of the 720 invitees—that was the number of people the Queen's Theatre could seat—who had paid $235 each for their tickets. The bejeweled, titled guests walked—or, in C.Z. Guest's case, ran—down the long marble corridor to the gilded Théâtre Royale, where they took their seats and were entertained at the pre-fashion show by the likes of Rudolf Nureyev, Liza Minnelli, the Crazy Horse Saloon strippers, and a forty-piece orchestra. Sixty-seven-year-old Josephine Baker, the opening act for Saint Laurent, performed in a flesh-colored sequin bodysuit topped with a feathered headdress.

The French portion of the show, an hour-and-a-half-long segment with elaborate floats from each designer, was first. By the time the Americans took the stage, it was one-thirty in the morning. Their segment was entirely different—just thirty-five minutes long, it was fast-paced and spare, full of movement and color.

"The Americans presented their best original pieces and themes not from any collections but designed special for the event to showcase American fashion," remembers Burrows. The Americans started their portion of the show with Liza Minnelli, dressed in a white Halston cashmere outfit with hat and thin umbrella, singing "Bonjour, Paris," revised for the show by Kay Thompson. It was a crowd pleaser that had the French roaring their approval. "A good publicity move to warm up the French to *les Américains*," says Burrows.

When it was time for Halston's segment, set to the music from Visconti's *The Damned*, the first models out on stage were Elsa Peretti and Chris Royer. "We were wearing black and white silk jersey dresses, Elsa holding an enlarged silver compact and I an elongated cigarette holder—we were like salt and pepper shakers," says Chris. "Alva [Chinn] was on a pedestal in a red chiffon dress over one shoulder and she revealed her bust. Marisa [Berenson] came out center stage with a halter sequin dress with an elaborate sequined mask. China Machado was covering her bare breast with a one-of-a-kind Elsa black feather silver-handled fan. Pat Cleveland was rigged up to fly across the stage wearing a nude chiffon pleated dress."

The performance culminated with Liza front and center stage

Liza Minnelli onstage in complementary Halston ensembles of black-and-white cashmere turtlenecks and pants in Le Grand Divertissement, November 1973. Her number, "Bonjour, Paris," culminating the American part of the show, got the French audience on their feet and made history.

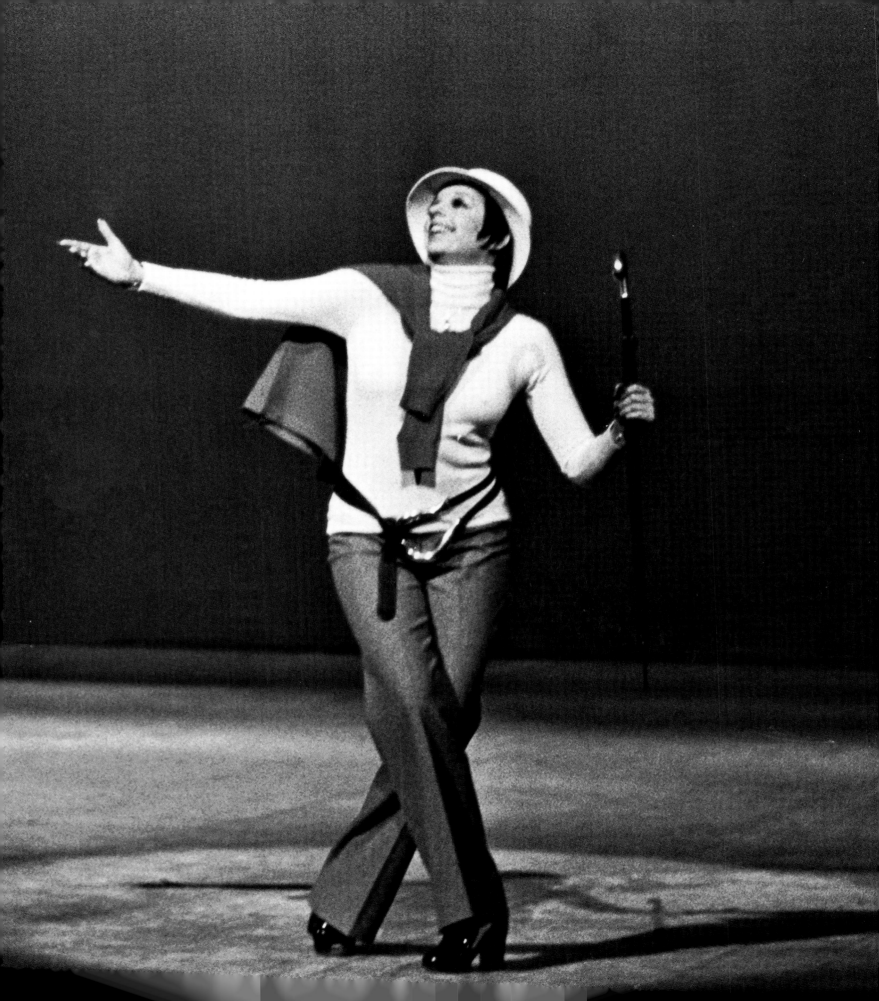

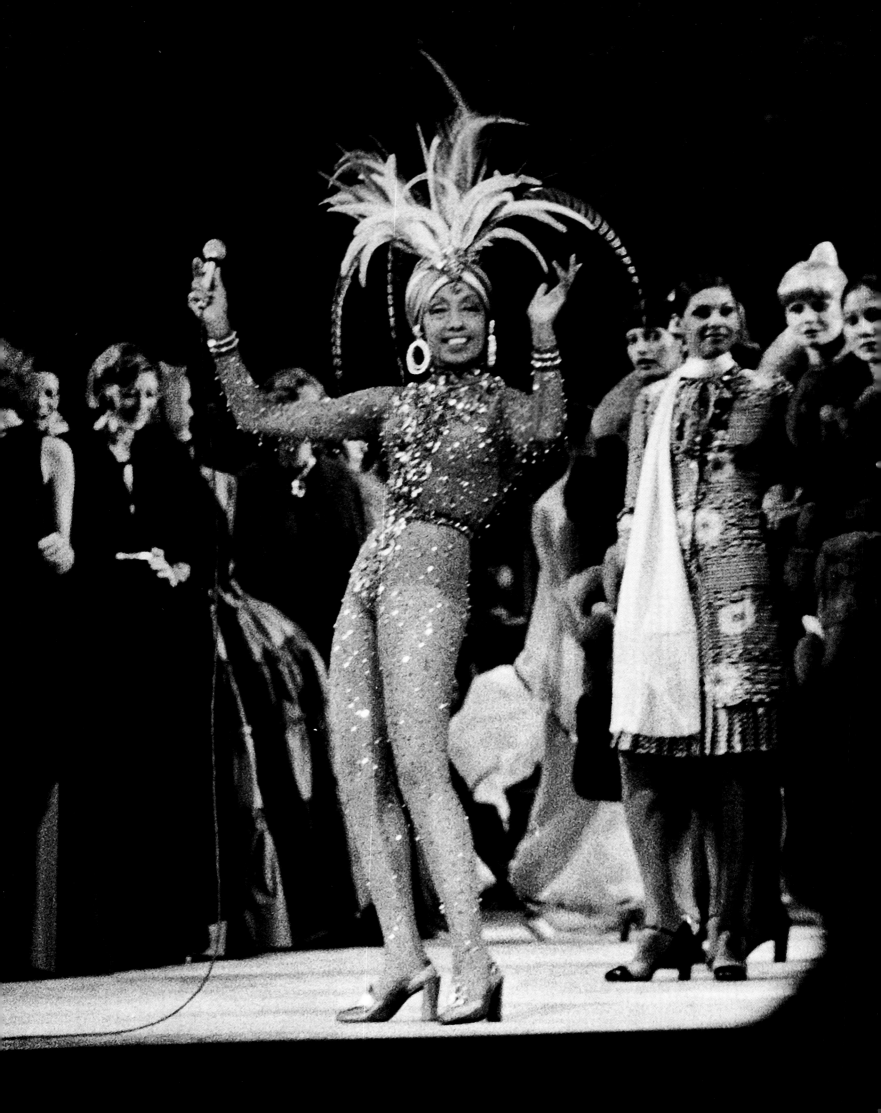

wearing a Halston cashmere pants and turtleneck ensemble with a big Elsa silver horseshoe belt and carrying an umbrella. Liza remembers, "While I was singing 'Au Revoir, Paris' suddenly the curtain goes up and the American crew is seated around small tables with white tablecloths with a single red rose in the middle. We were wearing different values of black, fabulous black satins, velvets, our legs sticking out from the tables expressively. We finished and the audience went nuts. All the models got so excited we were standing on chairs waving and singing 'Au Revoir, Paris.' It was one of the most successful things I have ever seen." Burrows recalls, "The crowd jumped to their feet and we stole the show. We really wowed them and showed them, perhaps to their dismay, that Americans were coming into their own in the fashion world."

Pat Shelton, who was then fashion editor of the *Chicago Daily News*, says, "The Americans wiped out the French. The Americans had commissioned Joe Eula to create the background; the French came on with fancy frou-frou sets that belonged back in the nineteenth century. The Americans came on stage so clean and modern."

My father's tour in Paris had just wrapped up a few months before this historic fashion event. Sadly, our family unit was falling apart so neither my father nor my mother were able to attend. Otherwise without a doubt my parents would not have missed the party of the century, attired, I am certain, in the latest Halston togs. I was now at an age when I was better able to appreciate his designs. When *Vogue* was delivered to our house, my girlfriends and I would gather around it in a flurry of giggles and excitement. We'd anxiously flip through the pp., looking for another stunning Halston spread, which we would then surgically remove and stick (with nonarchival glue, I'm sorry to say) into my ever-growing Halston scrapbook. I was very proud that my uncle was becoming such a famous de-

signer. I was also developing a deep appreciation for his sleek, chic fashions. Even as a young child I took notice of his hats that he bestowed upon my mother and, of course, those that his mother always donned at our family gatherings. My mother was very meticulous with her clothing, always carefully folding and storing outfits in mothballed plastic containers. She also had the original Bergdorf and Halston hatboxes that she took great pains to protect throughout our numerous transatlantic moves. At the time, I found it so tedious to have to take such care of my clothing. In hindsight, I can appreciate how wonderful it was of her to have protected these millinery jewels for our family legacy.

My first big Halston moment came in the spring of 1974, when he dressed me for the Young Diplomats Ball. He invited me to his boutique, where he decided that I would look best in a full-length red cashmere sweater-set dress with black silk satin pumps and shoulder-length matching red cashmere gloves. To polish off the look, he selected an Elsa Peretti silver perfume-bottle necklace with a silver cuff bracelet. I was the most chic teenager at the ball. Ever the marketing genius, Uncle H capped my Cinderella moment by contacting his friend Nina Hyde, the fashion editor of the *Washington Post*, and persuading her to do a story for the paper called "Some High School Fashion." I was going through a rough patch with the looming divorce of my parents and part of his motivation was, I'm sure, to make me feel good about myself, to treat me to a fantasy girly event and give me the chance to model. But I'm sure he was well aware of the promotional opportunity! Nina could not have been any nicer putting me at ease for the "shoot."

As part of the *Post* process, we flew up to New York and spent a few hours at his atelier trying on ready-to-wear clothes from his boutique. Pat Cleveland was pulling items from the inventory downstairs while, up on the third floor, Joe Eula was

lamorous in fur at Maxime's in Paris, Pat Cleveland, (opposite, top left) the night before Le Grand Divertissement, November 1973. The dinner party was sponsored by David Mahoney of Norton Simon to the tune of $25,000. Opposite, top right: Marisa Berenson in a Halston black sequin dress, taking a break backstage at Le Grand Divertissement. Opposite, below left: Halston and Loulou de la Falaise making an entrance arm in arm into the dinner party at the Château de Versailles. Opposite: below right: C.Z. Guest and John Fairchild dashing down the hallway at Le Grand Divertissement. This page, top: Carrie Donovan, fashion editor for the *New York Times*, entering the party at Château de Versailles wearing a Halston sequin mermaid dress. Below: Halston talking with his dear friend Marisa Berenson at Maxime's in Paris, the night before Le Grand Divertissement.

H alston (left) congratulating his friend Yves Saint Laurent at Le Grand Divertissement, November 1973. Below: Halston at dinner with the Duchess of Windsor at Maxime's in Paris. Opposite: Liza Minnelli in black sequin pantsuit for an act at Le Grand Divertissement.

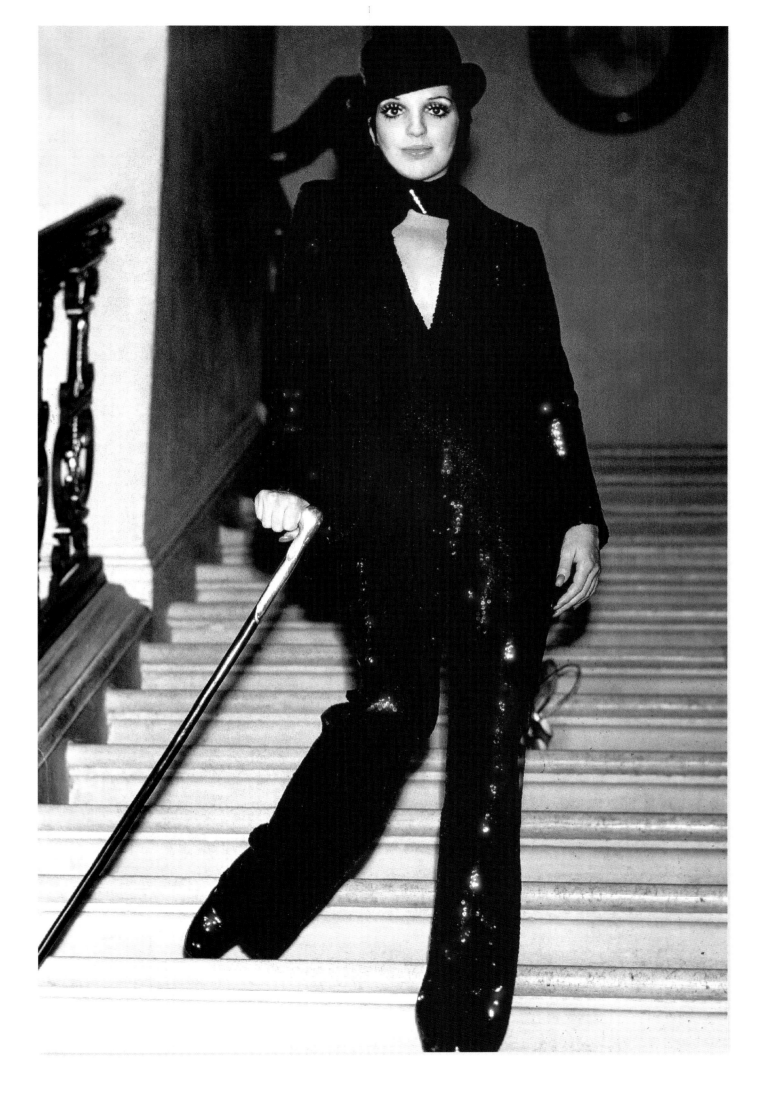

warming up his illustrious marker. Dennis Christopher was also there, assisting with selecting clothing that they thought would meet Halston's approval in the correct colors—those that would complement me. I chose three cashmere turtlenecks in beige, white, and red; two Ultrasuede skirts, one taupe and one chamois; and a white linen pant suit.

By this time, the decor of chez Halston had shifted from the early hippie-chic batik-and-horn-furniture look to sleek, creamy, and minimal Parsons desks and Bauhaus Breuer cane, with lots of mirrors and strategically positioned palm trees hiding doors that led to workrooms and changing rooms. Also omnipresent were the famous Halston orchids. Halston had recruited the talent of a florist named Tony Dupace, whose little flower shop sat adjacent to the main entry on 68th Street, and it was Dupace who supplied those early specimens. An alternative history says that it was Ali McGraw who first showed Halston the visual appeal of this pricey flower when she sent him a dozen white phalaenopsis orchids as an apology after complaining that a dress was ill fitting, only to realize that she hadn't put it on properly. Personally, I think Halston's orchid fixation might have come from my grandfather's habit of taking my grandmother a single rose every morning.

Back up in his design room, Halston decided which outfits should be featured in the spread, then asked that I "model" them while Joe sketched the outfits for Nina's reference. There was a full-length pale blue cashmere sweater dress accessorized with black satin pumps and an Elsa perfume-bottle necklace and cuff bracelet; a red cashmere cardigan sweater with matching knee-length skirt and beret worn with tan luggage-leather sling-backs; a chamois Ultrasuede skirt with an ivory cashmere crewneck sweater set with the same tan sling-backs; and a turquoise silk shantung pantsuit worn with a black ribbed silk tank top, an Elsa onyx-and-crystal locket necklace, and open-toed black satin sling-back sandals. The final item was a blue denim button-up sleeveless dress worn with a white cotton jersey shirt, a silver Navajo concho belt, matching denim espadrilles, and a denim umbrella. Dennis later told me that he was encouraging Halston

to get into the denim business. Though he dabbled a little in this all-American textile, he preferred to work in exotic, flowing fabrics. As I tried the outfits on, Joe Eula quickly and easily sketched them, including notations for accessories. I remember meeting Elsa for the first time when she came down into the studio from her quarters upstairs, a lanky Italian beauty sporting a chic boyish haircut and an omnipresent cigarette. She had prototypes of her jewelry to show Halston.

We broke for lunch, which consisted of a clear chicken broth complemented by a *salade verte* and tea, all served in fine white Limoges china. There we were, lunching with my uncle, who was, after all, just my father's younger brother. He was fabulously famous and successful, but he was just my funny uncle whom I loved so much. I was astounded at how generous and thoughtful he was with me during this tough period. The article gave me a sense of glamour and excitement that none of my peers would have ever experienced, though I was so shy at the time that I wanted to skip school for a month after it came out. I had made an art of keeping my uncle's fame a secret.

I'm not sure how Halston found the time to orchestrate my fashion makeover, as this happened shortly after he bought his one and only house, 101 East 63rd Street, on March 6, 1974. Halston called us in Bethesda to tell us the exciting news that he had just acquired this fabulous town house in Manhattan, the only one to be built in the borough since World War II. He described it as his very own house in the middle of the city with a fireplace and something called "air rights" (of which we were clueless), to boot! He would be the second owner, after attorney Alexander Hirsch and his partner Lewis "Sonny" Turner, for whom the town house was designed and built between 1966 and 1967. We shared in his excitement, but could not quite imagine just how extraordinary the house was. Designed by architect Paul Rudolph, one-time dean of the Yale School of Architecture, it's a masterpiece of modernism.

The exterior, made of smoky, chocolate-brown glass panes connected by steel beams, is so understated that the casual stroller might hardly notice it. The only distinguishing factors

Washington Post article "Some High School Fashion," with sketches by Halston, 1974. Halston orchestrated this Cinderella moment for me on the occasion of the Young Diplomats Ball in a full-length red cashmere sweater dress. Illustrations by Joe Eula.

98

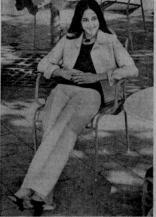
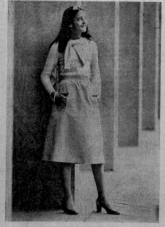
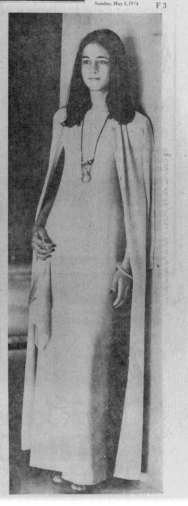

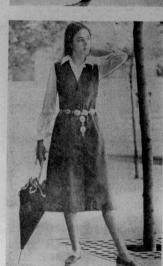

Some High School Fashion

By Nina S. Hyde

Like most other sophomores at Walt Whitman High School in Bethesda, Leslie Frowick has a basic wardrobe of jeans and tops. For Leslie, however, the jeans are mostly yellow and the tops mostly from one of the leading American designers, Halston.

Leslie is Halston's niece, daughter of Halston's brother, Robert Holmes Frowick, a Foreign Service officer recently returned to Washington from Paris, where he was first secretary at the American embassy.

Halston, whose real name is Roy Halston Frowick, generously doles out his creations to members of his family, hitching his gifts to a birthday, a trip or Christmas. Recently he made a special cruise wardrobe for his mother, including the costume for the ship's traditional dress-up evening, and sent along sketches suggesting how each outfit might be worn.

Leslie Frowick acquired her first long Halston cashmere dress to wear to the Young Diplomat's Ball this winter. The gala invitation never worked out, so the dress will be folded, camphored and put away until next fall. It's not the kind of dress one wears to a dance at Walt Whitman. "I don't go to them, but my friends say they only wear jeans to dances, anyway," she says.

For her 16th birthday last month, the same day as

Halston's birthday, "Uncle Halston," as Leslie calls him, gave her an ultrasuede skirt, denim jumper, turquoise silk shirt jacket and pants and the necessary sweaters and shirts to complete all the outfits.

"Sure it is extravagant for a teenager to have such expensive clothes," admits Halston, who has made clothes for the teen-age daughters of the late platinum tycoon Charles Englehard Jr. "Really good clothes can be worn at any age," Halston says. "And if you take care of them, they should last a lifetime."

Halston's outfits, clockwise from bottom left: blue denim umbrella and jumper with cotton jersey shirt and an Indian silver and turquoise belt; red cashmere pants of turquoise silk with black silk pullover and cardigan and skirt with matching beret; jacket and an onyx egg by Elsa Peretti; beige ultrasuede skirt set in pale blue cashmere worn with a Peretti silver with cashmere sweater set; and the ultimate sweater bottle with real flowers and an ivory bracelet.

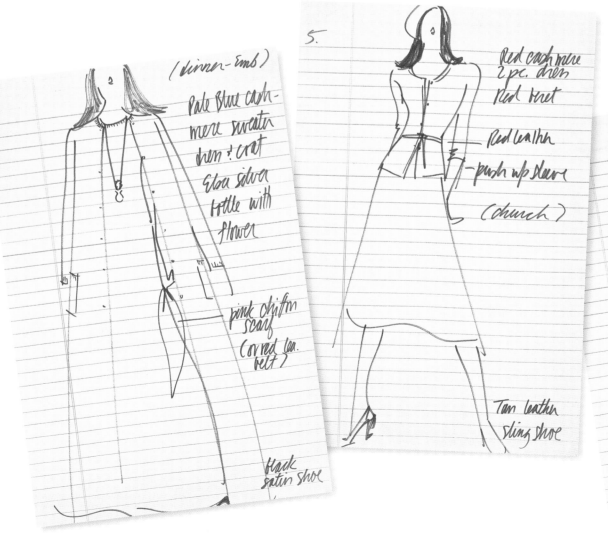

(dinner - Emb)
1
Pale Blue cashmere sweater dress & coat
Elsa silver bottle with flower

pink chiffon scarf
(corded lea. belt)

black satin shoe

5.
Red cashmere 2 pc. dress
Red beret
Red leather
push up sleeve
(church)

Tan leather sling shoe

(dancing dinner)
Turquoise silk harem pantsuit
black bib
silk T shirt
black onyx & Elsa egg

black satin shoe

in the dark brown facade were the prominent white numbers on the front door—101—just barely lit by an overhead canned light. Though it's now known as the Halston house, when Uncle H was in residence we called it "101."

One of the more luxurious urban elements of the entire house, especially for a single man living in New York who did not own a car, was the two-car garage tucked into the ground floor. Hidden by a standard electric garage door, it rarely opened on Halston's guard. When it did, it was invariably to let in deliveries for an important party. As Halston had 24/7 limo service at his disposal, it was otherwise unused.

Once inside, regulars would toss their fur or cashmere wraps onto the first landing of the "safe stairs" —i.e., the ones that had a banister—before proceeding down a dimly lit black-slate hallway to the main living space. The kitchen was made of glossy white laminate cabinets and counters with a sleek white electric stovetop. This is the spot where my stepmother Ann recalls standing when she first met Halston. "He swooshed in after a long day at work and told me to wait right there. He ducked into the garage and soon emerged with a smile. He put a beautiful diamond Elsa Peretti necklace around my neck and said, "Welcome to the family." There was no artwork in the hall so as to not distract from what lay ahead, which was a spectacular, two-story sunken living room with soaring twenty-seven-foot ceilings and a glass-walled, bamboo-filled greenhouse landscaped by Robert Lester. The space was especially dramatic at night, when it was lit with votive candles that were strategically positioned to reflect the mirrored back wall through crystal balls. This room was the heart of the building. In a story about 101 in the October 1977 issue of *House Beautiful*, Halston was quoted as saying, "Except to sleep and look at TV, I rarely use any room but this. Its proportions are so interesting, too, and it is here that I've discovered that modern is the only way to live. I like the simplification of living with only a few things."

The decor at 101 was sleek, minimal, and subdued: Rudolph-designed oversized gray wool-flannel boxy armchairs, upholstered banquettes, and a loooooong couch made up the seating in the living room, which, like the rest of the house, had gray carpeting and white walls. Later, Halston added a few stacked rectangular gray wool pillows in front of the fireplace, which is where I typically clung. There was also a stack behind his throne, where his pet Pekinese, Lindo, slept. Unsuspecting guests would sometimes mistake Lindo for their purse, only to be nipped when they tried to pick the little dog up. An eight-foot-square Carrara marble-topped coffee table anchored the space. The only other elements of decor were the orchids and a rotating selection of Warhols. The orchids—this was in the days when it was difficult to obtain tropical plants, even in New York—were then supplied by Peter Wise, who says that Halson "usually kept fifteen to twenty plants at 63rd Street and thirty to forty at OT." The Warhols included three portraits of Halston that hung in what was known as the Mezzanine, a floating handrail-less balcony above one end of the living room. The only way to reach it was to climb up the handrail-free stairs, which was not so bad at this level (depending, of course, on the number of highballs you'd had) but far more perilous when it came to traversing the catwalk to the hanging guest room. There, you felt like you were about a thousand feet above sea level, with nothing to keep you from toppling into the void. The guest room closest on the next level up from to Halston's room and adjacent to his storeroom chockablock with Warhols (and where I lived for one lucky year) was easily accessible by the safe stair, as was the spacious top-floor studio apartment. This top floor is where Halston would eventually set up his home office. Otherwise, it was where he would harbor friends in need of temporary shelter, such as Bianca Jagger, when her marriage to Mick was falling apart, and where family members stayed when they came to visit. A perfectly proportioned teak deck lay beyond the living space and over about one-third of the roof area of the great room. It was a private space where you could sunbathe on his Barlow Tyrie teak chaises during the high noon hours or savor a delightful lunch on a spring afternoon. Everything at Halston's house was appointed with extreme yet seemingly effortless elegance—which was the way he preferred to live his life.

Rudolph designed the house around the atrium and gave every

The facade of Halston's town house at 101 East 63rd Street. Pp. 102–3: The heart of "101" was Halston's expansive living room. With Paul Rudolph–designed furniture and the omnipresent orchids, the living room was like a sleek, minimal theatrical set for Halston's designs and a parade of celebrities, friends, and fashion.

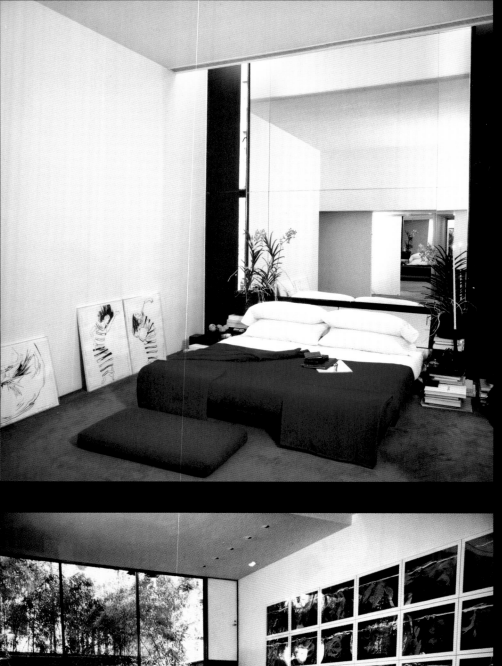
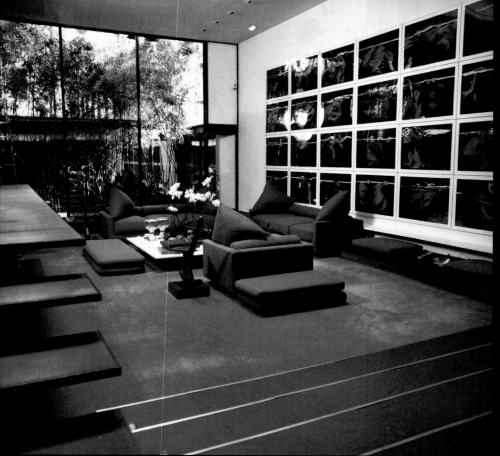

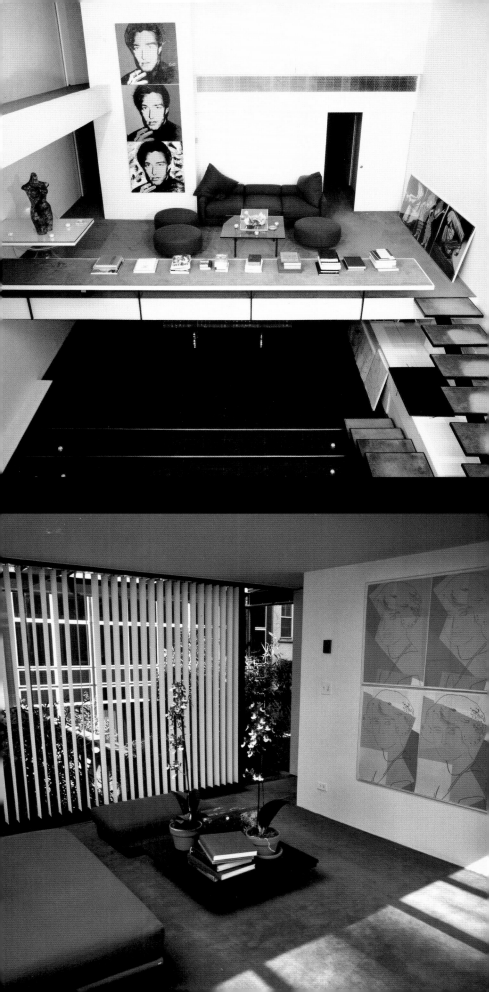

other room dramatic entry and observation points from which to appreciate it. In the guest room, for example, there was a mysterious door that seemed to lead to nowhere. But if you opened it, you'd find a little Romeo and Juliet balcony designed for one that overlooked the bamboo forest. The most treacherous spot in the house was the catwalk that led from the guest room to the balcony. Rudolph refused to put in a railing because he thought it would interfere with the flow of the room, and it remained that way in Uncle H's time.

One of Halston's quirks was to keep the air conditioning turned down to 50 degrees at all times. This meant that he could always have a fire burning for that special warm ambiance. Karen Bjornson remembers arriving at 101 in the middle of the summer. "I would always put on a Halston cashmere cape or sweater as I was getting out of the cab. When the sweating cabbies looked on in disbelief, I wouldn't even bother explaining." Overseeing the entire house was Mohammed Soumaya. He had come to New York with the king of Morocco's son, as his bodyguard, and met my uncle around 1973. The rest is history. Mohammed was Halston's fiercely loyal caretaker, standing by his side through everything. Mohammed tended to most aspects of caring for the house, making sure food, wine, and sundries were stocked and that clothing and sheets were impeccably dry-cleaned or laundered and ironed every day, as Halston did not appreciate wrinkles of any sort. Halston was also comforted by the fact that Mohammed was a double black belt, though luckily he never had to employ his martial arts skills. "The miracle of the house was that it looked as if it was designed by Halston, as if he commissioned Paul Rudolph to make this very sleek ultra-modern original house for him," says Bob Colacello, who met Halston through Andy Warhol. "It was very original—even the dark, dark brown seemed like a Halston color."

Bianca Jagger

The house was to become a symbol of Halston's aesthetic and the scene of many parties and photo shoots, like one in which Shirley Ferro ascends the floating slab stairs wearing a beige Ultrasuede Skimp dress and flats, a red Bobby Breslau bag flung over her shoulder. To walk into 101 was to enter his world. "I always remember sitting at that big coffee table and watching the people going up and down the big stairs trying to navigate the steps," remembers the photographer Christopher Makos. "It was a great theater setting for people to show off. If you are a designer it was a perfect place to show off the beautiful women and men who wore your clothing or were part of your brand."

If you were there for a large gathering, Mohammed would answer the door. But if it was just a tête-à-tête evening, then Halston would come to the door to greet his guests personally, clad in a red cashmere zipper cardigan, the ubiquitous black turtleneck, black gabardine pants, and red leather Hunting World driving shoes freshly sprayed with his Z-14 cologne. As you stepped over the threshold, you felt slightly intimidated, a feeling that was quickly overtaken by the sense of being enveloped in quiet comfort.

Halston was such a force in fashion by the mid-1970s that in 1975 *Esquire* ran an article called "Will Halston Take Over the World?" It certainly seemed that way, especially after the launch of his fragrance that spring. Though it's now standard practice for designers to launch a fragrance, at the time it was still a novel concept, especially in the United States—as Paul Wilmot, the vice president of public relations for Halston fragrances and now the owner of his own PR agency remembers: "There were only three American designer fragrances that were doing well."

The original Halston scent they created had no name on the bottle but was known as Halston Classic. This famous teardrop-shaped

Bianca Jagger at a party at "101." Opposite: Halston and Rupert Smith, one of Warhol's silk-screeners, selecting serigraphs to be sold for the Martha Graham School of Contemporary Dance fund-raising auction, 1987. Pp. 108–9: Andy Warhol serigraphs based on the photographs shot by Barbara Morgan of Martha Graham in the 1940s.

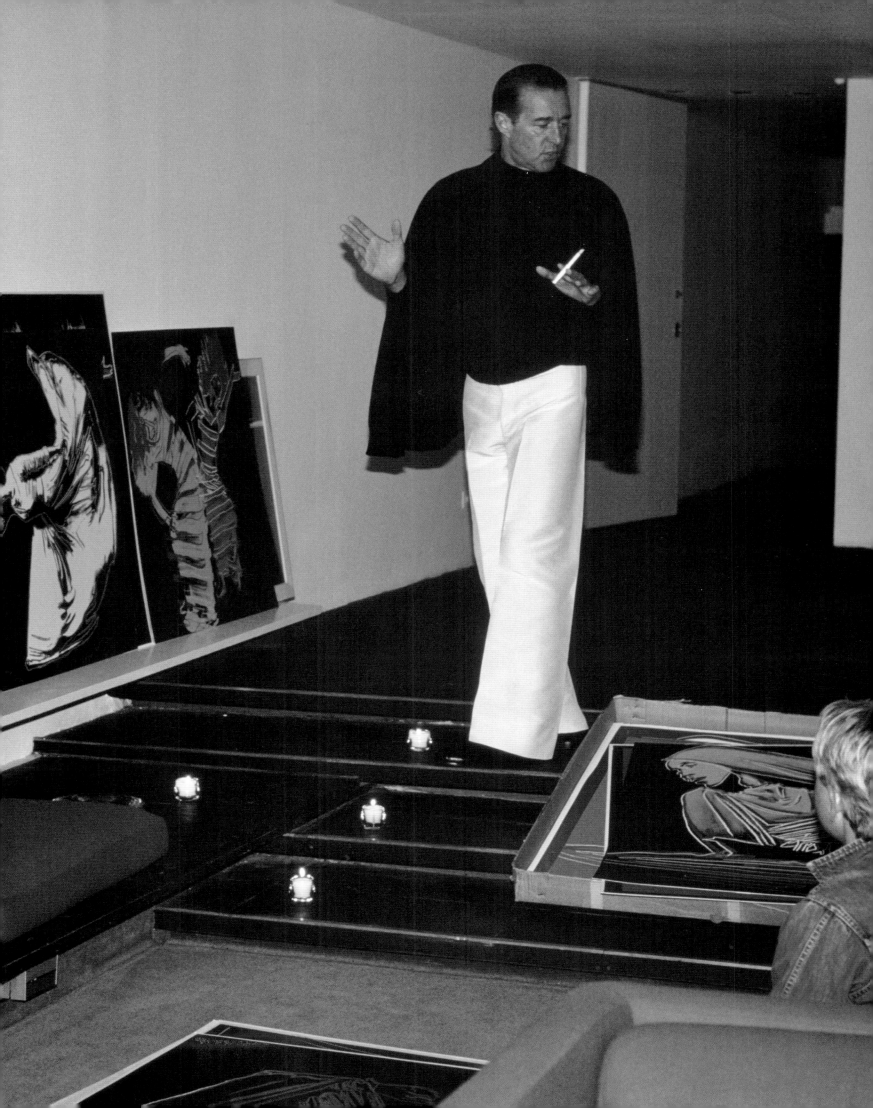

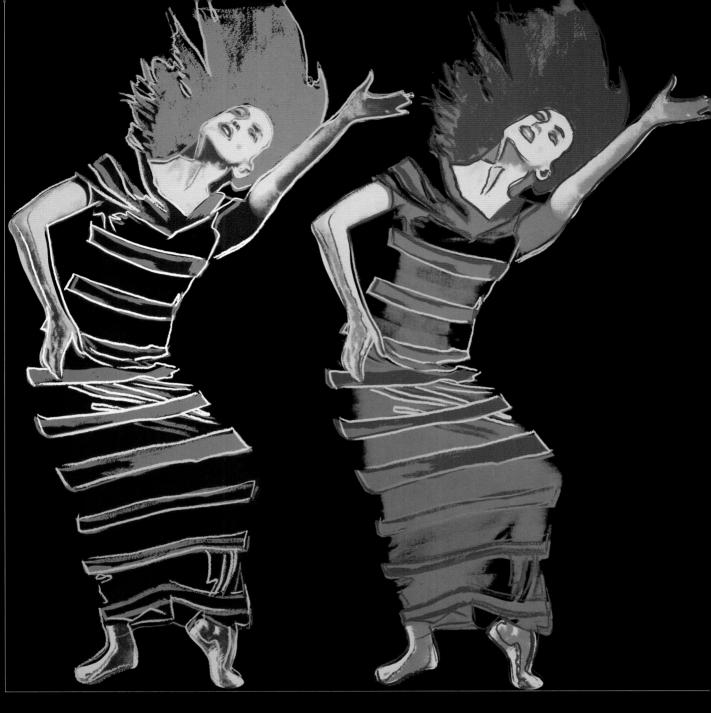

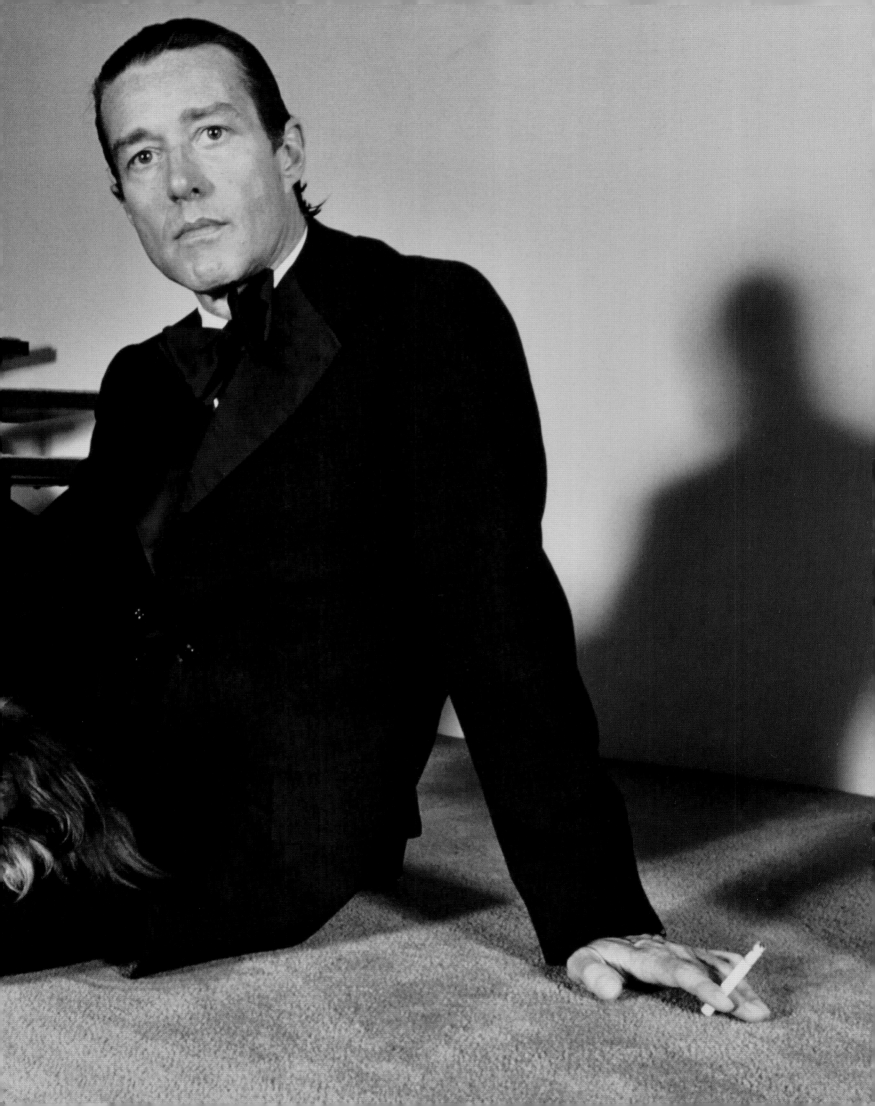

bottle was, of course, designed by Elsa Peretti and involved a protracted battle with Max Factor, who wanted something more straightforward. Elsa's bottle, which Halston intended to be a collector's item, was tricky to manufacture, required endless tinkering to create a leak-proof stopper, and couldn't be filled using standard machinery. Nevertheless, Halston prevailed. The perfume was an immediate hit and remained a strong seller in the luxury category for more than a decade. His next big hit was the men's cologne Z-14. A second men's fragrance, 101, which won Best National Advertising Campaign for a Men's Fragrance, -presented by the Fragrance Foundation—in part owing to the talent and expertise of Halston's preferred photographer, Hiro—and a second women's fragrance, called Night, were later added, as was a line of body care products. Cosmetics followed in 1977, again in Elsa-designed packages, this time shaped like hearts, but these and the latter fragrances never achieved the runaway success of Halston Classic.

Hillie Mahoney, whose husband, David, was the chairman of Norton Simon, remembers that Halston Classic was so well known that even cab drivers recognized it. "I remember sitting in a New York taxi and the driver saying, 'I love your perfume! That's Halston, isn't it?'

The deal with Norton Simon was keeping Halston busier than he had ever been. He typically arrived at the office by 8:00 a.m. after first stopping off to work out with two Russian gymnasts, who instructed him and Bill Dugan on the parallel bars, trapeze, and rings. He'd stay at 68th Street until past midnight, sketching and draping the various projects he worked on, which by this point included not just the ready-to-wear and custom-made collections but Halston III Raincoats; Halston IV at-home wear; the Halston V and VI collections, which were better-priced blouses and separates; Halston patterns for McCall's; Halston furs with Ben Kahn; Halston Ultrasuede luggage for Hartmann; Halston's menswear; Halston lingerie; and Halston Dynell wigs. "I can do a collection in a day, conceptually that is. Naturally it sometimes takes three months to work out those concepts but in an evening, if I am hot, I can cut an entire collection." I'm on the floor there, the model

is nude, we do the whole thing," he told *People* magazine in June 1977. "He would always tell everyone to sketch as he used to do all the time," says Bill Dugan. "We would sketch and sketch and if it might end up in the collection it was a thrill. No one had the complete vision that he did, though." Halston's vision, as he explained to *Women's Wear Daily* in the September 10, 1975 issue, was "clean, clean, clean," an assertion that led to the paper nick-naming him "Mr. Clean."

Halston's clean lines translated well into dance costumes for Martha Graham, whose work he admired and with whom he forged a very strong bond. Martha had always made her own costumes, but by the time of the golden anniversary of her troupe, her hands had become too arthritic to sew. Halston gallantly stepped in to offer his atelier, financial support, and his love. "We are friends and friends are the hardest thing to find in the world. She gives me more than I could possibly ever give her and I love her," he told the *New York Post* in the April 4, 1985, edition. Christine Dakin, a former principal dancer in Martha's company, says Martha "loved his gallantry and his gentlemanliness. When she saw what he made, she loved the lines, the drape, the organic simplicity of his design."

Halston assisted Martha with her company's annual performances in New York and once in London, where the company performed "The Owl and the Pussy Cat." Hamish Bowles recalls, "Liza was the narrator, Halston did the costumes, and Martha came out onstage to take her bow wearing her Halston beaded caftan. I recall Bianca was in the audience dressed in a smoky-brown organza petaled, layered sort of frothy dress—as frothy as Halston ever got. The experience was the last word in glamour." Andy Warhol, who was a guest that evening, wrote in his diary that "Halston and I left Liza's room and we began taking everybody's shoes from in front of their doors and moving them to other places. The funniest thing I ever did." (*The Andy Warhol Diaries*, p. 230)

In 1984, Martha Graham was presented with the Legion of Honor by the French government. Halston flew his entourage there for the occasion on the Concorde and dressed the entire

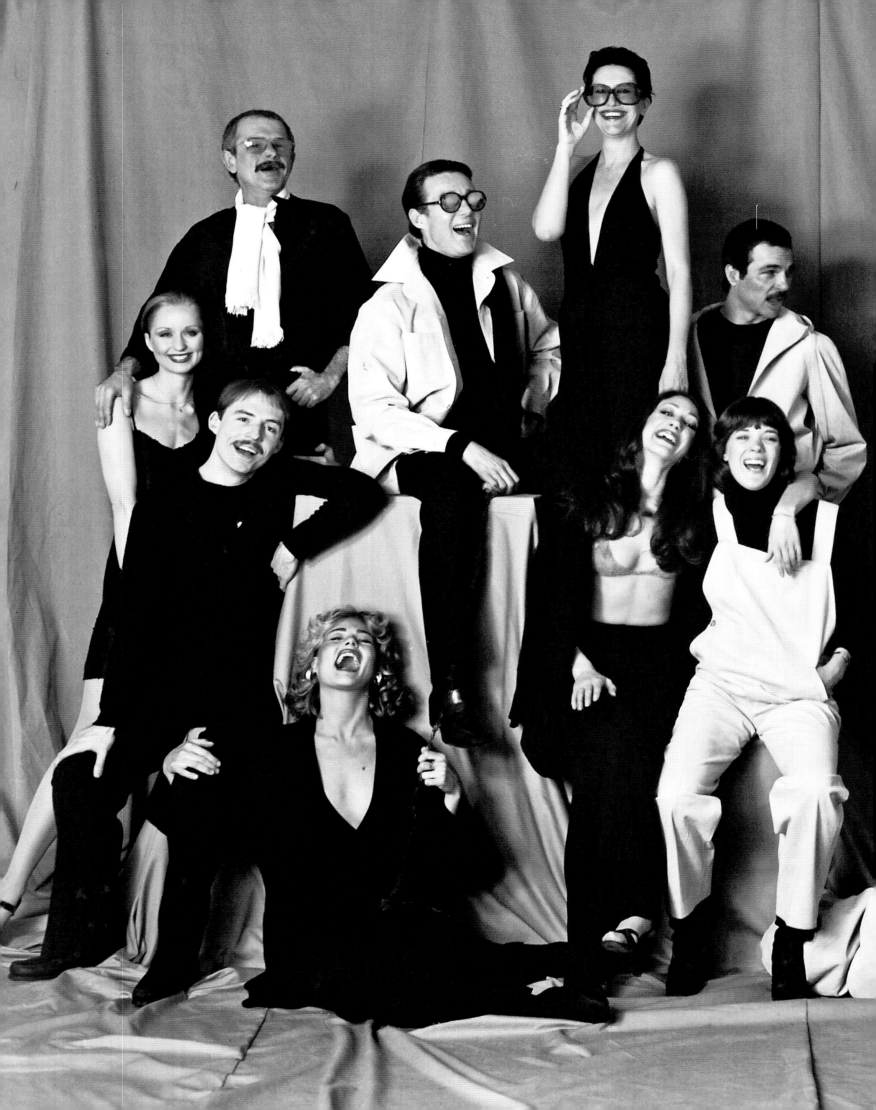

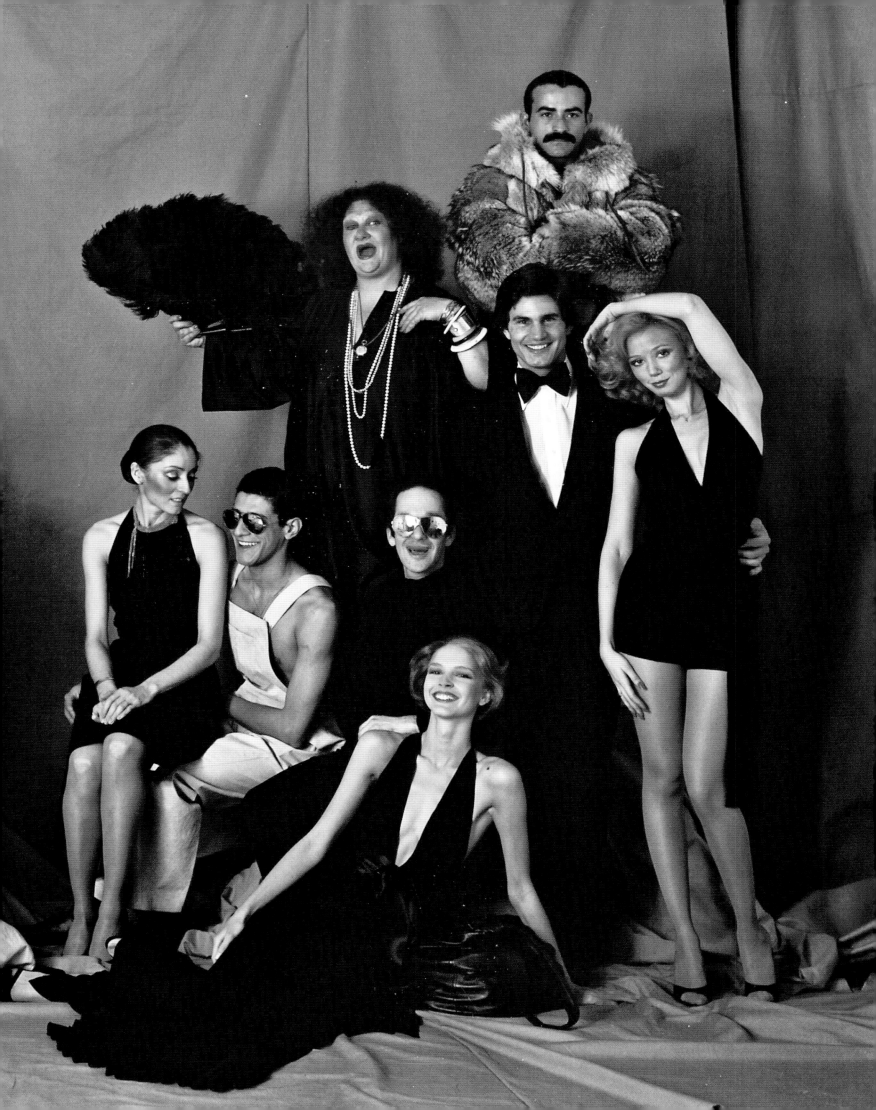

cast of characters for four action-packed days and nights. He was devoted to Martha till the end of his time in New York.

In a deal that must have appealed to his patriotic side during our bicentennial year, Halston was chosen to design the uniforms for American athletes to wear to the 1975 Pan American Games in Mexico City, the 1976 Olympic Games in Montreal, and the 1976 Winter Olympic Games in Innsbruck, Austria. The clothes were also sold in the Montgomery Ward catalogue, which was received by more than six million American households—making Halston a well-known name across the country.

Another publicity coup came in 1977, when he was approached by Braniff Airways about redesigning the uniforms for its flight and ground crews. With his instinct for PR, he didn't just submit sketches. At his urging, Braniff threw a party in Acapulco to launch the new uniforms, a seemingly simple suggestion that soon blossomed into a three-day, three-night junket to Mexico for 250 press and beautiful people, including Mrs. Alexander Calder, whose late husband had designed the outside of certain planes of the Braniff fleet; Henry and Nancy Kissinger; bandleader Peter Duchin; Loel and Gloria Guinness; São Schlumberger; and Lady Bird Johnson. Halston made sure his good friends D. D. Ryan, Jane Holzer, Betsy Theodoracopulos, and Loulou de la Falaise were on the flight roster, too. Mary Wells, a Halston client whose husband, Harding Lawrence, was the president of Braniff, hosted a party at their villa, and Halston hosted a dinner and fashion show of the new uniforms. There were Ultrasuede trench coats with matching hats, chic three-piece gabardine suits for the stewards, and beige rayon dresses for the stewardesses, as they were then known.

The Taj Mahal hotel was the backdrop for the main fashion show by Halston, where he introduced to the world his new uniforms for Braniff. Pat Cleveland recalls how terribly hot it was as they were gathering themselves for the rehearsal. She noted that Halston was such a proper gentleman that he never took off his shoes despite the heat. Bill Dugan recalls they were getting dressed in a big white tent where the show would eventually be held. "It was so bloody hot with no windows or flaps to allow air circulation. Eventually Halston took his scissors to the tent and crafted a few windows on the bias so that they could all at least breathe." The models danced on the runway that was dramatically positioned over the middle of the pool at the Taj Mahal nightclub.

Ever the showman, Halston knew that a great way to garner attention from the press was to surround himself with beautiful women draped in his designs. "Loulou said we were like marionettes," remembers Nancy North. "John Fairchild nicknamed us the 'Halstonettes' and it stuck."

While Halston and his Halstonettes were dancing on the beaches of Acapulco, our family was preparing for a winter weather celebration in Prague: the annual Marine Corps Ball extravaganza. It was staged in the Winter Garden of the American Ambassador's Residence, a mansion that had been the home of the wealthy German-speaking Jewish Pecek family, who fled from the Nazis in 1939. The palace was a Petit Trianon of sorts, complete with a pink marble-columned indoor swimming pool. The Winter Garden was a marble-clad patio enclosed by huge wrought-iron and beveled Czech crystal doors that could be retracted during warmer weather so the family could enjoy the rare sunny days. But as the Marine Corps Ball was held in the dead of winter, the doors remained closed. As always, Halston came through with several boxes of beautiful clothes that he sent to us via the diplomatic pouch. I chose the full-length goddess-style white pleated chiffon dress with plunging neckline, a gold leather obi belt, and matching gold strappy sandals. My father had remarried by this time, to the *ravissante* Ann, whom Halston also delighted in dressing, beginning with her wedding gown, a light beige, multilayered, full-length chiffon dress. On this occasion, she chose a similar chiffon goddess dress and was truly the belle of the ball. The European diplomat wives were always curious to see what the American designer's family would pull out of their wardrobes for the next official affair. We were, without a doubt, in a position to be envied.

Opposite, top: posing for a Braniff Airways advertisement, 1977. Halston's redesign of the Braniff uniforms had an appropriately (for Halston) over-the-top launch in Acapulco, Mexico. Opposite, below: Halston by Hartmann advertisements, 1976. Karen Bjornson finds the perfect Ultrasuede luggage, thanks to Halston (left), while the designer himself sits surrounded by his wares (right).

Halston by Hartmann
or how to take the excess out of baggage.

The new Halston Ultrasuede™ Collection by Hartmann is unconstructed yet well-constructed.

If that sounds like a contradiction, it isn't.

You see, this luggage is fantastically light. Which means it's easy to tote, easy to stow. Yet it's so strong you can crush it, step on it and roll it around. And all that happens is that it springs back to its natural shape.

This kind of flexibility is what makes the entire collection so packable. The sides just expand and expand as you fill it full.

Like everything Halston designs, the Ultrasuede™ Collection has had all the unnecessary frills removed. (In fact, the only thing excessive you'll find in it is the Hartmann workmanship.)

Even the outside combines a sense of beauty with a sense of function. It's Halston-discovered Ultrasuede™. It looks like suede, it feels like suede, but it doesn't bruise like suede. And it's ultra light and washes clean with soap and water.

Halston doesn't think there's anything stylish about luggage you have to lug around.

And Hartman obviously agrees.

Shown: The Hanger, The Tote, and The Flyer in burgundy. Also available in cocoa. There are other Halston pieces by Hartmann in ten women's sizes in both burgundy and cocoa. Also eight sizes in cocoa only for men. Other Hartmann luggage in industrial belting leather, rugged leather-trimmed fabric, and durable vinyl. For brochure.

Write: Dept. NV, Hartmann Luggage, Lebanon, Tennessee 37087.

Hartmann presents
the Halston Ultrasuede Collection

HALSTON HAS FINALLY GOTTEN HIMSELF SOME LUGGAGE.

That Halston. He's been so busy being America's greatest fashion designer, he just never got around to designing himself some luggage.

Until now.

What happens when a Halston meets a Hartmann? You get incredible luggage with the ruggedness of Hartmann's ingenious solid wood frame construction on the inside and the genius of Halston design on the outside.

And that outside is covered in luxurious Halston-discovered Ultrasuede™ It looks like suede, it feels like suede, but it's ultra-light and washes clean.

The brushed chrome handle, modelled after his famous silver belt buckle, the rich colors and the ZePel® treated "H" pattern lining are distinctly Halston.

The expandable side panels, Touch-O-Matic® locks and quality workmanship are definitely Hartmann.

"I always wanted to design luggage that would come out looking like this," said Halston. "And he did," says Hartmann.

HARTMANN PRESENTS
THE HALSTON ULTRASUEDE™ COLLECTION

ZEPEL

The Halston-Hartmann: Available in ten women's sizes in both burgundy and cocoa. Also eight sizes in cocoa only for men. From $335 down to $120. Other Hartmann luggage in industrial belting leather, backwoods suede, rugged leather-trimmed fabric, and durable vinyl. From $300 down to $45. For brochure write: Dept. VL, Hartmann Luggage, Lebanon, Tennessee 37087.

HALSTON LIMITED

THIRTY THREE EAST SIXTY EIGHTH STREET · NEW YORK 10021

HALSTON LIMITED

THIRTY THREE EAST SIXTY EIGHTH STREET · NEW YORK 10021

HALSTON LIMITED

641

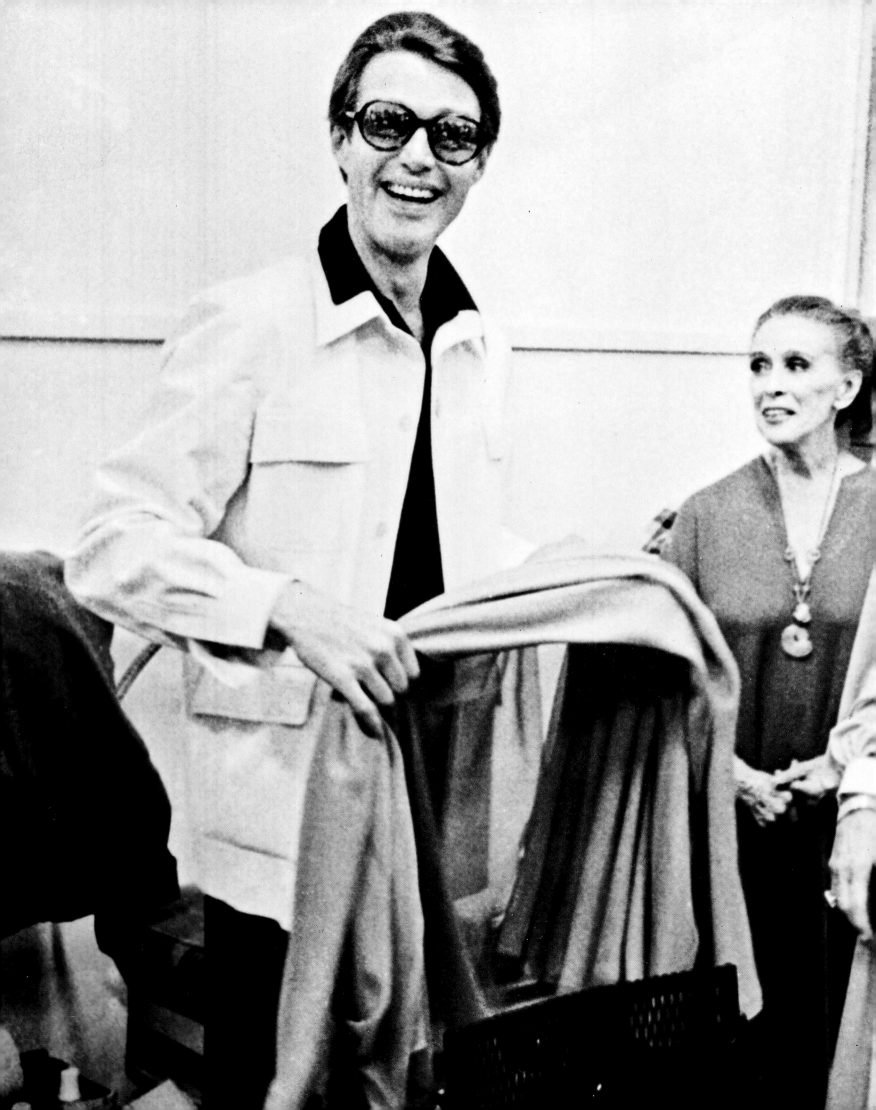

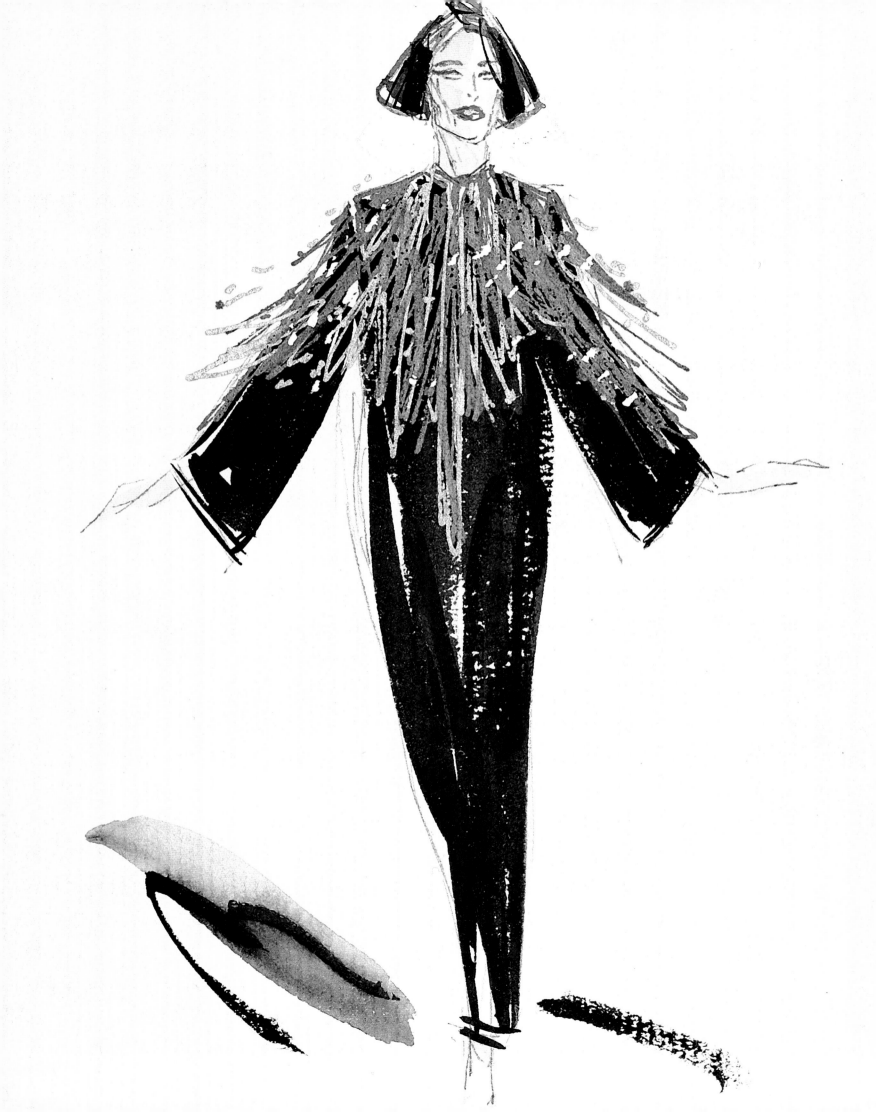

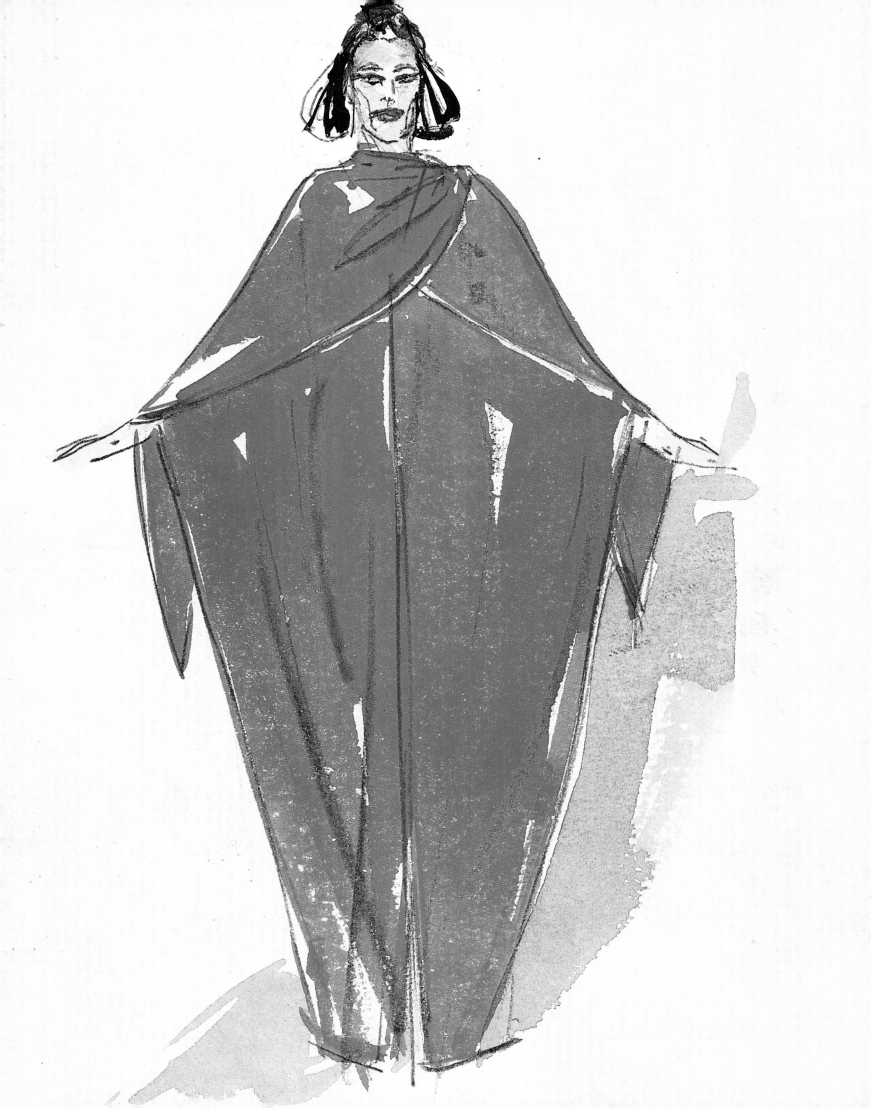

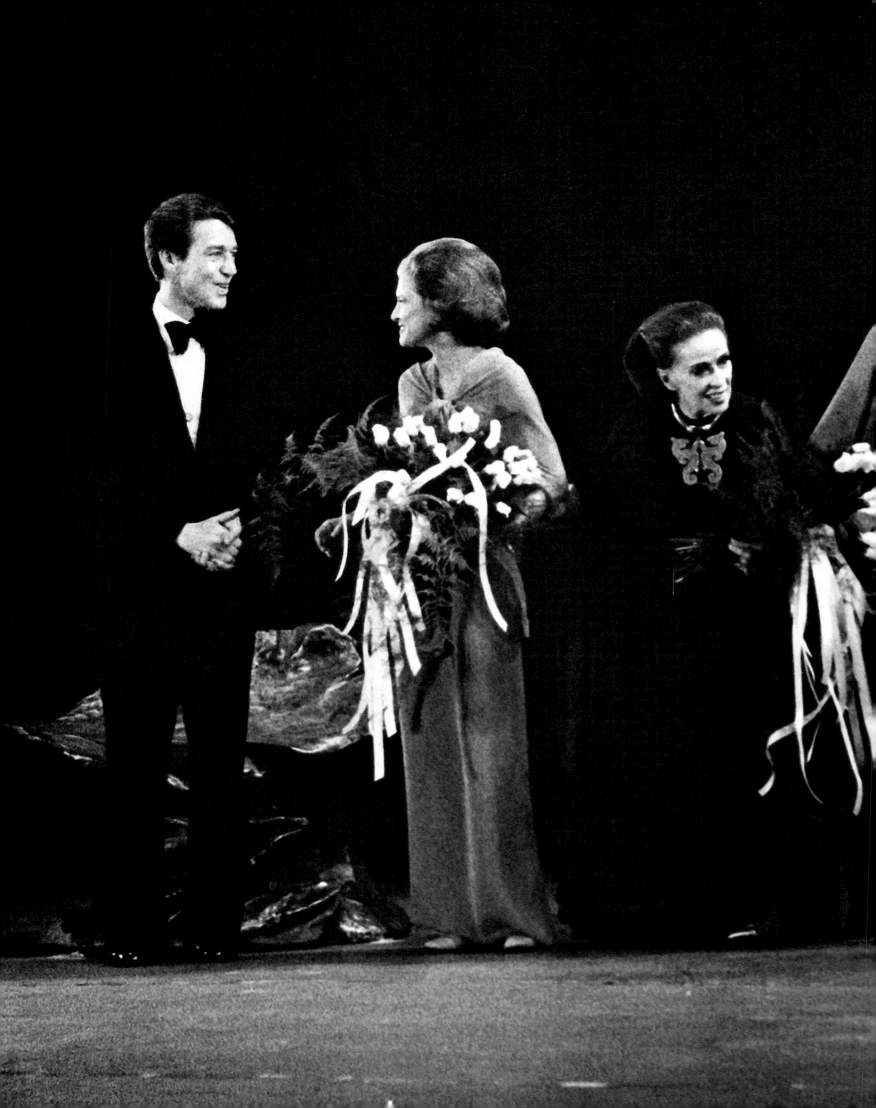

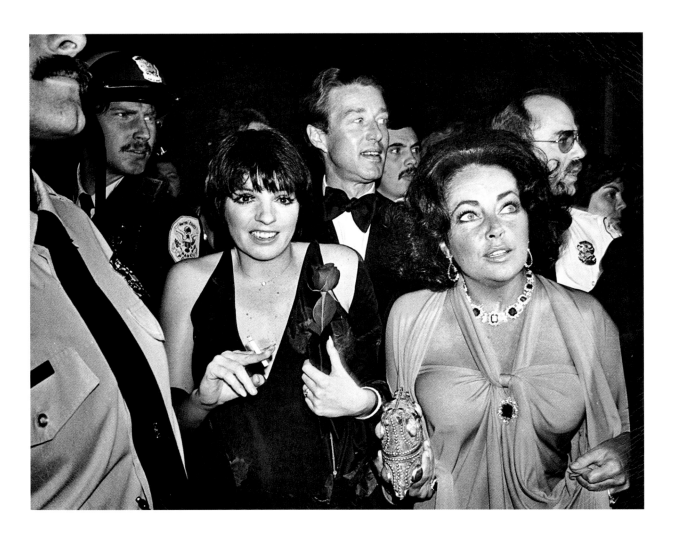

H alston and his entourage, which included Hollywood stars, celebrities and models, and luminaries of the Warhol crowd, arrived at parties fashionably late—and dressed to the nines, typically in Halston. Opposite, top: Halston, Liza Minnelli, and Elizabeth Taylor entering a star-studded party given by the Iranian ambassador Ardeshir Zahedi, Washington, D.C., 1976. Opposite, below: Halston with friend Barbara Allen, c. 1975. Above: Cheryl Tiegs, Halston, and Martha Graham on their way to a Martha Graham Dance Company performance, c. 1976. Below: Bianca Jagger and Halston, two of the glitterati attending the Met's Costume Institute Gala exhibition *Vanity Fair: A Treasure Trove of the Costume Institute*, at the Metropolitan Museum of Art, December 12, 1977.

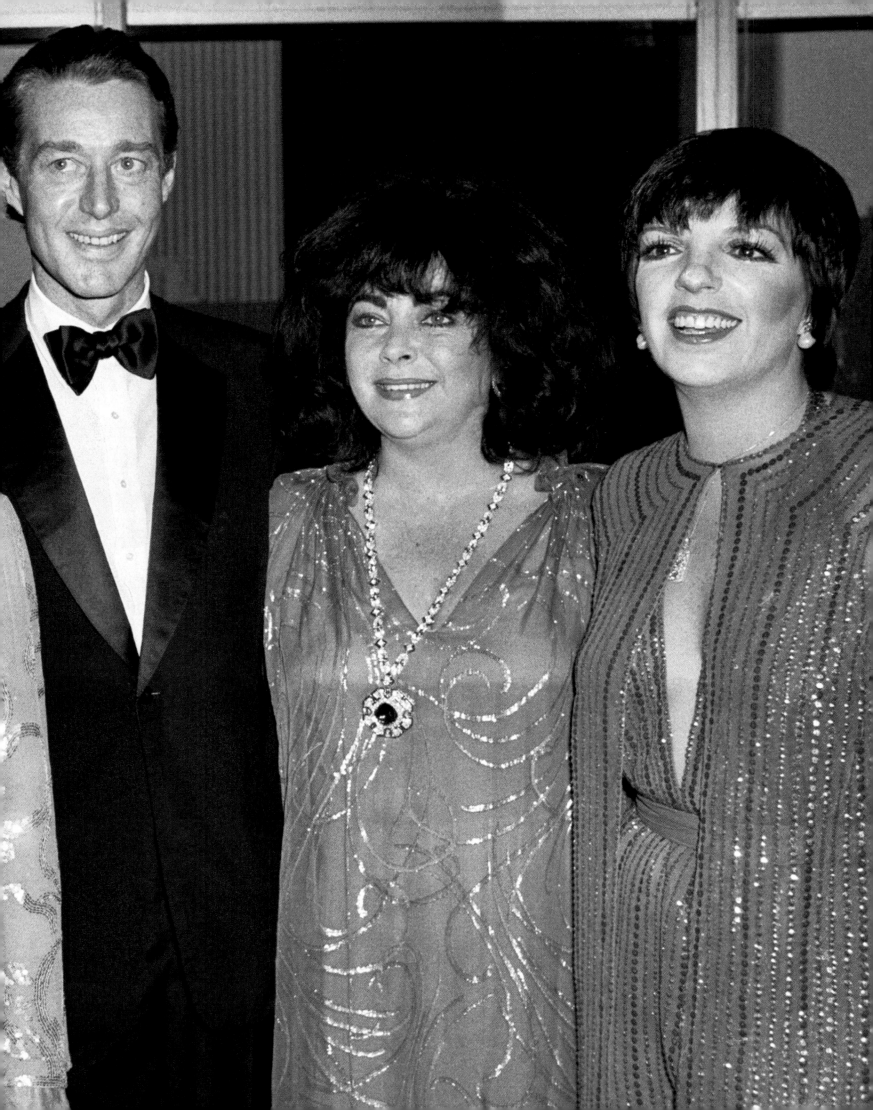

ALL THE BEAUTIFUL PEOPLE

By the mid-1970s, the brownstone that Halston had moved into in 1968 was seriously overcrowded, with about seventy employees crammed into its five stories. When a safety inspection revealed that the building was a fire hazard, Norton Simon stepped up its plans to find a new space better suited to Halston's growing importance. What they found, on the twenty-first floor of the recently built Olympic Tower at Fifth Avenue between 51st and 52nd Streets, was light-years away from the rather shabby nineteenth-century building where he'd first set up shop.

Olympic Tower was built to be part commercial and part residential. The twenty-first floor was the top floor of the commercial section of the building and located just underneath luxury apartments. Saudi businessman Adnan Kashoggi's pool was directly above Halston Enterprises. One night it sprung a leak, drenching the space in a few inches of pool water, halting work for a day at Halston's until the cleanup crew could rip out the carpets and dry everything out. The new office was one and a half stories high, with eighteen-foot ceilings—a soaring perch in the sky above Midtown Manhattan. The spires

of St. Patrick's Cathedral were so close you felt as if you could reach out and touch them. Halston fell in love with the space the minute he saw it and immediately took charge of the overall design, which he envisioned as combination working studio and theater/event venue for fashion shows and parties.

The northern end of the space became a workroom, while the rest was divided into four areas, all with mirrored walls and floor-to-ceiling windows: Halston's office, a conference room, and two fitting rooms for private clients. By means of mirrored, floor-to-ceiling doors, these smaller rooms could open up into one large, ninety-foot-long space that seated three hundred people.

Everything had Halston's distinctive stamp, right down to the Hs on the wall-to-wall crimson carpet made by licensee Karastan and the lacquered rust-colored Parsons tables designed by Charles Pfister.

"It was total attention to detail," says Faye Robson, his assistant. She describes how, when he saw how his bathroom light was originally in front of the mirror, he said, "'No, I want it from the back. That's the best way to see yourself—you do not want glare in your eyes.' So the electrician came back and put the light from the back instead of through the medicine cabinet."

Halston's office overlooked St. Patrick's and he arranged his desk so his back was to the window. Approaching him when he was sitting there, dressed all in black with his mirrored sunglasses shielding his eyes and the cathedral spires looking as though they were growing out of the top of his head, was quite an intimidating experience.

"Boy, did he have showmanship but not the bravado, the vulgarity that so often comes along with it," says Ralph Rucci, at the time one of Halston's assistant pattern makers and now the standard-bearer for the kind of luxuriously understated American style that his former boss pioneered. "He did it right." Joe Eula said. "He had class. When OT opened for the first collection, people were speechless."

The first fashion show at OT—what the Halston crew called Olympic Tower—was the made-to-order collection for summer 1978, which was held in February. Two of Halston's favorite superstars, Liz Taylor and Liza Minnelli, were in attendance, the former in the front row and the latter on the runway. The collection, Halston told *Women's Wear Daily*, "looks different from anything I have ever done. Flying saucer, big, full round.

It catches the air and moves beautifully" (*Women's Wear Daily*, February 13, 1978). Rucci describes the entirely bias-cut collection as "the most important in American fashion." Even the caftans had no side seams, just one spiral seam that curved around the body for an extra slinky fit. Liza closed the show, strolling down the catwalk in a black-and-white satin dress to the strains of her new signature tune, "New York, New York," a red rose in her hand, to wild applause.

Rucci had only recently started working for Halston and vividly remembers his interview: "The space was totally intimidating. The rooms were vast, the ceilings were high. I wanted to show up perfectly dressed and look the part in black trousers and cashmere turtleneck. My teeth were chattering with fear." Rucci met with Salvatore Cardello, Halston's Balenciaga-trained pattern maker. "He said, 'You will start in the workroom.' Which is exactly what I wanted," Rucci remembers. "I wanted to do it, learn the technique. It was the secrets I wanted. I draped toiles. My first project was a seven-layer chiffon on the bias. I was so intimidated. It was a test. Signore Cardello peeped over—he never said anything until after I was completed—and he said, 'I'd like you to shorten the layers by a quarter inch.' He looked at my face and said, 'This is what couture is about.'

"There were tensions between the pattern makers, sort of a rivalry," Rucci continues. "The standards were exacting and demanding; there was no room for error. Halston was doing things that had never been done before in terms of construction—all the bias-cut one-seam clothes. Any previous knowledge the great pattern makers had, they had to throw it out the window. Halston would write on each sketch what pattern maker was to work on that garment because he knew each one's area of expertise. He would do all the fittings himself. There were opinions involved, Bill [Dugan] and D. D. [Ryan] were there, but it was entirely his creation. You had to put yourself in his mind to understand—so many of the innovations were trial and error and that breeds tension and fear, but what everyone accomplished was extraordinary. You did feel enormous pride because people knew they were working in a very special place.

It was the highest level of fashion. It was the place and everyone knew it."

That summer, my family came to New York on a visit from Prague. What a culture shock it was to leave that communist city behind for Halston's glittering Manhattan! In his Olympic Tower office, it seemed that he was literally on top of the world. We arrived just as he was wrapping up a photo shoot at 101 for *Life* magazine photographed by Harry Benson. Though of course I had no idea at the time, the article subsequently turned out to be an inspiration and the thread that brought me together with several Halston colleagues who remain close to this day. After the photo session concluded, Halston escorted us up to the Olympic Tower for our first tour and lavished my stepmother and me with outfits and accessories. I was in awe. The regal red carpeting, the white phalaenopsis orchids, the constantly burning Rigaud candles wafting their familiar Parisian forest scent, the view of Fifth Avenue that stretched from Harlem to the Battery, the chrome racks of resplendent clothing from his most recent show, and everything reflecting in the mirrored walls—it was all so intoxicating. I wanted to be a part of the glamour. I wanted to work with him in that razzle-dazzle.

That evening, Halston dressed me up in a black satin halter, one-piece cowl-neck pajama suit with strappy high heels, and he and Andy Warhol took me to Studio 54. Not many people were there—I distinctly recall the dance floor was sparsely populated. I was very tan and feeling sassy. In all my youthful glory, I asked Halston to dance and was disappointed when he said no. My whole life I had heard what a great dancer he was, but I could not convince him to get out there with me and shake a leg. So I turned to Andy, who declined by giving me his funny little nasal chuckle. He always had an associate with him, a young guy from work who was there to take mental notes or simply to act as his wingman. Andy offered up that evening's wingman as my Fred Astaire and we headed out onto the floor. As the neon man in the moon with his coke spoon shone overhead, I danced until I glowed.

It was my first night at Studio 54 with my uncle but certainly

not my last. Co-founders Steve Rubell and Ian Schrager had opened 54 the previous year—on April 26, 1977, to be precise, three days after Halston's forty-fifth birthday. It was the beginning of what Bob Colacello described as "their delirious reign as the absolute monarchs of Manhattan nightlife." And Halston was very much a part of the Studio 54 aristocracy. He had an open invitation to what was the most exclusive club in the city, presided over by the master of the velvet rope, Rubell, who allowed in only the most glamorous, rich, beautiful, and interesting people, with a mix of straight and gay to maintain a balanced level of excitement. Rubell used to joke that the only reason he himself got in was that he was the owner. In his book *Exposures*, Andy Warhol wrote that his tip for getting into 54 was to always go with Halston or in Halston.

Halston made his maiden voyage to the club on its opening night, which was hosted by the trendy Italian clothier Fiorucci. His date was Bianca Jagger, who was living at 101 while she extricated herself from Mick. In the beginning, the 54 set was a close "rat pack" who would gather at Halston's before heading to the club. The core group was Halston, Bianca, Liza, Steve, and Andy. Halston, while enjoying the initial exclusive scene with his close friends and a few unknowns, started frequenting 54 more regularly to show his support for Steve and to help draw in the crowds. There were special networking parties, socializing with his star friends, dancing—and delving into the 1980s drug of choice, cocaine. Back then, when it all seemed so new, liberating, and chic, cocaine offered a means to be free, to express yourself with greater ease, to be able to keep up with the eternal nightlife. And that was all anyone who wanted to be anyone wanted—to be a part of this urban pulse.

To Colacello, then an editor at Andy Warhol's *Interview* magazine, the scene at Studio 54 was a milestone in Halston's relationship with Warhol. Though they had known each other for years and started their careers in fashion at roughly the same time, 54 was where they began to spend more time together. "I connect the real flourishing of their friendship to Steve Rubell and the opening of Studio 54, where they became much more in-

volved," he says. "It became like a joke. I think the New Yorker had one word for the pack: BiancaHalstonLizaAndy." Halston, Colacello notes, was not above teasing his friends. "Sometimes we would go to 101 before 54. He would serve a very light dinner, like smoked salmon, and cocaine. A lot of times Halston gave the girls dresses to wear out with him. Marisa went up and changed into something Halston wanted her to wear. When she came down the stairs, Halston said, 'Oh dear, she has the dress on backward but let's not tell her.' That was his idea of a joke. It looked great backward I have to say—it was not like it was embarrassing her."

Studio 54 became a fantasy island in the middle of the chaotic metropolis. Especially extravagant were the lavish theme parties, like the one Halston threw for Bianca Jagger's birthday soon after the club opened, in which she rode out from behind the stage curtain on a white horse escorted by a staff member wearing nothing but a head-to-toe tuxedo ensemble made of glitter. There was a circus party for Valentino, complete with circus ring, sand, and mermaids on trapezes. Studio 54 turned into an English garden for one fête and, for another staged by Alana Hamilton, a band of Hells Angels roared through the lobby and onto the dance floor. But nothing topped Elizabeth Taylor's birthday festivities celebrated on March 6, 1978. The Rockettes performed and then presented the movie star, who was standing on a float between Halston and her then-husband, Senator John Warner of Virginia, with a cake that was a full-sized portrait of her. To quote Andy Warhol, in his book *Exposures*, "She blew out the candles and cut off her right tit and gave it to Halston. The TV cameras zoomed in as Halston ate it. Then they waltzed."

In 1980, after Steve and Ian "left" the club (i.e., went to prison for tax evasion), Halston began to find the scene less appealing. Although a section of the vinyl banquet located at stage left of the dance floor was reserved for Halston and his entourage, he took to escaping the voyeurs by going to the basement where the "in" crowd hung out, waited on by hunky half-clad busboys who popped in from time to time with refills. Accessed by a gray door at the right of the stage, a dark and dingy stairwell

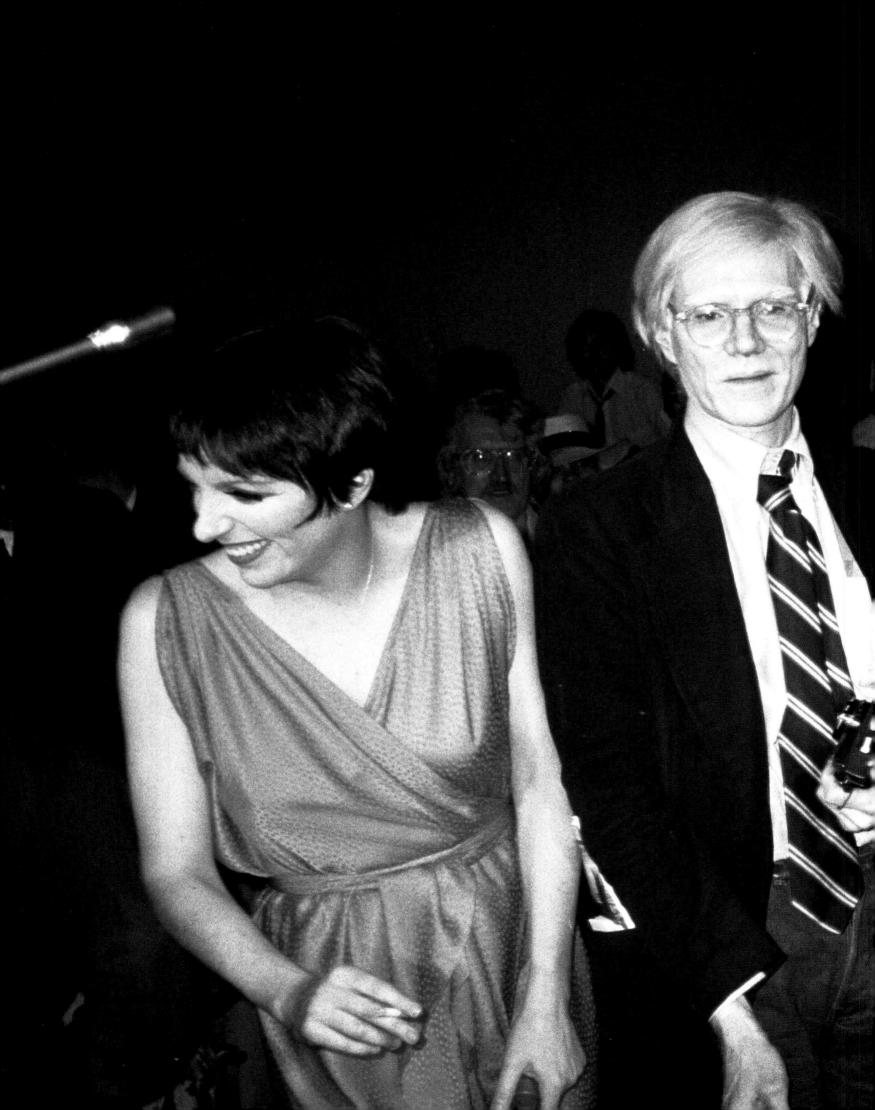

led to an abysmal basement labyrinth of storage spaces that were made of actual chicken wire. It was in one of these unceremonious "cages" that I once went with Halston to escape the throngs. Upstairs the "girls" were getting ready for that evening's drag queen entertainment, the first event like this I had ever attended. (It was amazing how much they resembled Barbra Streisand and Liza!) I was probably making the rounds with Victor Hugo, who ushered us to the basement, where we hung out on some nasty old chairs in that wire cage until it was time to emerge for air. The bowels of 54 were a far less glamorous setting than anticipated. That, too, became a less comfortable scene for Halston, so he began to frequent 54 less regularly, preferring instead to entertain at his home. As Liza recently told me, "There were times when we walked into 54 with flashing photographers, we would whirl around a little, and then we sat down, hobnobbed—photographs, photographs—and then I'd look over at him and say, 'Now?' and he would say, 'Now.' We would get up and go out the back door and get in the same car and go home." But 54 was important. It was exactly with the times—nothing he did was not with the times. His house was, in the end, the hottest disco in town. His friends were free to let their hair down in the privacy of 101, where the only intrusion was Andy and his omnipresent Olympus camera.

Following the successful Braniff Airways venture, Halston was approached by the Girl Scouts of the USA to design their adult uniforms. According to a memo dated January 1978, which reviewed the preliminary negotiations, Halston, a former eagle scout, was "all smiles" at the prospect. He believed in his country, and so, if there was a true American cause, Halston would devote his entire energy to completing the task. In this effort to better the life of the average American adult Girl Scout, Halston offered his services to the Girl Scouts pro bono, though there was an extended legal negotiation. In the end, he insisted on an exclusive five-year contract, with his own manufacturer, Lady Manhattan, producing the garments and labels so that he could maintain quality control through to the end of the production. He committed to five interchangeable pieces.

For the press party that May, Halston was his usual micro-manager self, involved in every detail, right down to the drinks that should be served. A Girl Scouts memo reads: "Halston does not wish to serve wine—he wishes to have an open bar. He said there are many members of the fashion press who would walk in and not be able to have their usual vodka martini, say 'ciao,' and disappear." Andy Warhol and Liza Minnelli were of course on the VIP list. After attending the press party Warhol wrote, "Halston had designed uniforms for the Girl Scout troop leaders. So many ladies pounced on me. I said that Halston must be making a bundle on this but it turned out he did it all for free. It's a great way for these ladies to get a Halston for cheap—pants are only $25. He did them in a funny color—it's not my favorite green—but then all the ladies wearing it did look pretty" (*The Andy Warhol Diaries*, p. 135).

The Girls Scouts invited Halston to their forty-first national convention in October of the same year. In front of six thousand Girl Scouts, he was serenaded with a round of "We love you Halston, we really do." A Southern Cheyenne tribe presented him with a pair of hand-beaded moccasins and the Girl Scouts gave him a brass ruler engraved with his name.

Not many people know that every First Lady is an honorary member of the Girl Scouts, and Rosalyn Carter was the lucky First Lady to wear a Halston for the Girl Scouts. In the end, "Halston, winner of four Coty awards and recipient of the highest honor in American fashion—election to the Coty Awards Hall of Fame—'believes that people make fashion.' Thanks to him, Girl Scout adults throughout the nation can own a designer creation and make fashion news" (Girl Scouts press release, May 16, 1978). And they did, from 1978 to 1984. Following what was referred to as the "hardship" post of Prague, my father was posted as political consigliere to the embassy in Rome in the summer of 1979. Our first summer in the eternal city, Halston once again flew his sister and mother, Hallie Mae, to visit us. As always, they flew out of New York so that he could treat them to an evening on the town and bedeck them in his latest fashions before they headed off on another

Previous pp.: These four friends were so often seen together in the New York social scene that the *New Yorker* called them by one name: "BiancaHalstonLizaAndy." Opposite: Halston with adult Girl Scouts of the USA at Olympic Tower, 1978. A former Eagle Scout, Halston redesigned the adult uniforms for the Girl Scouts for free.

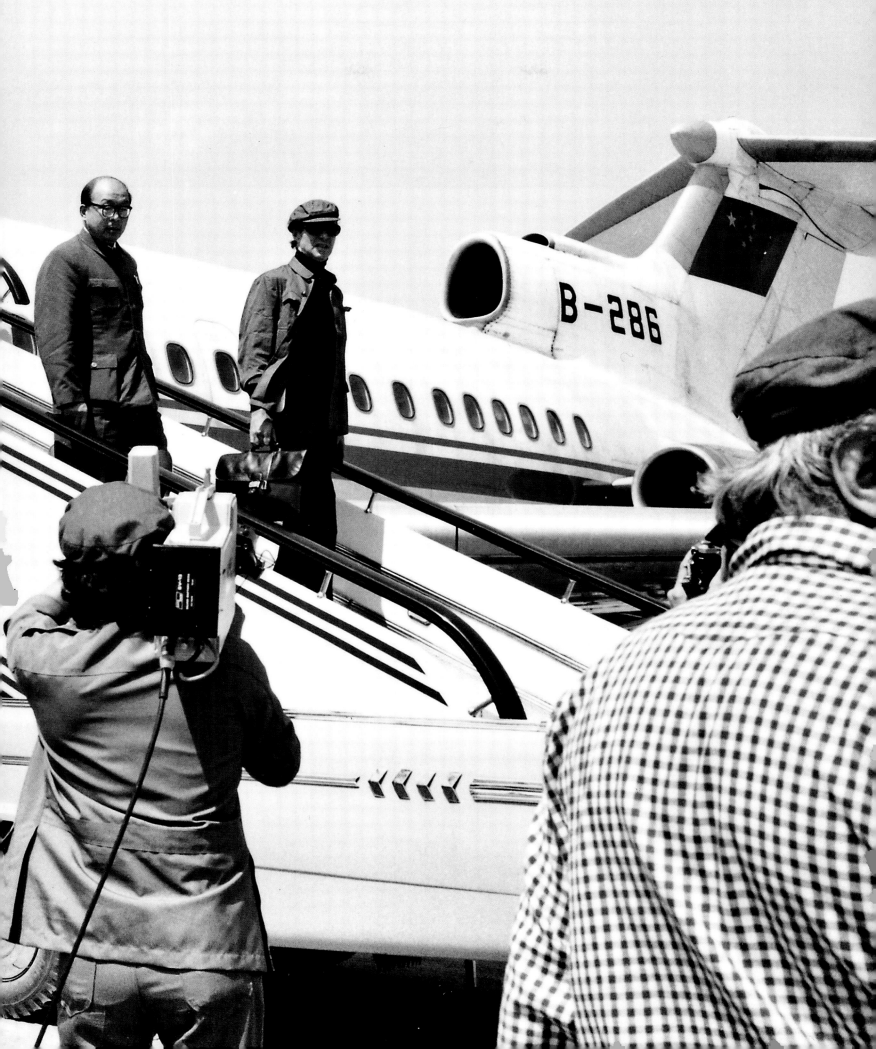

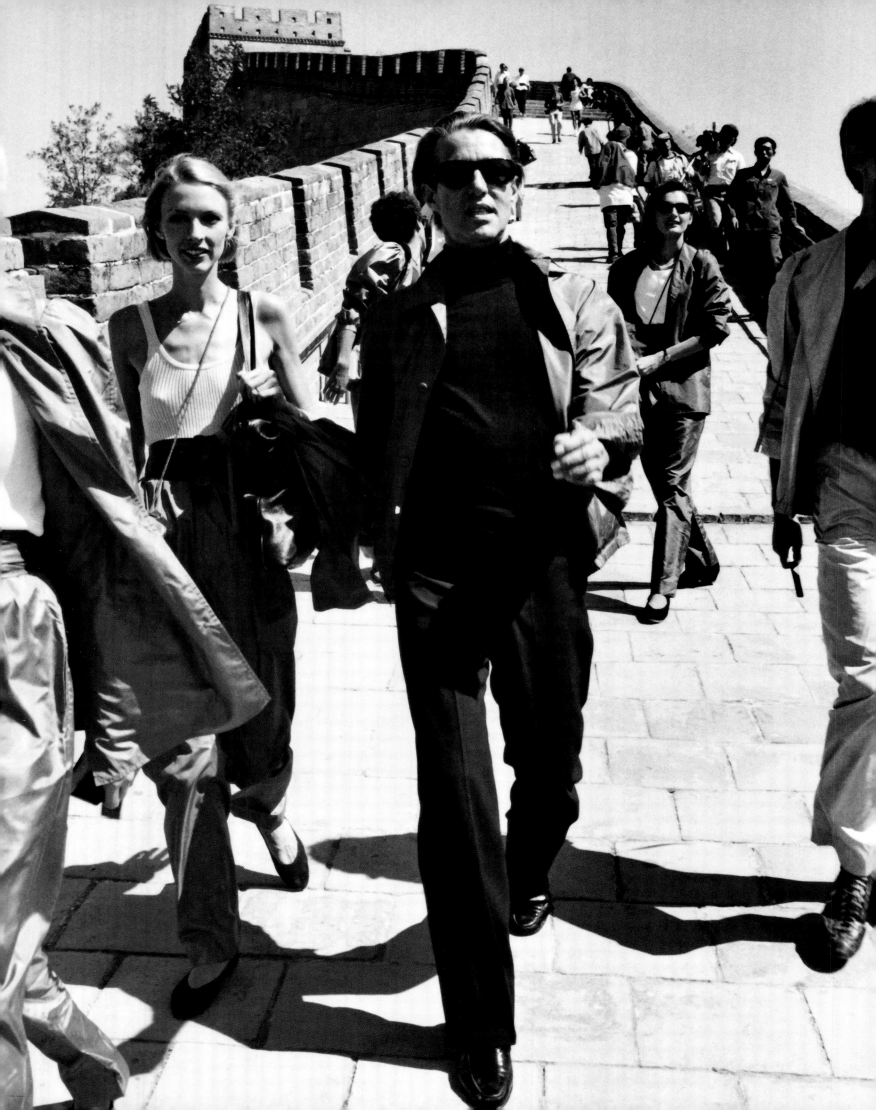

European adventure. In Rome, Halston continued to shower my stepmother Ann with boxes of clothing and accessories, including the fabulous pouch bags by Bobby Breslau. I really wanted to work for Halston at this point. I wrote long, pleading letters to no avail, though he did oblige once by making an introduction at his peripheral fragrance and cosmetics company Orlane in Paris. In the end, the job did not materialize.

In August 1980, Andy Warhol wrote in his diary, "Went home and glued myself together. Victor said he'd meet us at Halston's. I got there and Bianca was asleep under the white evening dress that I thought was a nightgown. Halston was working late, he had to finish the collection for China, he's going to China and Japan."

The idea may have been inspired through discussions with his diplomat brother, Robert, who kept Halston abreast of world affairs, especially as they related to U.S. relations with communist bloc countries. (The year 1979 witnessed the formal exchange of diplomatic recognition between the People's Republic of China and the United States.) Or perhaps it was a desire to make his mark as the first American designer to stage an around-the-world fashion tour. Whatever the motivation, in the spring of 1980, perhaps with some behind-the-scenes orchestration, the official invitation to explore the Chinese silk industry as a guest of the People's Republic of China came at approximately the same time as Halston signed a license to manufacture sportswear in Japan through the Kosugi Sangyo company. As ever, he turned it into a major marketing opportunity, planning a three-continent, six-city tour that was to last twenty-four days. The costs were split between Kosugi Sangyo, the Chinese government, the perfume division, and Norton Simon.

Marylou Luther, writing in the *Los Angeles Times* on September 8, 1980, said, "Halston says he's not going to China intent on

dressing one-fifth of the world's population in his latest designs or Ultrasuede workers' jackets, but to have exploratory talks about developing certain silk fabrics for his many apparel divisions. One of the reasons he's taking so many people with him, he says, is to make the trip to the Orient 'a visual exercise that will explain more about Halston and America than a million translated words.'" To share his experience with the American audience, David Brinkley's TV magazine aired parts of the trip in the United States.

Halston invited his close friends D. D. Ryan, Bianca Jagger, and the luminary photographer Hiro, who had lived in both China and Japan; the eleven male and female cabine models; and a few select staff. The entourage, or "corp de ballet" as Halston preferred to call them, landed first in Los Angeles. After collecting their beige and burgundy Hartmann Ultrasuede luggage and garment bags that contained all the outfits and accessories for each day abroad—"I just packed makeup and lingerie and everything else was supplied," remembers Karen Bjornson —they prepared themselves for a fashion show to benefit the Los Angeles County Museum of Art's Costume Council. Included in the show were Halston's iconic cashmeres and Ultrasuedes peppered with swirling ruffled silk organza gowns, each of which needed its own suitcase. These gowns, to be worn at the trip's official engagements, were all color coordinated for each event. This was followed by a dinner at Morton's, for which the models arrived in waterproofed silk taffeta parkas with matching pants, all in red. Halston pre-visualized the shot on the Great Wall: "I want to have it like a little movie. Just think. We'll all be on the Great Wall of China dressed in Chinese silks and Halstons" (*Los Angeles Times*, September 8, 1980). The first stop after L.A. was Tokyo, where a fashion show

0512-09A
July 28, 1980
HO:MO

KOSUGI/HALSTON GROUP TO JAPAN 1980

September 07, Sun. ARRIVAL IN JAPAN

16:05 Arrive at New Tokyo Int'l Airport by JL061. Meeting at
 airport and transfer by chartered motorcoach(or hired-car)
 to the hotel in Tokyo.
 Dinner and accommodation at HOTEL OKURA and IMPERIAL HOTEL.

September 08, Mon. TOKYO

 American breakfast at the hotel.
 All day is free at leisure.
 Lunch, dinner and accommodation at HOTEL OKURA and IMPERIAL
 HOTEL.

September 09, Tue. TOKYO

 American breakfast at the hotel.
 FASHION SHOW at Imperial Hotel.
 Accommodation at HOTEL OKURA and IMPERIAL HOTEL.

September 10, Wed. TOKYO

 American breakfast at the hotel.
 Full day visits in Tokyo which will be arranged by
 Hakuho-do.
 Dinner and accommodation at HOTEL OKURA and IMPERIAL HOTEL.

September 11, Thu. TOKYO - KYOTO

 American breakfast at the hotel.
 Full day visits to Department stores in Tokyo which will be
 arranged by Hakuho-do.
16:00 After visits of Department stores, transfer to Tokyo Station.
 Leave Tokyo for Kyoto by Japanese National Railways, Bullet
 train, Hikari 29.
18:53 Arrive at Kyoto station and transfer to the hotel.
 Dinner and accommodation at HIIRAGIYA RYOKAN and MIYAKO
 HOTEL.

September 12, Fri. KYOTO

 American breakfast at the hotel.
 Full day sightseeing tour in Kyoto visiting Kiyomizu Temple,
 Nijo Castle, Kinkakuji Temple(Golden Pavilion), Heian Shrine
 and Kyoto Handicraft Center. Lunch will be arranged at the
 Japanese style restaurant.
 Dinner and accommodation at HIIRAGIYA RYOKAN and MIYAKO
 HOTEL.

Nippon Express Co. Ltd.

September 13, Sat. September 14, Sun.	KYOTO

Breakfast at the hotel.
All day is free at leisure in Kyoto.
Optional tour will be arranged upon request.
Lunch, dinner and accommodation at HIIRAGIYA RYOKAN and
MIYAKO HOTEL.

September 15, Mon. KYOTO — OSAKA DEPARTURE

Breakfast at the hotel.

08:30 Transfer from the hotel to Osaka Int'l Airport by
motorcoach.

11:30 Depart for Peking by JAL783.

*** SA YO NA AR ***

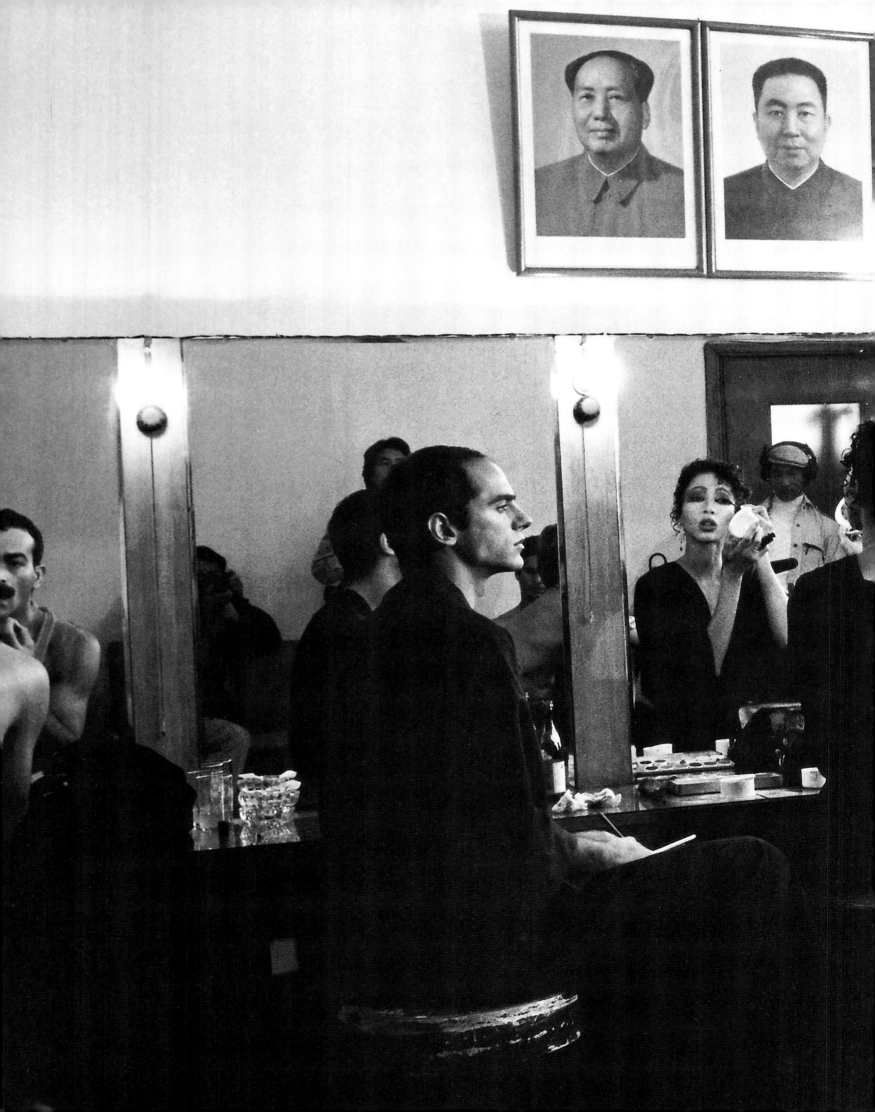

HALSTON ENTÉRPRISES, INC.

645 FIFTH AVENUE · NEW YORK, N.Y. 10022

LIST B

PERSONNEL APPLYING FOR JAPANESE VISAS

Name	Position on Trip
1. Roy Halston Frowick	President
2. Liza Minelli (Mrs. Mark Gerolmo)	Choreographer
3. Mark Gerolmo	Staging
4. Bianca Jagger	Assistant Director
5. Michelle DiPetrillo Dowgin	Design Assistant
6. William S. Dugan	Design Assistant
7. Dorinda Dixon Ryan	Design Assistant
8. Pedro M. Valls	Design Assistant
9. Ed Martin Riley	Design Assistant
10. Peter Eng	Design Assistant
11. Naeemuddin S. Khan	Design Assistant
12. Johanna Ricciardi	Design Assistant
13. Victor Rojas	Design Asst. & Staff Artist
14. Shirley Ann Ferro	Design Assistant
15. Michael J. Lichtenstein	Managing Director
16. Michael R. Pellegrino	Marketing Director
17. Frances Robson	Staff Administrator

HALSTON ENTERPRISES, INC.

645 FIFTH AVENUE · NEW YORK, N.Y. 10022

LIST A

NAME	ROLE ON TRIP	FEE
1. Mrs. Karen Bjornson MacDonald	model	$3750.00
2. Miss Chris Royer	model	$3750.00
3. Miss Alva Chinn	model	$3750.00
4. Miss Carla Araque (Miss Antonia Araque)	model	$3750.00
5. Miss Margaret Donohoe	model	$3000.00
6. Mrs. Patricia Cleveland Snaric	model	$3750.00
7. Mrs. Nancy North Dugan	model	$2000.00
8. Miss Constance Anne Cook	model	$3750.00
9. Mr. Pat Anderson	model	$3000.00
10. Mr. Carmen Anthony Spinelli	model	$3000.00
11. Mr. Martin Snaric	model	$3000.00

Total U.S. $36,500.00

had been planned by Kosugi Sangyo. "None of the Japanese clapped; they just bowed their heads," says Nancy North. "We were so tired going into Japan that when we arrived and were going to have dinner, we did not want to go; we just wanted to hang out in our rooms. Halston said, 'I'd like you to come to dinner in my room,' which was at the Hotel Akura. We said we were too tired, and so he asked us to leave and go back to the United States. Shirley [Ferro] was sent back. It was suggested from then on that you stay with the group, especially if Halston had planned a get-together."

After a few days seeing the sights in Kyoto, the corps moved on to Beijing, where they stayed at state guesthouses. They were treated like visiting dignitaries, remembers Faye Robson, Halston's assistant: "We were on tour 24/7 and it was very controlled. We were escorted around on buses while all the other Chinese locals were on bikes." Before going to their first official dinner, the group popped into the Friendship Stores to buy Mao suits. "We were at the dinner wearing gray Mao uniforms," remembers Pat Cleveland. "Each girl was positioned at a different table. I was with Halston

at a big round one that sat twelve people. We were drinking a drink called Maotai that tasted like gas. They would toast and tap on the table and you had to drink the Maotai down. They toasted poor Halston so many times, like fifteen toasts."

Halston choreographed the first American fashion show ever to be staged in China, for the Chinese fashion and textile manufacturers in Shanghai. Alva Chinn remembers how delighted the members of the audience were to examine the exotic western clothes. "They needed to feel and see the fabrics. What I loved about that day was the little Hs in the fabric. The workers would look in the fabric and it was like a gem to them. I remember a moment of helping a woman putting on the dress,

and I saw so much glee in her face."

One of the most challenging evenings of the trip was an official American Thanksgiving dinner for the Chinese silk industry and U.S. embassy dignitaries, a last-minute request that was left to Faye to organize. Her first move was to get in touch with my father, who was then working at the U.S. Embassy in Rome. He put Faye in touch with the American Embassy in Beijing, where the Ambassador's wife, Mrs. Leonard Woodcock, eventually assisted with locating the restaurant and obtaining the American food. Faye brought her CD player and a collection of jazz CDs. "The embassy contact helped with the

event by securing the services of all the cooks from the English-speaking embassies in Beijing," she says. "We went into one room that was all curtained, so we took down those curtains and replaced them with red, white, and blue ones. The chairs were covered with green fabric covers, so we looked under them and found to our delight that they were red! At the embassy, they were growing huge red amaryllis, so we borrowed those as centerpieces with the Chinese version of votive candles. We served a Thanksgiving

dinner with apple pie for dessert, all procured through the embassy commissary. They loved it!" Walking back into the hotel after cleaning up when everyone had left, Faye suddenly heard applause. She looked up the stairwell to see Halston and the models leaning over the stair railing, giving her a standing ovation. "When I say I was there in 1980 people say 'Ah.' It takes your breath away, the country was barely open," Karen Bjornson says. "The Great Wall was overwhelming. For the ride there, we were to wear the rain silk wear. Everyone was in the outfit assigned for that excursion. Being on one of the Seven Wonders of the World was amazing. And the photo opportunities—everyone clustered together, then everyone's camera would come out."

Previous pp.: Halston trying on a Japanese kimono, with D. D. Ryan looking on. Above: Halston and Bianca Jagger, seated serenely in a traditional room in Japan.

Opposite: Halston visiting with an elderly Japanese woman.

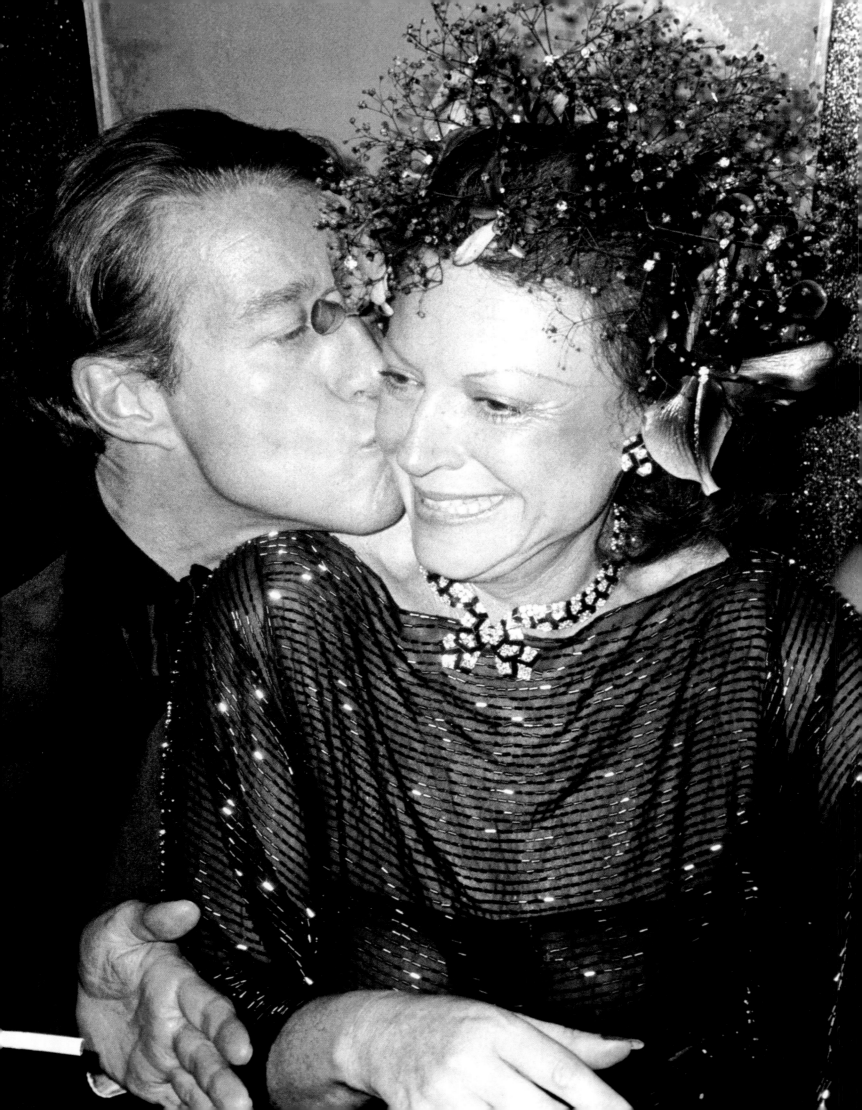

The last stop on the trip was Paris, where Halston threw a party at Maxim's to celebrate the recent introduction of his Classic fragrance in France. In a rare move, remembers Faye, he asked disco queen Regine to dance—"the ultimate club hostess dancing with the hottest designer."

By this time, Halston was a bona fide celebrity, even mentioned in two *New Yorker* cartoons. In one of them, a woman tells her husband, "I dreamt I was sitting in on a National Security Council meeting, and guess what. Liza Minnelli and Halston were there, too!" He appeared on talk shows and magazine covers, in public relations campaigns such as the I Love NY, and even, memorably, on a 1981 episode of the *Love Boat*, with a bevy of Halstonettes on his arm clad in his latest color-coordinated beads. Back at the office, he acted the part of reigning monarch. Receptionist Lisa Zaye, who says that her only qualifications for the job were that she was "tall, thin, and blonde," was tasked with letting everyone know when Halston was on his way in. Mohammed called the office after Halston had departed 101, then Lisa alerted the staff, including Viola McKee, who would get the white Limoges tea service ready on its black lacquer tray. All the doors were opened so that Halston could see from his desk at the St. Patrick's end of the floor all the way across the made-to-order room to 52nd Street. He would stride in carrying his black leather briefcase, silk coat or cashmere jacket over his shoulder, hair slicked back, and all sprayed up with Z-14. Once he was seated at his desk, Viola would appear with his tea.

"Sometimes D. D. would show up late and Halston would get really mad at her," Lisa says. "He loved her but she was so teasable. It was too much fun for him. Bill must have had radar, as he would show up an hour before Halston."

Shortly after being hired as the receptionist, Lisa was bumped up to the senior administrative spot, as Faye was leaving. "I think he liked me because I wasn't afraid of him," she says. "People were terrified of him. He came off as being sort of ferocious, but he was really nice. He did want things to be done a certain way, and it was to be perfect every time. If it was not, then he

held your feet to the fire, which sometimes was very intimidating for people. Overall he treated his employees wonderfully. He teased people when he knew it got to them. Shirley he teased, D. D. also. You know everyone has good and bad days— once I had clothes tossed at me behind the desk. Someone from the design room was supposed to send his clothes to 101 to be laundered and there was some miscommunication. When he saw they had not been sent over, he was upset and tossed them at me, yelling that I should take care of it right away."

As the first person whom callers and visitors to Olympic Tower encountered, Lisa acted as Halston's gatekeeper. If someone fabulous was in town, he or she invariably dropped by the office, where Lisa would escort him or her to the inner sanctum. "When the calls came in, we had to keep very careful records and wait for the right time to present the logs to him. He would decide who he wanted to speak with but for business stuff like magazines or newspapers, [Michael] Pellegrino would set up the interviews," she remembers. "If Liza called, he would always take her call, without exception. He also loved Cornelia [Cornelia Guest, Halston's upstairs neighbor at Olympic Tower and the 1980s Debutante of the Decade] and would always take her calls. He was amused by her and her enthusiasm for life."

When people came up to interview him, Halston liked to have the upper hand and would watch them in the mirrors as they made their way down the room to his office. Faye and then her successor, Lisa, would walk the visitor to the door as he or she looked around nervously at the millions of reflections, trying to seek out a safe passage to his or her destination. As the visitor came to the end of the not-so-fun-fun-house maze, the tall, mirrored door would open and there would be Halston, sitting imperiously at his desk, cigarette in hand and the New York skyline behind him. Another invariable element of insecurity for visitors was their wardrobe. After looking at endless mirrored images of themselves, it was inevitable that visitors would worry about wrinkles and uneven hems.

When it came to staging the fashion shows, the entire floor was cleared out. As ever, every detail from the candles to the

Previous pp.: Halston finding a rare quiet moment to meditate in a Japanese garden. Opposite: Halston kissing "Queen of the Night" Regine, mistress of disco clubs from New York to Rio, at the introduction of his Classic fragrance in France at her Club 7, during Halston's world tour, September 1980.

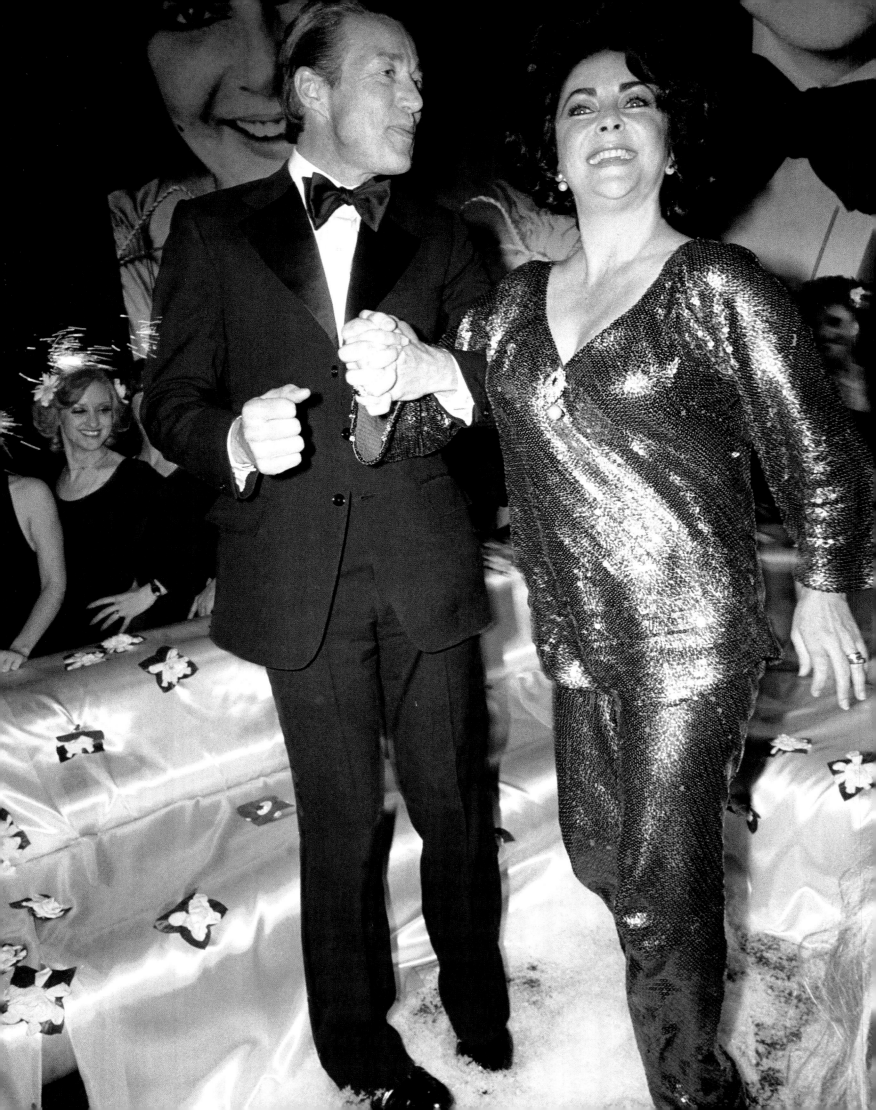

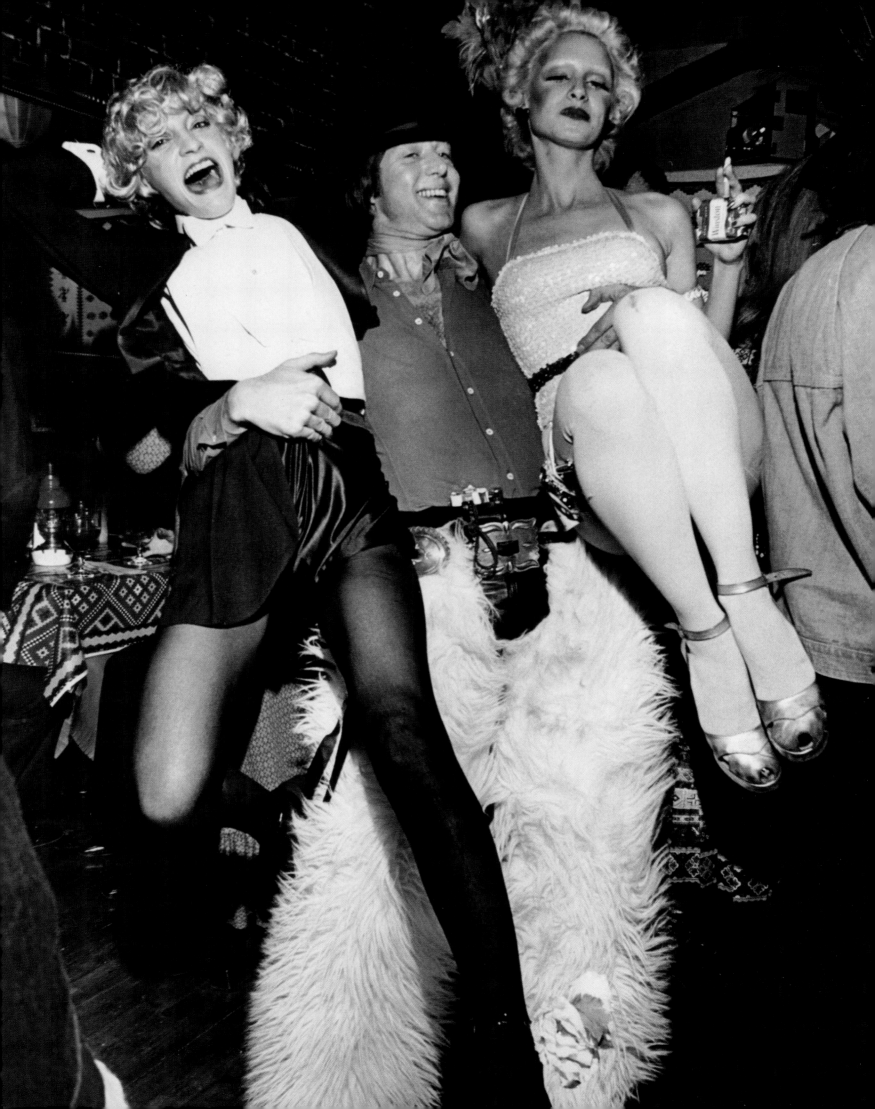

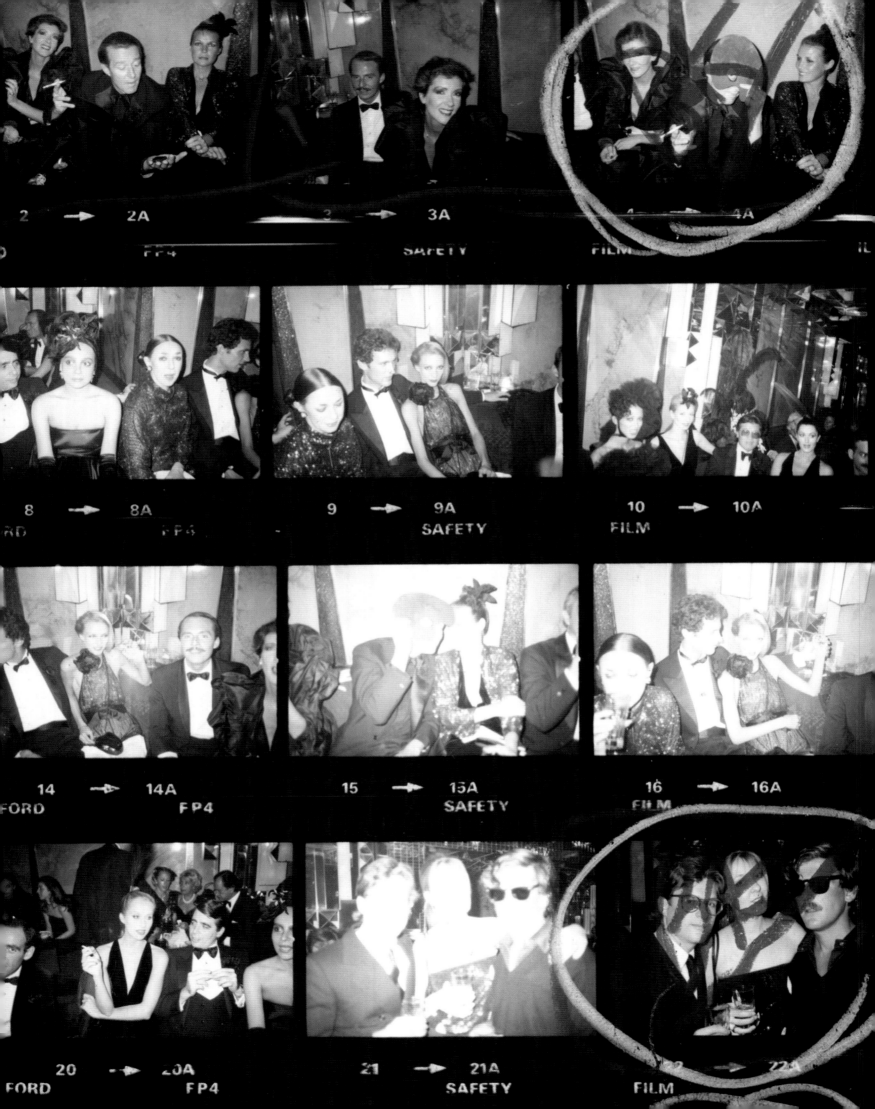

2 → 2A 3 → 3A 4 4A

FP4 SAFETY FILM

8 → 8A 9 → 9A 10 → 10A

FP4 SAFETY FILM

14 → 14A 15 → 15A 16 → 16A

FP4 SAFETY FILM

20 → 20A 21 → 21A 22 22A

FP4 SAFETY FILM

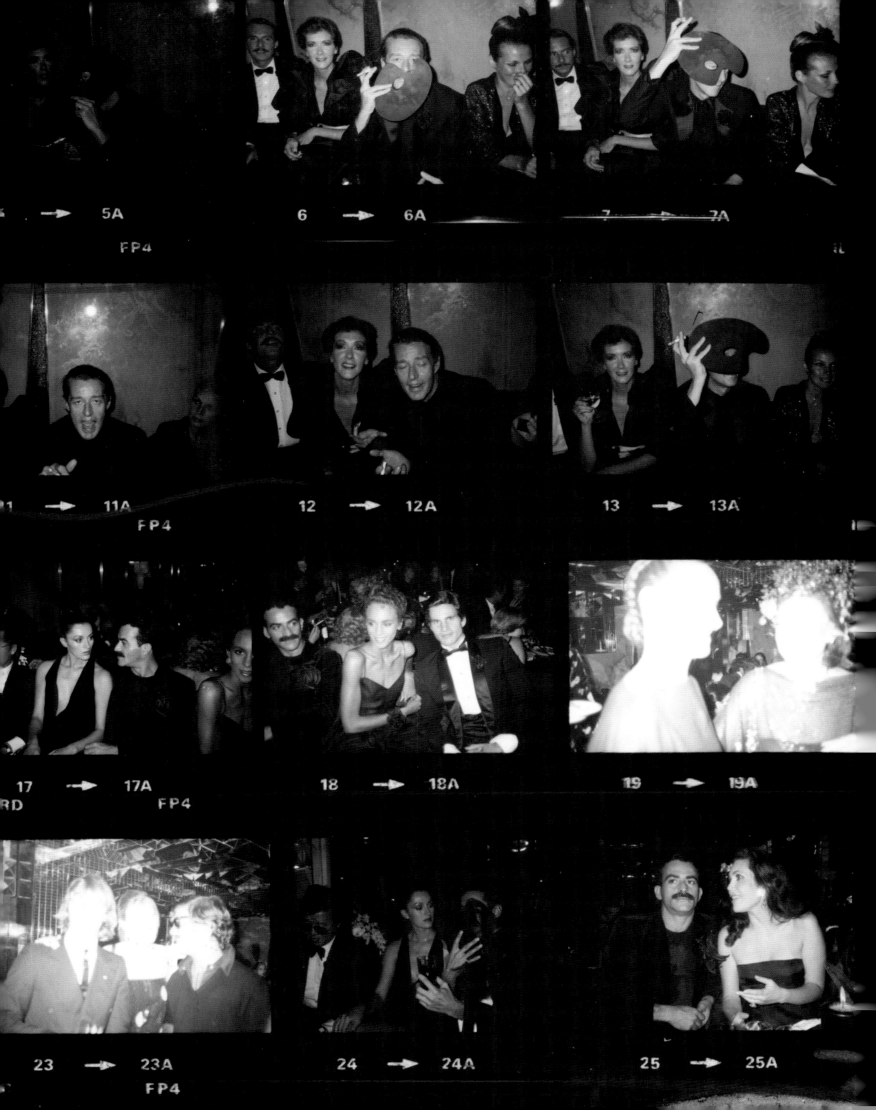

5 → 5A 6 → 6A 7 → 7A

FP4

11 → 11A 12 → 12A 13 → 13A

FP4

17 → 17A 18 → 18A 19 → 19A

RD FP4

23 → 23A 24 → 24A 25 → 25A

FP4

catwalk had to be thought out. Halston designated the 52nd Street end of the showroom as the press section, with cameras trained on the VIPs at the 51st Street end with St. Patrick's as their backdrop—an arrangement that guaranteed that any images of the show were as regal as possible. "He had sketched out the exact layout that he wanted and we all had to follow his directions to the T", Lisa remembers. "If anything was amiss he would not be happy and demand it be corrected immediately." Gifts for the press were lavish. One year, Lisa remembers placing silver Halston heart-shaped compacts and purse-size heart-shaped perfume atomizers on the seats. The sliding doors would be opened, and the catwalk set up with clear Plexiglas folding chairs, each with a guest's name written on a card stuck to it. Peter Wise arranged the orchids, and lit Rigaud candles gave a visual and olfactory ambiance.

Private parties were just as carefully planned. "When we had the company Christmas party, Halston made sure the food was catered by Glorious Foods, and there was champagne for every one," Lisa says. "He stayed for a little while to wish people Merry Christmas and have their picture taken with him. Then he left every one to have a good time." "At the party Halston was super generous to all of us," remembers Nancy Stone, his last illustrator. "We'd be hanging out and he'd pull out a couple hundred-dollar bills and say, 'There is a car downstairs—why don't you go down and have a good time out on the town?'"

Halston's displays of temper in the office may have been due to the pressures that were piling up on him in the design room. Halston loved designing and sketched constantly, but with all the licenses Norton Simon had negotiated, he was barely able to keep up, a problem that was exacerbated by his refusal to delegate design duties. He was a perfectionist—if it had his name on it, he wanted it to have his stamp. "I'm a very prolific designer," he told *Women's Wear Daily* in 1982. "I didn't sell myself out like some of the others did. As long as you keep your style and your standards, it can only enhance your name by reaching a broader audience."

When Halston made those remarks, Norton Simon had just announced a multimillion-dollar, six-year licensing deal with J.C. Penney. Beginning with the fall 1983 season, Halston would design a line of women's wear exclusively for Penney's, with children's and men's clothes to be added later. According to Norton Simon's estimates, the arrangement would bring the company a yearly income of $5 million. In today's era of big-name designers creating red-hot collections for Target and H&M, this sounds like no big deal. But in the early 1980s, it was unheard of. People were skeptical, especially about the huge gulf between Halston's wealthy, made-to-order customers and the average Jane, but he was confident he could bridge it. Halston had a dream to reach Middle America with his designs. He wanted to beautify the American public, to show the world that America could indeed be chic. It was a forward-thinking idea but not one the high-fashion world was prepared to embrace.

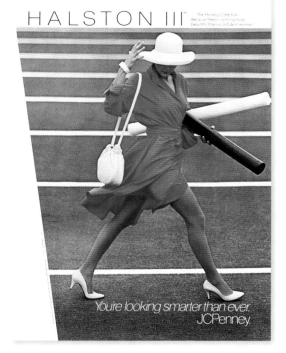

For Halston, it was the start of a very difficult period in his career and life. He insisted he could do it all. But staying on top of the eight collections per year he was already involved with, along with interviews for the press, licensing meetings, fund-raising events across the country and then eight more collections for J.C. Penney, meant that his workload was unmanageable. The pace was impossible to maintain.

The first J.C. Penney collection was unveiled in a fashion show

Catalog advertisements for Halston III for J. C. Penney, c. 1983. Although many fashion designers now design collections for chain department stores such as H&M and Target, at the time Halston's licensing agreement with J. C. Penney was unprecedented—and controversial.

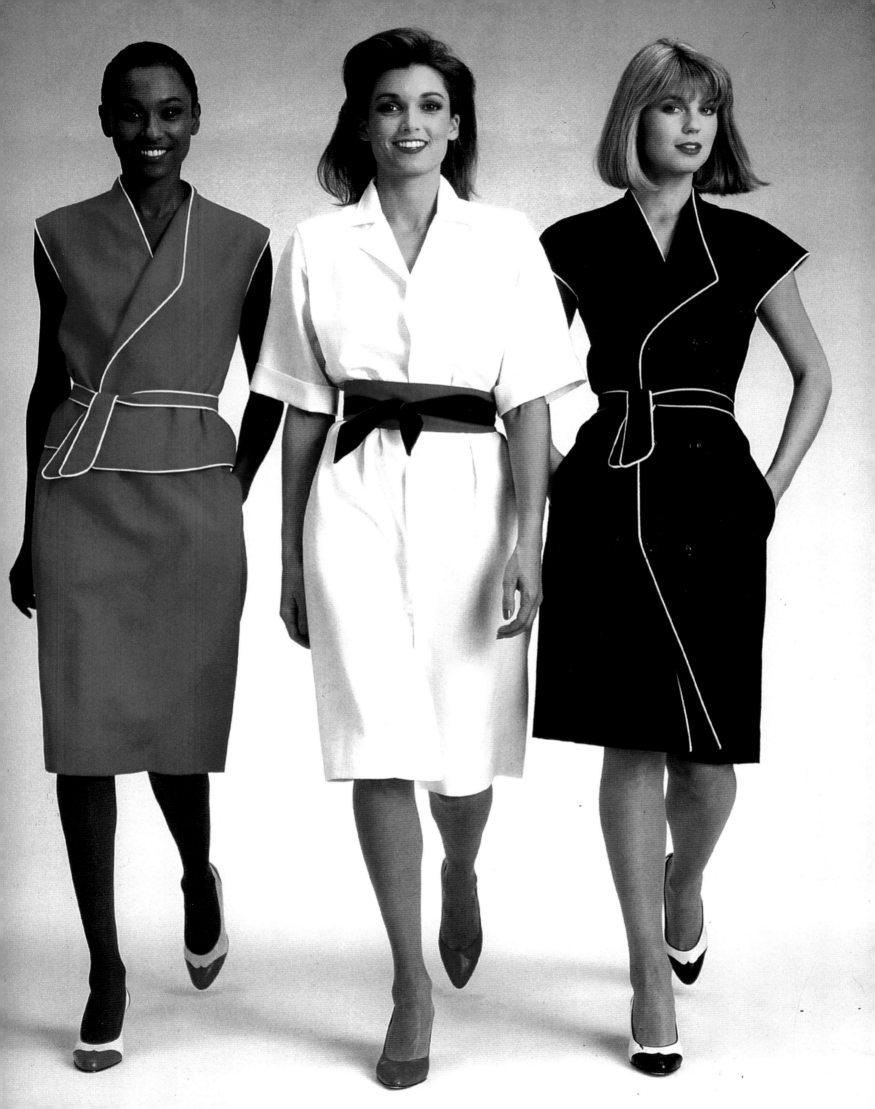

at the American Museum of Natural History in June 1983. The collection was made up of casual separates drawn from Halston's main line but modified to fit the J.C. Penney budget: argyle twinsets, knit dresses, red-and-black buffalo-check shirt jackets and scarves, and shirt-dresses. The show went on a cross-country tour, stopping in twenty-one cities to spread the Halston word.

The fallout was not long in coming. Bergdorf Goodman, the store that had given him his start and carried his designs for twenty years, announced it would no longer be selling Halston. And Ben Khan, which had been making furs under license to Halston, ended the agreement. To those at the higher end of the market, Halston's efforts to dress the hoi polloi made him persona non grata. They felt that he had compromised his public image and that associating with him meant being tarred with the same brush.

Three weeks after the J.C. Penney fashion show in New York, Norton Simon, Halston Enterprises' parent company, was sold to Esmark Inc. for $925 million. Almost immediately, Esmark was bought by Beatrice Foods, which quickly made Halston Enterprises Inc. part of its International Playtex Inc. division. In the blink of an eye, Halston had gone from working with people he liked and trusted, particularly David Mahoney, to being a small cog in a very large, very corporate machine.

It was into this volatile atmosphere that I unwittingly stepped. In 1983, as this was unraveling, I was living in Washington, D.C., and working for American Express. I'd just moved back to the United States after a few years in Rome, where my father was then posted. (Coincidentally, our neighbor there was the Marchesa Peretti, Elsa Peretti's sister; from time to time, if her daughters and I overlapped with our entertaining, we American girls would hang over our *terrazza*, luring the Italian boys up to our parties, which were, to our way of thinking, less formal and way more fun.) Soon after my return, I took the train up to New York to interview for a job in the Manhattan office. I was yearning to live in the big city. At that time, D.C. was still somewhat provincial, homogenous, and

bureaucratic. The job offer never materialized, but I got something far better out of the trip. I'd been in communication with Faye Robson, always a calm presence on the other end of the receiver, always patiently and diplomatically explaining why Halston wasn't available. Then, finally, Halston asked me to dinner at his town house. After a lovely meal, laughter, and a few glasses of wine, he casually asked me if I wanted to work for him. My jaw dropped in disbelief. This was a dream come true! There we were, me being devoured by his overly fluffy gray wool couch, discussing the date when I would move to New York. I've since wondered if he had an inkling that the end was near and he wanted the comfort of having a family member at his side when it came.

In October of 1983, I gave up my travel desk job in D.C. and went to work for my Uncle Halston in his enchanted world. It was an ever-so-fleeting moment of razzle-dazzle that I will never forget. For the following six years, I lived close to and sometimes with Halston. We developed a very strong bond and recognized in each other our ancestral Viking heritage trait, a.k.a. being "stoic Frowicks." Being a complete innocent to the experience of hostile corporate takeovers, this turned out to be a handy gene to stake claim to.

My first introduction to Halston's world was a party that he threw at Olympic Tower for my father, Ambassador Robert H. Frowick, who had just concluded a United Nations summit. Halston was proud to show off his tall, dark, and handsome older brother to his New York entourage—i.e., Andy, Bianca, Liza, and Hiro. In his camp, my dad was more than proud to escort his international delegation to a star-studded dinner event with his handsome and fabulously successful designer brother. The two brothers had arrived at the zenith of their respective careers, and this NATO party was to become a bonding milestone in their relationship. What I chiefly remember from that evening was meeting Walter Cronkite, not long retired from *CBS Evening News* and an A-list party guest. For the first few weeks, I shacked up on my lifetime friend Jessie's spare couch, on the Upper East Side, as I searched for a

Halston and his brother Ambassador Robert H. Frowick at a party Halston threw in his brother's honor at the Olympic Tower, October 1983.

spot to rest my incredulous head. Having only recently returned from the sanctity of a spacious and well-guarded (as in machine guns and bulletproof vests) villa in Rome, I couldn't get over how minuscule and expensive New York City apartments were. Each tiny apartment that I looked at, measured in cubic inches, would have fit snugly into a via Pinciana bathroom.

After a few weeks of fruitless apartment hunting on my part, Uncle H asked his friend Steve Rubell to help with the hunt, and within a few days we scored an efficiency at Gramercy Park. Halston did not think it befit his niece to live in such a "dump" and, although he appreciated Steve's effort, he always thought he could have done better. I was just grateful to have my own space, albeit a shoebox, in an acceptable zip code. This was despite the looming terror I experienced whenever I came home late after a long day's work in the design room. The cabbies, fearing for my life, would typically circle the 'hood until the drug dealers or prostitutes vacated our dimly lit entryway so that I could have a safe passage into the little space I called home.

The Olympic Tower design room was where I landed, just as the resort show was about to launch. I remember very late nights working with D. D. Ryan, Bill Dugan, and the assistants, pulling accessories, fabrics, mannequins, prototypes from the temperature-controlled sample storage room, and whatever it took to keep Halston supplied with the tools he needed in his perpetually creative hands. We helped chalk and pin and pull, but most of the effort was by *il maestro*. The scent of Halston Z-14 (his personal favorite) permeated the halls, unless Viola was cooking a meal, in which case we burned Agraria Bitter Orange incense that he stocked from Bendel's. Halston would have been horrified to have a client smell cooking odors.

I was in awe, intent on soaking up as much as I could. Halston, my uncle but also the great designer, was at work on the other side of those tall, foreboding mirrored doors that caused us to quiver in our boots whenever they opened.

Halston appreciated that I spoke Italian, as the principal seamstresses were Italian and had a tendency to become flustered and forget whatever English they knew in his commanding presence. There were three ladies in particular, Mariuccia, Rosa, and Flora, all of whom had a God-given talent of sewing seams as fine as angels must sew in heaven. One time, perhaps due to the language gap, they stitched the chiffon edging to perfection only to have him rip it apart, exclaiming that it was not the final product. "I asked for it to be basted!" he shouted. In the end, though, there was a mutual respect. And Halston was always happy to nurture talent. He was so impressed with a young pattern maker named Vito Emanuele, who could cut fabric with extreme accuracy and grace, that Halston decided to sponsor Vito's studies at F.I.T. He's now a successful fashion designer in his own right.

But you had to have a strong backbone to work for Halston. He could be imperious, demanding, and downright temperamental at times. Nancy Stone, one of Halston's illustrators after Joe Eula, experienced this firsthand. "One night as I was struggling with an illustration, he said something that made me cry, and then he said, 'Don't cry, you look stupid,'" she says. "He felt bad the next day so he asked me into his chambers and asked what I wanted. I chose a turquoise dress to wear to my sister's wedding. He wanted to toughen us up. But he was generous with so many people. He would be crazy and insult you and make you feel like a jerk, but then he'd say, 'Here's some diamond earrings.'"

In the mornings the general mood was fear and trepidation until Lisa Zaye would receive "the call" from Mohammed

Illustrations by Nancy Stone of Jacqueline Onassis in a Halston made-to-order green chiffon caftan and a red full-length jacket over cream pajama outfit, c. 1982. While Halston designed sportswear for J. C. Penney, he also continued to design couture for his celebrity friends and clients.

J. st. J.

Gold, wht., silver
fringe scoop nec[k]
Top –
wht. side wr[ap]
skirt.

indicating Halston was on his way. At this stage of his career, he was in full corporate combat mode. I had arrived on the cusp of the walls crashing down, so I can assuredly state that his mood was generally raw.

Halston demanded order everywhere. One morning he burst into the design room in a tizzy, took one look at the messy clothing rack, and yelled, "This is a mess! Does your closet at home look like this? Didn't your mother teach you to put like things with like things!?" as we trembled in our Garolini shoes. Actually, a fellow design-room worker named Anthony dissolved into such infectious giggles that we had to go upstairs to organize the shoes until his laughter subsided.

One of the most exciting places to be was the fabric room, which was stacked with shiny, furry, and exotic bolts, silks, and wools. During the year I was there, David Rojas was the fabric expert, with a little guidance from D. D. Ryan. I loved to see my uncle's creative juices at work as he called out for different colors and draped them on the house models as he and the model stared into the mirror. He would hold one hand on her shoulder and the other around her waist and ask, "What do you think?" as though he was using his own reflection in the mirror as an advisor. He knew exactly what he wanted and how to achieve it. The final product would always be his own concept, regardless of our input, but he took the time to use his assistants as sounding boards.

It was a privilege to have witnessed this genius of design at work. He would effortlessly tie a square knot bow so that it looked like a beautiful sculpture. His hands, with their long, elegant fingers, were so graceful and expressive that when he gestured at the design boards it looked as though he were conducting an orchestra, conductor's baton (that would

be the cigarette) in hand. He loved his work in the absolute sense. You could see it in his eyes as he looked into the mirror working a new version of a bias drape. The trials and tribulations to get to the end of each collection were all worth it to him, even if the fashion critics were not always on his side. He never stopped looking ahead to the next project and was perpetually designing with black Pentel felt-tip pens, simple lined-paper pads, scissors, pins, mannequins, and fabrics.

Halston loved to bestow nicknames on his friends and family. Some were terms of endearment and others had a more witty bite to them. Andy Warhol, for example, being from Pittsburgh, was lovingly referred to as "the coal miner's daughter." Bianca's nickname was Pussy. Bill Dugan and others close to him were referred to by their childhood names, like Billy, Patty, and Chrissy. Anthony and Jeffrey, the former being one of the few people in the world who could get me to giggle out of control and the latter a dear man with beautifully thick, straight brown hair that he kept long and cropped straight across at the shoulder, were known as Antony and Cleopatra. My nickname was Kiki. Halston and I got into a pattern of breaking bread together on Sundays—if not literally then we would check in with each other by phone. The conversation usually went something like this: He would say, "Hello, Kiki!" and I would reply, "Hello, Kuku!" and then we would exclaim in unison, "Kakaaaa!" This was one of the sillier levels of our relationship.

One day at OT, Halston suddenly swung open the mirrored doors and commanded to the secretary of the design room, "Get me the dummies." The secretary knew that Halston was sarcastically referring to the two young design assistants straight out of F.I.T., so she scampered off to corral them into the design room, then dutifully waited for the mirrored doors

to reopen so she could usher them in. When the doors opened and Halston laid eyes on the two assistants standing at attention, worrying that they had somehow misstepped, he burst out laughing and shut the doors as fast as he could. I suppose once he regained his composure he reopened the door and there they were, still at attention awaiting his order. "I meant get me the mannequins!" he exclaimed.

My job became that of escorting the garments by Town Car to the photographers' studios, making sure to coordinate Halston's predesignated outfits with the correct models, and helping to do any minimal styling needed on set. Hiro, the principal photographer, soon became my idol. He was incredibly generous in asking me to look under the black cloth of his 8x10 film camera and point out anything that I saw that was not correct. Invariably, it was a sublime photograph, with perhaps a scripted item for me to catch. I was privileged to have such a teacher!

At another shoot, this one for J.C. Penney pantyhose, Hiro revealed more tricks of the trade. It was a simple, elegant shoot. The model, wearing a mini cream silk satin robe and simple high-heeled sling-backs, reached down to pretend to adjust her ankle strap. With lights heating up the studio, the veins in her hand were bulging, and Hiro had to keep asking her to raise her hand to let the blood pressure adjust to fix the problem. The more perfect a photo was initially, the more likely it was to meet publishers' deadlines. Hiro's photographs were pure perfection, something that Halston recognized and was deeply appreciative of. Hiro was an integral part of the team. Halston felt most confident with those team members he knew he could rely on.

As the shows approached, we found ourselves staying in the office until very late. I would usually get in around ten in the morning and stay until midnight or later. We worked around Halston's schedule and he was a night owl; as he stated in a four-part Warhol video interview about fashion, "I do my best work late at night between midnight and one a.m." His schedule did not suit the standards of the new managers put in place by Playtex. They did not wish to try to understand the diva designer; their principal focus was the bottom line.

There were many a late evening ordering in noodle bowls from Dosanko's or pizza while we waited for direction from Halston, perched on the edge of our chairs in front of the long mirrored vanity that stretched across the length of the far wall in the design room. There was an unspoken rule that we had to stay until we got the okay to leave, otherwise it would be perceived that we were not true devotees. Judging by an early Eula note that read, "Fuck the collection. What about our holiday?" I believe this work ethic was enforced very early on. To while away the time, we sometimes played with the cosmetics displays. I was still learning how to be glamorous and always looked forward to receiving attention from Anthony, who was a great makeup artist.

I don't recall that we were paid overtime, as I was constantly pinching pennies. The arrangement I had with Halston was that I would be the lowest-paid employee, but when I needed money, I should approach him directly. I was not brought up to ask people for things so only went to him once, feeling terrified and incapable. He was fine with honoring his agreement, but that was the only time I asked. Halston was more than happy to help those in need, if it was his idea. He helped us when he could, given the tightening corporate noose. And there were often random acts of generosity that made up for the slave wages—for example, when he noticed that the shoes of Jeffrey Wirsing, one of the design-room assistants, were less than pristine, he sent him to the shoe room to get a new pair (even in 1983, there were only so many pairs of shoes you could buy when you were making $150 a week). And most of us were able to avail ourselves of the Lincoln Town Car service that would safely escort us home when we worked far into the night.

As a rule, our tasks as design-room drones were to keep the accessories and shoes tidy and to bring Halston whatever he needed. When made-to-order clients had appointments, the illustrations by Nancy Stone would be assembled on the corkboard

Catalog advertisement for Halston III for J. C. Penney, 1984. Halston held fast to his forward-thinking dream to reach a broad audience, despite pressure from high-end stores like Bergdorf Goodman, who ultimately dropped his couture designs.

HALSTON III™

Introducing the next step in hosiery.

Sheer to the Waist Pantihose by Halston. Noticeably soft and breezy cool, their sleek luxury pampers your legs in seventeen shades: from seductive skin tones and blacks to sensational Halston Red. Regular $3.00. Queen $3.25. Only at **JCPenney**™

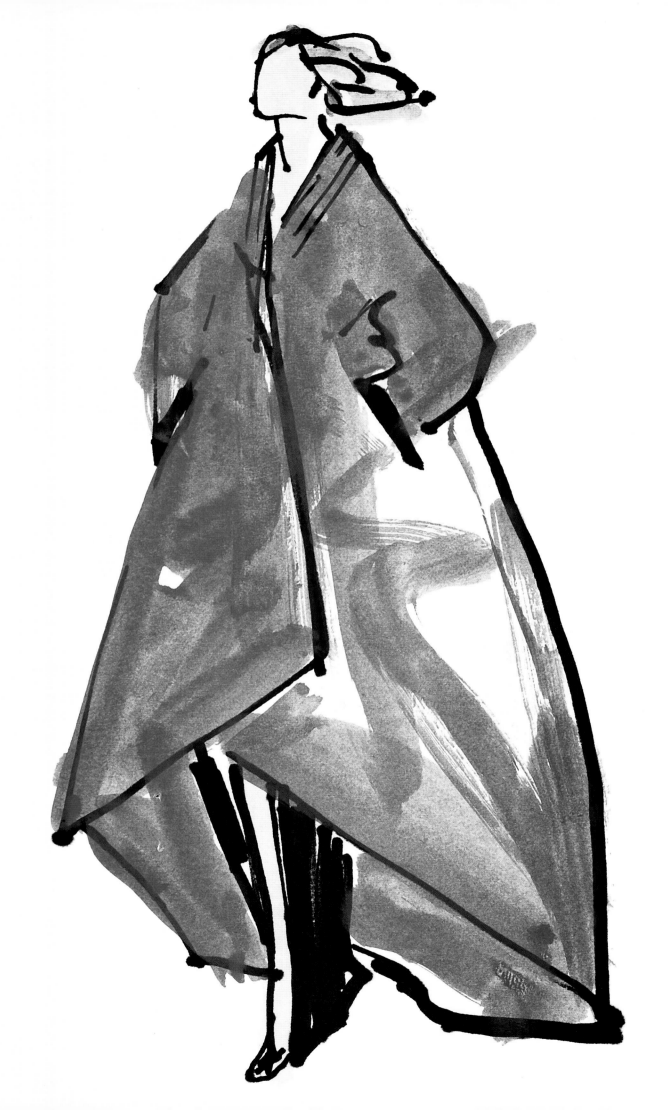

and he would ask for help dressing the ladies after he had held court in his great mirrored room, with New York's legendary cityscape as the backdrop. Sassy Johnson, made-to-order representative extraordinaire, had departed shortly before I arrived. Consequently, D. D. Ryan and I were charged with helping the Halston harem with their new attire. The regulars were Katharine Graham and her beautiful daughter Lally Weymouth; the gorgeous Dina Merrill; newcomer Vanessa Williams, fresh off the Miss America stage; Doris Duke, Lauren Bacall, Barbara Walters, and Cornelia Guest; and, of course, Liza. She always had a private fitting with Halston, who would drop everything for her. Some of the stars melted in his presence, intimidated because not all knew how to style themselves. They looked to Halston to solve their wardrobe dilemmas.

I recall one episode when Lucille Ball came in for a fitting. As D. D. and I were helping her try on fifteen or so outfits, she suddenly collapsed. Initially, I thought she was pulling a vaudeville act, but she remained motionless on the floor for a brief period. D. D. held her hand while I ran to get her a glass of water. We were pondering whether to call 911 when I guess she realized the show must go on and got up. She refused medical attention, the rest of the appointment went off without a hitch, and she walked away after lots of theatrical thanks. And that, we thought, was the end of that. A few weeks later Halston received a strange letter with the payment from her business manager. It was a long, calligraphed proclamation complete with a gold seal indicating that Ms. Ball had expired upon receipt of the hefty bill. I was worried that she really did die, given her collapse, but it was in the end a silly ruse.

Halston often asked me to attend after-work functions with him—parties, theater openings, movie screenings, openings at the Met, a few events at Studio 54, and opening nights at Lincoln Center for Martha Graham dance performances. Before we left, he would dispatch me to the current collections room to select a few potential outfits. I would change into them and present the look to Halston for his approval. He had to be sure that his niece—especially since I was working with him—was properly attired with the correct accessories: satin obi or Elsa Peretti heart-shaped compact attached to the perfectly tied silk cord, etc.

As the lowest-paid employee, I was making a little over $10,000 per year. After late-night dinners at Halston's, I would pretend to hail a cab, but after we'd exchange air kisses and he closed the door to 101, officially concluding the swank part of the night, I would then steal away to the subway at 60th Street and Lexington and take my chances on getting home alive. I was convinced that the boogiemen lurking in the subways at that hour, when all the doped-up troublemakers were out (this was the era of subway vigilante Bernhard Goetz), assumed I was an undercover cop all dolled up in high heels and fox-fur velvet capes. My guardian angel looked over me throughout those six years I was in New York.

In April of 1984, Halston and I celebrated our birthdays together with the gang for the first time. Bill and Nancy Dugan, D. D. Ryan, James LaForce, Jeffrey Bilhuber, Tom Scheerer, Bianca, and Hiro were there. Unbeknownst to me, Halston had asked Viola to bake two cakes. After a gourmet dinner and adequate libations, it was time to serve the cakes. Halston took great delight in announcing, "We have an angel's food cake and a devil's food cake. The angel's food cake is for me and the devil's food cake is for Lesley." Then he roared his signature naughty-boy laughter. He loved to tease me. I always fell for it and then would collapse into a pile of giggles.

The last collection Halston designed was for fall 1984, which

Opposite: Illustration by Joe Eula for a blue satin jacket that Halston designed for Lauren Bacall to wear to an Academy Awards ceremony, c. 1978. Above: Illustration by Nancy Stone of *Washington Post* publisher Katharine "Kay" Graham in a Halston pink chiffon dress, c. 1983.

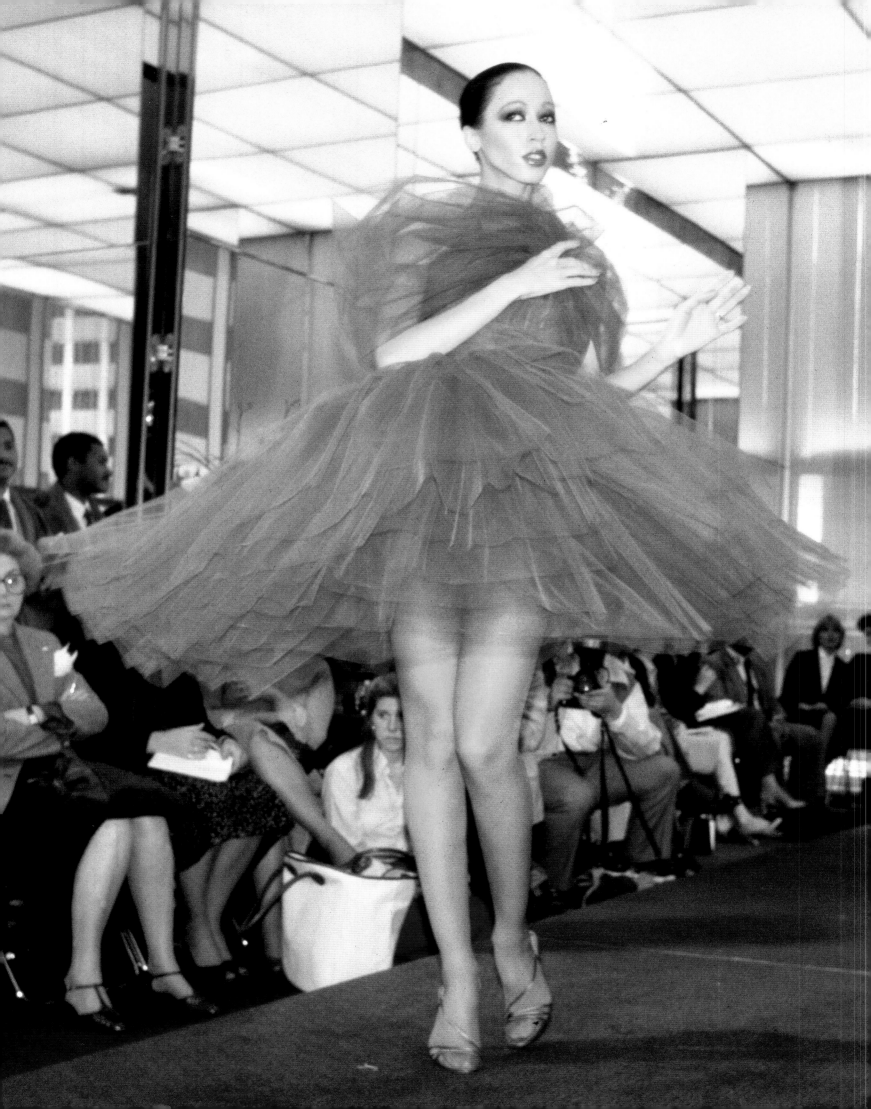

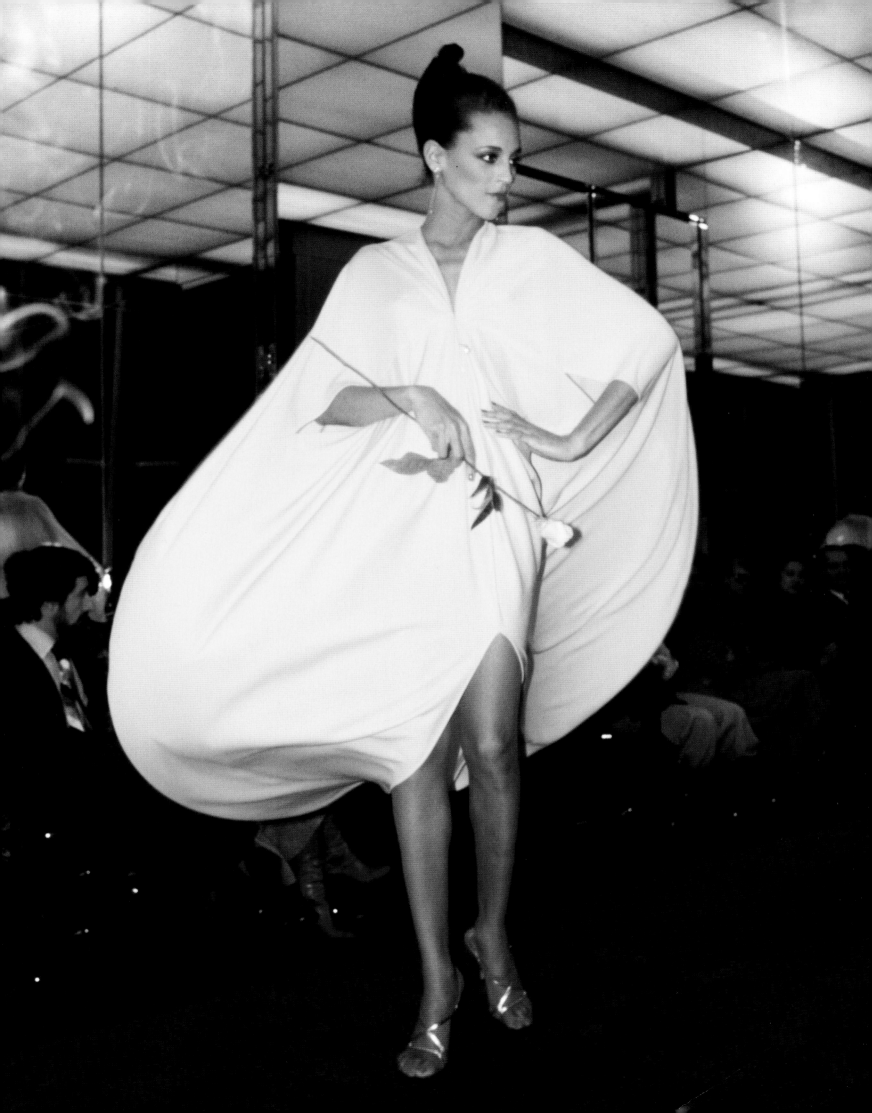

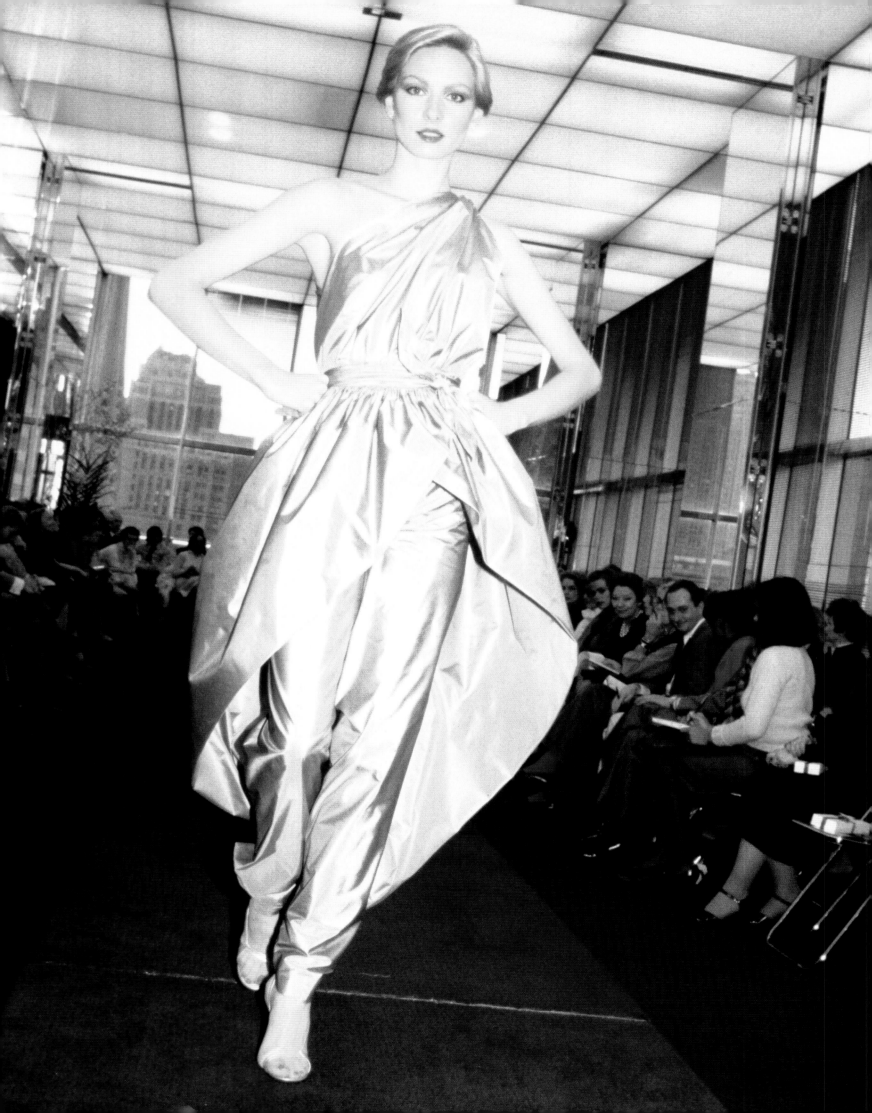

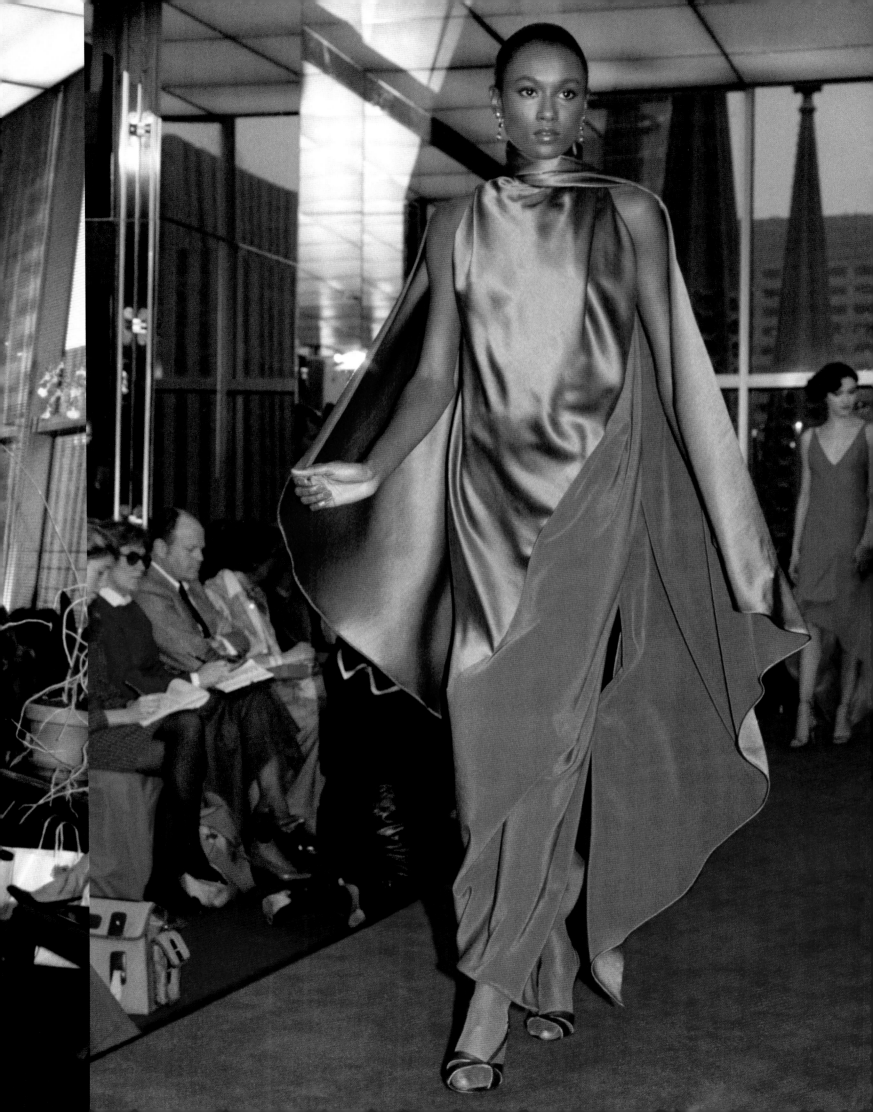

was shown in the late spring. He was working with double-faced woven alpaca tailored suits and coats, cowl-neck tunics and dresses in natural silk linen on the bias, and show-stopping, very structured multilayer organza dresses. Had we known that would be his last effort, I wonder if he would have done it differently.

During the early summer of 1984, the corporate tsunami struck Olympic Tower and sent Halston's life tumbling into a legal abyss. Who could have predicted that after giving up my career ambitions in the travel industry and moving to New York to work for the great Halston, there would be a coup d'état of sorts, with the result being one fateful afternoon, Halston and his closest allies, yours truly on his heels, would find themselves walking out of Olympic Tower, effectively ending an era in American fashion history?

In mid-1983, while the ink on the infamous J. C. Penny deal was still drying, a "corporate mechanic" arrived at Olympic Tower with the initial intent of whipping the company into fiscal shape. In the process, he proceeded to systematically dismember the Halston business.

The marathon "memo wars," as Bill Dugan refers to them, commenced. Every morning Halston, D. D. Ryan, and Bill would arrive at the office to find fresh stacks of memos dictating what new operational changes would soon be put into effect. The more the corporate bosses tried to exert control, the more Halston resisted. It was completely contrary to his nature to be dictated to by the suits in the executive suite. As one staffer later told the *New York Times*, "It was an underwear mentality in a high-fashion business."

The plan seemed to be to push Halston out of his own company for good. On July 17, 1984, Halston sent a letter to the board of directors of Halston Enterprises, stating that he could not collaborate with its choice of manager "on a productive long-term basis. However, I am fully prepared to undertake a full fledged collaboration and live up to all my multifaceted responsibilities as I have always done, with a managing director who possesses the full qualifications and experience that are essential in our varied and complex business; a person with whom I can work

with trust and full confidence." Some have interpreted this as Halston throwing temper tantrums during a corporate squeeze. But the sequence of events unfolding over the next four years would be unbearable for even the strongest of heart.

In a letter dated July 19, 1984, the legal representative from Playtex offered three alternatives to Halston "in a stated attempt to resolve the problems which were presented to him. The first alternative offered to Halston, was that Playtex would sell Halston Enterprises; second Halston would have a limited future involvement with HEI; third Halston would have no involvement at all with the business." In the interim, according to legal correspondence between Playtex and Halston, there had been a key promise made that "the status quo of the business would be maintained." That promise was broken almost immediately, but it was some time before Halston and his legal team were able to determine to what extent.

From the date of that letter, the Playtex manager wasted no time in launching into a systematic slash-and-burn approach that, as far as I could tell, was intended to destroy Halston Enterprises as we knew it—while at the same time the legal council to Playtex was leading Halston to believe that Playtex would divest itself of Halston Enterprises with the intent of selling to Max Factor. Halston was developing a cordial relationship with Max Factor's then managing director Linda Wachner. I recall them meeting numerous times over dinner in his living room to discuss a business plan.

That August, he retreated to the house in Montauk that he rented from Andy Warhol. He needed to take a deep breath while trying to understand what was unfolding at Halston Enterprises. I think he remained strong and positive for my sake and for the inner circle. That summer of 1984 we spent many weekends bonding over meals he prepared from the bounty of fresh produce and seafood. He taught me how to make the perfect burger, how to slice a beefsteak tomato into thick slices of perfection, how to prepare the perfect homemade French fries. It was essential to him that he keep the creative juices flowing in whatever capacity. The discussions of

how to get back into design were unwillingly protracted. And it had only just begun. We discussed his dreams to come back, to appoint the family to key positions of the soon-to-be-founded family business. He was in discussion with his three siblings, trying to figure out where they would all best fit in. He was in constant negotiations with his devoted attorneys Malcolm Lewin and Howard Chase, who spent hours drafting the most creative briefs and petitions in efforts to preserve the business Halston had spent decades building. In the end he found he could trust no one but the very inner circle.

Within the next month, the Playtex manager proceeded to fire key people allied with Halston. While this is a typical action with new management, it was done in a most calculated manner. Per Halston's legal team, there were actions taken that "severely and irretrievably damaged the artistic integrity of the Halston name and trademark." That month marked the beginning of the irreversible push to erase "Halston the man" from the business. I was still employed at OT—and in shock. I had come to work for the grand master of fashion design and here I was witnessing a coup d'état by a "girdle and tampon man" as Halston called him. The pillaging commenced with the rape of the cosmetics and fragrance drawers. Boxes and boxes were walking out the door with no oversight from management. Then it was the "sample sale" from the cold storage room. The Playtex people referred to it as clearing out the "old and obsolete inventory," per legal correspondence, but they were seemingly oblivious to the artistic—not to mention historic—value of these pieces, which should have eventually joined the collections of great fashion designers or gone to the Costume Institute at the Metropolitan Museum of Art or the Museum at F.I.T. The decision was made, under the guise of helping the bottom line, to unload these priceless gowns—every last Halston original prototype, for less than the cost of materials. Many, many racks were systematically liquidated over the course of a little over a week. Oh, to be sure there were some happy clients who purchased these originals for, let's say twenty-

five dollars a skirt or two hundred dollars a beaded gown, but it was a travesty. In addition to this rampant pilfering, some of Halston's personal objects were "walking" out of OT. Aside from pleas from his attorneys to cease this behavior, Halston found himself powerless to stop it.

Nancy Stone, still employed at OT, recalls how things unfolded from within: "I stayed on to work with workroom manager John David Ridge [who had been appointed to design the Halston originals and the J.C. Penney collection after Halston left] but it became a desperate search to produce a line to replace Halston. I was just waiting until they let me go. The people in workroom started leaving. They were insulted by the standard of stuff they were asked to produce for prototypes. Of course, the made-to-order clients left, too, because they knew Halston was gone. It was just a matter of time." Original Warhols and Elsa Peretti silver, clearly Halston's personal belongings, were treated as company property. "They said, 'We own the company, so this is ours.'" "It was the end of the high fashion atelier, the last gasp, then it was gone," Stone says.

The workroom manager suddenly assumed the role of design manager. He was personable and droll enough; however, he was ill equipped to carry on the Halston mystique. The inner circle was left helpless, not wishing to abandon ship in the event that Halston would come back. After a month or so, when it became evident that negotiations were getting stickier and the design manager was attempting to settle into the emperor's shoes while dismissing what he called Halston's "stale old designs," I told my uncle that I had moved to New York to work for him and that it was very uncomfortable for me being at Olympic Tower without him there. I felt part traitor and part moving target in the eyes of the vultures who were now in charge. He suggested I take a leave of absence and come stay with him in Montauk until things settled down. Things never did settle down, but in some ways this was a blessing in disguise, because it meant that Halston was able to reconnect with his family when he most needed us.

New color - 2 Piece

Red O.S. — Brunu Jessen.

Dear Phil,

When you get this
I'll be in Heaven!...
Phil! For 2 weeks, I have
to see you when I get
back, you

Love you
Madly

Josie

Halston,

One night in
the gown. And I blinded
half the audience
Now I'm going to
to do a benefit for
the Blind.

love
You

LIZA MINNELLI

Darling H,

I loved my beautiful flowers and I love you.

Dearest A,
I'm so ashamed that I ever
thought of wearing the yellow
robe & I promise to wear my
new robe on all auspicious
occasions. I love it, thank
you.
Love
Liza

Dear Halston –

You really are the most thoughtful person in the world – I was so touched and delighted to

find my beautiful plant when I got home – Now I shall have the pleasure of watching it open and wondering what color it will be –

So many thanks

Jackie

Dear Halston

 I love this suit — but it looks a bit short now. Do you think someone could do a little miracle around the waistline — and put a piece of velvet there that would add about 2 inches? It wont show much as the jacket will always be on —

 Maybe someone could call when its time to come for a fitting —

 thanks so much

 Jacqueline Onassis

Anita Loos

Feb 22ⁿᵈ, '75

Dear Halston — Its about time you came out with a perfume! The package and bottle are utterly divine and I'm thrilled that the scent lives up to your reputation. I tried it out when it arrived yesterday and its still with me, I can't thank you enough for my gift, It's exquisite.

These are the sort of times when its good to have you holding that fort on Madison Avenue, where everything remains beautiful and chic, Thank you — thank you Halston! And much love,

Anita.

P.S. Gladys heard you on radio and was thrilled.

Wednesday, Sept 17th

Halston —

A thousand thanks for the most beautiful evening in your incredible house. It was out of this world and I couldn't have appreciated it more.

A bientôt —

Lee R.

Beverly Johnson

Feb. 6, 1976

Dear Halston,

Just a little note to let you know that all things go well with me and that your dress and belt and Elsa jewels help so much to make my first Cosmo Cover a success. Thank you so much.

Hope to see you soon

Sincerely

Beverly Johnson

only you

Halston,
Carris could turn
ont a delightfull
Smart! party on
Lex. ave & 59th St
So sorry- did not
see you. was so
love - Diane

Dear Halston,
 I promise not
to punch you in
 1987.

SEASON'S GREETINGS

AND BEST WISHES FOR

THE NEW YEAR

Much love,
Chér

A few ♫'s from
 Carol Channing

Halston you dear!
Let's share
strawberries this
afternoon and
have fun!
 XXXX,
 Carol

P.S. Just can't wait to
see you.

Darling Pussy —

A little something to cheer you up. I hope you're feeling better.

Lots of love,

Bianca

Aug. 13th

Dear Halston —

Not only did I do the enclosed but the anchors of Live at 5 apologized on air to you for giving you short shrift when they ran out of time the nite of the party. It all sounds grand. Sorry I missed it. I sent Liza the story that was in the Wash. Post.

Love Liz

LiZZiE

October 15, 1959

Miss Ruth Jacobs
Women's Wear Daily
7 East 12th Street
New York, New York

Dear Ruth:

We wanted to thank you for the nice little story you
ran on October 6th on our new designer, Halston.
There were, however, a few misunderstandings. He
was head of the wholesale and retail operation of
Lily Dache in New York, not Chicago, and he also was
their designer in New York. Furthermore, he is
definitely a designer of recognized stature, not
a "stylist" as your article stated.

Enjoyed seeing Priscilla Meyer on Tuesday at the
luncheon, and your Wednesday story was wonderful.

Sincerely,

BM/pa Barbara McGinniss
 Public Relations

NEW YORK. — Halston, mil-
linery designer, has joined Berg-
dorf Goodman as stylist for the
store's custom millinery depart-
ment. Halston, whose full name
is R. Halston-Frowick, was for-
merly with the Chicago organiza-
tion of Lilly Dache.

August 5, 1975

Dear Halston,

What an honor it was for me to wear the elegant gown you specially designed on the evening of the 50th anniversary celebration of the Martha Graham Dance Company. I certainly appreciate the generous donations and energy that you put into making Martha's benefit so successful and enjoyable for everyone in attendance. Not only was your sense of commitment impressive but also your enthusiasm. The costumes were just so glamorous and contributed so much to this memorable occasion.

Thank you, also, for the lovely time I had at your party. It was such a pleasure to meet so many of your friends and associates, and your warm hospitality is sincerely appreciated.

I wanted to share the attached pictures with you for they bring back such fond memories.

With warm best wishes always,

Sincerely,

Betty Ford

021

20, DECEMBER '86

DEAR HALSTON,
I'M HAPPY TO HEAR FROM YOU. MY RESPONSE IS LATE BECAUSE THE REQUEST SURPRISED ME BUT I WILL GIVE WHAT YOU SAY — EITHER A FASHION DRAWING OR ONE OF MY ODDER, HARD TO CLASSIFY DRAWINGS — ALTHOUGH NEITHER SORT SEEM QUITE RIGHT IN CONNECTION WITH MARTHA. I TRUST YOUR JUDGEMENT AND BESIDES ITS FLATTERING TO BE ASKED.

IF ITS NOT TOO LATE FOR THE AUCTION IT MAY ALSO BE NOT TOO LATE TO WISH YOU A HAPPY CHRISTMAS, WHICH I DO, AND BEST WISHES FOR 1987. SINCERELY,

Kenneth

BAZAAR Harper's

Monday, June 12th, 1961

Dear Mr. Halston,

I've meant to write to you for many weeks to thank you for the perfectly beautiful hats you have been making for us. First they are exactly what we need when we need them, and secondly, they are too beautiful for words and so marvelously made - You are really a perfectionist and all of your things are too beautifully made to even describe - The top is the mink cloche - It is extraordinary ! Also I do think the berets and caps and cloches for Mrs. Kennedy are marvelous - Between her beauty and your talent, you have indeed made a young woman in a hat look perfection - All my congratulations -

Do share this with Miss Jessica because, of course, it is she who we also thank a thousand times for the wonderful hats because only she has the largesse to "allow" such extravagances to be made as I suppose they are not what you might call "runners" and "bread and butter"!! And as darling Jessica has always allowed us to indulge her department in the crazinesses we thank her so much also -

All my congratulations -

Sincerely,

Diana Vreeland

Diana Vreeland

DV:cmt

P.S. I do hope that no magazine or newspaper will publish any of the large brimmed hats you've made for us until well after September 1, as we are putting them on the cover and throughout the magazine in order to create a different well used silhouette -

August 4th, 1981

Dear Halston,

 We spoke on the night of the opening of
"Key Exchange". You had a lovely party after
the party at your home. It was there I grew
wrestless with inspiration. I mentioned an
artist, that night, named Kieth Haring, most
noted (publicly) for his graffiti glyphic
Kieth is an incredible artist even at this
point truly a phenomenon. I have seen no one
as simple and clearly as this cross that line
from graffiti into Art. Graffiti has prompted
Kieth's image as surely as did caligraphy to
the Abstract Expressionists. I know you would
be enthralled by his work and I cannot help
being persistent about this issue. I have seen
prints of Kieth's whose originals are still
available. That is why I remain entirely in-
sistent on your looking at his work and

 I believe now is the time.

 Most Sincerely,

 Mary-Ann Monforton (M.A.)

Western Union **Mailgram**

4-012511S053 02/22/87 ICS IPMBNGZ CSP NYAB
6022971433 MGMS TDBN TUCSON AZ 63 02-22 1057P EST

► HALSTON
101 EAST 63RD ST
NEW YORK NY 10021

DEAR HALSTON
I JUST HEARD ABOUT ANDY'S DEATH AND FELT SO SHOCKED AND SADDENED I
CAN IMAGINE HOW YOU MUST FEEL HE WAS A REMARKABLE FRIEND TO HAVE HAD
I HOPE YOU ARE OKAY AND I THINK OF YOU OFTEN WITH MUCH LOVE AND
TENDERNESS. MY ARMS ARE AROUND YOU.
ALL MY LOVE
 E.T.

22:55 EST

MGMCOMP

March 9, 1987

Dearest Halston,

Thank you for the very beautiful orchids
that you sent me for my birthday !

They added to the sparkle of the day -

Much love,

Elizabeth Taylor

ELIZABETH TAYLOR

Dear Halston:

I was going to write you this little note several weeks ago, to tell you that I had 2 "major" nights to deal with — one in LosAngeles, one in London — for which I pulled out both of my ravishingly beautiful sarong dresses (black velvet, & skin-coloured crinkled satin) — & knocked everyone dead in the Best Dress of the Night ☺ I wonder if you remember my

ordering those 2, to be worn after all the "Ladies" had moved on to the next fad — & kept forever? It must have been 10 years ago? Anyway, they, & so many of the wonderful things you made me remain my real aces-in-the-hole, & I just wanted to tell you that —

But somehow I managed to let my impulse to write this note lag, & then this weekend I read the distressing article

·3·

in the New York Times — And it seemed a perfect time to say Thank you for all of my "Halstons", & to tell you that I am really sorry to learn of the difficult & disagreeable time you have been having.

I hope it all soon passes into a bad, forgotten memory, so that you will be

free to do what makes you happy.

I send you my very best wishes, & affection ☺

Ali (MacGraw)

16 March 1987

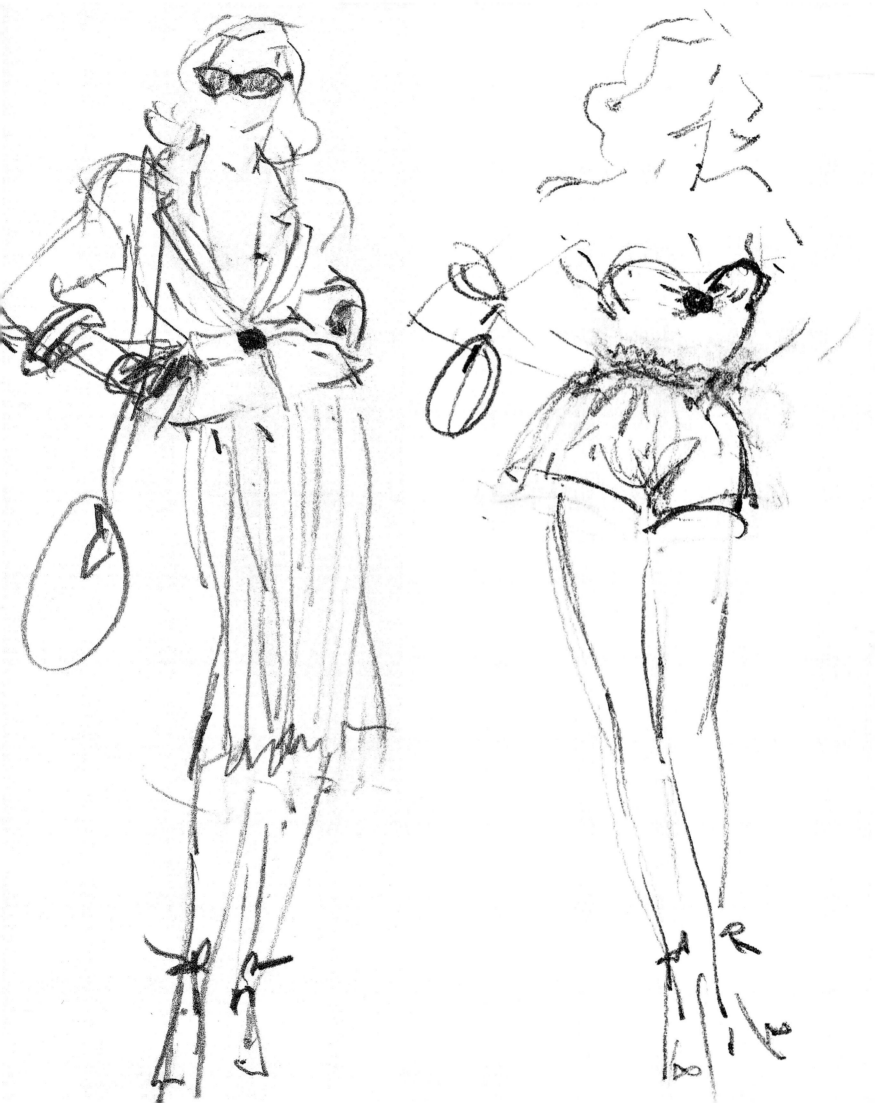

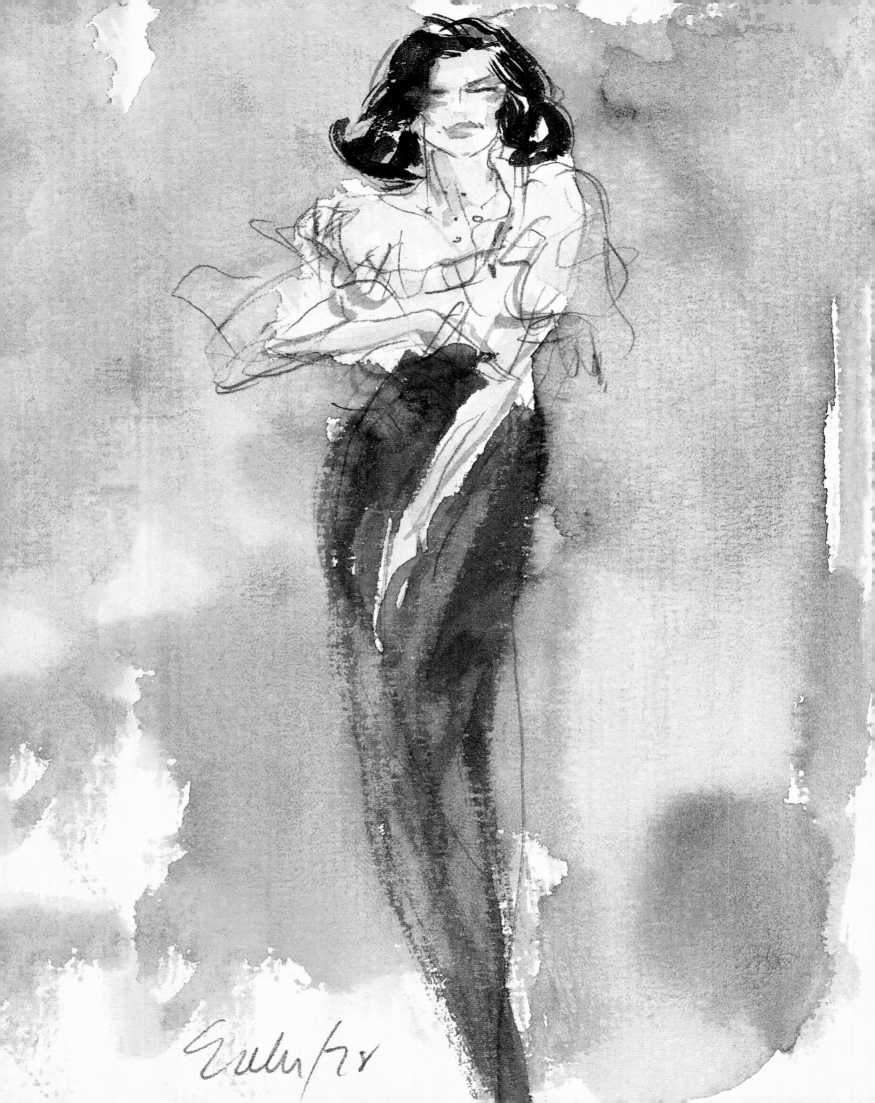

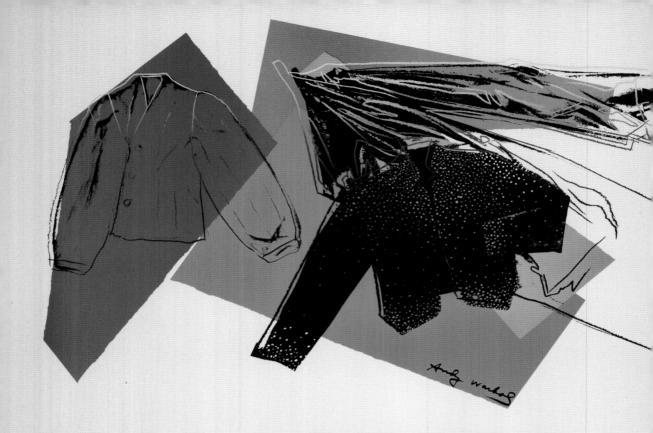

HALSTON

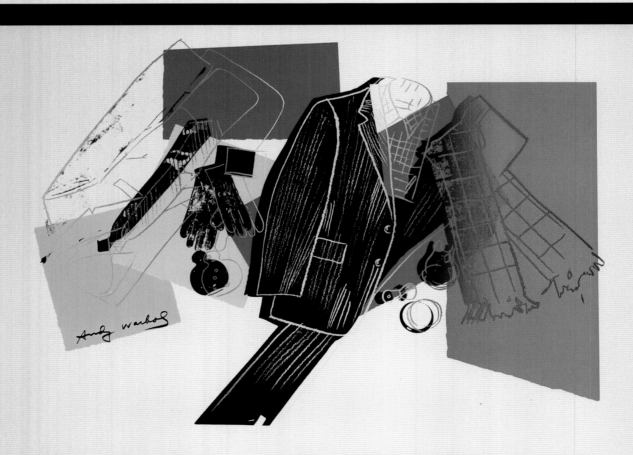

HALSTON

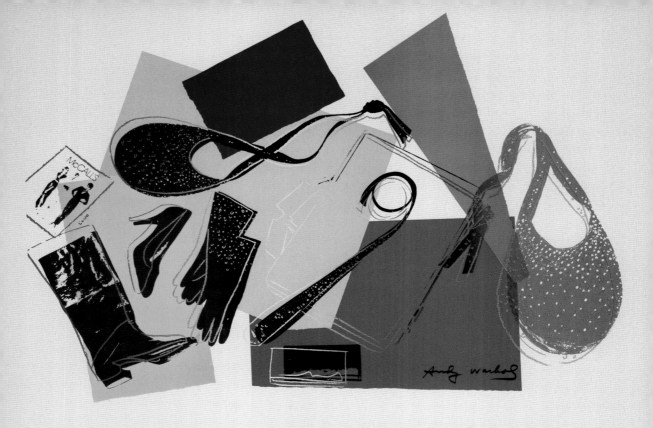

HALSTON

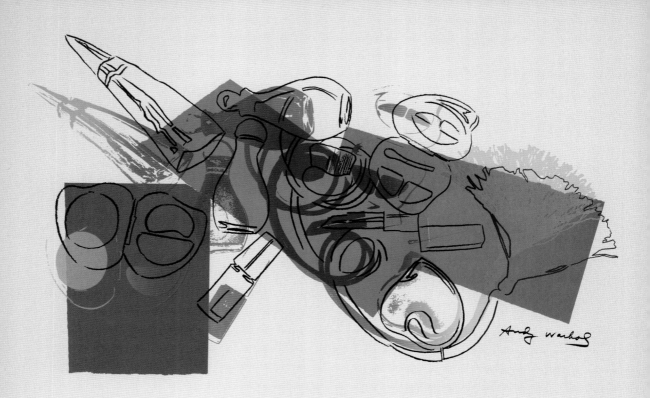

HALSTON

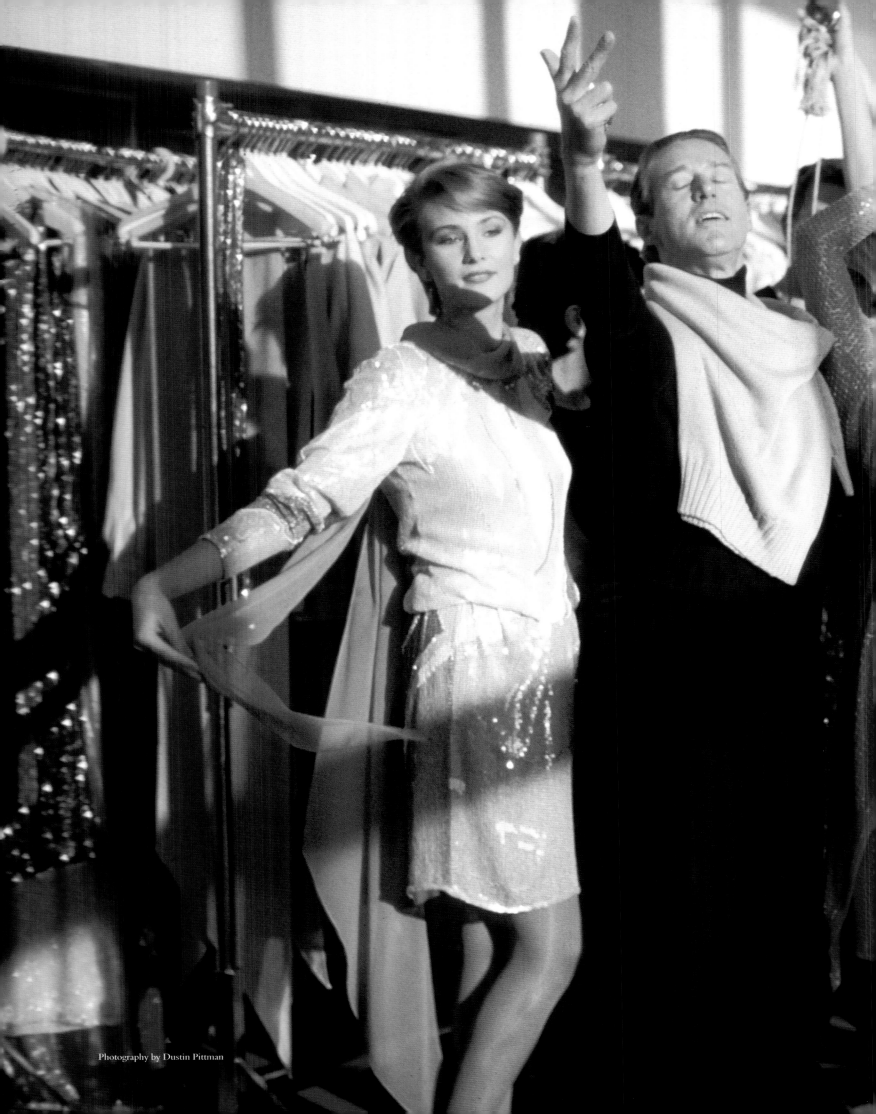

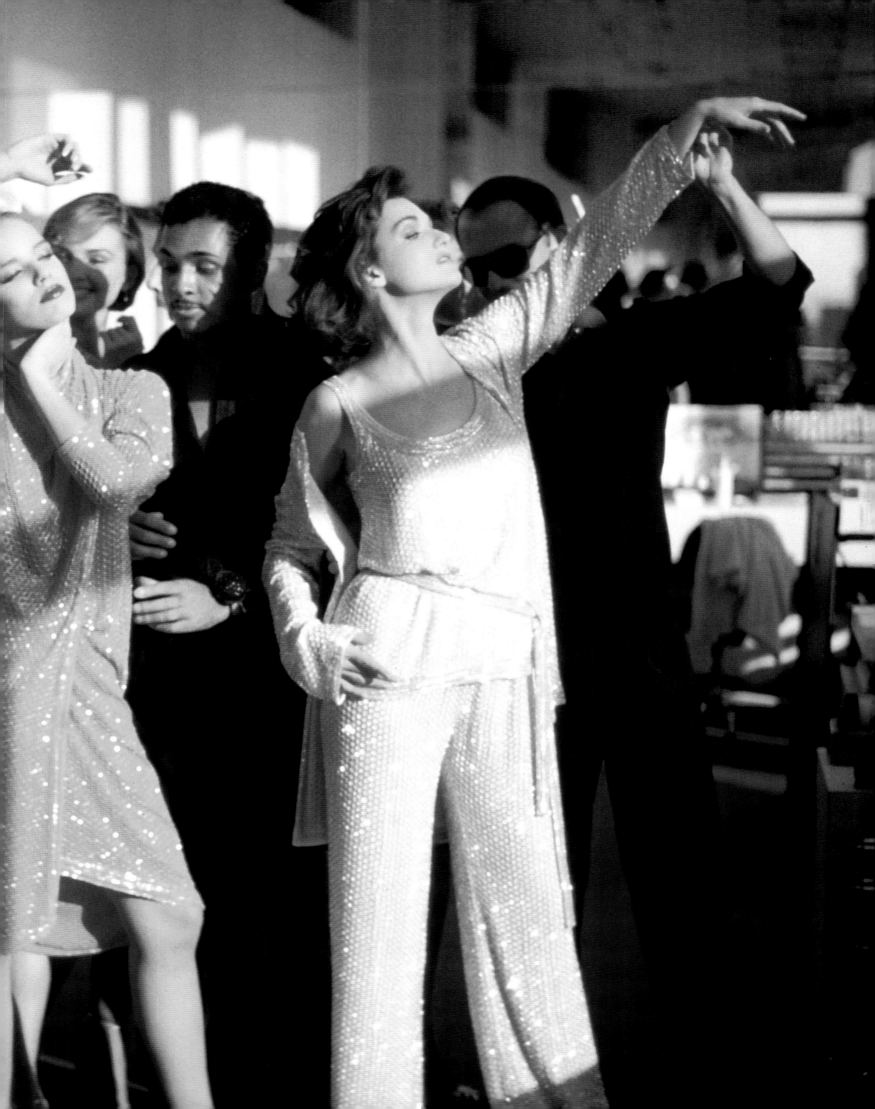

355/6

Ms L Frowick
Ms Nureyev

LUNDI 23 JANVIER 1984

MARTHA GRAHAM
DANCE COMPANY
THEATRE NATIONAL DE L'OPERA DE PARIS

VOUS PRIENT D'ASSISTER
A L'ISSUE DE LA REPRESENTATION
A UNE RECEPTION AU
CHAMPAGNE MOËT ET CHANDON
DANS LE GRAND FOYER

**CETTE CARTE SERA EXIGEE
A L'ENTREE DU FOYER**

313

HALSTON
VICTOR HUGO
PAT ALEXANDER
BILL DUGAN
NANCY DUGAN
LESLEY FROWICK
HIRO
CAROLYN JONES
D.D. RYAN
ROBERT FROWICK
ANN FROWICK
KIRK FROWICK

TOTAL: 12

THE MARTHA GRAHAM DANCE COMPANY :

MARTHA GRAHAM
RON PROTAS
ALLAN WALLACE
ANN O'DONNELL
MR./MRS. JAMES NOMIKOS
THEA NERISSA - DANCER
LEE BETTS - ELECTRICIAN
JAY BENTTNER - PROPERTY MGR.
JACQULYN BUGLISI - DANCER
TERESA CAPUCILLI - DANCER
DEBORAH SHERETUN -DANCER
WILLIAM DAVIS - STG. MGR.
CHRISTINE BAKIN - DANCER
JUDITH GARAY - DANCER
SOPHIE GIOVANOLA - DANCER
DAVID HATCH-WALKER - DANCER
TAKAKAO ASAKAWA - DANCER
HOPE HERING - DANCER
DAVID HOCHOY - DANCER
LINDA HODES - ASS. ART. DIR.
TAKI BEN-DAVID - DANCER
JULIAN LITTLEFORD - DANCER
STEPHEN MAUER - CARPENTER
CAROL S. MEAD - DANCER
JEAN-LOUIS MORRIS - DANCER
STEVE ROOKS - DANCER
JEANNE RUDDY - DANCER
COLEMAN RUPP - STG. MGR.
YURIKA KIMURA - DANCER
KIM STRAUD - DANCER
TOM SMITH - DANCER
STANLEY SUSSMAN - CONDUCTOR
KEN TABACHNICK - LIGHTING DESIGNER
GEORGE WHITE JR. - DANCER
LARRY WHITE - DANCER
ED ZUIKOWSKI - DANCER
BURT TERBURGH - DIRECTOR

TOTAL: 37

GRAND TOTAL: 49 RESERVATION MADE FOR 50 PERSONS

ITINERARY FOR
PARIS TRIP

SATURDAY, JANUARY 21, 1984

ALL LIMOS AND VAN WILL MEET AT HALSTON'S HOME AT 101 EAST 63RD ST.
AT 10:30 AM. SUGGESTED ARRIVAL TIME AT JFK AIRPORT: 11:45 AM.

TRAVEL INFORMATION

1:00 PM DEPARTURE ON AIR FRANCE #2 CONCORDE FROM JFK AIRPORT
10:45 PM ARRIVAL AT CHARLES DE GAULLE AIRPORT IN PARIS

HALSTON'S PARTY:

> HALSTON
> VICTOR HUGO
> PATRICIA ALEXANDER
> BILL DUGAN
> NANCY DUGAN
> LESLEY FROWICK
> HIRO WAKABAYASHI
> CAROLYN JONES
> D.D. RYAN
>
> TOTAL: NINE

AIR FRANCE REPRESENTATIVE AT JFK AIRPORT: MR. ROSARIO MARIANI.
PLEASE PLAN TO CHECK IN AND BE IN THE CONCORDE LOUNGE BY 12:15 PM
LATEST. IF MR. MARIANI IS UNAVAILABLE, ASK FOR DUTY SUPERVISOR.

NOTE: IT WILL BE HELPFUL TO HAVE AN EXACT COUNT OF ALL LUGGAGE
FOR THE TRIP GOING AND COMING BACK.

A-2 SERVICE, A SPECIAL SERVICE FOR CONCORDE PASSENGERS, WILL
ASSIST YOU FROM TIME OF ARRIVAL TO WHEN YOU BOARD LIMOS FOR
HOTEL. IN CASE OF PROBLEM, CONTACT MS. ROLANDE FISCHESSER. 862.2290.

NAME OF LIMOUSINE COMPANY IN PARIS:

> INTERNATIONAL LIMOUSINE, INC.
>
> PARIS TEL. 553.1424
> NYC TEL. 800. 368.5623 CONTACT: DOUG

A STRETCH LIMO WILL BE ON CALL AT ALL TIMES FOR HALSTON.

HOTEL ACCOMMODATIONS

PLAZA ATHENEE HOTEL
25, avenue MONTAIGNE
PARIS

TEL. 723.7833 / CREDIT MGR.: PHILLIPE BESSIERE

HALSTON VICTOR HUGO	2 BEDROOM SUITE	NIGHTS OF 1/21 - 1/25
BILL DUGAN NANCY DUGAN	1 DOUBLE ROOM	" " "
HIRO CAROLYN JONES	1 DOUBLE ROOM	" " "
PATRICIA ALEXANDER	1 SINGLE	" " "
LESLEY FROWICK	1 SINGLE	" " "
D.D. RYAN	1 SINGLE	" " "

ARRIVING ON SUNDAY, JANUARY 22 :

ROBERT FROWICK ANN FROWICK	2 BEDROOM SUITE	NIGHTS OF 1/22 - 1/25

FOR YOUR INFORMATION:

MARTHA GRAHAM ANNE O'DONNELL	2 BEDROOM SUITE	NIGHTS OF 1/18 - 1/27
RON PROTAS	1 SINGLE	" " "

MARTHA GRAHAM DANCE COMPANY IS STAYING AT:

ROYAL ST. HONORE
221, rue ST. HONORE
PARIS 1

TEL. 260.3279 / CONTACT: JIM NOMIKOS

SUNDAY, JANUARY 22

DAY - FREE

6:00 PM LEAVE BY LIMOS (1 STRETCH FOR HALSTON, 3 ADDITIONAL
 CARS) FOR:

6:30 PM - RECEPTION FOR MARTHA GRAHAM
9:30 PM HOSTED BY AMBASSADOR AND
 MRS. GALBRAITH
 THE AMERICAN EMBASSY
 2, AVENUE GABRIEL

 TEL. 296.1202

 RETURN TO HOTEL PLAZA ATHENEE BY LIMO.

9:00 PM DINNER HOSTED BY HALSTON*:

 MARIE ANTIONETTE SUITE
 PLAZA ATHENEE

 * SEE INVITATION LIST ATTACHED

MONDAY, JANUARY 23

DAY - FREE

7:30 PM PICK UP AT HOTEL FOR TRANSFER TO PARIS OPERA HOUSE

 PARIS OPERA
 PLACE DE L'OPERA

 TEL. 266.5022

8:00 PM GALA PERFORMANCE / MARTHA GRAHAM DANCE COMPANY PERFORMS:

 SERAPHIC DIALOGUE
 ERRAND INTO MAZE
 PHAEDRA'S DREAM
 ACTS OF LIGHT

 ***** MARTHA GRAHAM IS AWARDED THE LEGION OF HONOR ****

 IMMEDIATELY FOLLOWING THE PERFORMANCE BEFORE A GROUP OF
 150-200 PEOPLE ON THE STAGE OF THE PARIS OPERA, ONCE
 CURTAIN HAS BEEN DRAWN. A BUFFET DINNER IS THEN SERVED
 IN THE GRAND FOYER OF THE PARIS OPERA HOUSE.

MONDAY, JANUARY 23, 1984 (continued)

HALSTON'S INVITATION LIST FOR MONDAY NIGHT:

> HALSTON
> VICTOR HUGO
> PATRICIA ALEXANDER
> BILL DUGAN
> NANCY DUGAN
> LESLEY FROWICK
> HIRO
> CAROLYN JONES
> D.D. RYAN
> ROBERT FROWICK
> ANN FROWICK
> KIRK FROWICK
>
> AMBASSADOR GALBRAITH
> MRS. GALBRAITH
> MR. MARESCA
> MRS. MARESCA
> LOU LOU KLASSOWSKI (?)
> MR. KLASSOWSKI
> NONNIE MOORE (2)
> KEVIN McCARTHY, WWD (2)
> GRACE MIRABELLA (1)
> SEICHI YAMAGATA (TORAY IND.)
> YOSHINOBU KIMURA (TORAY IND.)
> MASAHIRO UGAYA (TORAY IND.)

TOTAL: 26 TICKETS

HALSTON AND HIS PARTY RETURN BY LIMO TO HOTEL.

TUESDAY, JANUARY 24, 1984

DAY AND EVENING - FREE

WEDNESDAY, JANAURY 25, 1984

DAY - FREE

7:00 PM LEAVE BY LIMO (1 STRETCH FOR HALSTON, 3 ADDITIONAL
 LIMOS) FOR:

> PARIS OPERA HOUSE
> PLACE DE L'OPERA

WEDNESDAY, JANUARY 25, 1984 (continued)

7:30 PM MARTHA GRAHAM DANCE COMPANY PERFORMS:

 SERAPHIC DIALOGUE
 ERRAND INTO MAZE
 PHAEDRA'S DREAM
 ACTS OF LIGHT

 HALSTON'S INVITATION LIST FOR WEDNESDAY NIGHT:

 HALSTON
 VICTOR HUGO
 PATRICIA ALEXANDER
 BILL DUGAN
 NANCY DUGAN
 LESLEY FROWICK
 HIRO
 CAROLYN JONES
 D.D. RYAN
 ROBERT FROWICK
 ANN FROWICK

 BERNADINE MORRIS (2)

 TOTAL : 13 TICKETS

 RETURN TO HOTEL BY LIMO.

THURSDAY, JANUARY 26, 1984

8:45 AM HALSTON'S STRETCH LIMO PLUS TWO REGULAR LIMOS WILL
BE AT HOTEL FOR A 9:00 AM PICKUP UNLESS OTHERWISE
INSTRUCTED. ALL PASSENGERS MUST BE AT CHARLES DE
GAULLE AIRPORT BY 10:00 AM AT LATEST.

PATRICIA ALEXANDER: CONTACT LIMO COMPANY NIGHT
BEFORE TO CONFIRM TIME, ETC.

IT TAKES ONE HOUR TO GET TO CHARLES DE GAULLE AIRPORT.

RE LUGGAGE: IT IS ESSENTIAL THAT ALL LUGGAGE BE
PICKED UP OUTSIDE THE ROOM DOOR BY 8:30 AM.

AT THE AIRPORT: ARRANGEMENTS WILL BE MADE TO SEE
THAT LUGGAGE IS CHECKED THROUGH. HALSTON AND HIS
PARTY CAN WAIT IN THE CONCORDE LOUNGE UNTIL DEPARTURE
TIME.

11:00 AM DEPART ON AIR FRANCE CONCORDE #1
8:45 AM ARRIVE JFK AIRPORT, NEW YORK

THURSDAY, JANUARY 26, 1984 (continued)

AIR FRANCE PERSONNEL WILL BE ON HAND TO ASSIST
IN RE-ENTRY AND WITH LUGGAGE, ETC.

9:00 AM BERMUDA CAR WILL HAVE ONE STRETCH FOR HALSTON, VAN
AND TWO ADDITIONAL LIMOS ON HAND TO TRANSPORT
HALSTON AND HIS PARTY TO NEW YORK CITY

BERMUDA LIMOUSINE COMPANY

TEL. 249.8400

END OF TRIP.

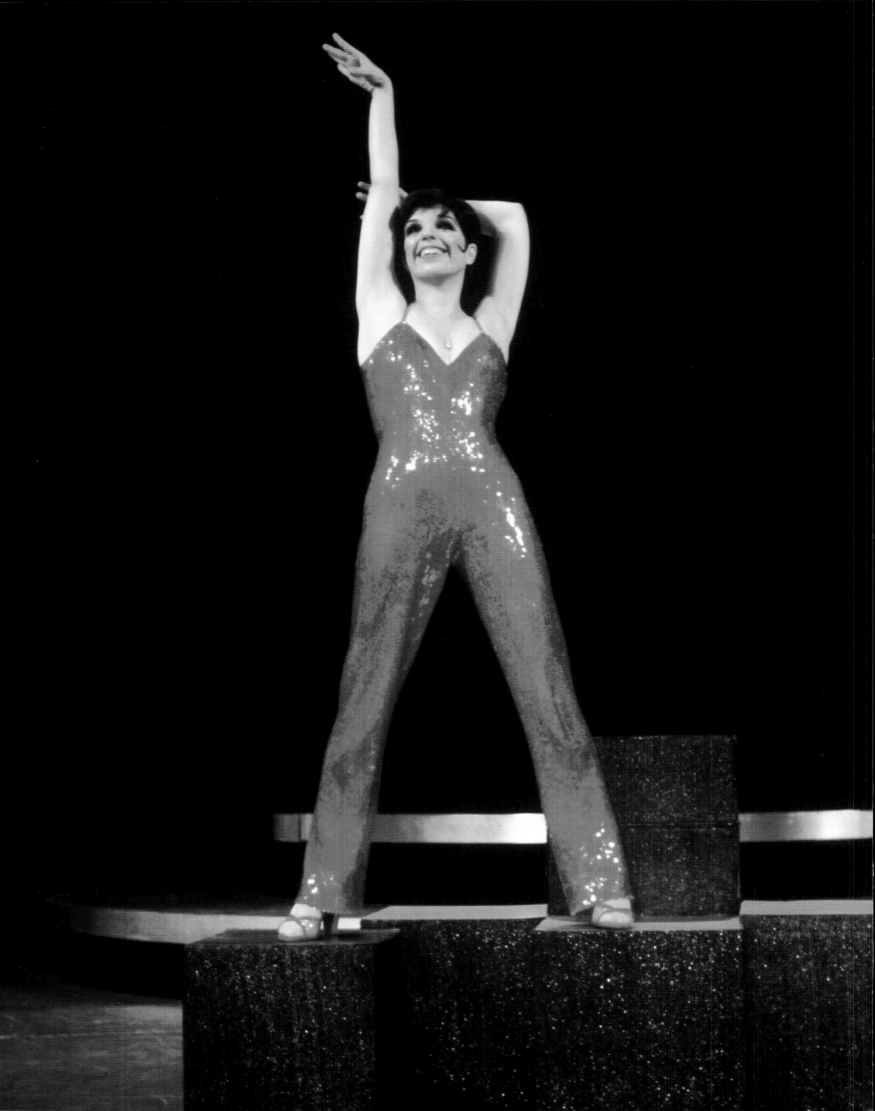

Frank.

Bias Scarf. attached

Back

3. Chorus Girls for Rizzy

3. Shades. Red.

Suff. in fr[ont]

slit sides
+ front

note:
Sep. Skirt.
2 pcs.
note,
Bill:
Red Stocking.
Dyed to
match,

to[p]

y Skirt,

Back.

Sofie.

Liza. M.

Wht. Sequin.
jump suit
a. farmer
overhauls/

to go over.
Blk. a. Gold.
jump suit/

velcrow. Back.
straps on.
jump suit

BB. Wht. Sequin.
farmer. Hat/

Candy. Pink chiffon
Scarf. around
Neck.

A. new hija:
Beige — Belk. Grey
Sequin.a
pcs.P.5

→ Belk. Chiff
Scarf

Finale Dress
1. Cape.
Bordered with
Feathers
or Fox,
in Green,

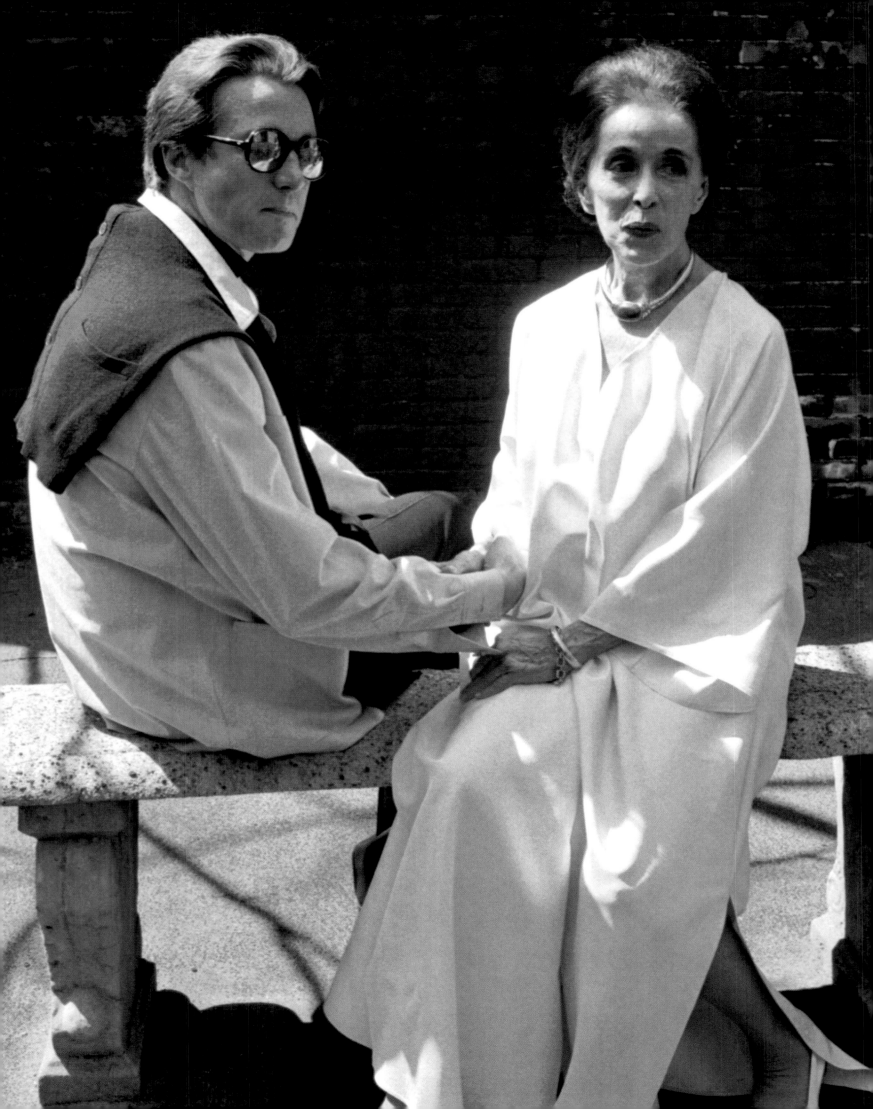

DEAREST HALSTON,

MAY THIS YEAR BE ONE OF BLESSED

IDEAS FOR YOU, BLESSED IDEAS

THAT COME FROM WONDROUS DREAMS.

THIS IS A CHINESE MEDITATION

STONE. IT WAS A POWERFUL FORCE

IN MANY LIVES.

MAY IT SUSTAIN YOUR GIFT OF

DIVINE CURIOSITY AND HELP YOU

TO LOOK FOR THE NEW SOMETHING

THAT IS ALWAYS IN OUR HEARTS

TO FIND.

I CANNOT TELL YOU HOW MUCH YOU MEAN

TO ME.

I SEND YOU MY LOVE AND BLESSINGS,ALWAYS.

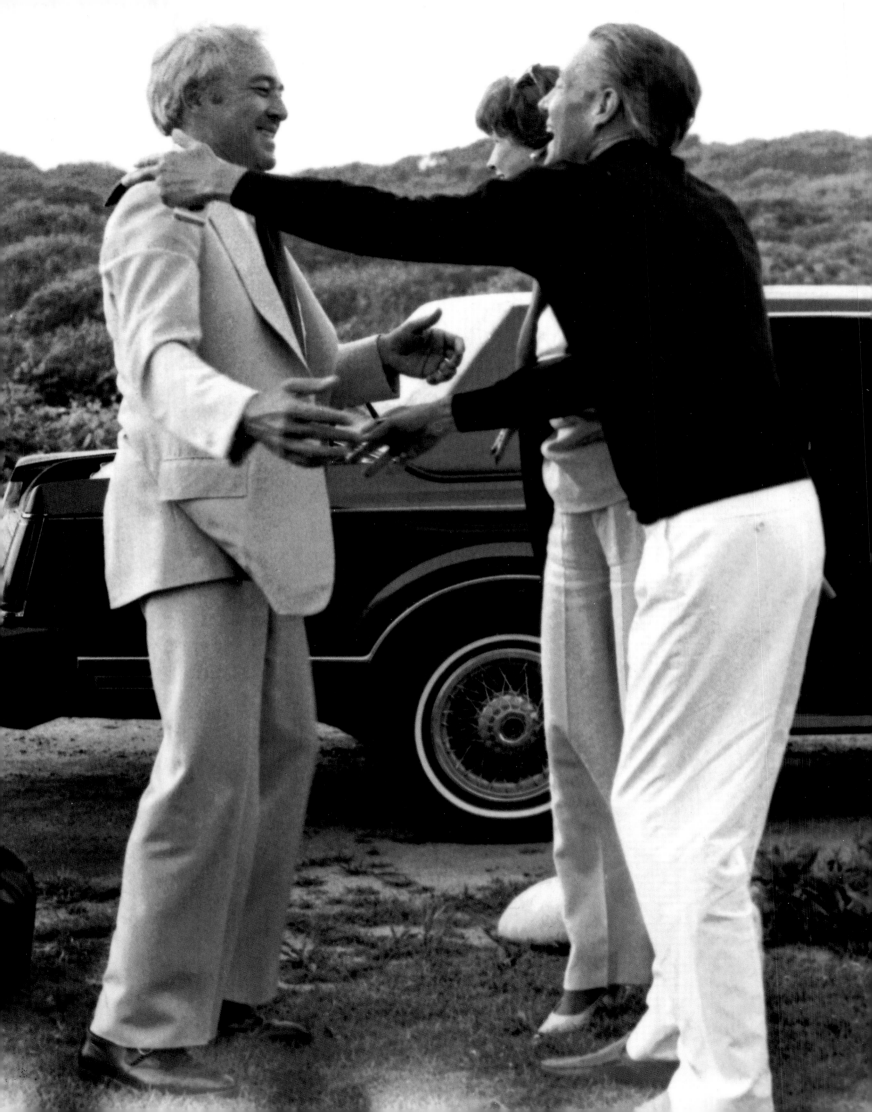

MAKE IT LOOK EFFORTLESS

Following the fracas at Olympic Tower, Halston retreated to a place that was psychically as different as possible from that overheated atmosphere: the house he rented from Andy Warhol in Montauk, at the easternmost tip of Long Island. The house was a fishing lodge built at the turn of the century for the James Church family of Arm & Hammer acclaim and, per Halston, legend had it that his daughter fell in love with the lowly stable-hand and so the family, not wishing a less than aristocratic man for their daughter, moved away and did not look back.

Andy had purchased the house in the mid-1970s, but apart from the summer when the Factory group filmed there, he was rarely in residence. Because of his sensitivity to the sun, the result of a skin condition that stemmed from a neurological affliction commonly known as St. Vitus's Dance, which he'd had as a child, Andy wasn't exactly an outdoorsman. He never ventured into nature without slathering his face with white

zinc salve and he'd wear long sleeves and carry a parasol for even the shortest stroll to the beach. In fact, that is exactly what he did the only time he came to visit during my six years of weekending in Montauk. On one foray, he found at the edge of the shore an oddly shaped rock. The rock in its original life had been a cluster of bricks, perhaps from an old foundation, that had been converted by the rolling waves into a remarkably close effigy of Curious George. Halston kept it on his fridge in Montauk for years and then on the fridge at 101. He gave it to me and it's had the same place of honor in my home.

Halston fell in love with the house when he visited Andy there

in the late 1970s, not only because of its grand slate-floored living room (shades of his New York town house) with dueling fireplaces at either end but also for the privacy that it allowed. At the time, Montauk was a deep-sea fishing community without any of the distractions of Manhattan. The house became Halston's refuge, one he loved to share with family and friends. It was an isolated oasis, a rustic Cape Cod-style lodge that he transformed into a chic weekend retreat complete with rust-colored lacquered furniture, strategically positioned ElsaPeretti terra-cotta sugar pots and candlesticks, votive candles, heart-shaped rocks, giant clamshells, and, in deference to the landlord, his collection of Warhols (the last, along with Mother Nature, provided the main decor). The permanent collection was composed of Warhol's pen-and-ink drawings of flowers, which Halston hung on the principal walls of the house. More recent acquisitions would be brought out to Montauk for the season. I remember the fruit series and the Mao series scattered about in key spots toward the end of my uncle's tenure. Out on the terrace were blue padded chaises where he would park himself and breathe in the fresh air, far away from the nonsense of the world. It was a place where he could let loose and be himself. The house certainly did see its fair share of swank gatherings, including the time Mick Jagger rode up the drive and through the house on a horse during a raucous Rolling Stones party while they were recording an album over a long weekend. On another weekend, Halston allowed me to shoot part of my final photography project for the International Center of Photography at the house, bringing my three subjects out

Opposite: Halston's brother Ambassador Robert H. Frowick and his wife, Ann, greeted by Halston as they arrive in Montauk from Brussels for a family reunion, 1985.

Above: The main lodge at Montauk, Halston's retreat from the stresses of life in New York.

with me. He was so generous to let them stay the weekend, a beautiful sunny one at that, and provided meals and bonfires with roasted marshmallows for both nights.

There were also sweet moments, such as the time Karen Bjornson spent at the house with her two young daughters, Laura and Maggie, while she and her husband, Tim, were having their apartment renovated. "He was such a wonderful host and made everything look so easy," she says. "We would make his favorite meatloaf and have a fire every night in the fireplaces. We were in the little house. I told the girls not to touch anything, so they would be in the big house with their hands behind their backs being really good. One dinner at the round table off the great room, we had chocolate mousse for dessert and Maggie had it all over her mouth. She was in her high chair. We all started looking at her and laughing. She looked over her shoulder to see what we were all laughing at and we roared even more."

Typically we would drive via Halston's limo service to Teterboro Airport to catch a private Cessna flown by a pilot I only knew as "Captain Mike." Once we were airborne, Halston would recruit all available eyes to watch for other planes. That, coupled with the severe updrafts flying over the New Jersey Palisades, meant that I was generally a basket case by the time we landed. I must have transferred my fear of flying to Halston, or could it have been his hearing constant warnings of the perils of flying small planes, but he eventually switched to hiring a van to drive us out during the last few summers.

He only went to Montauk in the summer, as the house had never been winterized. I tried to stay there one fall night in 1988—the last possible night before he packed it all up and moved to California. He allowed me to shoot photos of the house. I was with my fellow photographer friend Tony Israel, and although we had a hearty pasta dinner with lots of libations, it was still very cold and drafty.

Montauk took on an increasingly calming role in Halston's life as company negotiations became more insufferable. Someone once said a river flows by, a lake is still, but the ocean keeps coming at you with rejuvenating breaths. Montauk was a healthy place for him to be during those trying times. He was, of course, always impeccably dressed but he preferred for the most part to hide from the masses under a little floppy cap.

My uncle used a nondescript rental car, a white station wagon that we called Moby, to drive into town for supplies. His favorite shop was the ma-and-pa Herb's Market, which is still there. Herb makes the absolute best BBQ sauce that was ever created by man. It is so good that Herb will not reveal the recipe.

I'd like to think that Halston, always a trendsetter, encouraged and supported locally grown produce before it was fashionable to do so. There were a few farmers who had specific items that he loved—tomatoes and potato bread from one, organic lettuces and herbs from another. And then there was Gosman's Dock, a Montauk institution, where he would go to pick up either a beefy lobster for a special treat or flounder when it was in season. A little-known fact about Halston is that he was a gourmet cook. We regularly enjoyed meals such as flounder "dragged" through mayonnaise then lightly floured before being fried in sizzling hot canola oil, accompanied by sweet Silver Queen corn. Thickly sliced beefsteak tomatoes always accompanied the summer fare. We ate well in Montauk.

When Halston didn't cook, Viola supplied the meals for

Opposite: Montauk was one of the only places where Halston could stop thinking about difficult business matters and be himself, goofing off with family and friends. Above: The kitchen at the Montauk house betrayed the little-known fact that Halston loved to cook, although the invaluable Viola would often pack up food for the weekend as well.

Montauk weekends. On Fridays, she'd load up black canvas tote bags with potpies, paellas, or fried chicken for our feasting pleasure. His favorite dessert was Häagen-Dazs Elberta Peach ice cream. Halston preferred to keep the food in the pantry rather than the refrigerator, as that was where food was usually stored in such old, drafty New England homes. Normally, this was fine. But there were a few occasions when the temperature in the pantry rose above 41 degrees Fahrenheit, resulting in some dubious culinary experiences, like the time Tim and Karen reheated the paella for dinner only to discover that the clams were definitely beyond the pale. It was while we were doing the dishes, sans Halston, that we exchanged notes about how truly rancid it was. Tim quietly trudged down in the dark to the sea, carrying the rotten paella at arm's length, and tossed it out to the ocean, hoping that Halston would not find out—partly so as not to insult him, and partly because Halston, Depression baby that he was, hated to waste food. Unfortunately, the paella fell short of his target and the next morning we could see a sludgy mass splattered on the main large rock that sat at the end of the heart-shaped walkway, in full view from the chaise longues.

Halston led a healthy routine in the country. He would usually rise at nine o'clock, shower and splash himself with his favorite Z-14 cologne, then put on his country-casual white gingham shorts and a red or white cotton jersey polo shirt. He'd make a pot of French press coffee accompanied by an English muffin or a slice of the potato-flour raisin bread, then tend to a little phone business before claiming a chaise on the flagstone patio that overlooked the sea. He would read or sketch ideas or just contemplate life in the summer sun. There was never a dull moment in his company. We always had things to do or talk and laugh about or places to hike to in the tick-infested forest around the little boggy lakes and the rocks.

My first summer at Montauk was bittersweet. The squeeze was on at the OT. Halston and I initiated our first serious discussion, with me pulling on all my "stoic Frowick" reserves, about how to best approach the crumbling empire. I was not a tough corporate-business type and was having a difficult time letting things roll off my back. He suggested that I take a leave of absence until the dust settled and invited me to stay with him in Montauk, where we could dream of what the next phase would be.

A few days into the visit, searching for something to do, I decided to go fishing. The house was built as a fishing lodge, I reasoned, so why not put it to its intended use? With some help from Lorenzo Velasquez, one of Victor Hugo's Venezuelan contingent and at that time Halston's housekeeper in Montauk, I outfitted myself with a rod, and with that in one hand, a floppy white hat on my head, and the better part of a bottle of sunscreen on my skin, I appeared in the great room. Halston smirked as I exited the screen door. I made my way down over the rocks, moving due west toward Peter Beard's windmill home that sat above a private sandy beach. A little hike, but oh, so worth it: not two seconds after I cast that hook into the sea I got a big bite. (This isn't a "fish story"—it really happened.) I reeled it in with a bit of an effort and there it was, a three-foot-long bluefish twitching at the end of my line. Now what? I plopped it into the pail and ran back as fast as I could over the rocks to display my flopping prize. He laughed and asked, "Now what are you going to do

Opposite: Elsa Peretti–designed terra-cotta candlesticks holding a place of honor at Halston's table. Above: An Elsa Peretti–inspired still life—
her candlesticks and sugar pot alongside nature's bounty.

with it?" He definitely got a kick out of us city slickers trying to do the outdoorsy thing; he chuckled while he watched me squeamishly try to pull out the hook, giving me helpful tips as I offered prayers to the fish gods. Watching the poor fish seemingly in such pain, I was apologizing profusely to St. Carpus and even weeping as I tried to yank out that vicious hook. I kept assuring the fish that it was part of the food chain and Halston roared with more laughter. (Later, he loved to repeat my prayer to the fish gods whenever we dropped lobsters into the pot, telling them in a sympathetic voice, "You are part of the food chain," as he looked over at me with a mocking smile.) Meanwhile, Lorenzo, whom Halston called Lola, was hovering over me dutifully joining in the prayers, accentuated by his gasps of "Ay, Dío!" as I kept trying to pull out the hook. Finally, the lousy hook was extracted from the mouth of the traumatized fish, but then what? Do you think either of the men in the house would offer to fillet the fish? They both scattered until the dirty work was done, though

Halston did enjoy cooking it in a light butter-lemon sauce after I'd finished the filleting. In the end we discovered that bluefish is a little too oily for our palates.

In the summer of 1985, Halston hosted our first family reunion. I had been encouraging him to reconnect with the family. He would say, "They do not understand my life," to which I would always reply, "But we love you." And so I think he came to understand once more that family is there for you no matter what. He wanted to remain the almighty Halston to us and to the world, but once he found a level of comfort with his family, he could reassume the brother role and reach out again, unencumbered by the trappings of what

he thought we believed he should be.

Halston felt the reunion would be a great opportunity to open a family discussion about our potential roles with the soon-to-be-formed company. He had conversations with each of us asking if we would commit to being part of the family enterprise, and of course we all welcomed the idea, mostly to be at his side to protect him. My stepmother, Ann, an artist and jewelry maker, was just coming out of some health issues. He had encouraged and supported her jewelry making, possibly as a diversion from his own problems. But he always loved to encourage talent and watch it blossom. She had created some beautiful pieces that he integrated into his last show—buttons, belt buckles, snake necklaces, and bracelets cast in bronze. His creative juices never stopped nor would he allow the conflict with the company to bring him down.

As part of the preparations for the reunion, Halston launched into a redesign of the Montauk house. He bought a bolt of white canvas and resurrected some sling chairs that had been gathering dust in the third cottage. He sewed these by hand, using huge sail needles. He said his hands are too big for a regular needle; I never saw him use a machine. They were the quintessential, body-cradling deck chairs, perfect for sitting in the summer breeze, watching the sunset over the Atlantic. There happened to be extra fabric so he whipped up a Montauk outfit for me: pants and jacket finished with some extra buttons that Ann had made for his last show.

Planning the reunion took his mind off business matters. We kept making lists of possible fun things to do; each event had to have a theme. I wrote the letter to the family, and Halston put his edits in it before I recorded it onto cassette tapes,

one for each couple. The inspiration was *Mission: Impossible*. Family members would all arrive at JFK at approximately the same time; my father and Ann flew in from Vienna, where he was stationed as U.S. Ambassador to the United Nations mission, and the other siblings came from various points south and west. They'd been instructed to then play the cassette tape, which gave them an overview of daily activities and detailed instructions for the first night. Then it curtly warned that the car and tape would self-destruct upon arrival. By the time they got to Montauk three hours later, each couple via limousine with fully equipped bar, no one was feeling any pain.

Each couple had a cottage, which we had decorated with flower arrangements. The beds were made up with two-tone beige-and-brown fuzzy alpaca blankets, each adorned with one elegant H woven into the lower right, all the better to show off the perfect hospital corners. Halston the prankster also had another trick up his sleeve, which he recruited me to help execute. Before family members arrived, he had gone about the cottages hiding plastic figurines of Godzillas, spiders, and snakes under their

bedsheets, behind the shower curtains in the old-fashioned claw-foot bathtubs, in the fridges, and anywhere that would illicit a shocked yelp. I usually stayed in the main house, in what he called the Martha Graham room, as that was where she slept during her weekend visits. My bed, as I would discover after one too many glasses of wine, was not spared from Uncle Halston's sense of humor. I'm sure when he heard my shriek on the other side of the knotty pine-paneled wall, he had a good chuckle.

We had a rigorous timeline planned for all lunches, outings, dinners, and entertainment, including, naturally, outfits for all occasions. Each night the predetermined couple planned

our dinner fare; one night was chicken fried steak from Arkansas, another was cooter (turtle) tail from Florida, and a third was lobster—my dad's favorite.

After the aperitif on the first night, we directed them to go back to the cottages to change into the white sweat suits that I had run back to lie out on their beds. All the siblings and spouses were then blindfolded and instructed to sit as close together as possible on the oversized comfy couch. Halston stood behind them and, as he was telling them a story, he dumped the entire contents of a black trash bag full of dollar bills all over them, and I took pictures. He told them they had to grab at the "garbage" and grab as much as they could because he had a surprise for the one who could grab the most. He had crafted what would end up being his very last millinery effort, a wide-brimmed straw hat made of a hundred one-dollar bills. It was similar to one he had made at a party ten years earlier in a similar game. The person who had won, Dr. Robert Giller, was a nutritionist to the stars who was a fixture in the New York scene, delivering vitamin supplements to help alleviate the impacts of stressful New York lifestyles.

Back to the bag full of dollars—our family members were not following directions properly, instead grabbing handfuls of the paper stuff and tossing it back into the air. Halston became a little annoyed and sternly told them they had to scoop up as much of the garbage as they could so they could see what the surprise would be. He had determined that his sister, who was in need of money, should win the game and before he took off her blindfold he placed the hat on her head. As the blindfolds were removed all the siblings marveled at the paper that they thought was garbage was in fact a hundred one dollar bills.

For day two we scheduled an afternoon "jungle safari"

through the property, beyond the bluff and over hills, through wetland marshes and . . . marijuana groves. We had our suspicions as to whom they belonged but mum's been the word all these years. For this activity, I'd purchased all sizes of fatigues and camouflage gear, shoulder bags, plastic tommy guns, and a machete from the army surplus store on Canal Street in New York City and had schlepped them out to Montauk in Halston's white whale of a rental station wagon. I was carrying the "ammunition" bag and had been instructed to pull out the rubber rattlesnake that was concealed in it and throw it at someone in our party once we'd blazed a trail deep into the woods. It was another great moment of childish but exhilarating fun.

We had a scavenger hunt around the property, with bejeweled treasure bracelets that Ann had made for all of us as prizes. We planned theme dinners complete with appropriate garb; one night was "hick night," for which we dressed up in overalls and bonnets and had wheelbarrows filled with cornstalks and straw. One of the fun moments of the weekend was the rally around the turbo-charged Poire, a French pear brandy that knocks your socks off after one sip. Sitting by the fireplace, gussied up in beaded Halston dresses, we took turns swigging directly from the pear-shaped bottle. After each swig we all would yelp, "Poire!"

This first reunion was such a success that Halston called for another the following summer. To this second one he invited his wonderful Aunt Dottie and her husband, Uncle Jim, as they were still living in nearby Connecticut. Halston had designed and challenged Ann to sew silk shantung caftans for all the ladies while the men were told to wear jackets and ties. I had carefully laid out the caftans in solid colors of red, turquoise, white, and pink on their beds. After everyone changed and came to the main house at the predetermined time, we greeted them at the door with a silver tray of champagne flutes. Halston requested that each couple drink down their champagne as fast as they could, although it was his usual high standard of Dom Pérignon.

They obliged by chugalugging it down—and there at the bottom of each lady's glass was a necklace of semiprecious stones, similar to the Elsa diamonds by the yard that he had designed, and each made in complementary colors to the caftans! This was followed by a dinner of seafood from Gosman's and lots of music and dancing.

And then there was the turkey-feather extravaganza. Halston had made turkey-feather fans and headdresses for all the ladies so that they could perform an after-dinner entertainment in style for the gentlemen, as they had done when they were kids back in Des Moines. Even Great-Aunt Dottie was out there fanning her man and dancing around the great room having a blast. The family eventually bid adieu and returned to their homes across the world, leaving Halston a little more uplifted.

Montauk was truly Halston's Shangri-La. He'd say, "It's good to be off the treadmill," and made sure that I understood that the doors were always open to me. Nevertheless, I would always wait for an invitation. Many weekends there were spent relaxing and philosophizing over food. He introduced me to what he called "safaris" or walkabouts on his property that he owned with Bob Williamson, Lauren Hutton's partner, and Paul Morrissey. While Andy and Paul owned the house and a chunk of land, Halston used to say that Andy had to drive over his land to get to the house. Halston had purchased the land that ran from the road to the ocean in the late 1970s; however, he often lamented the fact that a large segment of the acreage was considered wetlands, which, according to the county, made it nearly impossible to develop. There was a brackish pond adjacent to the south side of the property, where redwinged blackbirds, perched on swaying cattails, would sing and awaken me on sea-misty summer mornings. If you followed the ocean side of the pond uphill, there was a secret entrance to Halston's property that only a few people knew about, where, once you made your way a few yards inland, the forest opened up to a path that led deep into wild nature. He would take me to Gosman's Dock to pick out lobsters or

fresh flounder. He loved to drive to the local farms and chat with the farmers about the weather or the crops while he was picking out the best beefsteak tomatoes, Silver Queen corn, and potato-flour cinnamon bread. Though he wasn't given to self-pity, he appreciated the simplicity of these down-home experiences, which I think reminded him of less stressful times. He was certainly unhappy with the progression of events with HEI but strangely at peace with being able to live his life close to nature.

One day, while we were sunbathing on the sea-blue chaises, he spied a woman on the adjacent beach. He said, "That's Lauren Hutton, I can tell by her prance." He predicted that she would come over to chat and end up staying for dinner and the night—which is exactly what she and her boyfriend, Bob Williamson, did. Halston had come into some fun turkey-calling tapes, and we lounged around the great room, drinking wine and doing our best to compete with the professional turkey hunters. We had a lot of laughs that night.

Halston was at heart a very private person. He never revealed if he was feeling "puny" as he called it. You couldn't say you had a cold—it was a "complaint." He never said "sick." In fact I never saw him sick, except, of course, at the end. And even then he kept a stiff upper lip. He always said, "There are no problems, only opportunities," which while not necessarily a unique expression, was his creed. This mantra helped carry him through the rough times ahead.

I returned to the OT toward the end of August 1984. The new manager met me at the door—blocking it, actually—swinging his key chain and asking what my business there was. I was still an employee, but I was no longer welcome. Although I had been told to report to the head of design upon my return, that no longer seemed like an option. Instead, I was asked to accompany the manager to his office. The end result was that I was fired for insubordination.

Less than two months later, Halston was out, too. On October 11, 1984, his lawyers Malcolm Lewin and Howard Chase had a meeting with the Playtex people. "One result of that

lengthy meeting was the stated petulant refusal of the J. C. Penney and HEI design-room managers to do any more work unless Halston was kept out of his own office and prevented by Playtex and HEI from having anything to do with the designs and products bearing his name," wrote Mr. Lewin in a case review letter. On Friday, October 12, 1984, Halston was relieved of all his duties at the company he had founded. The following Monday, he was asked to leave the company's offices at OT. Legend has it that he stormed out with his silver Elsa Peretti candlesticks under his arms. The reality was that Halston, D. D., Bill, and I, all shell-shocked but heads held high, gathered our belongings, bade farewell to Lisa Zaye, and walked out the doors of OT for what we felt was the last time. The next day, Mr. Lewin sent a letter to Playtex stating that Halston "continues to be willing and able to discharge his responsibilities as President of the company, as otherwise."

Halston was a member of the board of his own company, although the other board members ignored this fact and continued to make decisions without his participation. His attorney Malcolm Lewin spelled out a crucial point in the Halston trademark issue when he wrote to International Playtex Inc. legal counsel on November 9, 1984, "While elements of the living trademark may now belong to the company, it is not the company's exclusively…Thus the continuing integrity of the Halston trademark is not a property value which belongs only to the company. A very substantial part of it now (and forever during his lifetime) belongs to Halston. I do not think that adequate arrangements or means are being undertaken to insure the continuing integrity of the Halston name."

That's not how the suits at HEI interpreted things, though. Halston should have been consulted about what products his name was being used for, but he wasn't. Yet he was still expected to endorse their plans and decisions. And when it benefitted HEI, they continued to demand that Halston be paraded about in front of licensees as though he were an integral part of the company. That was the case with

the "Night of 100 Stars" fiasco at Radio City Music Hall (or, as Halston referred to it, the "Night of a 100 Dickheads"), a huge fund-raising event for the Actors' Fund of America on February 17, 1985, in which J. C. Penney requested that Halston participate. The powers that be saw this celebrity-studded fashion show as a huge marketing opportunity and wanted to make sure the star attraction would be there. They asked Halston to appear on stage, attend the dinner dance that was to follow, and be available for interviews and personal appearances. Halston's attorneys had urged him to participate, never anticipating that the parent company would be locking him out of all design responsibilities before the very event he was to design for. As the date approached and the lockout happened, HEI refused to allow Halston to return to the Tower. In the meantime, Halston recruited, with his own money, the talented illustrations of Pui Yee to render Halston's ideas for the two stars he was to dress from the fashion show, Teri Garr and Jill St. John. Barring the actual fittings, which took place at the Tower, Halston was forced to coordinate this design effort from his home. When we finally were able to gain access to OT, the reception was hostile at best. I assisted with the fittings, using pins and chalk that we brought from Halston's home. Pui drew the final sketches as the two stars paraded down the catwalk for Halston, who continued to maintain his grace under fire. As he always said, "You have to make it look effortless, like you waved your magic wand." The stars were charmed by Halston and oblivious to the backstage hostilities.

Despite daily inquiries from journalists about what was going on with his name and business, Halston remained publicly quiet about what was transpiring. He would invari-

ably reply diplomatically but the reality was far from encouraging. But he played the game, hoping that he could get back into his company as a more active participant. He used to tell me, "I am being paid a million dollars to do nothing." Of course, being a workaholic, he did not in fact just sit around and do nothing. Despite being denied access to his workroom and staff, he designed for the family, for Liza and Chita Rivera in the Broadway musical *The Rink*, for Liza's comeback performance at Carnegie Hall, and for Martha Graham's seasonal dances, all on his own dime, and he carried on with his altruistic endeavors. His fiercely loyal seamstresses continued to sew for him on a freelance basis.

He was also preparing storyboards for J. C. Penney meetings to show in good faith that he was still actively involved with designing. Pui went to 101 numerous times to assist with the process of transferring Halston's design ideas onto paper, as had been his practice for the last seventeen years. Halston remained cooperative, always optimistic that there could be a resolution to this painfully drawn-out legal drama. Unfortunately, it was incredibly acrimonious. But Halston was a formidably strong-willed character. He was in it for the long run. And he never lost his sense of humor. During this whole process, HEI dispatched bills to his attention, requiring him to pay out of pocket for practically everything. So to add a little whimsy to an otherwise depressing scenario, one night when he and D. D. were settling in for a night of Jack Daniel's, socializing, and laughs at 101, they decided they were craving comfort food in the form of chili. Halston decided to call the limo service and sent Lindo, his snaggle-toothed pet Pekinese to P. J. Clarke's to pick up a few tubs of chili and coleslaw. Limo drivers, who see it all,

Illustrations by Pui Yee of Halston designs for Jill St. John (left) and Teri Garr (right) for Night of 100 Stars, a fund-raising event for the Actors' Fund of America, 1985.

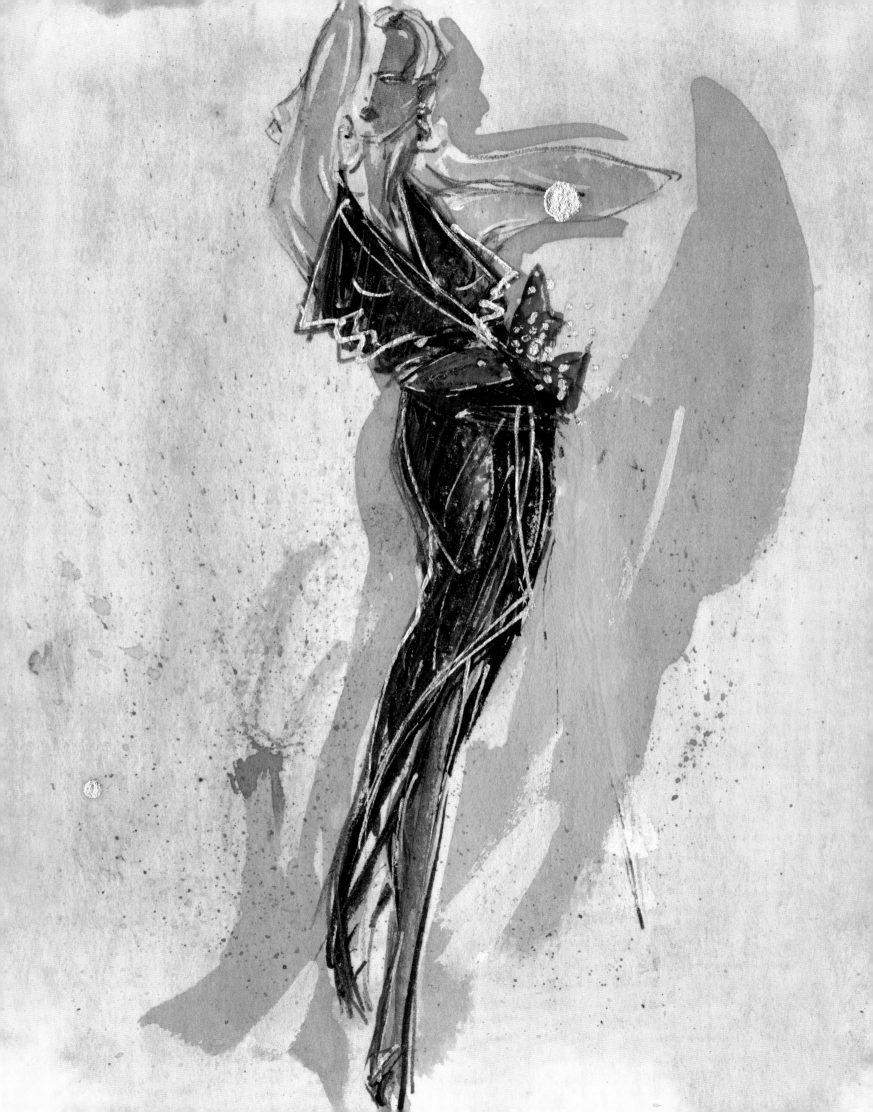

don't question anything. But I wish I could have seen the look on the faces of the HEI drones when they saw the limo bill for the chili-dog adventure.

In late December of 1985, Halston felt an urgent need to assist his long time friend Martha Graham, whose school was teetering on the edge of financial collapse. With the increased expenses that he was incurring due to the tightening corporate noose, he felt that he needed a more creative way to support her school rather than simply giving her money. He dreamed up the idea that he could design, under his name and with Martha's blessings, a line of dance and rehearsal costumes—stretch body suits, leggings, chic satin warm-up jackets, headbands, etc.—that would continue on into the future, with Martha's company as sole beneficiary. He and Martha were in close communication about this effort. It would have been a win-win, with Martha gaining financial stability, which would possibly enable her to start a foundation, and Halston being able to design. But for whatever reasons— a concern that the new venture would draw attention away from HEI, that it would be competition with HEI, or a just plain mean-spiritedness—after another several rounds of legal sparring, the idea was squelched. In the end, the ultimate travesty was that the eighty-nine-year-old Martha Graham, an American modern dance icon, lost out on a unique opportunity that could have sustained her school indefinitely.

In January 1986, Halston tried to secure a final deal that would enable him to use his monogram "RHF" (Roy Halston Frowick) as a design signature. He hashed out details of the contract. But the other side refused to budge.

Another puzzling business maneuver was when the HEI manager announced to Malcolm Lewin that he had decided to liquidate Halston's Seventh Avenue showroom, (his complete ready-to-wear division of Halston designs available to department stores across the United States where the business of buyers took place) of all apparel and show archives and he was offering Halston a two-hour window to gather as much as he wanted. Halston dispatched Lewin to the showroom. Once Lewin had had a chance to look around, he raced to the nearest pay phone and dumped in all his quarters so that he could recite as many articles as he could recall for Halston to select. He detected a melancholy tone in Halston's voice as he recognized the pieces being described. Halston had a near-photographic memory, especially about his designs, so as Lewin ran through the list of what he'd seen, his running commentary was, "Oh, that was the gown I designed for Liza for such-and-such party, oh, that was the one for. . . ." Halston told Lewin to take as much as he wanted and give it to his wife. Instead, Lewin loaded a clothing rack and delivered it to Halston at 101.

Week after week went on with no positive developments in the legal wrangle. Finally there was a fleeting breakthrough with Revlon, the new parent company, which seemed prepared to allow Halston to design under his monogram, RHF. As fate would have it, he had just learned he was ill and did not wish to sign on with Revlon if he could not honor a contract through the end of the term. So instead he carried on with his dream to start a family business, which in the end never materialized.

Also on Halston's mind at this point was the town house on East 63rd Street, which he'd bought after signing the deal with Norton Simon. He embarked on an extensive program of updates and renovations with architect Donald Luckenbill, who had gone out on his own after working with the house's designer, Paul Rudolph. Some of the changes were cosmetic; others, like the much-needed upgrade of 101's heating system, were necessary. "Halston called me, we talked and he said, 'Donald, I want to do some work on my place. I have a monthly electric bill of three thousand dollars. Do you think that is high?' I told him, 'We need to get together immediately,'" Luckenbill remembers.

A new rooftop heating/AC unit was installed and both kitchens, which were at that point twenty years old, were replaced. The greenhouse, badly deteriorated, was rebuilt. The house was repainted, the carpet replaced, and the furniture reup-

holstered. "Halston was demanding to work for," Luckenbill remembers. "He was a perfectionist in many ways, which is good. It keeps you working hard. The artistic clients like Halston, who know what they are seeing, are good because they will support you to do it well. He asked to have things explained to him and he really understood how to bring it back to the level of the piece of art it had been originally conceived as. In the end, he wanted things to be done right. He was an involved client. We would have discussions before we started on anything; we would explore ideas, price things. We went through a process that evolved, which is a good way to work with a client."

Not one to submit to having his routine changed, Halston wasn't pleased with the disruptions caused by the renovations and requested that the workers not make any noise until one o'clock in the afternoon. Luckenbill pointed out that this was impractical and suggested that Halston stay in Montauk for a few weeks while the work was completed. "With the things going on in his life, he found it entertaining to occasionally come work with us and get involved with

the construction," Luckenbill says. "It was a tricky time for him due to the changes taking place in his career. He wanted to get the town house in really good shape because he wanted to have the press come over. My impression was that he felt he was going in a new direction with his career so he wanted to get it ready for upcoming events."

When the renovations were done, the house was even more spectacular then before. The designer Jeffrey Bilhuber, who was introduced to Halston by D. D. Ryan post-OT, remembers vividly what it was like to be welcomed into his orbit. "Mohammed would serve you a drink on that lovely little black lacquer tray, the size of a forty-five record. It was very

civilized," he says. "And then there was the anticipation, the buildup of Halston coming down the stairs or the elevator because he was usually up there getting ready. Descending from his area was part of the presentation, the package. He knew how to make a good theatrical entrance. The house was ravishingly beautiful, highly influential. I had never seen anything like it, and most people still haven't. There were orchids everywhere and candles. Everything was monochromatic and you realized it was an illusion, there are mirrors behind bamboo and Japanese music playing in the background…it was a fabulous atmosphere, it was magic, it would transport you. My first vision was, 'This is why I came to New York—this is what you get when you get to the city and what you want to find.'"

Meanwhile, Halston was encouraging me to get on with my life. I had taken a few temporary jobs while we waited for the negotiations to settle. Then, as nothing materialized, Halston told me I should proceed with my own plans but asked for me to be available once he was able to establish himself again in the design world. I decided I wanted to go to photography school, inspired by Hiro, Halston's favorite photographer. Hiro told me to eat, live, and breathe photography, so I immersed myself in the General Studies program at the International Center of Photography from 1984 to 1985, when Cornell Capa was still at its helm.

Shortly before I started, Halston made me another life-changing offer. One Friday morning, he called me up to see if I was bringing my significant other with me to Montauk. I hemmed and hawed, unwilling to admit that things weren't going well between the two of us. This irritated Halston, who liked to say that weekends in the country were fun provided they were well planned—he wanted to know

Mohammed, Halston's right-hand man, and Halston in the kitchen of Halston's home, 1987. Mohammed was the one who made sure that
Halston never had to worry about preparations for his houseguests and parties.

how many potpies to bring and how much fish to buy. But when he picked me up later that day from my nonprofit job at American Field Service (AFS), he could see immediately that something was wrong.

Halston generously asked me to live at 101 while I attended photography school. What a unique ride that was. Rather than question me about my relationship problems, he simply asked, "Do you want to live with me while you attend ICP? You can house-sit while I am out of town and help me entertain." I knew how he hated to see people cry, so I sucked it up and with a quivering lip pondered his generous offer. My first reaction was that it would never work. He was a very private person and at that point I was leading a somewhat unsettled lifestyle. But my tears evaporated as we discussed the idea and by the time we got to Teterboro airport, I was persuaded that the arrangement would be mutually beneficial. I moved in the summer before starting at ICP.

In hindsight, I wish I had taken notes during this incredible time. Understandably, Halston didn't allow me to take pictures of his famous friends when they came over; he didn't want to compromise his friendships and wanted to protect their privacy so they could be who they wanted to be in the comfort of his home. As difficult for me as it was, I would leave my camera in my room, though the Polaroid would surface and produce a few party shots for posterity. Andy Warhol, however, had preferential treatment—his point-and-shoot Olympus was ubiquitous.

It was, on the one hand, a privilege to live in the most architecturally fabulous townhouse in Manhattan. On the other hand, our schedules completely clashed. I got home evenings after ten o'clock, which typically coincided with the beginning of his frequent "get-togethers." I would arrive with developer stains dripping down my grubby smock, reeking of fixer and green around the gills from a long day in the darkroom. I'd try to sneak in unnoticed, at which point he'd call out, "Lesley, come in and meet my friends." It was anyone's guess who might be perched on

the couch and always embarrassing to be looking as I did in the home of the top designer in America. I think, *enfant terrible* that he was, Halston enjoyed the ensuing torture of the introductions. But in general, he and I gave each other lots of space. As far as I was concerned, the biggest sacrifice I had to make was to give up garlic. Halston did not like anything about the "G word." He considered it to be peasant food and claimed, "It repeats on me." Before he politely asked me to stop cooking with garlic, I wondered why he was burning so much incense. So I suffered through withdrawals and lived garlic-less for a year. It was a small price to pay.

When I first moved in with Halston, I kept my living arrangement a secret from my friends. If I was meeting someone, it would be at least several blocks away from the house. Once, when I was dating a collegiate-type guy, Halston said, "Why don't you have him come here for a drink—I want to meet him." The poor guy rang the doorbell only to be greeted by Halston while I, by arrangement, stayed in the living room. My friend was shocked and nervous when Halston invited him in. I think H delighted in being the one to reveal my secret and witnessing the resulting discomfort of my visitors. He also enjoyed occasionally answering my telephone line and freaking out my friends, who didn't know how to speak to the great Halston. When my closest friend Jessie Newman called, he'd tease her mercilessly. At a party once, Joe Pesci, then pre-Oscar, went home with a hat that Jessie had saved for a year to buy me. Halston squelched my protests as Pesci walked out the door with it, saying he'd get me another one. (Not that I would ever remind him of that.) When Pesci's girlfriend showed up at the OT a few days later to return it, I was quite impressed.

We celebrated scads of important occasions in the warm, gray woolen living room at 101. Halston's favorite holiday to fête was Thanksgiving, which he produced just as his family would have back in Indiana: turkey, stuffing, mashed potatoes, fresh green beans (he grew up eating "limp and horrible" canned green beans sautéed in bacon grease and onions, while at 101

they were lightly braised in butter and lemon), and pumpkin and apple pies. The latter were homemade by Viola. The guest list consisted of his surrogate family. During my time, that could include Andy and his entourage (Rupert Smith, Benjamin Liu, Sam Bolton), Bianca Jagger, Jane Holzer, D. D. Ryan, Tim and Karen MacDonald, Hiro, Arman and Corise, Marisol Escobar, Peter Beard, Cheryl Tiegs, Jeffrey Bilhuber, and Bill and Nancy Dugan. This was his close inner circle, all of whom either had no family at that time or had family members so far-flung that visiting every year wasn't feasible. Halston filled in the void with his warm familial treatment. To be honest, though, he didn't need a holiday as an excuse to serve his very favorite meal—he prepared stuffed turkey and gravy throughout the year, as comfort food.

For Christmas 1985, I convinced Halston to come with me to Brussels to be with our family. I think it may have been the first Christmas he spent with the family in decades. We had a great time tooling around Brussels, hitting all the linen and lace stores—he must have cleaned out the city's entire supply of the finest sheets, hand towels, and eiderdowns. Dad and Halston and I ventured off to Bruges and Dinant, quaint medieval towns perched over the Meuse River. Halston loved the castles, the food, and the wine. We had so many laughs my stomach ached. During a later trip to visit my dad in Vienna, he made a side trip to Florence, where he had another shopping spree at the Santa Maria Novella pharmacy. D. D. had turned him on to this beautiful thirteenth-century apothecary, where she purchased her signature patchouli scent. Halston bought a number of their specially blended patchouli potpourri satchels, which, to this day, carry the fragrance in my turtleneck drawer.

H and I grew even more fond of each other during that year. He loved that I went to Africa on a photo safari after graduating from photography school. It was no-frills—we camped out in the game reserve feeding grounds. I came back tan and sporting sun damage on my left cheek, which Halston christened my Gorbachev patch. We would hang out on the chaise longues at Montauk while I told him about my African adventure. We talked of life, work, photography, politics, and people and marveled at the beauty of nature surrounding us. One night after a simple dinner of lightly fried flounder and thickly sliced beefsteak tomatoes with a green salad and a few glasses of Chardonnay, I glanced out the kitchen window and saw the full moon rise over the ocean. "Guarda la luna!" I exclaimed (a line from the film *Moonstruck*, which had just come out). Halston was too proud to ask me what it meant but he must have consulted someone because the next month, after similar dinner fare, when the full moon once again rose, he opened the kitchen door and exclaimed, "Guarda la luna!" then glanced over his shoulder with his "gotcha" look.

I am a procrastinator and Halston was always encouraging and nudging me along. He even recruited Hiro to help me with my plans for a career in photography. He offered the Montauk house as the setting for a catalogue Hiro was shooting for Elsa Peretti when she owned Kuma, and he also offered me as one of Hiro's assistants. Hiro and his crew came out for a picture-perfect weekend. I was charged with dusting the lenses and reloading film for his Hasselblad. In the evening, after a long day of photography, I changed hats to become the chef and hostess extraordinaire. It was strange for me to be first the lowliest assistant and then the commanding hostess for Hiro and Halston and the crew. I awoke the next morning with the rising sun and dashed out to prepare coffee and breakfast when I spied the crew out by the shore already shooting. I changed and ran out sans caffeine, apologizing profusely as I had understood they would wake me when they were ready to start. All Hiro said, as he continued looking through the viewfinder, was, "You'll learn." Halston just loved that comment and believe me, I heard it numerous times over the next several years after a blunder: "You'll learn!"

Before he was stricken with HIV/AIDS, Halston was never sick. The only time I knew him to have a serious "complaint" was in 1988. He had to spend some time in the hospital then and swore me to secrecy about it. I went to visit every day

and, as he refused to eat the hospital food, brought a different meal with me each time. One day he requested fried chicken à la Viola. I built on the theme and prepared a picnic complete with basket, fried chicken, baked beans, coleslaw, checkered tablecloth, and plastic ants. He got a kick out of the ants. He had made me laugh for so many years and I was pleased to have an opportunity to bring some humor to his otherwise worrisome day. Years later, I found out I was not the only one who knew he was sick. His attorney Malcolm Lewin recently revealed to me that he arrived in Halston's room shortly after the picnic, while Halston was still sweeping up the crumbs and lining up the ants on his bedside table. Lisa, who was working as his part-time assistant then, informed me that she too knew and had gone to visit him with office paperwork.

In 1986, human immunodeficiency virus, HIV, became the official name of the retrovirus that causes AIDS. Soon thereafter, a lawyer named Geoffrey Bowers sued his former employers, who had fired him when AIDS-related Kaposi's sarcoma lesions appeared on his face, a case that became the basis for the 1993 film *Philadelphia*. And then the model Gia Carangi died, one of the first well-known women to succumb to the disease. But people still weren't really talking about AIDS. It was considered something to hide. You wouldn't see someone for a while and then you would hear they died, and you just knew. Or you would note how drawn and haggard someone looked and know their end was near. With each new casualty, those left standing counted their blessings, knowing that at any moment they, too, could become a statistic. Halston and I had that experience one day when we were out for a carriage ride in Central Park. From time to time, he liked to crawl out from the sanctity of his town house to test the waters, so to speak—to see who might still recognize him. He needed the recognition, yet when people did spot him, he did not want to be bothered with a fuss. On that day we went out to "blow the stink off," as he would say. We were lumbering along in the carriage

when a man's voice called out his name. We looked out and there was Jon Gould, Andy's boyfriend. But was this really Jon? He looked ravaged and had lost considerable weight, but he still had his sweet, loving personality. He chatted with H and gracefully acknowledged me. They had a brief moment of talking together, Jon jogging alongside the carriage. He kissed Halston's hand and as he let it go, he stood where he stopped, saying, "I love you." It was like a scene out of a movie, but it was becoming clear to me what those words meant when they were delivered like that: a final "I love you," and a fading away with no acknowledgment of the cause. When we learned of Jon's passing that September we knew, although the usual practice then was to blame the deaths on some other cause, usually pneumonia, for fear of repercussions. Andy was devastated.

I got to know Andy, as well as Halston intimates such as Liza Minnelli and Bianca Jagger, during my time at 101 and in the years that followed. I was at Andy's birthday party in 1986, which we celebrated out at Montauk. Andy had asked Halston to interview the graffiti artist Keith Haring (who would die of AIDS just a month before Halston) and used this as an excuse to come out to the house for the first time in more than six years. As Halston was wont to do, we planned the weekend carefully—it was, after all, Halston's best buddy's country house. Halston agreed to my silly idea of making it a kid's-style party, to be held in the kitchen with balloons and colorful streamers as decor. What with Andy's "golly gees," I thought the theme was perfect.

After dinner we played pin-the-tail-on-the-donkey and let the birthday boy win (I seem to remember guiding him toward its derriere). The interview took place the next afternoon. Andy got out the tape recorder and the rest of us sat back and listened. I remember Keith saying that in 1978 and '79, the graffiti on the subway trains had been incredible, but because the city now had buffing machines that used a chemical wash to scrub the cars clean, no graffiti writer was going to spend eight hours on a piece the way they used to.

Shortly after the interview, they packed up and shipped out. Liza ranked among Halston's dearest friends. They loved each other like siblings and thrived in each other's presence. He was honored to be able to dress her for performances, and he was certainly appreciative of the PR. She would come over to 101 to practice her numbers, singing and doing her dance moves on the black slate landing in Halston's living room, while he sketched ideas for the proper flow of her wardrobe. One of the more important times I witnessed was prior to her three-week engagement at Carnegie Hall that opened on May 28, 1987. Liza was just coming out of a challenging moment in her life and was very excited for this one-woman show. She and Halston decided the wardrobe's color scheme should honor the newly renovated hall's colors, red and gold. "It's our tribute to Carnegie Hall," she told *Women's Wear Daily* on May 28, 1987. "I literally dreamt about this opening over a year ago, what it would look like and I came running over to Halston's and we began." Despite Halston no longer having access to his workroom, he found a space and put his favorite seamstresses, Mariuccia, Maria, and Flora, to work. He designed a short white silk jersey slip dress with matching kimono jacket embroidered in India beads, pearls, and sequins, made at Naeem Khan's family atelier; a black silk velvet dress with a short skirt made of layers of silk organza that Halston said looked like flowing hair; and a red velvet strapless "grand concert dress" with an underskirt made of fifteen layers of pink tulle. Halston marveled at how Liza could change from this theatrical dress into the blue-black honeycomb embroidered pull-over and pants in twenty-seven seconds. But she did it! I vividly remember when she started singing, "I can see clearly now the rain is gone." For the first time, after hearing that song I don't know how many times, the words truly came to life. I felt so happy for her. She must have come back onstage for no fewer than ten curtain calls that opening night; her town was so pleased with her comeback performance. In the epilogue to her story about the show, columnist Liz Smith wrote in the *Daily News* on June 1, 1987, "Now a word, please, about Liza's incredible costumes by Halston. All I can say to those corporate meanies who won and held the Halston name hostage, is, 'Let our Halston go!' We need him back designing for us even if we won't look as good as Liza does in his sequined minidress, campy red velvet concert gown, his sparkling off-the-shoulder top and pants, and his final dazzling robe."

On a homier note, it was Liza who gave Halston his first microwave oven, back in the dawn of the microwave era. I noticed this humungous, clunky machine at one of our Sunday dinners. Halston told me that Liza had given it to him because she was tired of waiting until after midnight for the baked potatoes—a Halston favorite—to be ready. I, too, was always so tired when ten o'clock rolled around that it was torture to wait the two hours for the lousy potatoes to finish cooking, so this new device was a welcome addition to the family.

Liza's comeback performance happened just a few months after Andy Warhol's tragic death. That was a huge shock to Halston. Andy was a close friend, someone he had come of age with, so Andy's passing was a chilling reminder of his own mortality. I went to 101 that evening to have our regular Sunday dinner, and as I was pouring a glass of Cabernet, Halston came down the floating stairs and said in his most serious voice, "You did not hear the news. Andy died." I couldn't believe it. Andy had been to 101 just a few weeks earlier. I remember he had mentioned that he was in a lot of pain and needed to have his gall bladder removed. I didn't think anything of it except that I felt bad that he was not feeling well; you don't think of a superstar as being in anything less than perfect physical and mental health. Then he seemed to be recovering well from the routine surgery, but he died in his sleep.

Halston was blindsided. Two days after Andy's death, he told the *New York Post*, "I still don't believe he's gone. . . . I'm sure he's going to send back a fake Andy, an impersonator to make

us all happy again." The memorial service was held at St. Patrick's Cathedral on April 1. More than two thousand people crowded in to pay their last respects. I was convinced it was a macabre Pop art performance hoax that Andy had orchestrated and that he would be resurrected to deliver his own eulogy. The actor Nicholas Love read about death from Andy's journal: "I do like the idea of people turning into dust or sand. And it would be very glamorous to be reincarnated as a great big ring on Liz Taylor's finger." Andy had produced serigraphs for Martha Graham's fund-raising auction, an event that was imminent, but everyone was still so shell-shocked about his death. Nevertheless, Liza and Halston determined that the show must go on, so the fund-raising event proceeded and was a huge success.

After Andy died, his close publishing associate Pat Hackett excerpted sections of Andy's diaries in *Newsweek*. It was so reminiscent of Truman Capote's exposures of his "swans" in his own writing that Halston, who had amassed a large collection of Warhols, felt betrayed and

decided to sell it all. Halston expected discretion from his friends. That Andy wrote about Halston in his diaries was bad enough; that these diaries were published, Halston felt, was a breach of trust. Up to that time, on any given day in Montauk or at 101, you were surrounded with Warhols— hanging on the walls, propped against the walls, displayed in the bathrooms. Halston bought and sold them as though they were last year's fashions to be recycled. Most gifts he kept, even if they had no place in his minimalist aesthetic. Hand-crocheted doilies from Great-Aunt Lucy, for example, were appreciated for their thoughtfulness, but he would never have let them see the light of day at 101. I had once made him a Taurus needlepoint pillow only to discover it in

a box twenty years after his death. (At least he liked it enough to save it, but I'm certain it never emerged from its box.) The Warhols, on the other hand, had to go. Perhaps Halston knew he would be moving on and this was merely a good excuse to purge his collection.

During Halston's last two years in New York he charted his future carefully, not knowing what it had in store for him. He continued to have intimate dinners at his town house and appear at fund-raising events about town. Once he let the Montauk lease go, he became even more of a homebody. He visited my father in Vienna for Christmas in 1988 but otherwise did not travel anywhere. He said he was getting his house in order.

In the spring of 1989, I was making plans to move to San Francisco. The idea was to drive cross-country in an Airstream trailer, taking pictures along the way. Halston got a kick out of my campy plan and once I secured the vehicle, I decided to take him for a drive up the Hudson River. It was a sparkling, sunny day, absolutely perfect for a drive. Until he revealed to me that he had recently been diagnosed with HIV/AIDS. My life flashed before my eyes. I could not bear the thought of leaving him to live out his last days alone but I had already quit my job and my departure seemed irreversible. He emphatically insisted that I continue to play out my dream and assured me that his diagnosis was "not a death sentence." He commanded me to go, as only Halston could deliver a command, one that was so strong and irrefutable that I had no choice but to proceed with my plan to leave on the target date of May 1. In turn I encouraged him to move to California, where my dad was planning to retire. This was a painful and stifling burden knowing that my beloved uncle was dying of a horrific terminal illness.

Jeffrey Bilhuber, D. D. Ryan, Halston, and Bill Dugan (left to right), at my bon-voyage party, April 1989. This was one of the last big parties at "101."

This was early on in the AIDS epidemic, when so many talented people, especially in the arts, were dying. Almost daily we heard of the latest person to succumb. Known as the "gay disease," its diagnosis was so stigmatizing that Halston was quietly having a very difficult time processing the changes it would have on his life. Nor was it something one could easily hide. The symptoms of AIDS were already beginning to take their toll, and he was losing weight and feeling "puny," although he never complained. After one Sunday dinner at his home, as we were parting ways, he stood up, looked me in the eye, and said, "Lesley, I am fading away." It broke my heart but I had to play the "stoic Frowick" role: stiff upper lip and remain positive.

On April 23, our joint birthday, the gracious Barbara Dente, fashion stylist extraordinaire, invited us to her freshly renovated apartment in the West Village for a celebration. It was a bittersweet party that year, no angel's food or devil's food cakes, with my departure looming. Though I didn't know it, it would mark our last birthday celebration together. Tim and Karen ordered a surprise cake for us in the shape of an Airstream with the Warhol portrait of Halston next to it. It was a memorable celebration of friendship, family, and life.

Soon Halston busied himself planning the ultimate farewell party for me. It was part bon voyage, part last hurrah, for Halston as well, probably one of his last parties held at 101. He rallied for the occasion, even though I knew at that point he was already feeling rather ill and tired. He generously opened his doors to all my friends and his/our inner circle: Tim and Karen, Bill and Nancy, Hiro, D. D., Jeffrey Bilhuber, Tom Scheerer, and more. I was never able to put into words how deep an impact this parting gesture meant to me. I remember him leaning on the stereo console, dressed in his signature black turtleneck and gabardine pants with his concho belt slung around his increasingly slimmer waist, giving me that connective twinkled gaze from across the room. He focused all his energy on being excited and happy for me. I tried again to be a "stoic Frowick," but I was crumbling inside. A few days later, with tears welling in my eyes, I left New York, Halston, and the amazing life I had known for the previous seven years. The next eight months were the most melancholy of my life. During the trip, I checked in with Halston on a regular basis from the pay phones that dotted the landscape plentifully in those pre–cell phone days. It was only a few weeks into my trip that he fell very ill and was admitted into the hospital. I was compelled to inform my father, as he was the elder brother and should be there at his side in his most dire time of need.

Although Halston had told me he would give me power of attorney, I knew I was not prepared to handle such a responsibility. I wanted him to have a family member with him, someone who would look out for him and love him unconditionally as I had for the past seven years. I wanted to go myself but Mohammed firmly told me that Halston would not want me to cut short my trip. My dad took leave from his high-powered ambassadorial position to the United Nations mission in Vienna to step in and take over Halston's legal affairs. My father stayed with Halston until he made a miraculous recovery—my family and I suspect that was entirely due to the ray of loving light that my dad brought back into his life. By this point Halston had essentially cut himself off from all people in his New York life except Mohammed, Lisa Zaye, his attorneys, and me. He did not want even his siblings to know he was sick, partly to spare them the agony but partly because his condition had a stigma attached to it and he was not, in my opinion, prepared to deal with the drama of explanations. So many things were left unsaid in our family and this was one that was a silent understanding. We loved him unconditionally, which is what I had tried to convince him of during the seven years that I lived near him. I think what strengthened my relationship with Uncle H was that on my mother's side of my family I had another gay uncle, Jeff, a.k.a. Unca Jaff, to whom I had grown close. As fate would have it, my two closest uncles both passed away within three months of each other, from the same disease.

I was in New Orleans when I found out Halston was in the hospital. Once I knew he was in the gentle care of my father, I was able to carry on. I drove on to Baton Rouge, where I met up with my friend Terry Little and spent a beautiful weekend with the gracious Parlange family. It was a highlight of the trip, albeit darkened by the shadow of my grief. Though I knew he wouldn't have allowed it, I wanted to be beside him, holding his hand. It was at once an agonizing and fulfilling personal journey.

When I arrived in San Francisco, I learned that Halston was packing up his household in New York prior to heading west. Mohammed and Lisa, who had left the OT behind after the birth of her son Russell and had gone to work part-time for Halston, packed up all his personal belongings before the movers arrived for the heavy stuff. They were, as always, thorough and thoughtful in sending a list of his personal items to each sibling and to me, per Halston's directions. In my shipment they even included a box of carefully wrapped half-burnt candles—a memento of the last dinner party he had hosted at 101.

Once in California, Halston stayed first for a few months on and off, between trips back to New York or to visit Liza in Lake Tahoe, with his sister and my father in Santa Rosa. My little sister Brook recalls a gallant gesture. "My last memory of Halston was in our family living room here in Santa Rosa. He walked with his beautiful stride toward me by the front door. He welcomed me home from school and gave me a big hug and I remember that feeling to this day; my head was touching his chest and I could smell that wonderful scent so uniquely Halston—that combination of cashmere sweater and Z-14 cologne. It was one of the most wonderful gifts he gave from his heart because it showed how much he cared about me."

In January 1990 he spent one month in the penthouse suite at the Mark Hopkins Hotel in San Francisco. It was a stay that was peppered with a few visits to the Pacific Presbyterian Hospital. I met him there for dinner almost every night after work. Before he left New York, he began negotiations to purchase a piece of property outside of Santa Rosa, on a mountain that overlooked Bennett Valley toward my father's and aunt's homes. On a clear day with binoculars, one could almost see as far as San Francisco. During our time in Montauk, he would explain to me his designs for his dream home, which is what I believe he would have liked to have built on that property. It would be Japanese in style, with an inner atrium surrounded by three bedrooms, each with their own separate entrances spilling out toward a beautiful view. The atrium would have Zen landscaping and a trickling waterway. The dining and relaxing areas would be separate from the living accommodations. An architect assisted Halston with his plans and his dream home came true—at least on paper. He took the family out to see the property over Thanksgiving 1989. At dinner, he handed all the ladies Tiffany & Co. boxes, each with a different Elsa Peretti silver necklace-and-earring set, which he instructed us to put on. The next afternoon, we all drove up to the property to have a look. There was a rusty old tractor left over from the ranch hands that seemed to be perfectly positioned under a centenarian oak looking out toward the vista. In awe, we gazed at the view of the gently rolling Sonoma County hills studded with coastal redwoods. Halston stood next to the tractor, one foot up on the pedals, perhaps dreaming of what could have been his last big design effort. I think we were all hoping for a miracle that afternoon. It was Halston's last Thanksgiving.

As his illness progressed, it soon became evident that even if he were able to purchase the property, he would not live long enough to see his dream home built. Halston tried to carry on normal life as long as possible, always perfectly dressed in his black cashmere turtleneck and freshly pressed wool gabardine pants. He wanted to spare his family the potential embarrassment of the public reaction to the "gay disease." Although San Francisco's Castro district had become the epicenter of "out," there remained rampant discrimination against "alternative" lifestyles and sexual orientations, which

has taken years for society to overcome; it seems that just this past year, in 2013, there has been markedly broader acceptance of civil rights in regard to one's sexual orientation. The Centers for Disease Control and Prevention had not even put an official name to AIDS until 1982. ACT UP (AIDS Coalition to Unleash Power), an international advocacy group working to impact the lives of people with AIDS, was yet in its infancy, staging protests to raise public awareness of what was still a cloaked disease. The AIDS Memorial Quilt/NAMES PROJECT was conceived and had its first public viewing on the National Mall in October 1987. With few pharmaceutical treatments available, AZT was, for most people, unaffordable at ten thousand dollars per patient per year. Many AIDS victims tried experimental medications to no avail (including my Unca Jaff, who tried an expensive and ineffective treatment called Compound Q) or with immediate deadly consequences. Sadly, there was little mainstream attention to what was being viewed by the scientific and medical communities as a pandemic.

That fall Halston bought himself a Rolls-Royce Corniche, and although he was capable of driving himself, my father was tasked with being his chauffeur. I believe they both outfitted themselves with tweed caps and kid-leather driving gloves. My father drove Halston along the majestic California coastline, through the redwood forests, around Sonoma County wine country and to the beach, our family always by his side. One weekend, the siblings drove to Big Sur and stayed at the earthy luxury resort of Ventana Inn. The first night after dinner, Halston retired to his room to relax and watch TV while his siblings took to their hot tub and fine wine, hooting and hollering and apparently raising a commotion. After a time, the irate management knocked on Halston's door and asked that the hot-tub party cease immediately. He got up and chewed out his siblings, telling them to go to bed.

In January 1990, Halston asked me to find an apartment for the two of us in San Francisco with the intent that I would be his primary caretaker. He moved into the Mark Hopkins while I launched an all-out house hunt. With his exacting taste and specific requirements—no steps, easy parking, two bedrooms, close to the hospital—this was no easy task. There was a large Victorian apartment on "Snob Hill" with the largest moose head I had ever seen over the fireplace. That would be a big NO. There were a few cute, pink places in Noe Valley, one with great view but with too many steps, while another contender was ruled out because it was on noisy Church Street. Finally, I found the near-perfect apartment on the border of the Mission and Castro districts. It was recently renovated, two bedrooms, white walls, new wall-to-wall gray carpeting reminiscent of 101, Victorian charm, a fireplace, and new kitchen and bathroom. Save for two steps, it was perfect. I made a quick presentation of the Polaroids and he approved. I signed the lease and awaited his arrival.

But it wasn't to be. In late February, he went into the hospital and didn't come home again. Every day on my lunch break, I zoomed over to be with him. I wanted him to know that there was at least one person in the world who would be there till the end. In reality, the line of adoring family and fans would have wrapped around the world a few times, but they were all kept at bay. I would drive over to be with him for dinners in his hospital room; he would order Meals on Wheels and watch me eat and ask how it tasted. We would watch *Entertainment Tonight* every night and he would comment on all his friends who appeared on-screen under Mary Hart's narration. We discussed life and how things could have been different. He told me, after we watched a documentary about Karen Carpenter, that he was giving me his personal archives so that if I wanted to write a book on him I'd have everything I would need. He still held his head high and would make jokes or poke fun at me but he always encouraged me to follow my own dreams. I would call him every day to let him know when I was coming. Our last night together, I rubbed his leg and told him I loved him and would see him tomorrow. As I stood with the door ajar, about to leave, I said, "I

love you." He said, "I love you, too," and a tear welled up in his eye. He didn't break eye contact. It reminded me of how we would play staring games when I was a kid, but this time he was not doing it to provoke a giggle. I guess he knew he was ready to move on.

The next afternoon, as usual, I called from the pay phone booth in the back room of the photography lab where I worked. To my shock, the nurse answered. I experienced an instant rush of adrenaline—I knew the time had come. She would not tell me anything other than he could not come to the phone. My heart sank. I knew I was not equipped to deal with the emotional floodgate that would open and not close for years to come. I got to the hospital as fast as I could and stayed with him in his room. The doctors came. I told them to do something, but they said it was not his wish.

I kept asking myself, "How could he do this to me?" I could not bear the thought of not having his smile, his guidance, and his strength in my life anymore. The TV was on—it was March 26, the night of the Academy Awards, and the beautiful people were doing their red-carpet strut, some of them in Halston creations. It seemed like an appropriate time for Halston to fade away. And when the ad for Halston for J. C. Penney aired, I felt as if that was his final public statement to the world. What a hell of a life he had! Halston lived young, surrounding himself with youthful people, and I believe he would not have wanted to grow old. His time had come. His siblings and I were at his bedside for the last rites. The nurse shared our grief and the doctors all said what a humorous and delightful patient he had been. It was the Halston effect—he could charm anyone.

Although Halston was a private man, especially about his "complaint," my father had wanted to maintain a sense of dignity and truth about Halston's death, so after much soul-searching, he decided to make the cause official. I was at first deeply hurt, but in the end it would have been a bigger betrayal to deny the cause. AIDS victims needed visibility—so many famous and talented people were fading away unnoticed under the guise of other diseases.

March 31 was the packed private funeral at San Francisco's Calvary Presbyterian Church. I could barely walk. My brother George took me by the arm in order to prop up my pathetically weeping woman-child self—Halston would have hated it—as I took my seat. The pews were packed with family and close friends including, of course, the gang, many of whom had flown out together: D. D. Ryan, Bill and Nancy Dugan, Karen Bjornson and Tim MacDonald, Jeffrey Bilhuber, Berry Berenson, Dennis Christopher, Liza Minnelli, Lisa Zaye, Mohammed, to name a few. The service was followed by a life celebration at the Top of the Mark hosted by Liza. Afterward, the gang came to the apartment that he and I would have shared and, in true Halston tradition, we celebrated him into the wee hours, surrounded by his gray wool furniture, votive candles, and Elsa's crystal balls. I had set out as many photos of him as I could find. You could definitely feel his spirit that night in the living room.

Shortly after his death, Liza started planning the tribute at Lincoln Center's Alice Tully Hall. The day before the memorial, I organized a trip to Montauk, where Halston had had so many happy moments, for my stepmother, Ann, Liza, and me to scatter his ashes. We flew out on the same plane that Halston had used, with the same pilot, Captain Mike, who was honored that we chose him for this meaningful event. I found a skipper with an old fishing boat called the Oh Brother to sail us out to the perfect spot, and we swung by Herb's on the way to the marina in order to pick up Halston's favorite BBQ chicken. Rough seas forced us to cling to the sides as we prepared the ceremony, Liza singing a hymn as the boat rocked furiously from side to side. As soon as the ashes were scattered we had a group hug. Then a lone seagull strafed the side of the Oh Brother and the seas instantly calmed. Even the skipper made an astonished comment. It was Mother Earth letting us know that Halston was back at one with her, and it would all be okay.

Contact sheet of snapshots—some of my last photographs of my Uncle Halston—taken at Montauk, 1986. Following pp.: The last portrait session that Halston allowed at his town house, 1988. The photographs from this session were intended to be used in a brochure for Halston's donations of Warhols to the Des Moines Art Center.

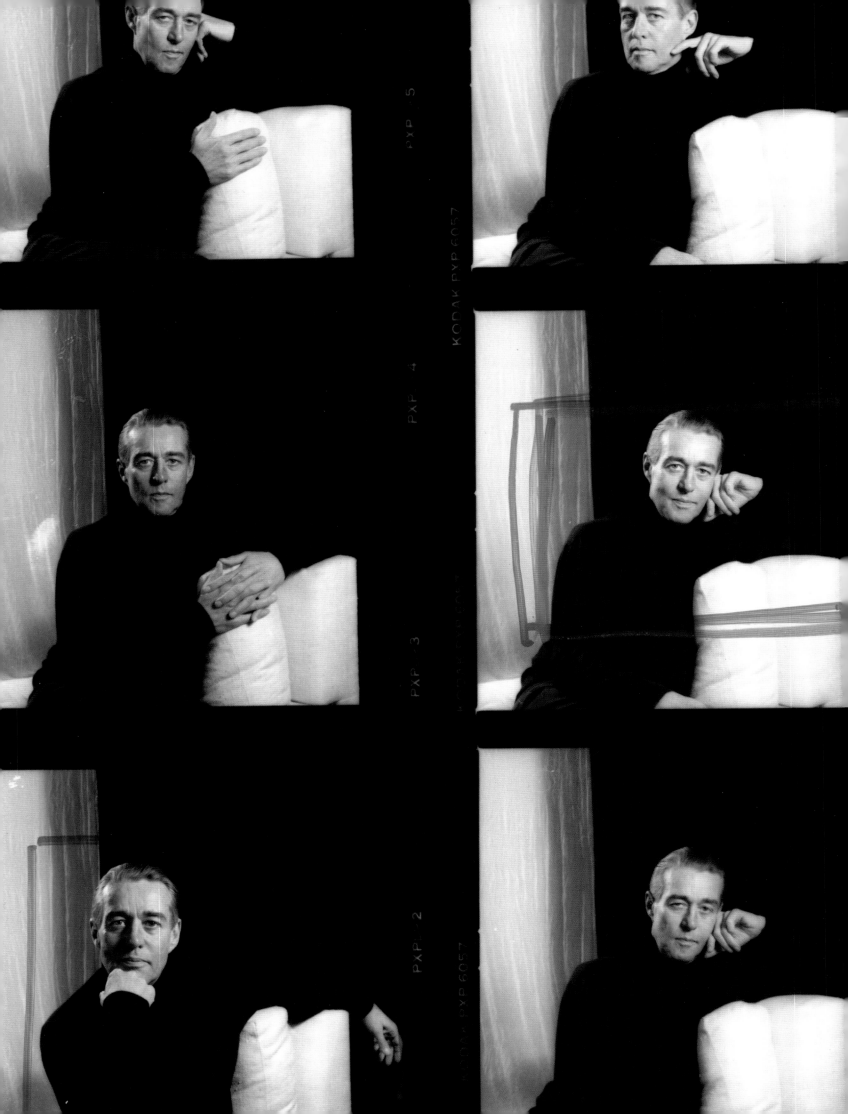

AFTERWORD

This literary journey has been bittersweet. Even after twenty-four years, I miss my uncle more than I can say. And, judging by the teary and poignant memories that his friends and co-workers shared with me, I'm not the only one. He was deeply loved by those who were part of his world. Everyone I spoke to felt as though he or she was important to him. That was a gift he had, to make people feel that way. This element of his legacy is not so well known, but it's one that I would like to call attention to. He's as present in people's hearts as he is in the fashion landscape that he helped to create. Through this book-writing process, I learned even more of what a thoughtful, impressionable person Halston was. I was impressed at the breakneck speed at which people returned my calls and at the outpouring of goodwill to help make this a fitting homage to Halston. I wish I had paid more attention at that time, now that I find so many people's curiosities are still piqued by the Halston lore.

There's no doubt that Halston left an indelible mark on American fashion. He made it modern. Yet despite the fashion industry's collective fascination with him and his legacy, no one has been able to replicate the Halston mystique. This is not for lack of trying; attempted revivals of the house of Halston are about as predictable as wool for fall and florals for spring. But despite the best intentions of a lot of talented people, the formula remains elusive. Without the master at the helm, it seems, there can be no Halston. And while that is sad, I think it's as it should be. Halston was one of a kind. During his twenty-some years of hard-core designing, Halston stamped his brand of chic on so many products and memories. Just the other day I pointed out an image on an H&M billboard to my son, Beau, exclaiming, "It looks just like a Halston design, a jersey cinched-at-the-navel halter dress." Later I showed him a Stephen Sprouse sketch of the exact dress design. Halston's influence will be felt beyond even the generations that will remember him. His dazzling time is lost; however, the brand remains afloat now, through the caring hands of its new owners.

Halston didn't do second-rate. When he made something, it was exactly the way he wanted it to be. He put forward his very best effort to make the world, and especially the lives of his inner circle, as beautiful and comfortable as he could. "I spoiled all of you," he used to say, and he was right. I still wear my own Halston originals, and when I do, I remember him telling me, "These clothes are of the best quality. Take good care of them and they will last you a lifetime." Again, he was right. When I wear them to receptions or on other special occasions, I always feel like one of the best-dressed people in the room. I think he would be thrilled to know, first, that I have managed to take fairly good care of his originals, and second, that he did in fact design for me the best overall practical wardrobe for day and night that has stood the test of time. For those of us who can still squeeze into our Halstons, and I know Liza and his cabine of models and my friend Jessie can, they do certainly remain head turners. My life has been immeasurably enriched by Halston's guidance and generosity, and to say I was privileged to be part of his world is an understatement. I believe he deliberately brought me into his milieu so that I could tell his story and keep his spirit alive. In inviting me in, he presented his life to me on a silver platter. It's my pleasure to maintain its polish.

Halston, photographed in 1988.

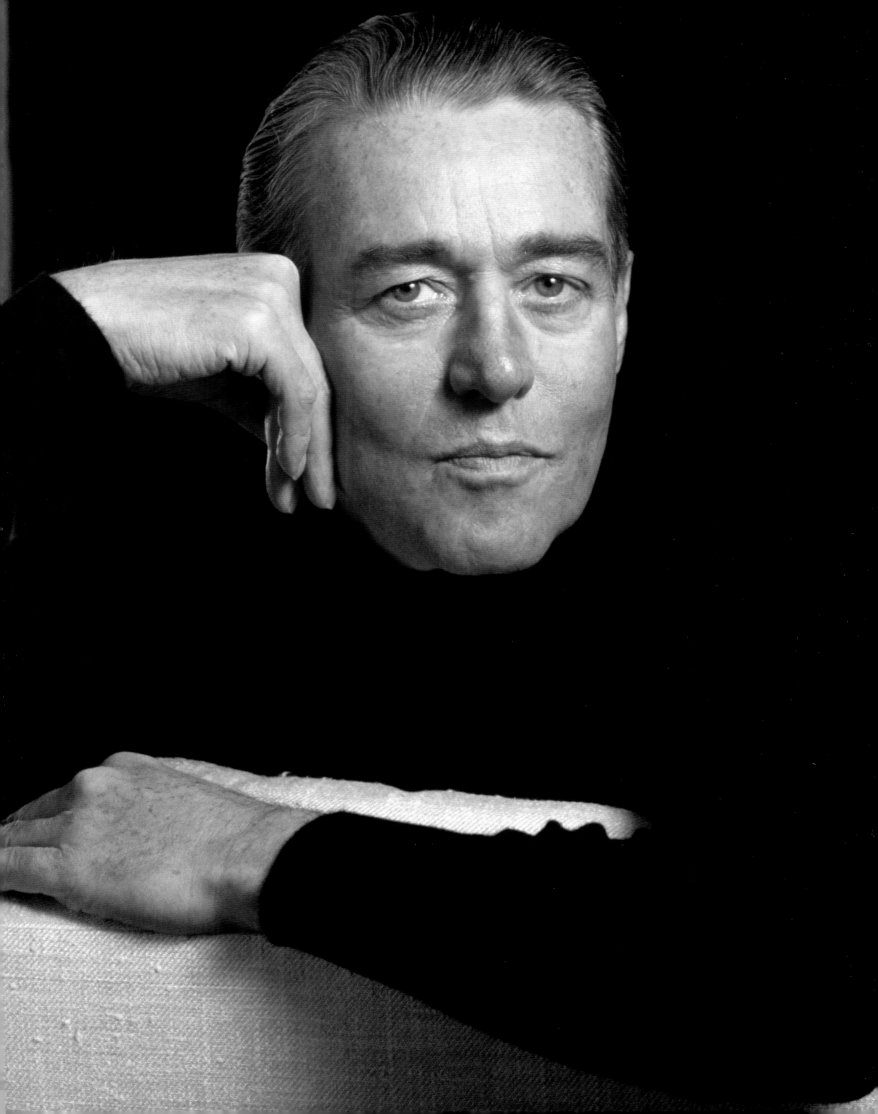

ADDITIONAL CAPTIONS

ONLY OPPORTUNITIES pp. 32–33 Sketches by Halston of masks, c. 1975. Masquerades and balls never failed to get the designer's creative juices flowing. **pp. 38–41** Early sketches by Halston of Paris couture fashion shows, c. 1966. Ambitious—some might say even driven—Halston was always working, observing details and silhouettes as models walked the runways at his peers' shows. **MOVE WITH FASHION pp. 104–5** Clockwise from top left: Halston's bedroom, accessible by the floating stairs from the living room; a view of the mezzanine at "101" with a Plexiglas sculpture by Arman; the top-floor guest bedroom; the living room with lush bamboo garden, providing a sense of repose even in the middle of the bustling city. Artwork hanging and leaning on the walls is by Warhol. **pp. 114–15** Halston's crew, photographed for Esquire magazine, 1975. Left, back row from left: Joe Eula, Halston, Elsa Peretti, and Terry Jarrett; front row from left: Chris Royer, Bill Dugan, Margaux Hemingway, and Marisa and Berry Berenson. Right, back row from left: Pat Ast, Victor Hugo, Tony Spinelli, and Heidi Goldman Lieberfarb; front row from left: Shirley Ferro, Victor Caraballo, Bobby Breslau, and Karen Bjornson. **pp. 118–21** Sketches by Halston, c. 1975. His iconic silhouettes were there, in line, from the very start. **pp 122–23** Illustrations by Stephen Sprouse of Halston designs, Spring 1975. Sprouse, a fellow Midwesterner and part of the next generation of influential designers, learned how to evoke luxury and simplicity with every gesture from Halston. **pp. 124–25** Illustrations by Joe Eula of Halston designs for shoes, 1975. The incomparable Joe Eula was one of the finest illustrators who helped define the Halston style. **pp. 126–29** Illustrations of Margaux Hemingway by Joe Eula, with fabric swatches, c. 1975. Long before her tragic early death, Hemingway was a rising star who was a close friend and went to clubs on Halston's arm. Halston's loose, swinging lines are heightened by Eula's skilled hand, complementing the garments' understated hues in luxurious cashmere and chiffons. **pp. 130–31** Halston, Martha Graham, and First Lady Betty Ford at the Martha Graham School of Dance, c. 1975. Halston's support of and admiration for Martha Graham was longstanding; Betty Ford, before her life in the public eye as wife of president Gerald Ford, had been a student of Martha Graham's, even performing with her troupe in New York City at Carnegie Hall. **pp. 132–33** Illustrations by Nancy Stone of Halston-designed outfits for Martha Graham, c. 1983. Martha Graham's dramatic look and stature as one of history's greatest dancers and choreographers and Halston's bold shapes and classic lines were a perfect match, both onstage and off. **pp. 134–35** Onstage in celebration of the fiftieth anniversary of the Martha Graham Dance Company, 1975: Halston, First Lady Betty Ford, Martha Graham, Margot Fonteyn, and Rudolph Nureyev. Nureyev is wearing a Halston-designed platinum-mesh costume in the title role of the dance Lucifer, and Fonteyn wears a Halston-designed headdress (see page 181 for an illustration). **pp. 138–39** Halston, Gerard Malanga, Pat Ast, and Berry Berenson sharing a laugh at Halston's salon on East 68th Street, 1968. **pp. 140–41** Martha Graham, Elizabeth Taylor, Halston, and Liza Minnelli at Olympic Tower, when Halston was presented with the third annual Martha Graham Award for his contributions of time, designs, and costumes to Miss Graham's works, May 21, 1979. **pp. 142–43** Left: Sketch by Joe Eula of D. D. Ryan and Halston in Acapulco, Mexico, 1977. Acapulco was the site of the extravagant and very successful launch for the Halston redesign of Braniff Airways uniforms. Right: Sketch by Joe Eula of the Halstonettes lounging by the pool in Acapulco during the launch of Halston's redesign of Braniff Airways uniforms, 1977. Halston knew that the sure way to bring press attention to his endeavors was to surround himself with beautiful models, who became known as the "Halstonettes." **ALL THE BEAUTIFUL PEOPLE pp. 156–57** The itinerary for the Japan leg of the world tour, September 1980. In between fashion shows and visits to department stores and other PR events, members of Halston's entourage were fortunate enough to see the sights of Tokyo and Kyoto. **pp. 158–59** Halston and models in the dressing room, preparing for a fashion show in China during Halston's world tour, September 1980. **pp. 160–61** The Halston Enterprises list of visas for Japan for Halston's world tour, September 1980. **Pp. 170** Halston dancing with Elizabeth Taylor at her forty-sixth birthday party at Studio 54. Halston invited the Rockettes to perform their famous synchronized kick while singing "Happy Birthday," March 6, 1978. **p. 171** Halston at a Halloween party with Loulou de la Falaise in one arm and Donna Jordan in the other, c. 1974. **pp. 172–73** Contact sheet showing Halston with his models, sister in law Ann Frowick, and party guests at Regine's Club 7 in celebration of the introduction of his Classic fragrance in France, during Halston's world tour, September 1980. **pp. 186–89** Halston's couture gowns were highlights of every fashion season. On the runway: Pat Cleveland twirling a Halston beige tulle party dress, 1981; Alva Chinn in a Halston yellow bias "saucer" dress, 1978; Connie Cook in a Halston sky-blue tulip tunic with pants, 1979; unknown model in stunning purple bias satin dress at Halston Spring Summer collection, 1983. **p. 192** Sketch by Joe Eula of Bianca Jagger's two-piece outfit she would eventually wear for a party, c. 1978 **pp. 193–208** Celebrity fans of Halston wrote appreciative thank-you notes as well as pleas for advice or alterations, sometimes flamboyantly showing their love with "xxxooos" and kisses. **pp. 209–11** Sketches by Joe Eula of Halston's muse and close friend, Bianca Jagger, c. 1978. **pp. 212–13** Halston Accessories advertising campaign by Andy Warhol, 1982. Longtime friends and fellow stars of the New York scene, Warhol and Halston often collaborated on campaigns for Halston menswear, fragrance and cosmetics, and

women's apparel lines. **pp. 214–15** Halston with his models wearing beaded creations from his last collection, design-room assistant Anthony Falwell, and right-hand man Bill Dugan at Olympic Tower, 1984, photographed by Dustin Pittman. **pp. 216–23** Invitation and packed itinerary for a trip to Paris on the occasion of Martha Graham being awarded the French Legion of Honor at the Paris Opera, January 1984. Always supportive of Martha Graham, Halston flew her and his entourage on the Concorde to Paris for the occasion. **pp. 224–29** Liza Minnelli wowing the audience in a Halston-designed red sequin dance costume in the Broadway production of The Act, 1977. Halston designed all of her stage costumes. Colorful watercolor sketches by Joe Eula capture Liza's dynamic stage presence **(p. 225)**. Sketches by Halston, also for The Act, take every detail into account **(pp. 226–29)**. **pp. 230–31** Halston holding hands with Martha Graham in the sun-drenched garden of her school on East 63rd Street. In a note to Halston, Martha Graham expressed how much he meant to her. As for Halston, he held "Miss Graham" in the highest esteem and would do anything for her. **MAKE IT LOOK EFFORTLESS pp. 234–35** The Montauk lodge's living room, 1985. Halston fell in love with Andy Warhol's beach residence, in part because of the living room's grand slate floors and two fireplaces. Soon after renting from Warhol, he transformed it into a chic and restful oasis. **pp. 238–39** Halston, the prankster, always had a trick up his sleeve—another little-known fact that only those who were privileged enough to stay with him in his Montauk haven knew. **pp. 264–67** Contact sheet of photographs from Andy Warhol's memorial service at Manhattan's St. Patrick's Cathedral, April 1, 1987. Two thousand people came to pay their respects. Halston was devastated at his friend's death and never really got over it. Notable faces include André Leon Talley, Yoko Ono, Steve Rubell, Ian Schrager, Kelly and Calvin Klein, Bianca Jagger, Lou Reed, Bob Colacello, Halston, Liza Minnelli, Lynn Wyatt, Richard Gere, Lou Reed, and Mary McFadden.

PHOTOGRAPHY CREDITS

ACKNOWLEDGMENTS

This book would not have been possible without the support and contributions of so many individuals whose memories have not only enriched the story of Halston but helped to shape his legacy as well. My overwhelming appreciation goes to Halston himself for inviting me into his orbit, for his unwavering love and generosity, and for his spirit that helped guide me through this process. Thanks to my son, John Halston, for his love, support (cooking meals for me), and patience during this four-year journey. To my family for their support and for sharing their loving Halston memories and personal photographs: Shirley Frowick, Ann Frowick, George Frowick, Brook Frowick-Drummond, Dottie Frowick Kummerer, Greg Norman, Heather Frowick, and Lawrence "Skip" Frowick.

A huge thank-you to Liza Minnelli for her extreme loyalty to my uncle, her generosity of spirit, and for sharing her tender memories of her buddy H. To Karen Bjornson MacDonald for her support, love, and loyalty to Halston. To the late Bill Dugan for getting me kick-started and for remaining loyal to Halston throughout all the highs and lows. To the late D. D. Ryan for being such a devoted friend and confidante to Halston. To Nancy North for her support, memories, and good cheer. To Faye Robson for supporting Halston during his formative years. To Lisa Zaye for being so good at what she does. To Alva Chinn for her solid support—namaste!—and to Pat Cleveland for sharing tears of joy. To Jeffrey Bilhuber for his friendship and for paving the way to Rizzoli.

A special thank-you to my editor, Giulia Di Filippo, at Rizzoli for her gentle guidance and grace producing this book, and to Anthony Petrillose for his good counsel and photo research. The text could not have been shaped into its final form without the help of Nancy MacDonell and Elizabeth Smith. Sam Shahid and Matthew Kraus of Shahid & Company produced a book design beyond expectations.

Gratitude to the following people who generously offered their artistry: Hiro for his friendship and loyalty to my uncle, and Peita Carnevale for her kind assistance; Alexandre Barthet for his generosity in offering the photograph by his father, Jean Barthet, for the cover; Christopher Makos, Peter Wise, Charles Tracy, Bill Cunningham—thank you! Dustin Pittman; Diana Walker; Gigi and Harry Benson; Neil Barr; Jean-Paul Goude; Robert Kevin Morris; Beau Ryan and the late Drew Ryan; Oz and Elvis Perkins for their generous contribution of photography by their mother, Berry Berenson Perkins; Nancy Stone for her fabulous fashion illustrations;

Joanne Sprouse for allowing me to feature Stephen Sprouse's illustrations in this book; Melisa Gosnell for her help with Joe Eula's illustrations; and Bill Zwecker for generously providing the photo of his mother, Peg Zwecker, who believed in Halston and helped launch his millinery career. To Peggy Cantlin-Kern (a.k.a. Moozlee) for allowing me constant access to "the nest" in New York, without which I could not have produced this book.

My profound thanks to the Fashion Institute of Technology and Karen Cannell for assistance with gaining access to the FIT Halston Archives; Matt Wrbican and Greg Burchard of the Andy Warhol Museum; Girl Scouts of the USA Chief Strategist Pamela Cruz; Janet Eilberg of the Martha Graham School of Dance; Christine Daikin; David Hochoy; Linda Hodes and Jeanne Ruddy; my dear friend Jeffrey Wirsing for his eternal support, good cheer, and memories; curator Niloo Paydar for the flower dress photo and the tour of the Indianapolis Museum of Art; Dennis Christopher for the fun memories and for being there; Stephen Burrows for sharing his Versailles memories; Tim MacDonald for being the wonderful man he is; Harold Koda for the generosity of his time and for being so eloquent; Vincent (did I say Dorian Gray?) and Shelly Freemont for their Warhol-Halston memories and for willingly negotiating those Victor deals; and Joel Schumacher for helping launch Halston's career and sharing his heartfelt memories of "the prince."

I'd like to extend special thanks to the following people for their assistance and for sharing their memories of Halston: Hillie Mahoney, Jeff Maddoff, Jane Holzer, Chris Royer, Hamish Bowles, Grace Mirabella, Marisa Berenson, fashion stylists extraordinaires Jade Hobson and Barbara Dente, Bob Colacello, Donald Luckinbill, Naeem Khan, Nick Lewin, Pat Shelton, Paul Siskind, Paul Wilmot, Ralph Rucci and Rosina Rucci, Reiko Ehrman, Enrique Maza, Richie Nator, Ernst Wagner and the Paul Rudolph Foundation, Cynthia Cathcart of Condé Nast, Lori Reese of Redux/New York Times, Kevin Gippert of Getty Images, Alice Crites of the *Washington Post*, Joanne Donaldson of the Des Moines Public Library, Robert Steir of Toray Industries, Hartmann, Phyllis Collazo of the *New York Times*, the late John Miller, my colleagues at National Geographic Betty Behnke and Maura Walsh, and Marylou Luther, who, had fate not intervened, would have written this book.

And to all those who had a hand in helping to shape Halston's amazing legacy, thank you.

Front Cover: Portrait of Halston in Paris, c. 1966, by Jean Barthet. Courtesy Alexandre Barthet Collection.

Back cover: Illustration by Halston of his sarong dress, c. 1975. Courtesy Lesley Frowick Collection.

Front and back endsheets: Sketches by Joe Eula of Halston at work, 1975 (front) and 1978 (back).

Contents: Portrait of Halston by Andy Warhol, 1974. Halston used this portrait in Halston Ltd. advertisements in the mid-seventies.

First published in the United States of America in 2014 by

Rizzoli International Publications, Inc.

300 Park Avenue South

New York, NY 10010

www.rizzoliusa.com

Publication © 2014 Rizzoli International Publications, Inc.

Whatever Makes You Happy ©2014 Liza Minnelli

Editor: Giulia Di Filippo

Production Manager: Susan Lynch

DESIGNED BY SAM SHAHID

Art Director: Matthew Kraus

2014 2015 2016 2017 / 10 9 8 7 6 5 4 3 2 1

ISBN: 978-0-8478-4349-7

Library of Congress Control Number: 2014936539

Printed in China